# GREEK SCULPTURE

GREEK

RHYS CARPENTER

# SCULPTURE

A CRITICAL REVIEW

THE UNIVERSITY OF CHICAGO PRESS

ISBN: 0-226-09473-1 (clothbound); 0-226-09475-8 (paperbound)
Library of Congress Catalog Card Number: 60-14233

The University of Chicago Press, Chicago 60637
The University of Chicago Press, Ltd., London

Printed in the United States of America

# FOREWORD

THE PRESENT VOLUME CONTAINS singularly little comment on
the lives, reputations, and accomplishments of the old Greek masters
and, instead, pays what may seem undue attention to sculpture as an
anonymous product of an impersonal craft. Nor will there be found
much consistent appreciation of the beauty of Greek sculpture as
something unique created by the genius of the individual artist
striving for self-expression of an inner vision of his own. An attitude
of intellectual aloofness without show of human interest is essential
to the purpose of this book, which seeks to understand and explain
the evolution of sculptural style in ancient Greece. It does not pre-
tend to provide an encyclopedic compendium of all that is known
about Greek sculpture, as though by some miraculous *multum in
parvo* a brief text accompanied by four-dozen illustrative plates could
summarize the thousands of pages and many hundreds of pictures
which any fully informative conspectus of the subject would require.

If so much of the text is devoted to technical procedure, that is
because the technique of the artist's craft is the mirror in which the
pageant of changing and evolving style is reflected. In dwelling so
much upon craftsmanship in common use and so little upon indi-
vidual artistic genius I take consolation from the thought that the
ancient Greeks, who are popularly credited with an appropriate

word for everything, had no single term for Art, but obdurately persisted in referring to it as *technē*, which is to say "skill of hand," "workmanship," "craft," and even "cunning," but not what most men mean today when they say "Art."

The illustrations for this book have been assembled with great care for their photographic excellence—herein I was fortunate in being permitted to draw on Alison Frantz's brilliant series. But although many of the finest surviving masterpieces are shown (along with little that is second-rate and nothing that is mediocre), the material has been selected with only one purpose in mind, that of making the evolution of Greek sculptural style visually intelligible. Without such aid no amount of verbal elucidation could convey any just comprehension of the matters with which this study deals. By confining discussion to a limited number of typical examples, rather than attempting to embrace and hold fast the Proteus of shifting shapes which Greek sculpture assumes, it has been possible to trace without serious break or omission the stylistic development of six hundred years of uninterrupted activity. This is so because art is not of any one man's making but is a cumulative wisdom and a gathered experience.

Where statues are mentioned without accompanying photographic illustrations, consultation of Part II of the Bibliography, which precedes the Index at the end of the volume, will provide access to reproductions of the work in question. There are now to be found on the market, in most general libraries, and on all professional shelves, several picture books on Greek sculpture entirely commensurable in quality with the excellence of the art which they reproduce.

In dispensing with all footnotes I am aware that my scholarship runs constant risk of unfavorable appraisal—but probably not so much from my own profession, which may be expected to discern between the lines the mass of commentary I omit.

# FOREWORD

To avoid all possible misapprehension, it should be noted that, where no further indication is added, the tally of centuries and years makes reference to the period before the birth of Christ.

If I have ventured to challenge several currently accepted attributions to period or authorship of well-known masterpieces, this is not because I belong to Pindar's "most foolish tribe among men, which scorns what is nigh at hand and searches for what is afar, pursuing empty nothings with idle expectations," but because instances such as these offer the surest proof that an understanding of stylistic changes (and of the reasons why those changes have taken place) is an effective and indispensable instrument of sculptural criticism. Few of those who consult the well-compiled and authoritatively written handbooks on Greek art have any suspicion that the proud edifice of Greek sculptural history is reared on a quagmire of uncertainty, ambiguity, and baseless conjecture. It could not be otherwise. The ancient statuary which has survived into modern times is largely anonymous; it carries no label to tell us what it is or whence it came. To put the scattered and fragmentary pieces into some sort of rational order, to find names for their makers and a background of time and place for their making, was the remarkable accomplishment of the last hundred years of archaeological scholarship. The difficulty remains that there is no external authority to which an appeal can be made to decide whether that which has been done with so much industry, devotion, and intelligence has been done correctly. The court of final cassation has been the *communis opinio* of those who themselves could have no greater knowledge. We must all accept the information that our teachers dole out to us, else we shall make little headway toward understanding; so that, unfortunately, a mere conjecture emanating from the scholarly workshop needs only thrice-repeated approbation, *ex cathedra magistrali*, to become authenticated and universally accepted fact. As in so much else, the only tests of truth are self-consistency and an absence of inherent con-

tradiction. But if it can be shown (as the present study attempts to do) that sculptural styles are not casual mannerisms, such as any artist might at any time invent and popularize, but are strictly conditioned by evolutionary laws which are in turn dependent upon the unchangeable dictates of the mechanism of human vision, then an external authority has been provided for testing the truth or falsity of our present reconstruction of Greek sculptural history—or for that matter, of any other sculptural sequence in human culture.

The parallelism in the succession of styles in ancient Greek sculpture and in the European sculpture of the present millennium has often been observed; but to my knowledge no explanation for its occurrence has been provided. In seeking to attribute the incidence of style to the pathology of human vision the present study tries to lay the groundwork for a rational understanding of stylistic evolution as something not invented by the artist but dictated to him.

# CONTENTS

PAGE

I. THE BEGINNINGS                                              3

II. THE ARCHAIC PHASE                                         27

III. EARLY RELIEFS AND HOLLOW-CAST BRONZES                   59

IV. TOWARD THE FORMATION OF A CLASSIC STYLE                  86

V. TEMPLE PEDIMENTS: CLASSIC DRAPERY                        109

VI. HIGH CLASSIC                                            152

VII. SCULPTURE IN THE THIRD CENTURY                         180

VIII. THE RENASCENCE OF CLASSIC FORM                        198

IX. THE INTRUSION OF PLASTIC FORM                           228

BIBLIOGRAPHY OF SOURCES                                     255

TOPICAL INDEX                                               266

PLATE CREDITS                                               273

PLATES                                                      275

# ILLUSTRATIONS

PLATES FOLLOWING PAGE 274

PLATE I          KRIOPHOROS OF THASOS

PLATE II         ARCHAIC KOUROS IN NEW YORK

PLATE III        ARCHAIC KOUROS IN NEW YORK: LATERAL
                 VIEWS

PLATE IV         LYONS KORĒ: TWO VIEWS

PLATE V          ANAVYSOS KOUROS: HEAD

PLATE VI         ANAVYSOS KOUROS: TWO VIEWS

PLATE VII        HEAD OF THESEUS FROM ARCHAIC PEDI-
                 MENT

PLATE VIII       STELE OF ARISTION: DETAIL

PLATE IX         MYRON'S DISKOBOLOS: RECONSTRUCTION

PLATE X          BRONZE CHARIOTEER OF DELPHI: TWO
                 VIEWS

# ILLUSTRATIONS

PLATE XI         EUTHYDIKOS KORĒ

PLATE XII(A)     HEAD OF "BLOND BOY"

      (B)        HEAD OF "KRITIOS BOY"

PLATE XIII       DORYPHOROS OF POLYKLEITOS: RECON-
                 STRUCTION

PLATE XIV        DORYPHOROS OF POLYKLEITOS: TORSO

PLATE XV         OLYMPIA, WEST PEDIMENT: KNEELING
                 LAPITH

PLATE XVI        OLYMPIA, WEST PEDIMENT: GROUP OF
                 LAPITHS AND CENTAUR

PLATE XVII       OLYMPIA, EAST PEDIMENT: ATTENDANT

PLATE XVIII      STUMBLING NIOBID

PLATE XIX(A)     PARTHENON, EAST PEDIMENT: SEATED
                 GODDESS

      (B)        PARTHENON, WEST PEDIMENT: "IRIS"

PLATE XX         MYRON'S DRUNKEN OLD WOMAN

PLATE XXI        PARTHENON, WEST FRIEZE: TWO SECTORS

PLATE XXII       GRAVE RELIEF OF DEXILEOS: DETAIL

PLATE XXIII      NIKE PARAPET: TWO FIGURES

PLATE XXIV       NIKE OF PAIONIOS

PLATE XXV        COLOSSAL CYBELE

# ILLUSTRATIONS

PLATE XXVI          LEDA WITH THE SWAN: TWO VIEWS

PLATE XXVII         MAENAD RELIEFS: TWO FIGURES

PLATE XXVIII        BRONZE BALLPLAYER

PLATE XXIX          BRONZE BALLPLAYER: DETAIL

PLATE XXX           BRONZE "ZEUS" OF ARTEMISION

PLATE XXXI (A)      PROTESILAOS

          (B)       LATERAN MARSYAS

PLATE XXXII (A)     CAPITOLINE RUNNER

          (B)       DRESDEN BOXER

PLATE XXXIII        COLUMN DRUM FROM EPHESOS

PLATE XXXIV         BRONZE SEATED HERMES FROM HERCU-
                    LANEUM

PLATE XXXV          BRONZE HEAD FROM PERINTHOS

PLATE XXXVI         APHRODITE FROM CYRENE

PLATE XXXVII        NIKE FROM SAMOTHRACE: TWO VIEWS

PLATE XXXVIII       "ZEUS-HERO" FROM PERGAMON

PLATE XXXIX (A)     KNIDIA OF PRAXITELES: HEAD

          (B)       APHRODITE OF MELOS: HEAD

PLATE XL            DEMETER OF KNIDOS

PLATE XLI           "MAUSSOLOS"

# ILLUSTRATIONS

PLATE XLII         MEDICI VENUS AND NEW YORK REPLICA

PLATE XLIII       FOUR HEADS: FIFTH, FOURTH, AND THIRD
CENTURIES

PLATE XLIV        BRONZE PORTRAIT HEAD FROM DELOS

PLATE XLV         BRONZE HEAD OF OLD MAN FROM THE
SEA

PLATE XLVI (A)   BRONZE HEAD OF BOXER FROM OLYMPIA

(B)   "HELLENISTIC RULER": HEAD

PLATE XLVII (A)  BRONZE "HELLENISTIC RULER"

(B)   COLOSSAL DIOSKUROS OF MONTE CAVALLO

## FIGURES IN THE TEXT:

PAGE

FIGURE I         RED-FIGURE VASE BY ANDOKIDES    42

FIGURES 2–3    THE FOUNDRY VASE IN BERLIN    78

# GREEK SCULPTURE

# I

## *The Beginnings*

WITH ONE POSSIBLE EXCEPTION, no truly primitive sculpture has survived from ancient Greece. This is not due to the mischances and destructions of time. Examples of such works have not been preserved because none such was ever made. The rudely incompetent experimentation which inevitably mars the initial efforts of self-schooled craftsmen is nowhere discernible in extant Greek sculpture —with one possible exception.

There is a unique piece of hewn stone, ineptly shaped to human form, which must unqualifiedly be rated as primitive. It was discovered in 1921 by a road-building gang constructing a highway in central Arcadia. Reportedly it lay close to the modern surface of the soil and without discoverable connection with an ancient site. This statue (if it may so be called) was a four-foot monolith of poor local limestone, showing little else than a crudely worked but well-rounded head upon a shapeless trunk. Round staring eyes, a perfectly flat, wedge-shaped nose, a straight-lipped expressionless mouth, a rather cleanly oval chin, constitute the distinguishable features. Such an uncouth production bears no resemblance to any known classical or Mycenaean work; and in view of its unparalleled style and inartistic clumsiness the query may be seriously advanced whether this *menhir herm* is not perhaps a Slavonic grave marker from the early middle ages of the Christian Era. If it is in truth of ancient Greek origin, then it must be the work of some isolated Arcadian highlander to whom

some verbal report of monumental statuary had penetrated without actual sight of its kind or any comprehension of the technique of its production. Accordingly, whether accepted or rejected as genuinely Greek, it remains outside the development of Greek sculpture, uninfluenced and itself without effect. For it was not out of a series of such rude experiments at teasing some poor likeness of humanity out of shapeless stone that the art of Greek sculpture took its rise, but as a technically already mature and artistically self-conscious process, schooled and skilled and sure of its results.

But such a situation is unthinkable, because humanly impossible, unless the requisite skill had been drawn from some already established tradition—if unavailable in Greece, then acquired elsewhere. Monumental glyptic sculpture, the art of cutting life-size figures out of solid blocks, is not an accomplishment that can be improvised; nor can it spring spontaneously expert from instinctive talent and innate skilfulness. Since technical instruction from elsewhere is implied for the oldest examples of Greek monumental sculpture which we possess today, there is no reason to claim that these examples need be much removed in date from the very first statues produced by Greek hands in Greek lands. If they strike us as already sophisticated artistically and of high quality technically, it is because they are not autochthonous beginners' trial pieces, but the work of marble cutters who have attached themselves to an already established and fully matured tradition in the craft.

Yet no such tradition had previously existed in Greece or in any Greek-speaking territory.

During the Mycenaean age no monumental sculpture in-the-round seems to have been produced. Large reliefs such as the heraldically opposed lionesses which still guard the gateway of the citadel at Mycenae presumably reflect Anatolian example; but for most of its artistic traditions and technical instruction Mycenaean Greece was dependent on Minoan Crete. And the precocious and impatient temper

of Minoan art with its emphasis on momentary visual appearances and arbitrary decorative effects inclined to pictorial impression rather than sculptural embodiment. The elaboration of more than merely optical shapes and fleeting appearances, which (as we shall see) sculpture imposes upon its practitioners, would have made little appeal to the Minoan mind—even though Minoan and after them Mycenaean Greek merchants were not infrequent visitors to the Egypt of the New Kingdom and must there have beheld sculpture aplenty. In any event, the enormous cultural regression, tantamount to complete political and economic collapse, which intervened between the Mycenaean and the Classical epochs would have precluded the transmission of an art so ambitious, so costly, and economically so unnecessary. No one has ever detected in the earliest classical life-size sculpture in-the-round any quality in the slightest degree reminiscent of any Minoan-Mycenaean manner.

But it is sometimes intimated that, since the making of miniature "sculpture" in the shape of clay and bronze figurines was demonstrably a flourishing industry in many Greek centers throughout the eighth and seventh centuries, monumental sculpture might have arisen locally and naturally by a gradual increase of scale until figurines had been expanded into life-size statues. Such a suggestion gains in plausibility because there are unquestionably statues of Greek workmanship and nearly of life size (such as the Naxian *Nikandrē* dedicated at Delos or the "*Lady from Auxerre*" of unknown provenance and now in the Louvre) which echo the so-called Daedalid tradition of earlier figurines and hence may be genetically descended from them. A survey such as the present one does not provide space for the unavoidably discursive demonstration that figurines and monumental statues belong to generically distinct orders of artistic form. But for exemplary indication that plastic (i.e., modeled) and glyptic (i.e., carved) sculpture are fundamentally distinct as art and not simply materially diverse in craft, the dual nature

of the classical Greek clay figurines may be cited. Throughout the classical period plastically formed clay figurines, modeled freehand without reference to major sculptural types, continued to be produced for the demands of a cheap popular market. These figurines consistently display archaic or even crudely primitive characteristics, no matter what their actual date of manufacture—a trait which has caused many a chronological misstatement of their genre in our museum labels. Quite apart from these, there developed the mold-cast "Tanagrettes," which were fully simulated statues in miniature and showed their adherence to sculptural art by copying the evolving mannerisms of the monumental style and not merely (though for this they have been greatly prized by collectors) the changing fashions of contemporary dress and costume. These, then, are truly statuettes rather than figurines, since they depend on the major art for all essentials. But if glyptic may thus exert a coercive influence on plastic production, it may be demanded why the reverse process may not have taken place to make Greek monumental sculpture a derivative from the Daedalid figurines. The proper reply is that neither art thus generates the other; all that has been observed is that, once both have been established, either may affect the other and inspire adaptive imitation. So different are the plastic and the glyptic conceptions, and so diverse are the optical problems inherent in the arm's-length focus of figurine modeling as opposed to the objectively remote construction of a full-scale replica of physical reality (which is what monumental sculpture must attain), that the similarity in subject matter is completely deceptive and gives no warrant for subsuming the two forms of artistic expression under the same category. Whereas the making of plastic figurines is as instinctive and natural in humankind as is the practice of drawing and painting, the creation of life-size replicas of objects in our visual experience is by no means an obvious or widespread esthetic response to the physical world. Apart from its communication through cultural diffusion, the notion

of freestanding monumental sculpture is so rare as to be almost an abnormality, even though we of the Western world, after so many centuries of familiarity with its production, are apt to take sculpture for granted as a universal and inevitable form of artistic activity.

From considerations such as these it is correct to conclude that the origin of Greek monumental sculpture must be sought elsewhere than in Greece itself. And since the date of the oldest surviving examples of the art seems provably coincident, within rather close chronological margin, with the Greek resumption of commercial relations with Egypt of the Nile Delta, and since it was Egypt which at that time most conspicuously practiced monumental sculpture, it is both natural and logical to look to Egyptian example for the necessary initial inspiration. There, in the Nile valley, the technically difficult achievement of extracting life-size solid images of men and animals out of quarried blocks of stone had been evolved two thousand years before the Greek classical era; and this art had endured with remarkable vitality and comparatively little change through all vicissitudes of political and economic history. Its origin, its formal traditions, and its unparalleled persistence are all accountable to the dictates of religious superstition and its accompanying credulous belief in magic. To the Egyptian mind, seeking assurance of continued personal immortality, a carved human effigy in wood or stone, hidden but accessible within the place of burial, offered an enduring substitute for the deceased body which, despite the embalmer's aid, might suffer destruction. The undecaying replica provided an alternate abode to which the escaped spirit might return at need, to receive the offerings of its descendants or other caretakers for the dead. In order to serve this magical purpose (the Egyptian reasoned) the substitute effigy must possess the outward shape and proper size of the body and, since personal individuality seems most essentially a distinction of facial features, a head displaying recognizable resemblance to the once living. This funereal requirement for a generic

body with a portrait head was the compelling force which shaped the sculpture of the Old Kingdom in the days of the great pyramids. And since magic invariably depends on fixed formulas, whether of spoken spell or mimetic gesture or visible presentation, Egyptian sculpture, once canonized, was not free to evolve through the progressive stages of realistic mimicry but remained stereotyped within the conventions of its magically adequate archaic phase. Those who examine it attentively can see that, within its formal restrictions, Egyptian sculpture does not lack the vitality of shifting interests and varying tastes. Yet, for all of these, what the Greek visitors to the Nile beheld in the seventh century was, formally and factually, sculpture in a pseudo-archaic phase, produced with great technical skill in an immemorially fixed tradition.

These Greeks had never before encountered life-size and colossal statues in-the-round. What they saw impressed them greatly—so much so that they were moved to emulation. Having no particular reason for making statues, they were possessed by a desire to make them and set them up in their own land. And never before or since has a people been so enthralled with this most unnecessary (but to the classical Greek utterly admirable) art.

Since the mere ambition to make statues would never suffice to convert blocks of hillside marble into smoothly fashioned images in passably human likeness, it must be presumed that among the Greek spectators of the wonderland of the Nile there were some who gained access to the native workshops and were allowed to watch how such figures were made. What they thus learned was the technique of a fully developed and thoroughly sophisticated craft applicable to an archaic—and hence formally immature—phase of art.

This was a highly propitious circumstance, because it greatly lessened the impact, always troublesome and sometimes calamitous, which attends any broad cultural or technical discrepancy where an advanced civilization inspires a primitive one to ape its methods

without comprehending its mentality. There was much in the Egyptian spiritual heritage that the Greek could not assimilate or understand; but there was little in Egyptian sculptural practice that could not be turned to immediate benefit.

We are reasonably well informed on the workshop procedure of the Egyptian sculptor. After a rectangular pier or cubical block of requisite size had been transported from quarry to workshop, its four vertical faces were dressed to surfaces on which were sketched profile and fullfront elevations of the intended figure upon a network of squares. By use of such a grille a standard drawing could be transferred and enlarged to any desired scale, insuring correct proportions and proper location for the various bodily parts. With these indications constantly preserved as the work proceeded, the superfluous envelopment of stone was little by little removed until a roughly modeled solid figure was secured, correctly contoured and rightly proportioned, but still without specific detail. Until this stage had been reached, the individual features—the ears, hands, wrists, elbows and similar anatomical elements—were left in block form or even— for eyes and lips and nails—not yet indicated. All these were then cut separately from pattern shapes on the surface. Finally by scrubbing and polishing with handstones and abrasives, coherence of surface and uniformity of texture were attained.

Every stage in this lengthy and laborious process required skill based on training out of experience such as could be assured only by transmission from master to apprentice pupil. Facility in handling and shaping any plastic medium such as modeling clay was nowhere involved because the production of a statue out of a solid block was a purely glyptic discipline pertaining wholly to the chipping, cutting, and polishing of stone or wood (or the hammering and attaching of sheet metal to wooden forms). It was sculpture in the etymological sense of the word, a process of cutting and carving as Cicero phrased it, "*e saxo sculptus aut e robore dolatus.*"

It is common knowledge that some connection with Egyptian sculptural tradition is unmistakably apparent in the prevalent Greek archaic type of the nude standing youth to which the Ionic word for a young man, *kouros*, has been very generally attached in modern times. (The label is too distinctive and too convenient to be discarded, and much to be preferred to the alternate nickname of "Apollo," which is clearly a misnomer.) As in the common Egyptian norm, so in the constantly repeated *kouros* statue, both feet are placed flat on the pedestal ground, with knees rigid but with the left leg slightly in advance of its fellow; and both arms are pendant but held tightly pressed against the thighs with the fingers of the hand clenched and the thumb pointed down. Even such an arbitrary detail as the cloth-like object projecting slightly from the clenched fist (the meaning of which seems to have been as obscure to the Greeks as it is to us) was occasionally included as part of the *kouros'* stock detail.

Since the Egyptian hieroglyph for walking was a pair of parted human lower legs, it is quite possible that the stereotyped Egyptian stance should be understood abstractly as a symbol rather than concretely as a physical representation of a power of locomotion assured to the dead body's statuary substitute. The visually-minded Greek, however, would have interpreted such an abstraction literally and (since no human being walks in such a manner) accepted the convention as the representation of a standing man at rest. It was to take many years before the Greek *kouros*, caught in the trammels of this unrealistic tradition, either stood still naturally or, if he purported to be moving, walked correctly. Two hundred years after the first Greek borrowing from Egypt, Polykleitos was to produce his famous canonic statue of the *Doryphoros* (Plate XIII), who seems to stand still while he walks and to walk while he is standing still.

Another detail characteristic of the Egyptian formulation, the entire nudity of the figure except for a loincloth around the thighs, was for the Greek no obstacle nor yet any source of embarassment.

Since Greek men were not thus costumed, the choice must be either to repair the nudity or remove the loincloth. Fortunately for the future course of Greek sculptural art, the second alternative was chosen (save among some of the Anatolian Greeks, who seem to have found it repugnant to their sense of dignity and authority to be displayed naked in public). In most of the Greek communities, social convention took no offense at sight of the naked male body, while esthetic sentiment frankly took pleasure in it. So it transpired that— quite opposite to the situation in later times imposed upon Romanesque and Gothic artists—the Greek sculptors from the very start were encouraged to represent the human male as Nature had created him and not as Society had concealed him.

On the north Aegean island of Thasos there was found built into a medieval wall an unfinished archaic statue representing at twice life size a nude standing youth bearing a ram in his arms (Plate I). Because no final completion of the work has obscured its preliminary sculptural state, it affords convenient and convincing evidence that the Greek, in this early period of the art, used the same statuary technique as the Egyptian sculptor. A single huge block of marble, quarried and faced as a rectangular pier measuring some 12 by 3 by 2 feet, has been roughly dressed into human form by carrying back into the solid stone the four bodily contours of front, rear, and lateral profiles. The ram has similarly been squared to a profile drawing. There are no features to the face, no interior to the ears, no fingers to the hands, no toes to the feet, no kneecaps or anklebones. (That the hair is already cut into beaded strands is due to the sculptor's initiation of the next stage of applied surface decoration before he abandoned work on the statue.)

When Herodotus visited Egypt he was struck by the contrariness of Nilotic custom. "For the most part," he wrote, "their behavior is the opposite of the rest of mankind: it is the men that stay home and spin, while the women chaffer in the market-place; it is the men that

carry burdens on their heads, while the women bear them on their backs." We must beware of passing a comparable judgment on the Egyptian sculptors by imagining that theirs was a whimsically perverse departure from a rational norm of artistic behavior. Statues cannot be cut directly out of formless blocks by other than the Egyptian method unless the stonecutter has knowledge of plaster casts and mechanical devices for their translation into the final medium. It is not arbitrary local prejudice but universal human necessity which makes archaic glyptic sculpture what it is. The human eye, which communicates to its possessor the vision of an external world of solid objects in a spatial setting of depth and distance, has no contact with such a world comparable to that which exploring fingers may attain. All that ever reaches the eye is a focused pictorial version, a mosaic of multicolored reflected light cast on the retinal screen. Within this planimetric projection of the illuminated surface of exterior objects all third-dimensional extension in depth has been converted into gradient appearances spread over a single continuous surface. What this betokens for the sculptor's art is reserved for the ensuing chapter of this survey. For the present it is cited only as a warning that any challenge that archaic Greek statues were not made by the procedure described, and as the *Ram-bearer* demonstrates, is not an expression of valid opinion and goes contrary to the fundamental physiological conditions of human vision.

With the characteristic features of the unfinished Ram-bearer in mind, it is easy to see that the famous *kouros* of the New York Metropolitan Museum (Plates II and III) is a product of the same procedure, with the addition, at a stage immediately preceding the final abrasive smoothing of the marble, of the details which the *Ram-bearer* had not yet acquired. In consequence of their belated application, eyes, ears, mouth, fingers, toes, kneecaps and ankle joints, and the anatomical articulation of the torso, front and back, are all superficial accretions of linear pattern forms which, precisely because this

is their nature, cannot greatly modify the solid structure already established in the preceding stage of contour shaping.

The claim that such a statue must be a derivative of the long-established Egyptian sculptural tradition does not rely so much on the identity in technical procedure (since, as we have said, there is no very different manner in which glyptic sculpture can be made at the outset of the art) as on the consideration that such a process is a complex and difficult practice that cannot be improvised by an untaught artisan or successfully performed by an untrained craftsman.

Yet it can scarcely have been the case that the sculptor of the New York *kouros* had ever visited Egypt to gain instruction and acquire the requisite skill. Had he done so, many of the details must have been worked to more naturalistic conventions; the stilted stiffness of bearing, the flatness of the planes of the torso, front and back, and the shallow modeling of the anatomic features could scarcely have occurred; and the device of raising some of these features as ridges above the surrounding stone is not normal to Egyptian sculpture. It must therefore be supposed that technical training in cutting out statuary figures in stone reached Attica (for the New York *kouros* is Attic work) at second or third hand. There is some missing intermediary. But that the ultimate source for Greek knowledge of the art was the active workshops of Saïs or Memphis under the philhellenic pharaoh Psammetichos I during the second half of the seventh century seems beyond profitable dispute.

There is, consequently, a concealed paradox in the earliest Greek monumental sculpture. By inheritance and adoption it begins at a mature archaic stage of technical proficiency; yet it displays various traits more properly characterizing untutored primitivism. In the New York *kouros* the enormous eyes are spread across the entire width of the narrow face, with the upper lids carried almost flush with the plane of the forehead; the lips are short and harsh; the ears wrongly set and absurdly shaped; the attachment of head to neck

and of neck to torso is uncouth; the chest is shallow, the abdomen flat, the hips and waist spindly; arms and legs are elongated and their joints wrongly articulated. (In the slightly earlier *Dipylon Head* the discrepancy between front face and profile is so great that, if viewed separately, they would not be judged to belong to the same statue.) In short, all is far from the norm of nature in these experimental structures, with the result that they display an ugliness of face and ungainliness of body quite alien to our latter-day notions of classic beauty and ideal harmony. Despite all this, such work may claim the distinction which often attends on the unusual even when it is ugly, and is made memorable in the present instance by an austerity of formal precision and a technical self-assurance that mark it a beginner's masterpiece—even though the beginner was not yet properly a master.

If we must posit that the talented craftsman who produced this statue had never been schooled in an Egyptian workshop, we cannot but be puzzled to suggest where it was, and from whom it was, that he learned his craft. His material was marble; but it was not marble from native Attic vein. Although it has proven to be extremely difficult to identify the various Greek quarries from their output, there is universal agreement that the earliest Attic statues were cut from marble quarried in the Cyclades and, specifically, from the magnificent crystalline lodes of the two central Aegean islands of Paros and Naxos. But because sculptors and quarrymen need not be one and the same, the sculptural workshops need not have been at the source of supply—such statues as the Attic *kouroi* and the Thasian *Rambearer* strongly suggest that they were not. Yet Thasos was a Parian colony; and there are early signatures and the recorded names of early sculptors who announced themselves to be islanders. It would therefore seem a plausible supposition that it was from Paros that the art of sculpture had been imported to Attica and that it was the Parians who had acquired the craft in Egypt. Neither proposition has so far found any archaeological support.

Herodotus lists twelve Greek towns which made Naukratis in the Delta their Egyptian trading center during the sixth century, remarking that "at that time of yore there was no other Greek port in Egypt." Athens is not in the list, nor do any of the Cyclades appear. Most prominent among the traders are the Milesians (who are known to have had a port at one of the Nile mouths even before Naukratis had become available), the Samians, and the Aeginetans. With the exception of the last, all in the list were resident on the Asiatic coast or its adjacent islands. Aegina, which faces the Attic shore, might consequently appear to be the logical candidate for the post of sculptural intermediary for Attica and the Cyclades; and such a choice would be reinforced by the observation that the theme of the standing nude male, or *kouros*, common in these latter regions almost to the exclusion of any other, seems to have been considerably less popular among the Asiatic Greeks. Yet the archaeological and literary evidence gives no encouragement for supposing that Aegina was interested in monumental marble statuary in the seventh century or ranked as an important sculptural center until she began to make her mark in the newer art of hollow-cast bronze figures in the sixth century.

If we match Herodotus' list against the available evidence, we must conclude that the technical understanding of monumental glyptic reached the rest of Greece through east-Ionian centers such as Miletos and Samos and perhaps Chios. At Miletos the inspiration for setting statues of seated priests and local dignitaries along the roadway leading from the sea to Apollo's temple at Didyma was patently inspired by the Egyptian custom of lining with sphinxes the sacred ways from the Nile landing stages to the mortuary temples. And their theme of the enthroned official would also have been taken from Egypt, where the seated had always been a common alternative to the standing pose (though the specifically Grecian costume of these *Branchidai* would have had to be improvised). As for Samos, the late writer Diodorus mentions a statue of Pythian Apollo there, "corre-

sponding in most respects to the Egyptian, as in his parted legs and his arms extended beside him"; and modern exploration has uncovered pieces of some thirty archaic *kouroi*, about a third of which derive from figures at more than human scale.

Such an interest in colossi is in itself a very telling indication of dependence on Egyptian precedent, since the progression from life-size to superhuman statuary is no more obvious or normal than the step from figurines to full-size rendering, and the Nile valley was full of huge and even monstrously gigantic stone figures set at the gateway façades or in the courtyards of the mortuary temples of the pharaohs. Judging by these Samian fragments, the *Ram-bearer* of Thasos, the unshaped hulk still lying in the old marble quarry on Naxos, and the shattered statue unearthed at Delos carrying the proud inscription "Of one block am I, image and pedestal!", Greek emulation was from the very first aroused by these supernatural presentations and not confined to the more naturally scaled figures of the lesser great.

If Samos and Miletos were glyptic monumental sculpture's chief points of entry into the Greek world, knowledge of the technique would naturally have traveled to the great quarry centers such as Paros and Naxos and have attracted thither stoneworkers from adjoining lands, eager to acquire the new learning. But whether this was actually the case or if the focus of diffusion remained in the Ionian cities farther east is not at present understood. In any event, diffusion from a restricted source must be presumed in order to account for the remarkable stylistic uniformity of archaic Greek sculpture; and the center for that diffusion must be situated in the southern Aegean basin in order to account for the permeation of the Cyclades and the adjoining mainland region of the Argolid, Megarid, Attica, and Boeotia with its all-but-mainland neighbor Euboea, leaving at first unreached and unresponsive the more western and more northern districts—until dedications at Olympia brought the art to the further Peloponnese, and motherland relations with the colonies

communicated it, somewhat enfeebled by distance, to southern Italy and the Sicilian isle.

For the present we cannot conjecture more accurately how and where Greek sculpture began.

Classical Greece had for heirloom a direct biological, linguistic, and material cultural continuity from the vanished Mycenaean world; but most of its higher accomplishments were of its own devising, even when incited or first suggested by foreign contact. When we read a play by Sophocles, it does not arrest our attention that the language is an aboriginal inheritance, the recording letters a subsequent Semitic importation, the poetic form and dramatic art a still more recent native invention. Greek sculpture is somewhat less of a hybrid. Its formal inspiration and technical processes were alien Egyptian; but otherwise it owed very little either to the remoter Greek past or the contemporary foreign present. Like Attic tragedy and comedy, it must be rated as the manifestation of the uniquely original creative Hellenic genius.

There is a pertinent and striking parallel between the Greek adoption of monumental sculpture from Egypt and the introduction of writing from Syria little more than a century earlier. Toward the close of the Mycenaean epoch, along with many of the higher cultural accomplishments of the second millennium, practice of the Minoan syllabary in its adapted form for recording Greek inventories ("Linear B" to the modern) had fallen into disuse. During several hundred years all the Greek-speaking region, with the seeming exception of the Greek communities on Cyprus, remained without knowledge of writing until a renewal of commercial maritime activity brought Aegean Greek traders once more east to the Syrian coast. And just as the making of sculptured forms could not be acquired by simply gazing at foreign statuary, so the mere contemplation of Phoenician written documents could not have sufficed to

impart skill in their use to men of alien speech. For proof that oral instruction must have intervened, we need but notice that the Greek alphabet not only copies the shapes of the Semitic symbols but preserves the Semitic name for each and the sequence in which they were memorized. No amount of staring at Phoenician writings could have communicated this knowledge, which demands an environment of direct oral communication between Semite and Hellene.

So it was with sculpture. It was not enough that Ionian Greeks should have beheld and admired stone statues at Memphis or at Saïs; they must have had access to the Egyptian workshops and watched and had explained to them the process of statuary production. Only in this way could they have learned how a quarry-cut pier may have, laid off on its surfaces, the measured proportions which will insure appropriate volumes in correct relative position for every part of the human body. Only by watching the actual performance could they have grasped how the various bodily features could be cut into the stone and released from the smothering mantle, and how, finally, the use of polishing stones and abrasives could produce an even texture of surface and an harmonious transition from part to part.

The Phoenician alphabet was not entirely suited to recording Greek speech. But by a few (though important) adaptations, such as the allocation of phonetically suggestive or superfluous symbols to function as vowels where the Semitic prototype recorded only consonants, Greek needs were met. Then, after a comparatively brief period of practice and experiment, an utterly illiterate culture was transformed into the most brilliantly literate civilization of antiquity. Greek sculptural apprenticeship performed a comparable miracle. A people without sculpture became the world's most proficient devotee of the art. Here, too, the pupil was destined after only a little trial to leave his master an immeasurable distance behind.

'n Egypt the prime function of sculpture was funereal, an out-

growth of religious-superstitious belief in expectation of a quasi-bodily immortality. Honorific statues to represent men and women still alive were not in demand—much less statuary with themes taken from myth, romance, allegory, or other genre, none of which had any place in the Egyptian sculptors' repertory. Their Greek imitators seem to have accepted the ritual meaning which attached to the art; as far as we can judge, the earlier specimens of the life-size standing *kouroi* were very generally set up as grave markers, even though Greek belief could never have endorsed the Egyptian tenet that such an image could affect the bodily or spiritual survival of the dead. By the close of the sixth century this aura of un-Greek magic had been dissipated and the significance of *kouros* figures reinterpreted. If sculpture continued to commemorate the dead, it preferred to do so allusively and pictorially with a carved relief for tombstone in place of an actual image in-the-round. In any case, it was easy to shift sculpture's reference from the dead to the living. The seated statues lining the sacred way to Didyma might equally well have been set during the lifetime of their dedicants. The inscription on the "*Hera of Samos*" states that the figure was dedicated to the goddess by a certain Cheramyes; and since the costume is feminine, the statue cannot be a funereal image of the dedicant. Neither can it be an image of the goddess herself, since the mutilated attribute in the broken hand betokens a worshiper with gifts. The reference is therefore to a living act.

The semantic transference from human to divine was equally easy and obvious to the Greek mind, since it had long visualized the gods in completely human guise, garbed in Hellenic costume or nude like Hellenic youth, standing and walking or seated in chairs like mortal men and women, and indistinguishable from humankind save by greater strength and stature, untainted health, and sheer beauty of face and form. (Even so, one of their company, the smith-god Hephaistos, was lame and swart; and another, the messenger

Hermes, was for long an elderly, bearded wayfarer.) Already, before the art of monumental sculpture had been learned, the gods had been shown as carved wooden figurines (*xoana*) at their places of worship. Accordingly, once the funereal reference had been passed over, there remained no thematic distinction between religious and secular art in Greece; monumental sculpture encountered no obstacle in serving divine as well as mortal needs. The *kouros* could become Apollo or, with a little aging, Zeus or Poseidon as easily as he could surmount his funereal origin to commemorate an athlete at the site of his victories in the national games. And the draped woman could equally well be a goddess or her votary or a heroine of legend and myth. But in this latter instance, whether she was divine, heroic, or human, her sculptural representation could not, like the *kouros*, keep close to Egyptian precedent.

It is a striking instance of the power exercised by social convention upon art that the Greek sculptors could reproduce and even intensify to total nudity the Egyptian theme of the scantily clad male, yet could not similarly adopt or adapt its transparently costumed feminine counterpart, because Greek custom exacted from wives and daughters a modesty which it never dreamed of demanding from its sons. As a result of this prejudice no compromise was possible with the outrageous Egyptian feminine fashion of clinging transparent clothing; and the Greek sculptor was obliged, if he hoped to include the sex in his repertory, to improvise as best he could the outward semblance of a more modest dress. To this end there was little that he could do except trim the quarried block to a noncommittal columnar shape or inarticulate four-sided pier, without more precise anatomical indication than head and neck above, forearms and hands at midlevel, and projecting toes at the bottom of the block, to conform with what social convention permitted to be seen of the living woman. All the rest of his statue (unless the sculptor could here and there evade censure by surreptitious transgression) must be a bodiless

mass of blank stone upon which the folds and surface patterns of con-
temporary costume were incised. The well-known *"Hera of Samos"*
in the Louvre is the standard example of such a creation. From base
to hip-level the block is as abstractly cylindrical as an Ionic column,
with tiny, closely crowded fluting; at mid-height the cylinder ex-
pands into more rectangular section to permit a veiled indication of
the curving forms of arms, breasts, buttocks, and back.

In this seeming unwillingness to sacrifice entirely the bodily form
to an inanimate sheathing of opaque cloth, Greek sculpture asserted
from the very start an extremely vital and esthetically fundamental
principle in sharp contrast to that of the European Middle Ages
when (presumably under Christian religious constraint) drapery it-
self, with a minimal anatomic comprehension, was the paramount
theme of sculptural study in representing either sex. Thus, at Chartres
not only the magnificently stylized archaic figures of the Royal
Portal from the twelfth century, but, equally, the already more
naturalistic statues of the South Porch from the thirteenth, show
little more than heads, hands, and feet; whereas in a comparably
early Greek work such as the still entirely archaic figure of the Attic
*Lyons korē* (Plate IV) the voluminal contours are so revealing and
the applied drapery patterns so lightly scored as to suggest a rebel-
lious longing for the Egyptian license of illusionist transparency.
Thus, from the very beginning, artistic impulse seems to have op-
posed the dictates of social prejudice. But the struggle was to be a
long one; and it was not until the fourth century that public opinion
sanctioned fully the eminently logical thesis that the goddess of
bodily beauty should display a beautiful body. Even so, what was
won for Aphrodite could not be transferred immediately to any save
the most convinced of her human votaries.

It is due to this prejudice that, at the outset, there was an almost
paradoxical diversity between the *kouros* and his feminine counter-
part (which with dialectical incongruence the modern historian of

art has chosen to call a *korē*), not merely because one was nude while the other was clothed, but because one was stylistically advanced while the other was more nearly primitive. The paradox is resolved the moment that it is seen that the stylistically more advanced male type is an exotic importation whereas the naïvely hewn draped figure is of local derivation out of the native Greek "Daedalid" figurine. If the New York *kouros* and the *Nikandrē* from Delos could be set side by side, the archaeologically uninitiated would imagine that the almost shapeless woman must be of much earlier manufacture than the fully rendered nude youth, whereas in actual fact they may well be contemporary productions.

In contrast to the nude "walking youth" and the even more immobilely erect draped maiden (the *kouros* and *korē* types), all other themes of the early archaic phase, with the possible exception of the draped enthroned ruler or divinity, are distinctly of minor moment. The reason for this imbalance of sculptural interest need not be sought in the Greek conviction that the sculptural study of mankind is the human body itself, whether nude or clothed, so that all variations of pose or of individual age, rank, or office must all be secondary to this prime propaedeutic. Nor yet is the sculptors' devotion to these two themes to be explained by popular demand for the *kouroi* as grave markers and for the *korai* as dedications at sanctuaries. For, as we have remarked, the *kouros* outlived his funereal function and was interpreted as a living athlete or a god undying, while the draped standing woman could serve a similar variety of interpretations. A better explanation must be sought for the archaic restriction to so few major themes. It may be found by reflecting that glyptic monumental sculpture was an intricate technical procedure operating with precisely preformulated recipes. An artisan educated to such a discipline does not hold a mirror to the visible world in order to copy what he sees before him. In his experience the end term of his art is not outside, but within, himself, previsaged in terms of a routine be-

havior toward a result already implicit in the quarry-block before he begins to give it explicit shape.

A clue to comprehension of the essential and unavoidable qualities of the archaic manner is to be found in the mechanism of human vision, thanks to which we behold an exterior world in depth and distance (which means that we see before us solid objects distributed in a space external to ourselves) but apprehend this world only through its pictorial transformation on the optic screen of the retina. Could we construct on a conveniently larger scale a counterfeit of exactly what we see at any moment (of "what we see" in the precise sense of that gathering of reflected light which the lens of our iris has focused and transmitted), we should have before us a mimetically accurate *picture*. It would not by any possibility be a sculptured shape because no three-dimensional form unconverted into its pictorial equivalent ever reaches us. The sculptor cannot directly reproduce what he sees, for the reason that "what he sees" is a pictorial transformation. Out of that transformation he can utilize, for direct imitative recording, only those aspects which have not been distorted in the process of projection—the unforeshortened contours of solid objects as they are seen outlined in space, and the unforeshortened linear patterns of areal shapes upon their surfaces. All the rest of objective reality must be inserted by inference, controlled by the time-honored check of trial and error.

On reflection it will be appreciated that this is a correct and adequate account of archaic sculptural procedure.

If the outcome is unreal—in the sense that, when beheld, it does not look exactly as the purported original would appear to us—this must not be condoned on the supposition that the sculptor, because he could not act other than he did, was blind to the discrepancy or would remain content with his product because it had been skilfully and pleasingly executed. It is perfectly clear that (in Greece at least, whatever more conventional schools may have done in other lands

at other times) the archaic sculptors constantly consulted visual appearances in order to correct their own faulty representations. Otherwise it becomes impossible to account for the persistent naturalistic advance in rendering detail which is discernible decade after decade. Every such advance toward mimetic accuracy was incorporated in the existing formula of routine procedure, to become an item in the expanding technical repertory of glyptic devices.

On its technical side, art is a cumulative wisdom. Unless there is a transmission of technical knowledge, the outgrowth of experience and experiment, an art such as monumental glyptic sculpture can neither progress nor continue to exist. And it is within the strict confines of acquired technical tradition that, during most of the phases through which a mimetic art evolves, the individual artist is able to respond to the incentive of novel accomplishment even while his work continues to be a repetition of already established and long-accepted procedure. In his own contribution to his heritage, precisely because he moves on the forefront of a still vital development, he senses not the tedium of repetition but the exhilaration of progress in the exercise of an enviable professional aptitude. Artistry thus fuses with craftsmanship, so that technical determinism still permits individual genius. In such a period of steadily increased accomplishment as the archaic phase inaugurated in Greece, a new statue did not aspire to be something new in the sense of being unlike previous *kouroi* or *korai;* quite simply, it sought to be a better *kouros* or *korē.*

Nonetheless, there were occasional attempts at a wider repertory of themes and subjects. Such deviations as the *Ram-bearer* of Thasos or the much more original and remarkable *Calf-bearer* of the Athenian Acropolis were adaptations of the *kouros* type to themes already familiar to the less restricted repertory of plastic figurines. The sphinxes and gorgons were a transference, to monumental scale and glyptic form, of exotic Oriental themes previously introduced in the minor arts of repoussé metalwork, carved ivory, and painted vase

design. The suggestion that secretaries of official boards might be represented sculpturally as seated figures with stylus and tablet came presumably from Egypt, where the similarly accoutered scribe, albeit in different pose, was a millennial sculptural theme. But the life-size nude horseman astride his steed was a most ambitious and remarkable conversion of an undistinguished commonplace of the coroplast to the exacting precision of monumental art. As such, it may rank as the most brilliant invention of early-archaic sculptural effort.

That the horse should thus be admitted to the very forefront of sculptural interest (as was certainly the case throughout classic times) may not seem reconcilable with the anthropocentric preoccupation of the Greek racial genius with its blind faith in man as all things' measure. But we may account for it by extending some sympathetic understanding to the emotional bond which exists between horse and rider in a horse-breeding community. Whatever may have been true for the chariot-driving Mycenaeans, in the classical age the ridden horse had become so much a part of human experience throughout mainland Greece (and perhaps also such a token of social caste and aristocratic upbringing) that the arts could not exclude it from their ken. However defective in their equine anatomy, the half-dozen surviving horses of the Athenian Acropolis are notable works because they are superb stylizations. And it is important to see that they have not been stylized in the sense in which an archaizing mannerist of a later period might have affectedly altered or deliberately omitted the wealth of naturalistic detail which he had learned to discriminate and which he could have introduced into his work if he had so desired; instead, they are stylized without other artistic intention in the intensely direct simplicity which governs unspoiled archaism as it sublimates the inaccurate and wavering contours of primitive draftsmanship into coherent pattern and harmonious run of line. From this early inception shortly before the middle of the sixth century until the very extinction of pagan artistic tradition, the horse never

lost its place in the sculptors' esteem. However unlike these archaic riders, even the high emperors of Rome would not disdain to be shown to the world as horsemen on steeds of gilded bronze.

Much more grudgingly, the dog and the Greek dog-like concept of the unfamiliar desert lion were allowed a marginal place in the sculptural repertory, with other beasts and birds held in even lesser heed. The intense Hellenic self-concentration of the sculptor on his own kind—which barely extended to contemporary foreign-speakers, deprecatingly lumped together as *barbaroi*—debarred from the costly and greatly prized art of life-size bronze and marble all but himself and his horses, his high gods, his unforgettable heroes of epic legend, and such imaginary creatures of myth as the centaurs, most sublime of horse-men, and the part-animal satyrs of the wild. For all its restriction, there was enough here to keep generations of artists active and alert at their enthralling task.

# II

## *The Archaic Phase*

ARCHAIC SCULPTURE, whether Greek or other, has a peculiar appeal and exercises a very special charm for the present day. Its conventional irrealism (to coin an appropriate term) is no deterrent to its enjoyment; and its mimetic naïveté, its decorative self-sufficiency, its vigor and clarity and wholeheartedness, all contribute to make the contemplation of archaic sculpture an unperturbed delight.

But it is improbable that even the most convinced admirers of the archaic have any comprehension of the source of its peculiar qualities. Nor could they offer any explanation for the extraordinary stylistic similarity which pervades all archaic sculpture, no matter what its provenance or period.

There is, of course, no compelling need that the appreciative public should be so informed. The human values of art depend only indirectly on its intellectual understanding; and the study of the technical evolution of its forms of presentation is closer to the contemplative attitude of Science than the emotional apprehension of Art. However, there will always be those who are curious to explain to themselves intelligibly, in contradistinction to those who wish only to experience emotionally, sculpture's strangely moving transformations; and to these the present analysis is directed.

The distinctive and ever-recurrent behavior of glyptic sculpture in its early phase of development is primarily due to no other cause than the physiology of human vision. Since some familiarity with

this subject is fundamental to a proper comprehension of the patholo-
gy of the archaic style, a seeming digression here is unavoidable.

Everyone who has paused to consider the phenomenon of vision
must have been struck by the anomaly that the eyes can convey im-
mediate sight of tridimensional objects possessing spatial extension
and distributed at appreciably discrepant distances, although all the
while the retinal screen has captured only a two-dimensional pro-
jection (or, as we rightly say, a picture) of such a world.

The frequently hazarded explanation that our stereoscopic appre-
hension of a third spatial dimension is due to binocular vision (be-
cause each eye necessarily communicates a different view, and the
superposition of these two slightly disparate pictures produces, as the
stereoscope demonstrates, a tridimensional effect)—this explanation
is hopelessly inadequate. By wearing a patch over one eye, anyone
can convince himself that even a totally unfamiliar scene is stereo-
scopically just as vivid and spatially just as intelligible with only one
eye functioning. If this experiment seems inconclusive, it may be
further urged that if binocular vision were the source of spatial appre-
hension no one should be able to differentiate spatial depth and dis-
tance while regarding a mirror or a photograph or a painted scene;
for in all these whatever appears far or near is actually at the same
distance from the eye and therefore cannot be evaluated by muscular
adjustment to focus. If binocular vision (which is sensibly effective
only for objects comparatively close to the viewer) has any useful
biologic function, it should be that of giving more immediate and
accurate apprehension of the distance of objects threateningly or
otherwise significantly close to us. For objects more than fifteen feet
away it is said not to be a muscularly detectable adjustment, while
beyond fifty feet it is completely inoperative. Yet visual space does
not cease to possess depth for us beyond either of these critical dis-
tances. I presume that we possess two eyes instead of one for the
same reason (or want of reason) that so many of our other bodily

parts occur in symmetrical pairs. Similarly, biauricular hearing has its discriminatory uses; but we can distinguish sounds in our environment quite adequately with one ear only.

Nor is a second common suggestion that stereoscopy is a function of linear perspective any more tenable, since (in the sense in which the late fifteenth and early sixteenth-century Italian painters relied on it as a scaffolding for spatial construction) such an effect exists only where a framework of precisely oriented axes chances to have been introduced into the field of vision. It is true that in an architectural or other artificial environment there necessarily appears such a tri-axial articulation in the walls, floors, and ceilings, the stairways and furniture within doors, and in sidewalks, streets, façades, roads and railways, telephone poles, and orchards and vineyards of the world outside; and these, as they are projected on a panel surface such as the optic screen of our retinas, create a spatial frame for depth and distance. But natural surroundings without these man-made intrusions—woods and glades and downs, dells and streams and lakes, mountains and moors—exhibit no such geometrical structure (which explains why the spatial scaffolding in the Renaissance paintings is so implacably architectural); yet we behold distance and spatial recession in a landscape with the same vividness (though perhaps not with the same degree of measured accuracy) as in any other scene.

It has at times been counted against the pictorial attainments of antiquity that the laws of linear perspective were never understood. In Greco-Roman paintings space opens outward on divergent axes toward ampler background distance, instead of converging inward on the panel toward a point of extinction. Psychologically (and hence perhaps with greater artistic advantage) the older solution corresponds to our actual experience of a world that continuously expands with distance instead of shrinking as it recedes. The mid-Renaissance painters' perverse conviction that the apprehension of aerial space in a picture was wholly a matter of linear perspective

threatened for more than a generation of artists to do serious damage to their art by constricting it to a geometric theorem.

The true explanation of the mechanism of stereoscopic vision has been given in brilliantly convincing analysis by James J. Gibson in his too-little-known book, *The Perception of the Visual World* (Houghton Mifflin Co., 1950). Its closely reasoned investigations have for central proposition the thesis that the mechanical conversion of the tridimensional external world of illuminated physical objects into its two-dimensional projection upon the retinal screen (a process which can be very exactly duplicated by the camera's focused lens and the color film) produces a complex series of "gradient" appearances. It is the stepwise arrangement of these "gradients" according to size, shape, hue, and luminosity which provides the seeing mind behind the eye with the material for their comprehension in terms of spatial depth and distance. Thanks to our habitual interpretative acceptance of these "gradients," our experience of a tridimensional world is not an intellectual inference from retinal data but is directly given to us in perception. Our retinas capture an illuminated *visual field* which the act of conscious seeing presents to us as an external *visual world*.

The distinction between these two italicized terms is vital to any scientific analysis of the representational arts. Any relatively full and faithful reproduction of the contents of a visual field is a picture, whether executed with pigments on a panel to produce a painting or mechanically fixed as a photograph or otherwise presented or suggested. In complete contradistinction, sculpture mimics not the visual *field*, but the visual *world* external to it.

Lest this explanation succeed only in clouding an *obscurum per obscurius*, it would be well to add some description of these "gradients," the intermediaries through which the visual field of the retina is perceived as a visual world in external space. Most of them are already quite familiar to us from their occurrence in paintings, while others will reveal themselves on introspection as everyday character-

istics of the world as it is seen. Thus, there are gradients of hue and atmospheric density in the graduated transition of color in normal landscape from foreground brilliance of green and brown to distant blue and horizon purple, accompanied by a progressive blurring of objective definition. Gradients of this type are normally operative only over considerable distances. Much closer to the spectator, and hence more effective for the visualization of immediate spatial depth, are the gradients of pattern and geometric structure. These are apparent in any repetition of an areal shape, which projects itself in diminishing size as its distance from the eye increases, and becomes continuously more and more foreshortened as the angle of vision lessens. (Exaggerated examples of this effect are Vermeer's and Pieter de Hoogh's tile-floored interiors and courtyards; but there are almost equally striking instances in the diminishing scale of less uniform structures such as ploughed and hedged fields, boulders and hill crests, stream beds and pasture land, groves and forests.) Among such geometric gradients the effects of linear perspective find their rational place. In addition, there are gradients of texture and surface, dependent on micropatterns too minute for unaided vision to disintegrate into their constituent elements. There are also gradients of luminosity and color intensity, rather summarily reproduced by the chiaroscuro with which painters impart modeling to objects which otherwise would appear flat. (Thus, despite all intellectual conviction to the contrary, the sun cannot be seen as a sphere but only as a flat disk, because it shows no gradients of luminosity; whereas a painter can convert a flat disk into an apparent sphere by introducing highlights, half-lights, and shadow.)

In order to make still more evident the differences between the visual field and the visual world (both inevitably present in any and every act of seeing), it may be helpful to draw attention to the profound discrepancy between things as they are viewed as transient occupants of the optic screen's visual field and as they are perceived

as permanent denizens of the external visual world. Thus, all the bounding edges which are set parallel in the objective world (such are the sidewalk curbs that line a city street, and the house fronts with their thresholds and eaves and their lintels over doors and windows) do not recur as parallels in the visual field, but converge toward a common and yet invisible point. Not only do all objects of measurably uniform width, such as streets and railway tracks, become ever narrower as their boundaries converge in the visual field, but even as they dwindle they move *up* the screen instead of away from the viewer. (Herein lies the explanation of the classical Greek idiom which refers to a ship putting out from the shore as sailing "up the sea"; in the physical world the sea remains level to the earth's slow curvature; but in the visual field a departing vessel moves *up* to the horizon line, whereupon it reverses its direction and moves *down* until it disappears *below*.) Just as paradoxically, while each object tends to maintain a constant size in the physical world, it incessantly alters its size in the visual field. More disturbingly still, it perpetually changes its shape and outline as it shifts position on the retinal screen.

But enough has been said to make it clear that, although they correspond one to another according to fixed equivalent forms, the visual field and the visual world are members of two utterly different orders.

For an understanding of sculptural formal behavior, the all-important point to be made out of all this should now be obvious: While painting presents visual fields, and visual fields only, the productions of sculpture are fully objectified members of our visual world. This is the meaning behind the common remark that paintings are "illusion," while statues and buildings are considered "real." Actually, a piece of sculpture is as much an illusive mimicry as a painted figure; but it operates at a different visual level.

If one could succeed in making an exact duplication of all that the eye beholds at any moment, that is, by reproducing the mosaic of

colored light which forms on the retina (and precisely such a record is afforded by the camera obscura and the color film), such a duplication would inevitably be a *picture*, since any counterfeit of a visual field has intelligible status only as a visual field. (This explains why we can see depth and distance in a painting or photograph; by accepting it as a workable visual *field* we see a visual *world* before us.) It follows that the optical content of vision, however exactly reproduced, will not be sculpture. None of the gradient appearances in which the world is presented to our sight can be introduced by the sculptor into his work; for these, being pictorial conversions, have no objective existence. Instead, his aim must be to reproduce solid shapes, of which his eyes inform him, but which he has never directly beheld as such. He cannot "carve what he sees" because he sees only pictorial transformations. He must somehow reach out beyond sight of the visual world to the source in which vision originates.

To that source we all have direct sensuous access, if not with our eyes, then through our fingers; for with these, by touching and grasping, we can extensively explore and spatially examine the material objects in our visual world. It is because of this immediate sensuous contact that the art of sculpture so generally has recourse to modeling in plastically conformable media such as wax or clay. But glyptic sculpture admits no comparable resource—at least, not until some device has been invented for translating a pliant plastic version in clay into the undeformably rigid replica in cut and polished stone. Until such an operation can be performed the construction of a preliminary plastic model will not greatly assist the carver of monumental statuary, since he cannot, by using his eyes, duplicate in stone a prepared clay figure with any greater ease or accuracy than he could copy its living prototype. Neither performance is technically feasible because of the physiological barrier of pictorial vision. Being a purely glyptic discipline, Greek monumental sculpture in its earlier periods shows no trace of any dependence on clay

models. Being an art of direct creation in solid form, it must be so judged and so perceived.

It must not be imagined that this was an unfortunate accident and that by mere historical mischance, because it was sculpture in stone which the Greeks encountered in Egypt and adopted for their use, Hellenic sculpture was handicapped or misled. There seems sufficient evidence for the assertion that monumental sculpture in terracotta (which is to say, in modeled clay) was developed at Corinth and thence communicated to Sicily, Magna Graecia, and Etruria. Certainly the impressive *Zeus-with-Ganymede* of Olympia testifies to a Greek, as the dramatic warriors in the New York Metropolitan Museum and the elegant Veian gods in the Villa Giulia in Rome testify to an Etruscan, mastery of this technically none-too-easy craft. If the rest of Greece continued to carve its statues out of blocks of marble, it was not because it never occurred to its artists that they might have used clay.

Although it is true that the modeler of clay can feel his way directly into tridimensional form, it is equally true that sculpture is a visual and not a tactile art, because it is made for the eyes to contemplate and not for the fingers to feel. Moreover, just as it reaches us through the eyes and not through the finger tips, so it is created visually, no matter how the sculptor may use his hands to produce his work. Insofar as it is something other than a mimetic craft for the accurate reproduction of living forms (and it would not be art if it were only this), sculptured form cannot be apprehended tactilely or evaluated by its tactual fidelity.

It may be argued—and with entire warrant—that sculpture frequently involves an appeal to our sense of touch and physical contact; but so does painting. Such tactile sensations are, in either art, induced and secondary, being derivative of subjective mental association. In a painting by Titian or Bronzino, the representation of material textures such as fur or velvet may be so visually exact that

it evokes in us a memory of how velvet and fur may feel when we stroke them. I do not think that sculpture's tactual appeal is very different or much stronger. Any dissenting opinion is probably inspired by the heightened physical actuality of sculptural presentation: we cannot directly sense a painted texture by touching the canvas, whereas we can actually explore with our fingers the solid sculptural shape. But the logic is faulty if it is thence inferred that sculpture is more immediately involved in the tactile sense; for, at best, we can only touch the material medium and not the artistic representation which is intended and calculated for the eye's contemplative vision.

Since there is no immediately evident guarantee of greater success for visual presentation attaching to a plastic rather than a glyptic technique of production, it would be unreasonable—at this stage of our survey—to challenge as mistaken the Greek acceptance of a glyptic tradition. Rather than reform or reject it, Greek genius enhanced it and raised it to new status in artistry by exploring and exploiting its hitherto unrealized potentialities.

This long digression into the physiological and psychological mechanism of human vision was unavoidable, since without it there is no possibility of rationalizing the specifically distinctive features of archaic glyptic art. Nor is it easy to understand why sculpture is so difficult an enterprise, subject to such a retarded speed of development, unless there is kept constantly in mind the simple theorem that the human eye has no direct access to the domain of solid substance.

As the exterior world is present in vision, its geometrically solid objects define themselves as *areal shapes,* that is to say, as areas of modulated color to which an enclosing boundary imparts intelligible over-all shape. Such an areal shape can be exactly counterfeited by tracing a line mimicking its boundary or contour. But the other constituent elements of the visual field, the "gradients" of luminosity, texture, diminishing pattern, perspective, and the rest, cannot be re-

corded by the sculptor because all are properties of the visual field only, being optic "signs" or "signals" of the objective world without materially objective existence. This is the reason why the prime components of archaic sculptural representation are the defining contour line, by which an entire structure is given intelligible shape, and the areal surface pattern, by which each distinguishable part or portion inside the total boundary is given a recognizable appearance.

Since foreshortening is a geometrical conversive gradient existing only for the visual field, the least foreshortened aspect of any object will necessarily appeal to the sculptor as the nearest equivalent to its actual structural shape. Hence the areal shapes which the sculptor records will be their *frontal aspects* of maximum extension in the plane of the visual field. The so-called memory images and frontality phenomena of an outmoded theory of archaic stylistic peculiarities are more properly to be re-interpreted as areal shapes subjectively constructed out of unforeshortened aspects.

If we examine the ears on an archaic *kouros* (Plates V and VII), it will be instantly evident that the sculptor has treated this organ as a self-contained entity, unrelated to the other recordable features and possessing its own distinctive configuration. Only in its size and relative location has it been considered as participant in the whole bodily structure. It might be suggested without metaphoric intent that the artist has made much the same distinction that ordinary speech observes when it applies a specific word such as English "ear" as a sundered label to which all ears, but ears only, are entitled. As member of a generic class, just as it has a distinctive but universally applicable name in speech, so will an ear possess for the archaic sculptor a characteristically differentiating, but abstractly generic, shape in the visual "language" of statuary. In everyday visual experience this characteristic shape is apprehended and identified as a recurrent pattern of appropriate size; and such a pattern is precisely what is applied by the sculptor to the block of his statue by first tracing its discover-

able outline in frontal projection, then cutting back the marble around this outline, and lastly grooving into the stone the linear pattern of its interior configuration. As the result of such a procedure, the statue's ear is represented by an isolated patternization solidly attached to the main mass of the marble block and rather uniformly raised above it.

It would be tedious to pursue such an examination for each feature of the human head and body. The outcome would always be the same—a succession of patterned linear shapes, cut away so as to stand out or grooved to sink in, but always anchored, as it were, on the surface of the block. Because the seeing eye receives only two-dimensional projections of the illuminated surfaces of objects, it operates with flat areal shapes, to the detriment of the converted dimension of spatial depth. The archaic sculptor draws on this fund of areal shapes and re-projects them, spatially unconverted, upon his statue's surface. (In technical jargon, he "fixates his visual field.")

Although (presumably) the experiment has never been performed, it would be entirely feasible to acquire plaster casts of archaic statues and saw them horizontally across to lay bare their geometric transverse section. Such "stereographs" would be to the stylistic theorist what x-ray photographs are to the medical investigator: they would show what was going on inside the body of these statues. For the archaic period the cross section would invariably demonstrate that only the outer rind of the block is alive, while all the rest is unaffected, being unreached by the sculptor's formative activity. This observation would apply with especial cogency to the early archaic draped statues, where nothing stirs beneath the blank expanse of costume.

To recapitulate, because of the physiological mechanics of human vision, the archaic sculptor is fettered in his work to the frontal plane of the block which he cuts. That block, in order to be serviceable to his final intent, has been given some abstractly simple over-all shape,

such as an erect quadrangular pier for a *kouros* or a cube surmounted by a solid rectangle for a seated figure; and out of this, by chipping or splintering off the superfluous envelope, the sculptor must make emerge the shape and substance of a human body. But because his eye receives only flat projections in areal shapes when he looks abroad at the objective world, and he has only pictorial access to reality, he has no ready apprehension of solid depth, but tends to carve all interior detail as flat pattern projected upon the undifferentiated smooth surface of the block. In the stilted (and mildly ridiculous) language of a pretendedly scientific vocabulary, the clinical description of archaic glyptic sculpture would be an undeveloped stereomorph upon which linear areal patterns have been projected.

The design of these superficially attached patterns is highly schematic, in the sense that they are generalized formulas which, once they have been accepted, will be made to serve over and over again, without structural alteration. Not merely are they transferred from one piece of work to the next; but on the same statue, wherever any extended surface is to be covered, they will be repeated in orderly precision of sequence and arrangement. It is the same creation of pattern through repetition of identical units of design which attaches to ornamental motifs decoratively applied, such as may be found in loom-woven cloth or plaited basketwork or vases decorated without pictorial intent.

The linguistic parallel is here again pertinent. Just as human speech is content to repeat unchanged the same phonetic sound-pattern every time there is reference to the same kind of object, so the archaic sculptor, having devised an appropriately characteristic *schema* (or pattern-shape) sees no merit in altering or modifying it, but repeats it intact whenever and wherever he has need of it. His is not yet a servile imitation of the casual irregularities of the physical world of things, but a craft of precision applied to schematically perfected visual abstractions, whose geometric clarity imposes accuracy of

execution as proof of artistic competence. Since marble must be tooled to pattern's guiding line, that line must be cut as cleanly as it is drawn—if straight, then truly straight to the ruled line; if curvilinear, to a geometrically consequent curve. There is thus a mental component (if only on the humbler spiritual level which modern Gestalt psychology explores) in all archaic form, operating against all haphazard irregularities in favor of a decorative repetitiousness of pre-established design. This produces an effect precisely comparable to that which Greek architecture exacted in the carving of its string-course ornaments. On the exquisitely cut detail of the Erechtheion at Athens, from the end of the fifth century, and the circular tholos at Epidauros, from the second quarter of the fourth, the running design on the carved moldings shows an exactly spaced and identically repeated ornamental pattern in which geometrical harmony is all-important and the faithful reproduction of botanical species of leaf or flower has been discarded. So it is with archaic sculptural detail where stereotyped patterns are repeated over surfaces which serve only as the ground to support and carry them (cf. Plate VII).

The decorative quality so noticeable in archaism is thus ascribable to an appreciation of the symmetrical structure of abstract pattern overriding the concrete evidence of unsymmetrical variability and imprecision in the physical world.

Since pattern depends on two-dimensional symmetry (tridimensional pattern being only mathematically comprehensible and not accessible to sight except as distorted in pictorial projection), visible pattern is an attribute of the visual *field* rather than of the visual *world*. That is why it is of such paramount importance to the art of painting. On a pictured panel the visual field imposes its pattern upon the unpatterned visual world which it portrays and thus fuses into a single moment of vision the abstract appeal of geometric form with the interested recognition of representational content. But during the contemplation of sculpture, the visual field is not a fixed constant,

as in a painting, but a shifting and changeful appearance where patterns can appear only as they attach to some particular (and therefore partial) view. In consequence, pattern will occupy the sculptor's attention most insistently in the archaic phase while he still works with pictorial projections of the visual field and has not yet advanced to any more extensive reproduction of its implied tridimensional structure. Precisely because it is only a visually projected surface appearance, the appeal to pattern which archaism so effectively exploits must weaken as the sculptor masters stereometric configuration.

We have not yet exhausted the formative influence of the norms of visual behavior upon the idiom of early glyptic sculpture.

It is an important formal property of the linear patterns which the archaic sculptor projects on his block of marble that each tends to be self-contained within a fully closed contour. As we look abroad on the world, seeking to understand the content of vision, we habitually convert every total visual field into an assembly of *things*, each of which is set apart by a characteristic shape within a defining boundary. As a result, everyone habitually regards noses, mouths, and ears, because they have individually distinguishable shapes, as isolated structural parts of the human body, without reflecting that it is only our own nominal analysis which has segregated them from the anatomical continuity of skin, flesh, and cartilage. It is this process of nominal objectification which compels the archaic sculptor in his reproduction of the human form to convert each distinguishable feature into a discrete unit of design—that is to say, a patterned shape delimited and set apart by its own enclosing boundary of closed contour (cf. Plate V). By this schematic disintegration into contiguous pattern, the nude torso is similarly converted into an assemblage of closely fitted pieces, a mosaic of linear shapes replacing the actual continuity of surface and organic singleness of structure (cf. the "neo-Polykleitan" bronze, Plate XLVII). It is from this substitution of an architecturally consistent and structurally ordered design for

the luminous pictorial gradations of the actually seen appearance of the body that the tectonic appeal of sculpture emanates.

Of this tectonic appeal much may be said—perhaps not unprofitably. It is most pertinently exemplified in Greek architecture. The exterior colonnade of a Greek temple, or the columned front of a stoa, communicates visually an impression of gravitational balance and structural stability in terms of abstractly patternized elements. The distinctively individual pattern-shapes of these component elements, intelligibly fitted one to another in a fixed sequence, combine to produce the over-all design of the "order." And this design is maintained on a single horizontal plane as a panel of evenly repeated *areal* shapes. So extreme an adherence to the projected two-dimensional appearance threatens to destroy any comprehension of the structure's depth and substantial mass. (The architects of the Renaissance were fully aware of this property when they applied the classic orders as an ornamental cover plate to any and every irrelevant construction which they chose to set behind them.) But this restriction of the visible building to the flat pattern of its façade was prevented from fatally weakening the essential architectural impression of ponderational support and material strength by compensating the loss in visible depth and density with a subtle linear articulation of the structural profiles and surfaces. One has only to look attentively at a standing Greek order with this in mind in order to see how effectively visual suggestion operates through entasis in the slendering column, unadorned bulk in the architrave, diminution of unitary scale in the frieze and cornice, and disintegration of the ponderable load through unrestricted ornament on eaves and gutters. This visual communication of weight carried in balanced support is what is intended by the expression "tectonic appeal."

Since any life-size marble statue weighs rather more than a ton, its brute mass constitutes a stone structure embodying (one might say) a potential architectural appeal. It is hardly an exaggeration to

assert that the Greek sculptor had an artist's awareness of this and sensed the surface structure of the nude in its sculptural transformation as a sort of architecturalized living order in which, as in a Greek building, the superimposed parts structurally vitalized a total design.

Equally compelling evidence for a sense of tectonic form may be

FIGURE I.—RED-FIGURE VASE BY ANDOKIDES

found in Greek ceramics. In any typical shape of the Hellenic potter's craft, each structural part—the foot or base, the containing body, the protruding handles, the narrowing neck, the turned lip—is a functional element distinguished by an appropriate shape of calculated size in pertinent location; and all these are subsumed to a total shape, whose contour supplies coherence and structural participation to every element (Figure I). If the comparison is not pressed too closely,

a Greek vase may be likened to a statue in the abstract; it is an articulated organism presenting in visual terms its structure and its gravitational balance. Reversing the comparison, a nude *kouros* may be said to display the tectonic coherence of a Greek vase.

It has been very widely recognized that the classic representation of the nude human form does not faithfully reproduce the normal appearance of the body, but re-interprets or re-creates or idealizes or in some other manner mutates it, as though to improve on Nature by substituting art for actuality. There is, indeed, a specific sculptural idiom for the nude which is universally identified as "classical"; and this has been admired and frankly imitated by some as an unsurpassable norm and outspokenly stigmatized by others as a frigid convention fit only for academic epigoni. There is no theme connected with classic art about which more voluble opinions have been uttered and less pertinent judgments passed. But if there is to be any comprehension of its true quality, the Greek formulation of the nude must be studied genetically. To be sure, historic origin is not necessarily the same as ultimate validity; the art's esthetic value must be something more than the end-term of its technical development. Nonetheless, one always has a better chance of understanding what a thing is if one has watched how it came to be. And the classic conventions for the nude are all directly descended—with only a single important modification of their character—from the archaic linear formulation, which in turn had its source in optical physiology. (The "single modification" was the conversion of the grooved linear demarcation of archaic areal pattern-shapes into a recession and protrusion of their surfaces, when the superficially attached schemata were reshaped into modeled depth of marble—a remark that will become clearer as our study proceeds.)

In the standard Greek formulation of the nude, as it occurs over and over again on surviving statuary, it is the enormous hip muscle which gives most offense to the modern anatomist (cf. Plates XIV

and XLVII). Undeniably, this is a preternatural exaggeration of normal appearances. Genetically, it resulted from a vigorous inguinal boundary line, drawn to demarcate the limb from the torso to which it attaches. It was allowed to survive in the classic canon because it helped to give structural articulation and definition. The overemphatic pectoral muscle, the oversharp separation of deltoid and biceps, the reduction of the thorax to an assembly of polygonal segments—all these are likewise the result of archaic linear representations preserved because of their structural eloquence and their tectonic vividness. Lacking any comparable interpretative presentation of its forms, the human nude tends to be sculpturally weak and unimpressive. Uninformed, it remains uninforming.

The tectonic structure of the anatomic canon, as formulated by the archaic masters and fully established before the close of the archaic phase, was to give to all classic nude sculpture a quality of coherent power and organic unity such as no merely exact duplication of the outward appearance of the human body ever attains. In the colossal *Horse-tamers* of the Quirinal (Plate XLVII B) which copy at twice its size a figure from the Parthenon's east pediment, the late fifth-century formulation of the canon may be read most clearly. For the early fourth century the bronze *Ballplayer* from Antikythera (Plates XXVIII and XXIX) preserves it intact, but with the divisional boundaries now less sharply lined and the transitions from part to part more tempered. For the late fourth century the *Apoxyomenos* of the Vatican, reflecting the growing realism of the Lysippic circle, shows the canon modified by more complex study of muscular articulation and moving as it were beneath the surface to re-interpret the linear scheme in fully plastic form. Praxiteles may seem to have departed from the canon by veiling it in a luminous envelopment of blurringly continuous surface; but where the eye cannot detect it in a normal photograph, oblique lighting of the marble will always bring out the persisting canon. It is, in fact, the veiled tectonic struc-

ture beneath the sensuously formless light-mirror of the surface which prevents Praxiteles from converting the properly sculptural into an improperly pictorial appeal. (His is a dangerously misleading manner for the modern imitator.) In the prolonged academic tradition of the imperial Roman era, the tectonic canon is still predominant, thanks mainly to the conditioned Roman taste which reverted to the period between Myron and the pupils of Lysippos as the Golden Age of sculptural art. Not until all sense for the classic tradition became submerged during the final decline can the tectonic formula be said to have lost its dominance over statuary form.

If the preceding analysis of the essential determining influences in archaic sculpture is substantially correct, it will be apparent that the formal study of sixth-century glyptic art is primarily a scrutiny and comparison of schematic linear forms. These schematic forms will be seen to have grown in complexity as the phase matures; for on the one hand they reflect a cumulative increase of detailed observation of natural appearances, and on the other they show a diversion and enrichment for decorative use. Since these two interests serve basically incompatible ends (because one moves toward, the other away from, fidelity to nature), the career of archaic sculpture seems at times an erratic oscillation between heightening realism and increasingly decorative unreality. There will be masters and apprentices in contemporary workshops, of whom some will be attracted in the one, others in the opposite direction. As a result, the incautious critic may fail to grasp the contemporaneity of their diversely oriented efforts and confuse logical with chronological sequences. A similar simultaneity of progressives and reactionaries, of stylistic mannerists, uninventive conservatists, and observant innovators has long been noted among the archaic vase-painters; but a comparable differentiation in the work of the sculptors is less easy to detect and still more difficult to prove. The true calendar sequence of sixth-century sculpture is, in consequence, still uncertain and, even where rather gen-

erally assumed as established, susceptible to extensive future revision.

If the Anavysos *kouros* (Plate VI) is compared, detail for detail, with the New York *kouros* (Plates II and III), the changes incident to nearly a hundred years of unremitted effort in the statuary craft in Attica may at first glance seem disappointingly slight. The theme and the bodily pose are unchanged: the hands are still held clenched beside the flanks; both feet are flat on the ground, with the barely advanced left leg still unbent at the knee; the hair at the back of the head is still a beaded curtain, preposterously (however attractively) unreal; and anatomic detail is still a matter of linear definition, even though no longer so abstractly unfactual or so unconscionably arbitrary. Yet none but the unseeing can fail to sense an enormous advance in lifelike suggestion and vitality, a new proud strength and sureness, with elegance in the running contour and proportionate coherence in the parts. Throughout, the measurable ratios have been greatly altered. The head is smaller in relation to the body, the facial features smaller in relation to the head. (The primitive draftsman always exaggerates scale when he attempts a representation involving much interior detail. Merely because there is so much to record in the configuration of the ear and the structural complexity of the eye, these invariably take more than their proper share of space in early art.) The hips are now much broader than the waist, the length of the lower leg more uniform with the upper, the whole body thicker in relation to its height. Profile and full-front are no longer discrepant (in the New York *kouros* the face and neck, viewed from in front, are thin and spindly, but broad and massive when seen from the sides). What is true of scale applies also to design; each separate bodily part is now shaped in closer agreement to natural appearances. The huge almond-shaped eyes staring horizontally out of the head have given place to smaller eyes set farther apart and correctly tilted downward. The structural intricacies of the ear have been remarkably well reproduced. (In the curious scroll of the New York *kouros* one won-

ders through which orifice the sound is supposed to enter.) A knee-cap is now a patella and not a shield of double crescent moons. Wrist, fingers, knuckles, and nails are scrupulously shaped to their natural forms.

In order to accomodate a less rigid profile, the quarry-block has been taken in greater depth and more strongly cut away so that chest and back curve powerfully and there is a more lively bend of the arm from the elbow. Where the New York *kouros* is stiffly outlined in flat stretches and abrupt angles, the Anavysos *kouros* in profile shows a running contour of curve and countercurve through shoulder, small of back, buttock, thigh, and calf. The smaller head is correctly carried on a shorter neck; the arms grow out of their attachment at shoulder and clavicle instead of dangling externally on a socketless torso; and in the anatomical detail of back and front there are no longer isolated ridges and grooves, but coherent pattern forms that seem to belong integrally to the body.

Such an analysis is far from exhaustive; but even if it were amplified and pursued in utmost detail, it would be deficient as a description of evolved archaic form. It fails to indicate the motive for all such alterations of contours, patterns, and proportions. That motive was the desire to impart an appearance of corporeal life to an inert piece of stone. In this sense every archaic master is by wish and will a realist.

Despite every effort the archaic sculptors could never attain their technically difficult desire because their conception of sculptural form remained linear, without depth. For this reason the critical history of the archaic phase may be written as a chronicle of continuous technical advance against equally continuous frustration. And the greatness of archaic art resides very precisely in the artists' evasion of this technical frustration by sublimating it into a sculptural idiom of persuasive and delightful unreality.

That the archaic period (which was very closely coterminous with

the sixth century) was quite literally a long probationary term of repeated experimentation in the transferring of visual appearances to the surface of a solid block of marble becomes more apparent the more closely the work is examined with an eye to the detailed rendering of the human body. Conscientious comparison between the more than a hundred *kouroi* which have survived, whole or fragmentarily, after two and a half millennia of accidental or deliberate destruction, will carry conviction that the release of a human form from a block of marble is by no means a simple accomplishment; that anatomic detail, even when schematically summarized, is highly intricate in its lines, planes, and proportions; that Greek statuary craft in its archaic phase was anything but a stagnant, contented, and incurious profession; and that, as sculptor was apprenticed to sculptor, mimetic fidelity to visual actuality exerted a guiding pressure on stylistic development stronger than any consideration of decorative attractiveness or sensuous delight. In short, the widespread modern appreciation of archaism for its delicious quaintness overlooks its inner earnestness of realistic effort.

As intermediate terms in the direct genealogical descent from the New York to the Anavysos *kouros* particularly deserving of attentive study and appreciation should be listed: the colossal *Sunium twins,* clumsy but not ungainly; the *Theran kouros,* flaccid but not feeble; the slimly elegant *kouros from Volomandra* (all these in the Athens National Museum); the pertly self-possessed *Tenean kouros* in Munich; and the superbly powerful *kouros from Keos,* in Athens; with subsequent descendants of especial note the "*Theseus*" of the Acropolis Museum and the two later *kouroi* of this same provenance, in which archaism at last openly gives place to a more truly living style.

In all of these, as throughout the period, one especial feature most vividly illustrates the archaic sculptor's difficulty in reducing objective visual reality to linear glyptic terms. I refer to that most intractable of all appearances with which the sculptor's chisel must contend

—the representation of the hair of the human head, for which no craftsman in any land or age has ever devised an adequately realistic glyptic equivalent. That is the case because the visual appearance of hair is the product of a textural micropattern too minute in scale for reproduction in carved stone. As we have seen, the distinctive hallmark of archaism is the linear contour pattern which sets the stonecutter a guideline for his tool. But when hair is viewed no patterned shape such as a chisel may cut is either seen or suggested. What presents itself to the eye consists mainly of luminosity gradients of texture and hue; and as these are phenomena of the visual field, their reproduction necessarily belongs to the painter's realm of pictorial presentation. Solid shape, however complex of surface, pertains (of course) to every living human head, whether wildly hirsute or tightly coifed or discreetly bald; but because this solid mass is superficially an intricate interweaving of bristle, lock, and strand, it occasions a geometrical complexity completely unreproducible by one who, like the archaic stonecutter, deals only in mentally distinguishable and materially reproducible patterns. Since something has to be done, archaic masters must either turn the task over to the painter for a pictorial solution in applied pigment (and of this we have several instances preserved, even though most of the pigment has faded) or have recourse to utterly arbitrary glyptic inventions.

In Attic sculpture alone we encounter archaic heads with hair represented by repetition of such surprisingly variant pattern schemes as a globular bead, a corkscrew twist, a corded cable (Plate VII), a spool or reel, a snail-shell spiral, a shallow wave, a chevron or zigzag, a lunate wisp. Since the archaic sculptor had no other way to make use of these than to spread them in continuous repetition over the surface of the marble, these various basic patterns produced geometrically abstract and highly ornamental mutants of reality. Thus, repetition of the bead converted the hair into a curtain of tightly strung globules (Plates II and III); the spool or reel transformed it into a rigid

49

woven matting; the chevron produced an architectural diaper (Plate VII); the snail-shell (intended for forehead curls) carried a twining tendril across from ear to ear (Plate V); the waving wisp, in similar position, gave the *Volomandra kouros* a headband of licking tongues of flame. None of these devices could aspire to solve the mimetic problem of cutting marble to look like hair. Yet one of their number, the running wave, a less angular variant of the chevron, came nearest to being a plausible solution. For, as everyone is aware, hair may be divided and gathered up in undulant strands; and these, as units of visual attention, raise the textual pattern to a sculpturally manageable magnitude. For lack of a better invention, Greek sculpture settled upon this schematic form as its abiding and universally accepted convention; so that in all subsequent work human hair was expressed in terms of separable strands and locks and wisps. By studied irregularity of treatment, the geometrical ornamentality of the recurrent interlocking waves could be blunted; and by undercutting and interweaving the strands, their surface movement could be given a modicum of substance and depth. Even Praxiteles, reputedly a master of illusionism, was to discover no better solution to the insoluble problem (cf. Plate XXXIX A)—unless perchance he invaded the painter's realm of optical appearances and introduced pictorial gradients of hue in coloring his statues' heads. (He is reported to have replied, on being asked which of his statues he rated most highly, "Those on which Nikias did the painting.")

Since Greek youths still wore their hair long during the period when archaic sculpture was made, its sculptural representation posed much the same problem on the male *kouros* as on the female *korē*. But in other respects the draped *korē* confronted the sculptor with a wholly different set of formal requirements and artistic opportunities. For, in greatest contrast to the clarity of structure which the nude male body had suggested to the archaic craftsman, the completely costumed feminine figure which social prejudice dictated to

the sculptor was an amorphous structure with no articulated pattern and little clue to its appropriate glyptic presentation. Fortunately, we are extremely well informed (for the Attic workshops, at least) on the brilliant resolution of the obstacles thus imposed. An inestimably precious record of stylistic evolution and of archaic artistry at its finest exists for us in the widely known and inordinately admired Maidens of the Acropolis. These constitute a series of more than a score of statues dedicated during the second half of the sixth and the initial decades of the fifth century, commencing with the *Lyons korē* (Plate IV), so expertly recovered to Attic art by Humfry Payne, and terminating in the staidly lovely *"Petite Boudeuse"* (Plate XI), dedicated by Euthydikos.

It might very naturally be presumed that the sculptor's acquired mastery over the anatomical patterns, contours, and proportions of the male body could have no pertinent application to carving the costumed *korai*, being replaced by the wholly unrelated task of working marble into a semblance of woven, dyed, and embroidered cloth. And yet this was not entirely the case. To the Greek sculptor even the most fully draped statue was something else than a carved and colored reproduction of texture, hue, and ornamental design of contemporary woolen and linen clothing. He judged it of the essence of his art that the living human form, so immediately presented in a *kouros*, should somehow be sensible also in the *korē* as a *forma informans* within the inanimate, intervening dress. In this typically Greek (and probably entirely unreasoned and instinctive) conviction that sculpture must be concerned with the presentation of the vitally energized human form and could not content itself with disquisition on its lifeless, external accessories, classical antiquity strikingly outpaced the Christian Gothic, which far more slowly and almost grudgingly diverted the sculptor from the study of effective involutions of cloth to an adequate mastery of the human figure.

I have already remarked on the unexpected disregard for feminine

modesty with which the master of the *Lyons korē* (Plate IV) indicated the naked body beneath the closely clinging dress; but I omitted to explain the technical procedure which made such an effect of textural transparency its natural and well-nigh unavoidable outcome. It is quite clear from inspection that the carver of this statue must have used profile views of the nude body to give the primary shape to the blank marble block and thereafter proceeded to incise upon the surface the schematic patterns for the features of the face, the pendant hair, and, *at the same level of execution,* the crinkled furrows and parallel folds and zigzag hems of the costume. He produced, in fact, a feminine version of the traditional *kouros* (with slightly more massive allowance of bulk marble) and clothed it by projecting upon its surface, in good archaic fashion, his linear patterns for drapery. Wherever he omitted to add these indications of costume (as the rear view of the lower half of the statue rather pointedly demonstrates), the not-fully-finished workform in the nude survives and felicitously imparts a visual impression of close-clinging diaphanous fabric. A fortunate accident of technical procedure has been exploited for deliberate artistic effect.

It is a pertinent observation that a precisely comparable procedure of first drawing the figure completely in the nude and then adding to it the drapery lines of a covering dress was common practice among Attic vase-painters of the red-figure period.

In sculpture, as the evolving archaic phase produced drapery that was less superficially linear and more solidly substantial, the primary nude profile had to be taken in greater bulk and less precise outline in order to leave sufficient marble for the deeply cut furrows and pendant panels of an outer garment. Even so, one has but to turn the pages of Payne-Young's picture book of the Attic Maidens to convince oneself that the contours on the nude form continue to be used as a guide in cutting the block to its primary glyptic shape. In the *"Pouting Girl"* (Plate XI) near the close of the series, the underlying

nude is persistently and intelligibly communicated beneath the crinkling chiton and the enveloping sheath of himation because the chiton waves and himation ribbings have been cut into the surface of a block already shaped to the body's swelling form.

Thus the emergence of a transparent drapery style in archaic Greek sculpture may be ascribed to an accident of technical procedure. Yet this explanation does not tell the whole story; the oldest examples of the type from the period anterior to the phase of decorative elegance—the earlier *"peplos korē"* and the two *"Samian Women"* from the Acropolis, the *"Hera of Samos"* and the *Nikandrē* from Delos—were not made in this manner. Consequently it is clear that a purely textural drapery style (as in Romanesque and Gothic) could have been evolved in Greece had the sculptors been so minded. If they preferred to reveal rather than ignore the nude within the costume, their interest can hardly be due to other than instinctive conviction that sculpture's proper domain was animate and not inanimate representation. If the sculptors were thereby beguiled into defiance of social convention and brought their art into conflict with decent bourgeois prejudice, this was probably of no great moment to the *kaloi k'agathoi* of Peisitratean Athens. What was of real and lasting significance was the discovery that drapery could be ancillary to the living form and need not be treated as an unrelated and uncorporeal accessory.

Meanwhile the continuing effort at mimetic fidelity which so greatly advanced the rendering of anatomic detail in the *kouroi* could not fail to induce for the *korai* a corresponding study of what might be termed the anatomical structure of cloth when made up and worn in Greek fashion. Primarily this meant assigning greater material substance and density to the woolen outer garment—though the more literal rendering of enveloping costume necessarily destroyed diaphanous illusion and put the bodily form beyond the sculptor's reach. By the second quarter of the fifth century the modeled feminine body became thereby almost wholly lost to the sculptor. Al-

though statues such as Furtwängler's "*Athena Lemnia*" or the bronze *Dancing Women* from Herculaneum or the "*Aspasia*" have been praised and admired, they have little but their simple severity of heavy, fluted drapery to commend them.

Earlier, in the sixth century, while archaic formulas still prevailed, the striving for mimetic completeness was largely directed toward reproducing in painted marble the woven patterns and embroidered designs of festal costume. Since these were worked in the surface of the cloth, they could equally well be incised and colored upon a marble surface. (A comparable phase may be seen in fifteenth-century Florentine painting with its tooled and gilded ornamentation. It is also pertinent that in Venetian art as late as Carpaccio, resplendent patterns were spread out over velvets and brocades without heed of their properly foreshortened distortion within the folds and turns of the material.) The same unnatural evocation of pattern through set repetition of schematic forms which turned the hair of the *korai* into decorative ornament also operated to cover their clothed bodies with symmetrical rippling chevrons over shoulder and breast and with evenly spaced runnels ruled vertically over hip and thigh, to terminate in elegantly curveting hems. With all these sharply patterned and exquisitely carved inventions accentuated in strongly contrasted colors, it is easy to understand how the late archaic Attic *korai*, unexpectedly preserved for modern discovery by a combination of Persian destructiveness and Athenian piety, captivated the late nineteenth-century visitor to Greece with their naïve self-confidence of perfected craftsmanship.

As might have been anticipated for an art in which the craftsman's pride in his technical skill was directed to strongly schematic patternizations, the exploitation of decorative effect to the detriment of visual fact appears very early in Attic work. Thus, the *Rampin Head* in the Louvre, conspicuous for its elegantly beaded hair and beard and its lace-like filigree of forehead curls and oakleaf diadem, had been

taken for an advanced archaic work; yet it was fitted by Humfry Payne to an Acropolis torso of a horseman of such crude anatomic rendering that a date long before the ripe archaic period is obligatory. However, the climax of decorative archaism in Attic sculpture must be set considerably later, after the century's middle decades had brought Ionian luxury in dress along with Ionic literature and elegant manners under the cultured despot whom only linguistic misinterpretation stigmatizes as "tyrant." Here technical art and social life seem to run parallel courses; yet it should be clear from the *Rampin Head* that if Peisistratos had never held sway in Athens, though there might have been less Ionic costume in Attic sculpture, the evolution of style would still have followed the same predetermined course. Similarly, it was only in fortuitous agreement with the hasty departure of the "tyrants" from Athens that Attic sculpture's divagation into ornateness did not endure for more than a single generation (let us say, from 530 to 500) and that, before the end of the sixth century, a reaction had set in against the excessive elaboration of finely etched line and daintily variegated color. This reaction had been presaged in Antenor's renowned *korē* (of much disputed date) with its forceful evocation of a strong, well-balanced body within a severely simple sheath of unembroidered drapery. Here, on a monumental scale considerably above natural size, the heavy vertical folds are kept subordinate, as structural pendants to the sturdily erect carriage of the wearer.

So genuine an interest in the living body within the inanimate garment was certain, sooner or later, to dispel the lure of superficial enrichment in decorative carving and coloring. Given time, it must dawn on even the most devoted practitioner that, if there was to be anything more to his art than a sort of petrified dressmaking, he must have recourse to wholly different devices and discover some means to raise the draped female to the level of living intensity achieved for the nude male. Artistically, the *kouros* had been moving on the right track while the *korē* had been led into a bypath.

We may ask what compulsion is discernible, other than that of loyalty to the external world of visual reality, which could have compelled the breed of sculptors to abandon archaism's skilfully evolved and richly repaying traditions? The archaic is a strikingly beautiful manner and, granted its artificial conventions, a fully perfected idiom of sculptural style. Why, then, was it discarded? Within the restrictions which such a style imposed on the representation of the living shapes of unclad men and costumed women, the accomplished statue-maker in marble enjoyed the exercise of high precision in manual skill, great decorative license, and an unrivaled opportunity and incentive to convert the world of ordinary existence into a specifically sculptural equivalent of unique sensuous experience. And he was fortunate in that for him artifice had not yet become stereotyped into artificiality or affectation—an advantage forever denied to his imitators. Yet, seemingly, the archaic masters could not continue indefinitely content with this inactual world of specious loveliness. Sooner or later, commonplace reality (precisely because it was real and everyday) must dissolve the archaic spell and draw the sculptor to itself.

The abrupt stylistic changes which invariably attend on the dissolution of an archaic stylistic tradition always impress, and very generally perplex, the critical historian of art. Yet they are phenomena which (like those of archaism itself) permit of straightforward explanation. The final cause is nothing more abstruse or mysterious than the obtrusion of the normal appearance of the everpresent surrounding visual world, which brings to the artist's attention, poignantly and dishearteningly, that he has failed in his self-assumed task. His deftly carved and brilliantly colored figures are exquisitely shaped and tinted marble, truly enough; but they are not like living men and women. And the more carefully his hands have wrought, the worse in this regard has been the outcome; for the less like real human beings have been his stiffly posed, nude youths and his simpering, rigid maidens.

Our modern public finds no impediment to the esthetic enjoyment of these archaic statues from the ancient world. Having dismissed mimetic fidelity as a necessary condition of artistic grace, it does not occur to us to object that these ornate figures are singularly untrue to life. And since visual patterns are easy to detect and pleasant to contemplate, and carved elaboration of line and vivid variegation of color exert an immediate sensuous appeal, the Maidens of the Acropolis set no barrier to our approving comprehension and demand no special preparation of mind or of eye for their enjoyment. They wear —if not their hearts upon their sleeves—a friendly smile upon their lips and much gay gracefulness on their brightly costumed exteriors.

Yet the ready response which archaic sculpture evokes from the modern admirer may betoken a more serious defect in his powers of sculptural appreciation. For sculpture, in its true and proper right, is the visual art of *solid* form; and it is precisely here that archaic representation is lacking. Its schematic devices are planimetric projections of the visual field; and the visual field is the *painter's* province. It may well be that it is this pictorial aspect of archaism which makes it so easily intelligible; and the opinion may accordingly be hazarded that a marked preference for archaic over more mature sculptural production is not the best warrant of sculptural sensibility in the beholder.

Be that as it may, it is noteworthy that no comparable enthusiastic appreciation was extended to archaic Greek sculpture by subsequent generations in antiquity. Although the specific examples at present familiar to us were mostly unknown to later Greek and Roman times because already hidden underground, archaic statues in great number must have still been accessible to view. Yet Greek and Latin authors alike pass over them, for the most part in silence, occasionally with hesitant commendation, never with outspoken admiration. According to established Greek judgment and the opinion of Roman collectors, who were submissive to this same appraisal, sculpture of real worth was not produced until the lifetime of Myron, Onatas,

and Pythagoras, who initiated the formal phase succeeding the archaic. We today are in no way bound to accept this verdict. But whether or not we concur in it, its existence in classical times is an important comment on the tenacity with which in popular appreciation mimetic accuracy is a prerequisite to approval. Vasari was to pass similar judgment on his predecessors and contemporaries among the painters of the Italian Renaissance, having little appreciation of the "primitives." It would seem to be a general rule that, as long as a mimetic art is evolving toward more extensive control of visual fidelity and objective truth, its practitioners and its public are inclined to condemn all previous performance as inadequate artistically because it is less successful mimetically. Throughout the creative period of antiquity, the archaic types which maintained themselves in production seem to have had some religious or historic rather than esthetic sanction. Not until Rome's second Greek Renaissance under Hadrian and the Antonine emperors did archaic Greek sculpture come to be prized for its own intrinsic worth.

However this may be judged, the archaic manner did not long continue to satisfy the sculptors of its own time. Before the fifth century was well under way, the archaic phase had ended.

# III

## Early Reliefs and
## Hollow-cast Bronzes

NO MENTION has thus far been made of relief sculpture, although it is a form of glyptic art that can claim considerably greater antiquity in the Aegean area than the monumental statuary with which the preceding chapters have dealt. The modeled bull and the plumed prince in hard gesso from the palace of Minos in Crete, and the heraldically confronted lionesses carved in dark limestone which still (though now headless) guard the gateway to the citadel at Mycenae, are sufficient evidence of a skilled understanding of relief in the pre-classical period. Whether any knowledge of such an art survived through the centuries of cultural decline between Helladic and Hellenic times may well be doubted; but there are extant reliefs, such as the "metope" fragments from classical Mycenae, which seem certainly to be older than the earliest surviving *kouroi*. And relief work that owes little or nothing to contemporary instruction by sculpture in-the-round occurs in some very early metope carvings from Gela in Sicily and Poseidonia (or Paestum) in southern Italy, which are so rudely uncouth as to be classable as primitive—a rating which cannot be accorded Greek monumental sculpture proper. Here the explanation must be that a lack of contact in the Greek West with the sculptural traditions of the Ionic East had left provincial art to explore as best it could the frontiers between pictorial and sculptural form.

There would be nothing untoward or inexplicable in an independent origin of relief sculpture without appeal to monumental sculpture in-the-round, especially if there were a contemporary graphic tradition to inspire it. There should be no hesitation in ascribing the very idea of relief carving to the prior notion of line-drawn picture, out of which it emanates. Relief does not become a by-form of sculpture until it has been attracted from pictorial to physically solid representation and has assimilated the distinctive procedure of sculptural form. How this shift from a pictorial to a sculptural orientation may take place is not difficult to discover.

In the initial stages of development, painting is little more than the act of applying a coating of varied pigments to a previously delineated drawing. Having established the requisite areal shapes by tracking their contours and interior outlines, the early artist proceeds to give each of these shapes some appropriately distinctive color. It is this formal dissociation of linear definition from the other visual factors which facilitates, at this stage, the invention of relief carving. Because the underlying design is an independent construction, it may be given an elementary sculptural status merely by incision. And this the artist may elect to do because of his experience of the unenduring nature of all painted work, on which the colors may fade or flake off or otherwise be damaged. To remedy such mishap and assure the survival of his work, it may quite naturally occur to the artist that the design may be permanently fixed on the painted ground by engraving it in place. With that act, the line-drawn colored picture begins to substitute sculpturally "real" for pictorially "illusory" form. Such an explanation of technical origin seems to fit well enough the Egyptian Early Dynasty tomb reliefs, which quite literally are glyptically reinforced linear designs and were so created in order to insure that uneffaceable survival at which all Egyptian funerary ritual was aimed.

In Greece, in similar fashion, the painted metope panels from the

early temple at Thermon may be taken as evidence that relief may here too have had its origin in painting; for they suggest that the carved stone metopes of the standard Doric norm are a substitute for painted wooden panels to close the open gaps between the ceiling beams of a timber structure. But even if this does not reflect an actual historical evolution in architectural practice, it remains significant that the designs carved in relief on the stone metopes of the archaic temples are strikingly close in theme, compositional manner, and graphic style to those that we find painted on such purely pictorial media as sixth-century vases. The mythic subject matter of Greek architectural sculpture, its dramatis personae and incidents of action or confrontation of characters, must be a transmission from the painters' repertory of graphic material. (Since painting sets a swifter pace and always outstrips sculpture in thematic invention and graphic representation, the inverse process of transmission from the carved reliefs to the painted vases is not a tenable hypothesis.) Although Greek relief need not have been developed solely and uniquely out of Greek painting, the temple metopes and some of the earliest relief-carved pediments afford reliable testimony that, in the archaic period, pictorial art was recognized as convertible (and was actually converted) into carved relief.

On the other hand, equally clearly and emphatically, there is another class of carved relief which owes its stylistic character to dependence on monumental sculpture in-the-round. If the profile view of a typical *kouros* is set side by side with a photograph of the *grave stēlē of Aristion* (Plate VIII), there is a striking similarity and no notable difference between the two, provided that the photograph does not convey the very great discrepancy between true "measured depth" in the statue and abbreviated "token depth" in the relief. It would seem that Aristokles (whose name we know because he signs himself as the artist of this relief) had drawn, on the smooth surface of a marble slab of much the same dimensions as the lateral face of a

statuary pier, precisely the same profile view of a nude standing male figure that he might have drawn if he had intended to make a statue in-the-round. Nor would his subsequent technical procedure have been very different, except that he cut away the stone around the figure's contour to a depth of only an inch or two instead of fully removing it to release the solid figure. If this was indeed his way of working, as though a statuary *kouros* were profiled before him, his mind must have been aware of sculptural form rather than of pictorial effect. For him, relief was not what it was for the metope carvers, a conscious recording in stone of a vase or wallpainting, but an alternative way of putting a statue upon a panel instead of cutting it completely out of a pier. Such dependence on monumental sculpture is confirmed by the greater scale at which this grave relief has been taken in close approximation to physical human size, even as the *kouroi* were; whereas the figures carved on the pictorially inspired metopes show the indifference to natural size characteristic of all pictorial representation. (A picture, being a visual field, treats objective size as a function of imaginary distance, to be enlarged or diminished at will, whereas sculpture presents its subject-matter statically and objectively as it is in the material world.)

In the making, every Greek relief began as a line drawing on the smooth surface of a blank slab. Conversion into sculptural form was effected by first cutting around the exterior contours of the drawn design so as to leave this raised above a uniform solid background (which later was painted a brilliant hue) and thereafter cutting back —but much less vigorously!—the various interior lines to clarify the pictorial forms, thus supplying each detailed part with an intelligible spatial depth and correct relative location in distance.

It would be misunderstanding the nature of Greek relief to assume that the total available depth of cutting, as measured from the original surface of the slab to its furthest sunken background (amounting in all to a small fraction of the true depth which such figures would

have possessed had they been cut fully in the round), was evenly allocated in pro rata distribution, as though the natural object had undergone uniform compression in the dimension of depth. So equitable a distribution of a diminished capital might satisfy a legal or a mathematical mind; but it would fail to meet the exigencies of artistic presentation, which considers visual effect rather than equity or geometric logic. The sculptor's purpose was to make visibly intelligible the succession of nearer and farther in the figures' construction and, having thus oriented all its separable elements correctly in spatial depth, to suggest the intensity of each recession, whether deep or shallow, abrupt or gentle. (Whenever a relief, purporting to be a classical work, fails to conform to these principles—whether because the figures have been modeled "pro rata" in uniform abbreviation of the fully rounded shape, or because they show no foreground plane of maximum projection in proof of a prior cartoon drawn on the virgin surface of the slab—such a relief is not ancient but of Renaissance or modern origin.)

How heedfully and with what variety of emphasis the archaic craftsman could introduce distinctions of depth into his carving of relief may be discovered by closely examining the *stēlē of Aristion* (Plate VIII). But since no photograph can make this fully apparent, recourse must be had to description. The total silhouette is sharply detached from the ground. The ground, once colored a deep red, gave an illusion of continuous extension beyond and behind the warrior, much as the sky is sensed to lie behind as well as beyond any figure seen against it. In the silhouetted form thus raised to the foreground of attention, whatever structural part required emphatic spatial distinction has been deeply scored along its outline and even slightly undercut where an impression of complete detachment was desired. Thus, the pendant right hand and forearm and upper arm have been sharply set off from the rest of the body, and the contours have been deeply cut as far as the biceps; but at that point the arm

suddenly ends where the shoulderpiece of the cuirass hides it, and the hidden upper arm and shoulder are united with the chest in a uniform level surface. The other, or further, arm is even more vigorously cut back from the intervening torso, which conceals most of it from view. The left arm accordingly appears to be set back by two very pronounced spatial recessions from the right arm; yet both hands lie at the same level, remaining exactly where they were originally drawn in the uncarved design on the surface of the slab. Such illusions of apparent distance in disagreement with the measurable depth of actual carving are not virtuoso displays of technical prowess nor due to any craftsman's pleasure in deceit; rather, they result quite automatically from an understandable tendency to leave as much as possible of the original design at its original place on the stone. So in the cavalcades of the Parthenon frieze the overlapped horses seem to be stepped back to a depth of five or six or seven riders in echelon; yet the farthest horse is actually level with the nearest, for the sufficient reason that both were sketched on the same continuous surface of marble paneling (cf. the overlapped horses of the west frieze on Plate XXI A). And where, in another sector of this same west frieze (Plate XXI B), the boy seems to be standing in front of his horse's flank, he is inset into it on the same level with withers and croup.

To revert to the *stēlē of Aristion*, in contrast to the deeply cut major contours the plastically less-pronounced detail is carved with shallower setback of its outlines but with great regard for appropriately graded depth to give due emphasis and accent. Thus, the hair of the head is cut more deeply than the beard; the garment which projects from beneath the cuirass on the upper arm and over the thighs is still more finely engraved; the edges of the greaves are (rather unexpectedly) indicated with equally delicate incision; while the purely decorative details of the armor, such as the shoulder ornament on the cuirass and the woven meander on the sword strap, have not

been sculpturally actualized by carving but were rendered in colored stain (which has faded long since, but not without leaving its ghostly weather-mark on the marble). All of these gradations echo the *relative* strength or slightness of spatial recession-in-depth discernible on a living model or on a fully rounded statue; but they have been quantitatively so reduced that they are simply visual guides to the optical interpretation of the theme—a sort of muted commentary *sotto voce* to a suggested tridimensional presentation.

Archaic relief thus proves itself directly and intimately dependent on linear design. But so, it will be recalled, was archaic sculpture in-the-round. Accordingly it would be incorrect to claim that, because of this dependence, Greek relief was more closely allied to painting than to monumental sculpture. The general status of relief is shifting and imprecise, because relief may incline more strongly toward painting, with little reliance on plastic sculptural presentation (as in most Assyrian and many Roman historical narrative reliefs and more modern examples from the Renaissance) or strive for strictly sculptural isolation of its figures without involvement in pictorial space (which was the typical Greek solution). Relief is in consequence a subtly protean form of art, such as German speech might pregnantly call a *Zwitterwesen*. It is symptomatic of the primacy of sculptural over pictorial appeal in Greek artistic mentality that, despite its emergence out of linear design, Greek relief so soon forsook its origin. Not merely archaic, but all classic Greek relief depends for its compositional design on a planimetric projection in graphic form; to this extent it still owes allegiance to pictorial representation. And yet, as the years passed, Greek conviction that whatever has been carved out of solid stone must be sculpture with articulate solid form, alienated relief so drastically from the painter's art that it obliterated all visible trace of this primal kinship. Not until late Hellenistic times was the pictorial carved relief to have any vogue, and not until the imperial Roman period was it to be widely favored and approved.

My very occasional reference to bronze statuary will have drawn attention to what must seem a strange omission from a survey of Greek sculpture. Only the most cursory consideration has thus far been given to work in bronze, despite the fact that in classical antiquity this medium outranked marble in popular esteem even as it exceeded it in costliness. The omission was deliberate, not because so very few life-size bronzes have survived from the archaic period, but because Greek statuary art originated and passed through its early formative phase as a stonecutter's art. Bronze was a latecomer on the scene and in consequence was for many years not the leader but the apprentice disciple of the firmly established glyptic tradition.

To the modern mind this may present an unexpected and implausible situation. That marble-cutting, addressed to the solid block, should have been a purely glyptic discipline without recourse to clay models may be surprising, but it is clearly a technical possibility. But that bronze statues should have been cast without prior dependence on clay or wax models, and on that account were not plastic creations at all but remained subject to the same glyptic restraint and determinant formal control as statues hewn in marble—this will be judged too unlikely to deserve serious consideration. Yet Greek bronze statues from the archaic, formal, and fine periods, that is to say, from the sixth, fifth, and fourth centuries, show no mark or sign of being replicas of a hand-modeled plastic prototype; and even the least technically trained eye can see that no important generic difference, other than that of material substance, divides Greek statues in bronze from those in marble.

It is true that Greek bronze statues are not as strictly contained within the confines of an imaginary pier or other geometrically simple solid, and that they often do not seem to have been generated out of a restrictive encompassing shape. The Roman marble copies of classical Greek bronzes, where they have been cut from a single block, often involve an enormous waste in discarded stone, such as

66

an original created in marble would not have necessitated. The cause of this is easy to discern; in the bronzes the arms and legs project freely into space. And there are other characteristics peculiar to works in bronze, such as the shallower incision of linear detail and the stronger luminous reflection from their metallic surface and, very obviously, the difference in hue and saturation between burnished bronze and metal inlay as opposed to crystalline marble and bright pigments carried by wax into its pores. But except for qualifications such as these, due to inevitable differences in working a medium with diverse physical properties, there is no striking distinction between a classic marble and a classic bronze statue. Admittedly, the practiced eye can determine whether a given marble copy has been taken from a bronze or a stone original; and it is possible to detect the technical influence of the bronze-casters on the marble cutters in such pieces as the *Kritios Boy* (Plate XII B) or the pedimental statues from the Aegina temple; but the scope of such observations is limited, and it is likely that none but the specialist is aware of them.

The explanation for this state of affairs is not so much esthetic as historical. Greek sculpture had begun as a glyptic craft and was already well formed and securely established before monumental bronze casting was understood or could be attempted. Previously, large metal statuary had been produced only by hammer-beating and nailing sheet metal over a fully defined wooden core, which was itself necessarily a glyptic statue produced by cutting and gouging, trimming, and smoothing, and hence generically identical with a figure cut in stone.

Up to the time when the Greeks derived from them their technique of monumental sculpture, the Egyptians had made little use of bronze and possessed no extensive knowledge of hollow-casting. It does not follow that there was no statuary in Egypt in any other medium than stone, since wood had been in use from the first and, from almost equally remote times, statues had been produced which

to all appearances were of solid copper or silver or gold; but these last were of the type just mentioned, being actually wooden statues with a thin veneer of metal beaten out over them and nailed fast. This was a procedure that the Greeks did not have to learn from the Delta since they were already familiar with it for statuettes and figurines. There are numerous references in Greek texts to "hammer-driven" images (*sphyrēlata*), some of which would seem to be small-scale *xoana* in "Daedalid" style like those found in Cretan Dreros, while others may have reflected the monumental Egyptianizing sculpture. But none of these would have shown any influence of freehand modeling in clay or wax, since they were not cast in a mold or constructed out of a plastic medium. Bronze figurines cast from a hand-formed model certainly existed; but they were of small size —necessarily so, because they were of solid metal and no larger figure could be poured solid. Apart from the extravagant cost of the material, a mass of bronze comparable in bulk to a human being would have been ruined in the casting, since incurable defects would have developed from the lack of homogeneous flow in the metal during the pouring and the violent contraction incident to cooling. The invention of a process for hollow-casting was crucial for statuary in metal because no figure of monumental size could otherwise be produced in such material except by the clumsy and unsatisfactory hammer-driven technique. The great and obvious need was a process which would yield, instead of a fragile veneer in thin sheet metal, a firm, metallic wall thick enough to withstand extensive gouging, graving, and burnishing and massive enough to dispense with any extraneous or internal support.

The inspiration for a practicable method of achieving this result was quite visibly at hand. For it could not fail to occur to some craftsmen that a serviceable casting mold might be taken directly from the same carved wooden figure to which he had been attaching his hammered metal sheets. But the obstacle remained that great

technical ingenuity would be required to replace the solid pouring of the usual foundry process by a thin-walled casting only slightly thicker than a hammered sheathing.

Ancient tradition has it that two Greeks of the island of Samos, Rhoikos and Theodoros by name, were the successful inventors of a workable method. That they were natives of the Greek city which under the tyrant Polykrates maintained particularly close commercial connections with Egypt may have some significance; but it was probably more important that during the seventh and into the sixth century Samos had been a leading (perhaps the foremost) Greek center for the production of bronze armor and utensils such as cauldrons, mixing bowls, and ewers. It is worth pausing to consider how these were made.

Cauldrons of very sizable proportions were constructed out of beaten metal sheets joined together by a riveted seam, with ornamental attachments separately cast solid and riveted in place around the rim. For other objects where sheet or strip metal was employed, ornamentation could be added by punching and hammering out a design from the reverse and then refining the detail on the exposed side with a graving tool. This *repoussé* technique—certainly in use as early as the eighth century—was to exert an indelible influence upon bronze statuary, which never failed to observe and exploit the distinction between the heavier precast elements impressed by the mold and the finer chased detailed added after the chilled metal had been freed from the matrix. We shall refer to the former as "cast work" and to the latter as "cold work," and take this occasion to point out that there is a qualitative gap or missing register between the heavy surface movement which the mold imparts and the minute disturbance occasioned by paring and graving with gouge and burin. In marble sculpture no such distinction is imposed, since all work is performed upon the medium in the same constant physical state. On the other hand, the hairline incision which is so effective on a mirror

surface of metal cannot be employed on marble because the luminous penetration and faceted reflections of the crystalline stone permit no shadows to form within so shallow a scratching of its light-flooded rind.

Even with the accumulated Samian experience in metallurgy at their disposal, Rhoikos and Theodoros (or whoever in truth invented the process) had still to solve the major technical problem of converting solid to hollow casting. It is very probable that success was first achieved on a modest scale, not for life-size statuary but for small objects such as ornamented pitchers and bowls which by their very nature could not have been made of solid metal. Once a method had been put into practice for these smaller objects, it could then be applied to the larger sculptural task. Yet even when this was accomplished, there was not to be casting of entire statues in monumental size in a single mold at one pouring. All the extant classical bronze statues produced before Roman (or perhaps we should say late Hellenistic) times prove on close examination to have been assembled from a number of pieces, which must have been cast in as many separate molds. But whatever the size of the casting, the problem remained of casting the piece as a hollow shell instead of as a solid mass of metal.

There was only one feasible solution. Somehow a nonmetallic core, which could later be removed, must be inserted into the empty mold. A hollow shell would then result from the introduction of molten metal into the interstice between the suspended central core and the surrounding mantle of the mold. The latter would leave its impress on the metal filling, to give it its shape and exterior appearance; the sole function of the core would be to prevent a solid interior from forming.

In modern times, and for a number of centuries past, bronze statuary has been poured in molds taken from plaster casts of the sculptor's preliminary model. The model is made of moist clay built up

on some sort of supporting framework (or "armature") and is fully shaped and fashioned while the clay is soft enough to be easily worked with the fingers and simple modeling tools. Undoubtedly, such a procedure offers many advantages; but ancient Greek bronze statues from the archaic and succeeding Formal Classic periods were never produced in this manner.

The basic physical materials have been the same in ancient and in modern practice—namely, clay, wax, and a molten alloy of copper and tin. Of these three substances, the wax and the metal played much the same part in the ancient as in the modern foundry; but the clay was confined to more restricted use. It was not employed for constructing a master-model for the work in hand and hence had no primary formative influence on its sculptural style. For it must not be overlooked that in Greece the stylistic tradition for hollow-cast statues did not derive from clay figurines or terracotta statuary but from the carved wooden *xoana* which served as foundations for the beaten and engraved *sphyrēlata*. In a word their stylistic inheritance was glyptic. Clay was, nonetheless, of prime importance in the casting process. It was used, first, for the exterior mantle of the casting mold, which had to be rigid under the sudden heat of the inflowing metal and stout enough to resist the pressure of liquid metal and gases during the pouring. Second, clay mixed with sand and organic matter to make it porous and friable was used for the interior core suspended within the mold. It was the core which transformed solid into hollow casting. Artistically of no moment, it was mechanically of crucial importance. The trick was to shape it and hang it so that it maintained between itself and the inner wall of the mold precisely that empty interval into which the molten metal was to be poured and in which it was to cool and harden. It was wax which made this feat possible.

If the clay mold were lined on the inside with a coating of wax to the thickness desired for the cast-metal walls of the statue, the rest

71

of the interior of the mold could be filled with spongy clay for the core. Then, if thin metal rods were driven at various points through all three elements, core, wax lining, and surrounding mantle, and a makeshift oven were built over all and heated, the core would be baked hard, the wax would melt and could be made to run out, while the core would remain suspended rigidly in place.

This was a precarious moment in the process, as any settlement or disturbance of the core while it was baking and its supporting rods were becoming set would ruin the casting. Still more fraught with risk of failure was the next step in the process when, with core hung in the mold, the crucible taps were opened and the hissing molten bronze streamed down into the passages between core and mantle. It is to this critical phase that Polykleitos was most probably referring when (according to a late classical tradition) he maintained that "the work is most difficult when the clay is on the nail."

This remark has usually been interpreted quite otherwise, on the assumption that Polykleitos was thinking of his own fingernail and referring to a "tacky" state of the modeling clay, in which it was particularly difficult to handle. Thus interpreted, the passage would seem to be direct evidence that fifth-century bronze casters made clay models for their statues. But I doubt that any modern professional would be sympathetic to such a curious stricture on his medium or admit that such a difficulty exists in handling it. Nor would a Greek have expressed the matter in quite these words, had this been his intended meaning. (That Plutarch in imperial Roman times understood the remark as applying to modeling is beside the point.)

The culmination to these long preliminaries sounds both simple and easy, though in actual performance it is highly complicated and precarious. Molten bronze was led from crucibles into a funnel at the top of the buried mold which, to give it resistance and make it accessible to the downward flow of liquid metal, had been sunken and tightly packed underground. . . .

*Fest gemauert in der Erden*
*Steht die Form, aus Lehm gebrannt.*
*Heute muss die Glocke werden!*
*Frisch, Gesellen, seid zur Hand!*

Days later, when the metal had cooled, the mold was broken open (and thus irrevocably destroyed) and the thin-walled metal casting removed, with its baked clay core within. . . .

*Schwingt den Hammer, schwingt,*
*Bis der Mantel springt!*
*Wenn die Glock' soll auferstehen,*
*Muss die Form in Stücken gehen.*

Only then could the master know whether his labor had been successful or whether the unevenly heated liquid metal had failed to penetrate every part of the mold, or had carried bubbles and dross to spoil its fabric with unmendable flaws, or pulled and split open in cooling. . . .

*Wenn der Guss misslang?*
*Wenn die Form zersprang?*
*Ach, vielleicht, indem wir hoffen,*
*Hat uns Unheil schon getroffen.*

Granted the dangers of miscasting had been avoided, there was still no statue but only a series of castings awaiting cleaning, patching, assembling, and finishing. From each of these the granular casting-skin had to be worked away with a scraper and the surface of new, clean metal burnished to a high luster. Bubble holes and other minor imperfections had to be cut out and patched with fresh metal insets, hammered into place, and burnished smooth. Arms and legs were attached to the trunk with tongue-and-groove joints so accurately fitted, hammered, and polished that they became invisible. Before the head was fitted to the neck, eyes of glass paste or colored minerals were inserted *from the inside*, the core within the head having been broken up and removed sufficiently to permit access to the eye socket from within. This socket was splayed so that the eyeball could not be

dislodged outward, and lined with thin lead plates which could be bent over the eyeball on its inner side to prevent it from falling inward. The outer edges of these lead plates were sometimes clipped to imitate eyelashes; but their real purpose was to hold the eyeball in place and permit its correct adjustment for expression. After the main assembly of parts was complete, minor accessories such as hanging locks or projecting masses of hair, headbands or free ends of ribbons, ornaments of dress or armor, were welded or soldered into place. Finally, occasional color was added by gilding or by inlaying with other metals such as silver, raw copper, or fused niello.

The entire ancient process (which can be reconstructed with considerable certainty by combining the various strands of evidence) was in principle simple and straightforward, however intricately difficult it may have been to carry out with the astonishing proficiency which ancient bronzes from the better workshops display.

The initial stage, as for the "hammer beaten" statues, was a full-size wooden image carved and assembled with finished precision. Since the foundries could not achieve a single casting of so complex a shape and so great a size as a life-size human figure, even in the compact *kouros* pose, there was no alternative except to dismember the wooden model into more manageable units for piecemeal molding and casting. Thus, for a nude standing athlete the standard practice required separate castings for the head, the trunk, the arms, and either the lower legs or the entire limbs according to the pose. For each of these parts a separate mold was made. This was accomplished by coating the wooden piece-model with a slip of fine sand and then smothering it in a thick and compact mantle of clay so constructed as to permit (1) the withdrawal of the wood (which might have to be broken up and destroyed in the process), (2) the introduction of a clay core within a wax lining, and (3) the attachment of pouring-tubes and funnels for the molten metal, and escape vents for the dislac ed air. Un dercut and awkwardly projecting elements in the

model were usually cut away and cast separately, and these, if too small for hollow-casting, were cast solid. Such were projecting locks or hanging strands of hair, accessory ornaments of clothing or personal adornment, weapons, insignia, and various attributes.

All in all, such a production represents a remarkable technical performance, requiring in addition to skill and experience a very considerable material equipment and a sizable outlay of funds. It has been described here at such length not merely because it is interesting in its own right, or because it makes comprehensible the extremely high value, economic and esthetic, attached to bronze statuary in classical times, but above all because it makes evident the enormous contribution of craftsmanship to the sculptor's activity and the paramount role played by training and inheritance, by apprenticeship in practical routine and formal tradition, without which such an art would have become bewildered and helpless and after a short struggle degenerate or extinct.

The process just described is by no means universally admitted to be an entirely correct account of the procedure of the Greek statuary foundries. Yet no other method can be reconciled with the evidence. The normal modern device of employing a mold taken from a plaster cast of the sculptor's full-size clay model must be ruled out for the classical period, if only because plaster casts were (on the specific authority of Pliny) unknown before early Hellenistic times when Lysistratos—brother to the most expert of all the Greek bronze-casters, Lysippos—"first devised a method for making plaster moulds directly from the living model . . . , and likewise discovered how to make casts of statues . . . , a procedure which became such a general practice that no statuary *came to be made* without the use of clay" (implying that, previously, clay was not so employed). Even without so definite a statement, the glyptic and unplastic character of the surviving monumental bronzes makes it clear that they are not cast replicas of clay models. I do not believe that anyone capable of an expert

technical opinion in the matter has ever maintained that they were.

A much more plausible hypothesis asserts that the preliminary models upon which the casting molds were formed had not been cut out of wood but out of very hard wax—wax so firm and resistant that it could be carved and tooled and engraved in fully glyptic fashion. Such a medium, being homogeneous without grain or fiber, could be more sharply carved and more delicately chased than wood; being amenable to heat, it would admit correction and replacement for any slip or error and allow a smoother texture to its surface; above all, by being fusible it would obviate all difficulty of withdrawing from the mold the undercut projections and complex saliences of the model and thus permit single castings such as were impracticable from wooden originals.

Such a process is eminently workable and actually has been frequently put into practice. For *solid-cast* objects such as bronze ornaments, parts of metal furniture, tableware, mirror-stands, jewelry, and a host of other items, there can be no doubt that the classical artisans formed their molds from hard wax prototypes, individually shaped for each casting. But this does not seem to have been the case for *hollow-cast*, life-size statues. For early fifth-century procedure the bronze *Charioteer of Delphi* (Plate X) furnishes cogent evidence. Here the head with its projecting hair has been assembled from separate castings; and this fact excludes the use of wax for the original model because a carved wax prototype would have permitted casting the entire head in a single piece. For later classical work the evidence is more intricate and depends on the following rather technical considerations:

As the process of molding large figures from hard wax has generally been practiced in modern times, a clay core is built up and coated with wax. It is allowed to harden and is then carved to finished detail. If a cast bronze shell of even approximately uniform thickness is to result (and this is a property eminently characteristic of classical

bronzes), the core itself has to be rather fully and accurately modeled into final form before the wax coating covers it. Such a requirement presupposes a technical tradition for modeling life-size figures in clay completely opposed to the glyptic tradition in which Greek sculpture originated. This consideration by itself would not be decisive (indeed, it might be claimed that to urge it would be a *petitio principii*) if we did not have evidence to prove that the molds for the classical bronzes were not made in the manner here described. Had the clay core been modeled (however sketchily) to the shape of the intended statue, the *inner* surface of the final bronze casting would show the modeled core's negative replica. Instead, where it has been possible to inspect the interiors of Greek monumental bronzes, they have been reported as comparatively smooth, unmodeled surfaces with occasional *positive* finger marks of the workman's activity. If this proves to be very generally the case—and thus far very little evidence seems to have been collected—it follows beyond further argument that the wax was applied to the interior of a shaped mold, with the clay core thereafter added to the wax. In that case it is out of the question for the core to have been constructed first and the wax built up over it.

A final possibility remains. Carved wooden manikins could have been thinly coated with wax in which the more minute details were engraved; an impression of this engraved model would have been taken for the clay mold; but the model would then have had to be withdrawn from the mold and the mold relined with fresh wax to the thickness desired for the bronze wall of the final casting. Such a process would reconcile all the available evidence; and though it may seem needlessly elaborate, I am inclined to think that it correctly describes the practice of the great bronze-casters from the period of Polykleitos to that of Lysippos.

An interesting bit of pictorial evidence bears on the problem. A well-known red-figure Attic vase from about 475, appropriately

named "The Foundry Vase," depicts the interior of a bronze worker's factory. A furnace with a crucible is being stoked; a bronze statue is being assembled from its parts; another statue is being scraped and burnished; on the walls are hung various tools of the trade; and among these there appears to be a pair of human feet. It is difficult to suggest why these are suspended from a nail on the workshop wall unless they are in fact wooden models of human feet

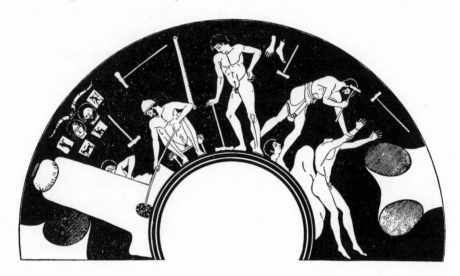

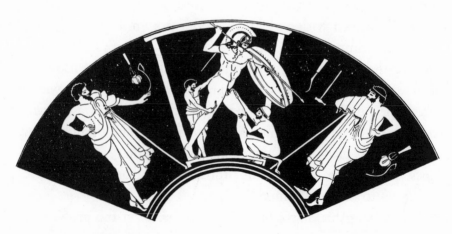

FIGURES 2–3.—THE FOUNDRY VASE IN BERLIN

intended for use in piece-casting. The feet of the *Delphi Charioteer* (Plate X), to the point above the ankles where they disappear within the long gown, are separate castings which presumably were made in molds taken from just such carved wooden models as the Foundry Vase shows. (Had the feet been cut in blocks of hard wax, the mod · els would have left no trace of themselves, and there would have been nothing to hang up on a workshop wall.)

We are left where we began—with an art of bronze statuary directly derived from a glyptic tradition without plastic context. Perhaps this is not a very impressive outcome of so many pages of explanation and argument; but it has led to the recognition of Greek monumental bronze sculpture as a glyptic art intimately allied to sculpture in stone. There were two very distinct materials in which the Greek sculptors worked; but there was only one sculptural art.

This is not to say that there are no discernible differences between classical sculpture in bronze and in marble. Most notable is the greater freedom of pose in bronze, a facility for representing bodily movement denied to the *kouroi* and *korai* of the marble cutters. The reason for this lies partly in the greater tensile strength of metal, which makes such poses materially practicable, but mainly in the release from spatial restriction which piece-casting gave.

There can be no question that classical bronze statues were assembled from separately cast pieces. Cleaning of the surface and the use of a magnifying glass will always reveal the tongue-and-groove joints when these have not become visible to the unaided eye through corrosion or breaking. In addition there is the evidence of the Foundry Vase, where the process of fitting arms and head to a bronze statue is depicted. (Characteristically, the poses of the two statues in the shop exhibit great freedom of movement.)

A further incentive to piece-casting was the convenience, perhaps the necessity, of fashioning the wooden models in a number of separate parts; for we can hardly postulate that in antiquity there was

timber economically available in the dimensions of the quarry-blocks from which marble figures were cut (the *Anavysos kouros*, for example, was extracted from a pier of stone $6\frac{1}{2}$ by 2 by 1 feet; a comparable piece of wood would demand a tree with a six-foot girth at man's height above the ground). Just as ivory-carving was materially conditioned by the size of an elephant's tusk, so wood-carving was limited to the caliber of accessible trees. It was therefore almost inevitable that the sculptor carved the arms and legs for his models out of separate pieces, building up a complete figure which could be readily dismounted for the requisite molds.

From these considerations it follows that the restriction within the parallel surfaces of a quadrangular pier, which so straightly confined the archaic marbles, did not apply to the wooden models or the bronzes cast from them. Their constituent parts were affected by restraint of material, but not their over-all assembled shape. To this— and only to this—is due the greater compositional freedom which the early bronzes exhibit in contrast to contemporary work in stone.

However, it is worth notice that this was a somewhat specious liberty, since it was only the limbs that were released and not the entire figure's volume in space. A glance at the *Tyrannicides* (which are copied from early fifth-century bronzes contemporary with the Foundry Vase) will make this apparent. Not even Myron's *Diskobolos* (Plate IX), which on first acquaintance seems spatially unrestricted, does violence to this rule. But in order to understand how it was possible for this statue to have been created by a master barely emerged from the archaic tradition, it is first necessary to inquire how any representation of the human body in action came to be intruded among the statically stolid *kouroi* and *korai* and the seated dignitaries and deities of the original sculptural family.

Whatever excellent properties may be discoverable in seventh-century Attic vase painting, its representations of the human form

are unarguably childish and, mimetically judged, absurd. But through steadfast effort and conscious desire to record the elusively changing outlines of visual appearances, the Greek artists little by little taught themselves to draw more correctly until by the late sixth century, while the sculptors were still enthralled in carving their motionless *kouroi* and *korai*, the Attic vase painters had mastered a remarkable range of bodily postures for the nude athletes and scantily clad revelers with which they adorned their wine cups and water jars. For—as must be virtually self-evident—graphic art evolves through its stylistic phases at a much more rapid rate than sculpture. This is partly due to the great difference in speed of production, since so many paintings (and an even greater number of line drawings) can be produced in the time demanded for the completion of a single statue (it has been estimated that an average archaic *kouros* must have been the better part of a year in the making). But another consideration of at least equal moment is psychic rather than material in its nature and stems from the distinction, on which we have laid so much emphasis, between the two-dimensional visual field, which all graphic representation reproduces, and the tridimensional visual world, to which sculptural representation aspires. Progress in graphic mimicry depends accordingly on interrogating what is already present in vision (since any complete reproduction of a retinal image, at appropriate size, must constitute a mimetically perfect painting), whereas sculpture must construct the physical reality beyond the retinal data.

The painters, therefore, were well in the lead and were able to delineate the human body in action long before the sculptors did so. And having—fortunately and inevitably—mastered the expressive contours of the fully visible form before advancing to the baffling complexities of its foreshortened aspects, the painters were drawing shapes which *relief-sculptors* could copy—and not merely copy in outline (which would not mark an advance) but actualize in more solid

81

shape by cutting away the ground along the bounding contours and modulating the surfaces within the interior lines. Once established in the repertory of relief, the same animated silhouettes could pass over to solid sculpture in-the-round, with some very curious and striking restrictions, as we shall discover. Now, shifting to bronze was much easier than to marble because of the lesser conflict between "mimetic" and "physical" balance. The human body assumes poses which bone and muscles can steadily maintain but which are precarious in an equivalent solid mass of stone and yet feasible for the lighter weight and greater tensile strength of a hollow-cast replica in metal. In addition, piece-casting of the limbs made it possible to translate the animated attitudes of the vase painters' figures into bronze. There is thus a hierarchy of communicable poses, originating in graphic line among the painters, transmitted through the mediating *Zwitterwesen* of carved linear relief to the bronze casters, and reaching last of all the stonecutters. Myron's discus-thrower (Plate IX)—one of the best known and most frequently reproduced of all ancient statues, both in antiquity and in modern times—is a perfect exemplification of this transmission from one art to another.

The original was lost long ago, destroyed perhaps (like countless of the greatest works of Greek art) in one of the conflagrations which time and again swept through the temples, colonnades, and palaces of Rome. But no one doubts that, as Pliny expressly states, the original *Diskobolos* was a hollow-cast *bronze*. In every detail of the pose except the turn of the head it presents a linear rendering in vivid contour, a silhouette of physical activity crowded into a pregnant moment. In addition to this obvious inspiration from an outline drawing, it closely resembles a relief detached from its background, as becomes apparent the moment that it is viewed from any point of view other than that from which its silhouette was traced (and from which it is invariably shown in photographs unless the art historian demands a different angle). From the rear the same silhouette re-emerges; but

otherwise, as the statue is revolved before the spectator, the action folds into unintelligibility until, when viewed laterally in the plane of the imaginary relief-ground, it practically vanishes from sight. The statue thus betrays itself, in conception even if not literally in the course of its original creation, as a figure in high relief deployed along a single plane—the plane of the draftsman's panel on which its silhouette was traced.

It is not suggested that Myron carved such a relief in his workshop, since an outline silhouette on a whitewashed wall or panel could equally well have been used for guidance; but the close formal resemblance of Myron's tridimensional version to a unifacial relief is strikingly demonstrated on the southwest corner metope of the Parthenon where much the same theme has been used for a Lapith youth wrestling with a centaur.

But though a line drawing can be converted into a relief without producing compositional difficulties, Myron's bolder act of transforming it into a freestanding statue entailed more awkward consequences. The technical task of constructing a wooden model from a life-size cartoon of a figure so posed, and the conversion of this model into molds of its pertinent elements, presented no abnormal problems; but no solidly substantial figure, freely poised in proper spatial depth, could result from such a process. *"Quid tam distortum et elaboratum!"* Quintilian was to exclaim half a millennium later, leaving us in doubt whether he was admiring or criticizing the work of art, but indicating that, while he could not analyze the cause, he was aware of something both strange and unnatural about it.

Myron's *Diskobolos* has repeatedly been taken as a text on which to base a homily on the representation of motion in art. And it is indeed suggestive of a highly intelligent and eminently logical mind to choose a pose coincident with a pause between the completion of one movement and the inception of another, thereby not depicting motion directly but implying its immanence in a moment of rest.

Like the pendulum which has completed a swing before reversing its career, the *Diskobolos* has drawn himself back for the forward throw. No one, it is remarked, can view a figure so engaged without anticipating the movement which must follow; and no one should complain that the bronze figure does not actually move. It has not destroyed motion by immobilizing it, as the camera snapshot substitutes immobility for the action which it purports to present. So precise is Myron's formulation that "Myronic moment" has become a textbook phrase for motion presented through its dynamic suggestion.

Yet, before awarding its discoverer the accolade of consummate esthetic logician, it would be only reasonable to observe that Myron could not have done otherwise than he did, because it is only such a moment of pause which could be sustained by a living model long enough to be recorded in outline by the artist. And it is significant that fifth-century sculptors did not remain content with this "Myronic formula," which speciously evades the issue by implying motion, past or future, and does not represent it as actually occurring. Far from admitting that a motionless mass of stone or metal should not impart an illusion of motion, the generation which succeeded Myron bent every effort to discover a sculptural device enabling them to introduce into their work a visual impression of movement taking place. As Aristotle might have phrased it, they sought to portray motion κατ᾽ ἐνέργειαν and not simply κατὰ δύναμιν.

To interpret these comments as strictures on the excellence of the *Diskobolos* would be to commit the prime metaphysical error of confusing historical origin with esthetic validity. Neither would it be an intelligent criticism to claim that the statue is faulty because no living athlete would thus flatten himself into a single continuous plane while readying himself for the throw. It is true that the statue's effectiveness is confined to a limited angle; but of course so is a relief or a version painted on a panel. Within its limited angle of effective visibility, Myron's statue has concentrated a vividly simple visual comprehen-

sion, a coherence of contour and surface, subsumed to a pattern of astonishing energy, which a comparable figure more correctly disposed in tridimensional space could not possibly attain.

It would be difficult to imagine any greater contrast between two contemporary works of art than that which divides the *Diskobolos* from the *Charioteer of Delphi.* Where the former is alert with the imminence of action, the latter stands motionless with slack reins in an untense hand; and where one is a nude in contorted pattern, the other is a tranquil study in undisturbed drapery which hides all but the head and neck, the bared arms, and the unshod feet. The source of this extreme difference of pose, mood, and manner has already been indicated: The *Diskobolos* derives from a graphic prototype, the *Charioteer* is a lineal descendant of the glyptic monumental line of the *kouros* and *korē.* His ankle-deep, single-girt, short-sleeved garment is the traditional costume of the driver of racing cars in the festival games; and its occurrence set the sculptor the problem of adapting to masculine use the drapery forms normal to the feminine theme without suggesting that the wearer was a *kouros* disguised as a *korē.* The task of clothing an erect figure in a fully enveloping garment was the same that had confronted the master of the *Votary of Cheramyes* (popularly known as the *"Hera of Samos"*), from which the *Charioteer* was separated by almost exactly a hundred years of sculptural activity. The stylistic change accomplished in this century is extraordinary. Even though the pose and stereometric profile of the two statues are surprisingly alike, there is the far-reaching and deep-seated difference that in the *Charioteer* the drapery is no longer incised upon the bodily form but has been given independent shape and substance; and instead of building up decorative pattern by precise repetition of a schematic unit, the sculptor of the *Charioteer* has taken infinite pains to vary the shape and course of every ridge and fold. By these two characteristic traits we may know that sculpture's archaic phase has been overpassed.

# IV

## *Toward the Formation of a*
## *Classic Style*

IN THE LONG HISTORY of the evolution of sculptural form, the revolt against archaism and the sculptor's escape from its trammels constitute one of its most surprising and least explained incidents—least explained, it should be added, only because it is not properly analyzed and hence has not been understood. A process which has been moving forward consistently as though to a determinable goal and has accumulated magnificent technical resources, suddenly and at the very culmination of effective artistry rejects its previous accomplishments, revolts from a long-established tradition, and strikes out on a wholly different path with an entirely new aim and interest. Yet that which seems at first sight a total change in orientation will prove on attentive scrutiny to be an unavoidable deviation from a course that had ceased to offer any prospect for further advance toward the sculptor's objectives. Just as there is nothing arbitrary, whimsical, or perverse in the original acceptance and subsequent development of the archaic sculptural manner, so there is nothing illogical, ill-considered, or surprising in its ultimate rejection. Despite its abruptness, its disintegration had long been immanent; and for all its apparently total break with the past, there is an underlying continuity.

That the archaic manner is conventional and artificial and untrue

to physical appearances may be considered by many to be wholly irrelevant to its artistic worth, since art need not be true to nature to be effective. And yet—unless some transcendental purpose intervenes, such as religious ritual, magic, or superstition, or spiritual distrust of the reality of the world of sense—it is precisely its failure to be mimetically true to the external world of visual appearance that causes archaism's dissolution.

The pictorial means of representation which the archaic glyptic craftsman employs because he finds no others available stand in open conflict with the attempt to create physical shapes in solid reality which is the distinctive property of sculptural art. The earlier sculptors, intent on expanding and perfecting their resources, remain unaware of the deceptive lure which the mechanism of human vision has set them. Because the external world comes to them—as to every man's sight—as a picture in illuminated color, their efforts to re-create objects from that world are liable to pictorial contamination. In carving intelligible detail on a statuary block they spread pictorial conversions over its surface; and the more they succeed in enriching their renderings, the more apparent becomes this categoric fault.

But if dissatisfaction at the specious unreality of his work ever leads the sculptor to ponder what he has been doing wrong and how he might more nearly do it right, there is no reason (if his mental equipment be adequate and his artistic sensibilities prompt him sufficiently) why he should not comprehend the cause of his misadventures and discover the clue to their correction. Formally considered, his task may be stated quite simply: He must invent equivalent geometric shapes in solid form to replace the linear schematic devices of surface pattern. In other words, he must rid himself of archaism's pictorial taint by substituting solid structure for linear definition.

Once the spring thaw sets in, winter vanishes with startling suddenness; it is much the same with the dissolution of archaic form. But the speed of the reaction and the violence of the change mislead the

casual critic in his estimate of the duration of the process. From the very inception of the archaic phase the desire to reproduce physical appearances correctly has been guiding the sculptor's chisel, even while his choice of action has remained confined to linear contours and planimetric projections. In order to convince oneself how strong and how steadfast is the influence of this desire for mimetic realism upon the archaic masters, it is only necessary to look attentively at the rendering by successive artists through the sixth century of any of the anatomical details of the human body—the eyes, the ears, the muscular divisions of the torso, the wrists and hands, the ankle joints and bony structure of the feet. From decade to decade, though there is not consistent advance at all times in every part and though there may even be some retrogression from one master to another, there is no lingering stagnation, but on the contrary an increasing approach to objective truth *within the restricting conditions of that definition by linear contours and linear patterns within which archaism operates.* It follows that archaism runs a course seemingly untroubled and unvexed, supplying from the visual field of picture what it cannot recapture from the visual world of stereomorphic shape; and all the while, provided that it continues to strive for realism in its renderings, it will be building up a potent force for its own destruction, because it has been borrowing from the painter's optic realm visual appearances without solidity. When the break finally comes, it quickly widens to a stylistic gulf, because the archaic forms are so consistently involved one with another that to discard any of them inevitably leads to the abandonment of all.

Such an account may sound abstract and theoretical. But the phenomenon which it pretends to describe is neither abstruse nor difficult when it is viewed in course of occurrence. A broken *korē* and the head of a lost *kouros*, both found on the Athenian acropolis, offer pertinent illustration of the process by which archaism superseded itself.

In the early fifth-century statue of the maiden which has been

nicknamed "The Little Pouting Girl" (*La petite boudeuse*, Plate XI), it is apparent, even without the evidence of the portion missing between waist and knees, that here the sumptuous elaboration of costume of the ripe archaic *korai* no longer prevails. Like a sheath, the clothing is wrapped tightly around the legs and clings to the body's curvature. Its texture is indicated by the familiar archaic devices of crinkled wave lines over the arm, incised catenaries on the small of the back, evenly spaced spirals winding around one of the legs and, elsewhere, parallel ribbon folds adhering closely to the body. But the sculptor has not been interested in the decorative elaboration of these devices. Some of the lines fade out into empty surface; others are little more than scratches in the marble; still others seem to be mere mechanical repetitions of uninteresting parallels. The sculptor's attention has been on other matters. He has ignored the patterns which the linear motives might create and, instead, has devoted himself to the direction of their flow, in order to use their running light and shadow as an accompaniment and a commentary to the solid forms over which they travel. The hanging hair in back is an opaque curtain of ornamented stone; its surface decoration is completely perfunctory. It is its movement outward and inward, following the curvature of head, neck, and upper back, to which the sculptor has paid heed. No less significantly, in the heavier folds of the drapery, in themselves monotonous and unattractive, the cloth has been shown as solid substance in visible projection and recession, paradoxically increasing the material interval between the visible surface of the marble and the imagined bodily form beneath it and yet, all the while, revealing what archaic pattern had concealed.

In this diversion of line from decorative surface pattern to functional presentation of solid volume, the *Pouting Girl's* master had predecessors in Attic work. The *korai* distinguished by the numerals 684 and 685 in the Acropolis museum (Payne-Young, plates 79–80 and 72–74) are of slightly earlier date; and both show interest in

carrying the drapery lines concurrently with the flowing contours and changing surfaces of the bodies underneath. But the *Pouting Girl* marks the first extensive break with the traditional archaic formulas and the earliest emergence of the new idiom of classic form.

Nevertheless, every significant detail still depends on its linear definition and every shape is still a patternized abstraction. The *Pouting Girl* must still be classed as an archaic work. The new manner has not yet overridden the old. Thus, the hair on the front of the head is a surface ripple of chevrons as orderly as the hood-molding of an English Norman doorway except for three strands on either side which break away at the temples and are cut as a separate solid mass unattached to the head behind them. The features of the face are sharply linear constructions and the forehead is a blank expanse on which no linear design has been recorded; but the cheeks are not similarly empty. The photograph perhaps fails to show how mobile the surface is and how much the unscored marble contributes of shifting light to the facial structure. In the mouth, it is no longer only the outline of the lips which defines the shape but the moving surface within these boundaries—the protruding modeled mass, not merely a bright red patch with sharply trimmed, arcuated edges. Indeed, it is quite specifically this effort of the sculptor to show the lower lip as flesh thrust forward and breaking away from the graphic design of surface pattern which (because it has been exaggerated somewhat, as all formal innovations are, if only to call attention to their existence) has given this *korē* her modern nickname.

Her blond "Brother" (as the statue has been called) has survived only as a bodiless head (Plate XII A) with hair which when first unearthed was "yellow like ripe corn." But the extraordinarily perfect preservation of this fragment suffices to show that in this early fifth-century *kouros* a sculptor had progressed still further beyond the frontier demarcating the Formal from the Archaic phase of glyptic art. Eyelids and lips have bodily substance and not simply

graphic definition. (Again the innovator has exaggerated; the upper lids have so much solid reality that they appear swollen.) It is apparent that eyebrows, eyelids, bridge of nose, nostrils, mouth, ears, and the facial contour in front view have been trimmed to linear patterns. Most of these pattern lines survive as sharply cut edges, with the areas which they define captive to their boundaries. But the under outline of the lower eyelids has been abraded into a smooth transition with the cheek, so that only the shadow on the stone defines its course. As in the *Pouting Girl,* the under lip is full and fleshy—perhaps the only parental feature which "brother" and "sister" share in common; they can hardly be the work of the same master! The structure of the ear is finely articulated in depth (archaic ears are often remarkably well formed); and though the forehead remains empty, the cheeks are modulated with great softness. On the rear half of the head the two twisted braids, intended to show that the uncut growth of hair at the back has been parted and plaited in two long strands crossed over one another and tied tightly together beneath the concealing forehead locks, are as harsh and textureless as leather whips. And all the rest of the hair would be little more than a carved pattern on a thickened skull were it not for the heavy overhang of looped ends across the top of the face; but here the depth of cutting gives such massive substance that the overhanging cornice of twisted hair thatches the skull as though with a roof of yellow straw.

A further matter deserves consideration. On many of the late archaic *korai* the crests and troughs of the wave pattern representing the hair are so neatly aligned in rise and fall that the whole surface seems to ripple as the waves travel over it. On the *Pouting Girl's* head the ridges and valleys are spaced as evenly as the terracotta tiles on a Greek temple roof. On the *Blond Boy,* because the waves ripple downward in every direction from the crown, their symmetrical rise and fall rings the head horizontally with alternating hoops and bands along the troughs and crests. Two undulations are here moving

at right angles to one another, the one a linear surface pattern oscillating right and left, the other a vertical ground swell in the solid mass of the block. Yet the two coincide precisely, crest with crest and trough with trough. The artistic purpose may not be immediately evident; but we shall see that it exemplifies a peculiar geometric subtlety which is a hallmark of the Formal phase every whit as characteristic of it as is linear schematization of the Archaic.

Finally, there is a peculiar quality to the facial features of the *Blond Boy*, easier to sense than to analyze unless its origin is understood. Although the features are unnaturally large, it is not their size alone which is responsible for the curious sensuous effect. Nor is it their schematic regularity of shape and outline which is disturbing. For these are typically archaic characteristics; and there is something else in the *Blond Boy*'s facial appearance which is foreign to the archaic manner. It is as though its traditional pattern had been revised under a corrective scrutiny to make it conform to some sort of abstract theorem of proportional harmony. And this is precisely what has occurred. We know the ancient term for this procedure, *symmetria*, the etymological ancestor of our English word "symmetry" but with the more restricted meaning of *measurable concordance*.

The critical eye, once it has become familiar with canonic construction in Greek sculpture, will recognize the presence of *symmetria* without need of empiric proof from calipers and measured rule. But the less-initiated will need to have recourse to these tools before they can be convinced of its rigidly accurate application by the early fifth-century masters.

An enlarged photograph taken precisely frontal to the face and level with its eyes, a pair of dividers, and a finely graduated measuring scale are all the material equipment needed for exploring this little recognized aspect of Greek sculptural procedure. A great many measurements have been taken of Greek statues in modern times; but they have in general yielded very little pertinent information. It is useless to pursue such studies without clear understanding before-

hand as to what is to be measured. Cranial indices, for example, or similar anthropologic data are wholly beside the issue. Vitruvius has given us more than a hint of how we ought to proceed.

In Book Three of his treatise, in introducing the Hermogenic system of proportions for an architectural order, he likens its *symmetria* to that of a well-formed man and proceeds to elucidate in considerable detail:

> For Nature has so constituted the human body that the face from [the base of] the chin to the top of the forehead at the lowest roots of the hair should be a tenth part [of the total height] . . . and the [entire] head from chin to crown its eighth part. . . . For the face proper, from the bottom of the chin to the lower edge of the nostrils is a third of the height; from the nostrils to the median termination of the eyebrows, the length of the nose is another third; and from this point to the springing of the hair, the forehead extends for yet another third part. . . . The other bodily members have also their measured ratios, such as the ancient painters and master sculptors employed for attainment of great and boundless fame.

Even without the express reference to sculptors it is clear from the recurrent mention of the juncture of forehead and hair that Vitruvius is drawing on a sculptural canon. For there is no biological significance in the location of such a region on the skull; whereas it is of great moment to the glyptic sculptor as defining the point to which he must extend the thick cap of stone on which the hair is to be carved. From Vitruvius' formulation it may be deduced arithmetically that the module for determining the spacing of the features along the vertical axis of the head is equal to one-tenth of the total height from base of chin to top of crown. If the tenth part of the height of the *Blond Boy*'s head is used as a unit of measurement along the central vertical axis in a sequence of 2, 1, 2, 1, 1, 3, the levels thus marked off will coincide with the mid-line of the mouth, the lower edge of the nostrils, the horizontal axis through the tear ducts and outer corners of the eyes, a line tangent to the uppermost curve of the eyebrows, and the highest point of the forehead at the edge of the cap of hair.

Being interested in pointing a comparison with the architectural orders, Vitruvius chiefly notes sculptural proportions along the vertical axis of the human body. But his omission of the horizontal proportions in the sculptor's canon can be supplied by other means. A great many fifth-century heads, including original marbles as well as copies made from them, indicate the tear ducts of the eyes by small circular pits. Similar marks are almost as frequently preserved at the extreme outer corners of the mouth. All these are surviving inner ends of deeply drilled soundings or "points" driven into the block at an early stage of the work as guides to the stonecutter in removing the mantle of superfluous marble and unveiling the features. They also served as crucially placed markers in laying out the face geometrically to its pre-established canon of proportions. The modern critic may make similar use of them in order to discover what this canon was.

If the horizontal axis marking the width of the *Blond Boy*'s head at eye level is divided into five equal parts, the central one of these divisions will coincide with the interval between the two tear ducts, and the adjoining divisions on right and left will define the length of either eye within its lids. This observation is the key to the module of horizontal proportion. Just as for the height, so for the width, the over-all dimension has been divided by ten, and this tenth part is the pertinent module. Applying this to the *Blond Boy*, the canon immediately emerges:

width of the nose (at junction with eyebrows)...... 1

width of eye socket beneath eyebrows ............. 3

interval between tear ducts....................... 2

width of eye within lids ......................... 2

width of face at eye level........................ $7\frac{1}{2}$

width of face at mouth level ..................... $6\frac{1}{2}$

width of mouth.................................... 3

width of nostrils................................. $2\frac{1}{2}$

94

It should be added that the frontal contour of the top of the head is the arc of a circle described on a radius of 4 vertical modules centered at upper eyebrow level, and the contour of the bottom of the face is similarly the arc of a circle on a radius of $2\frac{1}{2}$ vertical modules centered above the upper lip.

Even if careful measurement of the head itself should prove that these modular proportions have been slightly blurred in the course of cutting and polishing the marble, it remains apparent that the head with all its features is an abstract geometrical construction, based on natural appearances but modifying these to fit a superimposed harmonic scheme of simple numerical ratios.

Even the apparent discrepancy between the vertical and the horizontal unit of proportion is a carefully considered factor in harmonic proportion, because the width of the head at eye level has been taken at precisely three-fourths of the height, so that the tenth parts of these dimensions, which determine the moduli, preserve this ratio of 3 : 4.

There is nothing unique or unusual in this application of integral numerical harmony to early fifth-century sculpture. The head of the *Kritios Boy* (Plate XII B), carved about a decade later than the *Blond Boy*, is equally amenable to modular analysis. The two heads seem very different; but their differences depend on very slight changes in the canonic scheme. On the *Kritios Boy* the orbicular arch which bounds the eye socket has been continued down the nose as far as the axial eye level, and the shape of the eye socket has been modified and compressed thereby, with consequent elimination of the *Blond Boy*'s overheavy upper eyelids. For the contour of the face, instead of the broad and rather clumsy half-circle at the base, a continuous paraboloid curve has been carried from the chin past the cheeks to the temples; and the consequent narrowing of the head has diminished the value of the horizontal module of proportions, making all the features a trifle narrower and in consequence more delicate. But (except for the noted alteration in the eyebrows and an

abbreviation of the breadth of the nostrils from $2\frac{1}{2}$ to 2 modules) the canonic scheme is identical for the two heads.

Despite this underlying use of a common traditional rule of proportion, the *Blond Boy* and the head of the *Kritios Boy* when placed side by side seem not merely to be products of different artists but to belong to different epochs of sculptural understanding. We may do our best to assign an analytic explanation for their divergence; but over and beyond any formal alteration of technical method there has occurred a change in artistic psyche. The sympathetic spectator can sense this without hesitation or hindrance; but the critic cannot give it verbal explanation or convey its quality to those who do not, unaided, respond to it. It is well for the student of stylistic development to be brought up short, to be made to pause and remind himself that art may be studied scientifically but is never science, and that science cannot, fully and finally, explain art.

In view of this temperamental shift, which does not appear to depend on routine workshop practice but on some more fundamental factor in artistic attitude, those who seek to link such changes to the social or political environment will want to fix more narrowly the date of production of the *Kritios Boy*. Unfortunately, the chronology is deceptive. The head does not fit the body, break-for-break; on some previous occasion it had been broken off, and the restorer smoothed away the ragged fracture line and used a cement of marble dust to make a join. Since no such restoration seems to have been attempted in modern times, we must conclude that the repair was ancient; and since there is no reason for supposing that the statues overturned and broken by the Persian invaders of 479 were repaired and set up again, and since the statue was not discovered in the burial trench to which the *korai* and most of the other sculptural debris of the Persian destruction were consigned, there is no reason to connect the *Kritios Boy* with the events of 479. On the contrary, various details of style—the softening by abrasion of the linear boundaries on

the torso, the enharmonic canon of proportions in the facial features, the resemblance of the contours and proportions of the head to the bronze *Charioteer of Delphi* (which cannot be earlier than 470 if it commemorates a chariot victory in 472), the rolled-up hair, neither long enough to be braided like that of the earlier *Blond Boy* nor yet cut fully short as later fashion decreed—all these factors combine to place the *Kritios Boy* a full decade later than the Persian incursion upon Attic soil.

A stylistic resemblance has often been suggested between the *Kritios Boy* (whence his nickname) and the work of Kritios and Nesiotes, the collaborating sculptors who in 477 cast new bronze figures to replace Antenor's group of Harmodios and Aristogeiton, the "tyrannicides" responsible for the assassination of Hipparchos in 509. New statues were commissioned because the Persians had carried off Antenor's originals to the royal capital at Susa. It is not apparent (to me at least) that the *Kritios Boy* resembles our preserved copies of the *Tyrant-slayers* in any specific feature; but it is worthy of remark that the master of the *Kritios Boy* was influenced by certain qualities of contemporary work in bronze such as Kritios and Nesiotes might have been producing in their foundry, and has introduced these effects into his technique of marble cutting. Such is the fine engraving of the end-wisps of hair on the nape of the neck, reflecting the detail added with a graving tool after the cast metal has been recovered from the mold. Such also is the abruptly protruding wreath of rolled hair in imitation of the separately molded additions which bronze workers often employed for details that would have been troublesome for single-piece casting. And such, even more evidently, is the separate insertion of solid eyes, which must have been made of glass paste or semiprecious stone as in bronze statuary, instead of being indicated by wax paint on the smooth surface of the marble.

In every typical early fifth-century head, such as the two here discussed, the sharply linear definition and discrete isolation of each of

the features within the over-all facial pattern, the emphasis on frontal and lateral linear silhouette, the schematic rendering of the hair on the surface of the block—all these are manifest survivals of the archaic concept of sculptural form. As such they were aspects of structural approach and technical procedure which would have been extremely difficult to discard or to supersede with more fully modeled equivalents. As archaic glyptic art understood its portrayal, all anatomic definition was primarily a matter of projected visual pattern; and the heightened interest in measured proportions served only to encourage this linear articulation by demanding sharply defined boundaries measurable within exact limits. A more plastic rendering was debarred because it would have introduced uncertainty into the proportionate sizes and intervals and thereby impaired the effective operation of the numerical canon.

From all this it may be deduced that the so-called idealism and lack of individualization which we recognize as typical of early classical art were the direct outcome of archaic schematization reinforced by canonic abstraction. As these controlling forces weakened under the impact of steadily increasing approximation to visual truth, the "ideal" quality was gradually dissipated, to be replaced by greater naturalism in the late fourth and early third centuries. Quite comprehensibly, portraits possessing a recognizable resemblance to specific living persons could not occur until the tradition of canonic type had been overpassed and discarded. If, notwithstanding, every fifth-century (and every archaic) Greek statue has for us today its own distinctive personality, which individualizes it and keeps it distinct from all its compatriots in our thoughts and memories, this does not prove an attempt on the sculptor's part to reproduce an individual likeness but only that, through the incidents of matter and the accidents of craft, in art as in nature, the generic type may be One but its material manifestations are Many.

From the preceding considerations it should follow that in the fifth

century not only the facial features but all the other anatomical detail of the human body would have been subjected to commensurable measurement of canonic form. Just as eyes or mouth were located in their correct position and given suitable dimensions by modular proportion, so navel and groin, kneecap and ankle, breastbone and small of back, could be assigned due place and proper interval and correct relative size by modular measurement so that a correctly shaped and articulated figure might emerge from the block of marble. To this end numerical ratio was interpolated everywhere into structural form, and abstract number ruled over casual appearance, thereby applying to the nude body a formal device that by a strange paradox was invoked to insure truth to nature and yet made complete mimetic fidelity impossible. Undeniably, organic forms in nature depend greatly on symmetry and so display strict proportionate growth and balance; yet they do not achieve precisely integral ratio or make possible simple numerical formulas such as a sculptor could memorize and apply.

Just as the "measured heads" of early fifth-century art were ideal unrealities, so the statues to which they belonged, if these represented nude male figures, were equally tinged and tainted with abstract artifice. Out of the technical need of a preformulated recipe for laying out, in correct position and size, the various distinctively patterned parts of the human body there was evolved a complex sculptural canon controlling the entire figure of the nude male from crown of head to sole of foot.

Since some practicable rule of thumb is required for a glyptic process which creates its productions directly and uniquely instead of copying them from clay prototypes or other visible sources, the use of easily applicable numerical formulas in Greek sculpture must be virtually as old as that art itself in Greece. If it be recalled how Greek sculpture originated as a craft for extracting a likeness to a living shape out of a blank pier of stone, the utility—amounting to virtual

necessity—of locating in advance all the main points of glyptic pene-tration must be abundantly apparent. As a prior creation of the still invisible form which is to emerge, the canon in glyptic sculpture stands to the finished statue in much the same relationship as, in plastic work, the clay model to the final figure. But such canonic control seems not to have extended itself before the fifth century to the minutest distinguishable part of the human body. As far as ana-tomical patterns and shapes are concerned, there is no fundamental change discernible in the statues of victorious athletes which suc-ceeded the latest archaic *kouroi*. Nor is the anatomy of the so-called *Omphalos Apollo* (which copies some athlete-victor statue of the middle sixties) rendered in any strikingly different manner from the Aeginetan warriors of the Aphaia Temple pediments of the two decades preceding. The most significant innovation is not in the de-lineation of the parts but in their integration within an over-all nu-merical scheme. In the *Doryphoros* (or *Spearman*) by Polykleitos (Plates XIII and XIV) this process appears to have reached its culmi-nation.

Whether Polykleitos made his bronze as a practical illustration of his own numerical theories of bodily proportion, or wrote his accom-panying treatise in order to elucidate and justify his statue, may be of interest for our estimate of the artist's personal genius but is other-wise immaterial. It would be more valuable for our understanding of his contribution to sculptural history if we could learn the essen-tial precepts of his lost commentary by recovering his anatomical canon from the extant copies of his statue. Such copies have survived in unusual quantity and are frequently—as in the Pourtales torso in Berlin—of better than ordinary workmanship. Yet it must rank as one of the curiosities of our archaeological scholarship that no one has thus far succeeded in extracting the recipe of the written canon from its visible embodiment and compiling the commensurable numbers which we know that it incorporates.

I do not know how to account for this state of affairs. Perhaps through failure to grasp the principles on which the canon was constructed we do not perceive what measurements are critical and consequently set our calipers on the wrong spots. Or it might be urged that molding, paring, graving, and burnishing a bronze casting must inevitably obscure the preliminary measured dimensions beyond detection. And particularly, it might be supposed, a Roman copy—and we possess nothing older or better for the *Doryphoros*—must fail to reproduce the original proportions with entire accuracy. But this is improbable, since a typical mid-fifth-century head, even in a copy, will yield recognizably related measurements from which a canon can be deduced. More plausibly, as I suggested many years ago in my *Esthetic Basis of Greek Art*, Polykleitos, as a contemporary familiar with the Parthenon of Iktinos, may have held that the rigidity of numerical precision should be tempered by deliberate irregularity to give life and warmth to mathematical exactitude. Such a supposition would throw light on the remark attributed to Polykleitos (and hence presumably quoted from his treatise on the canon) that "Perfection *very nearly* is engendered out of many numbers." The apparent abandonment of simple integral proportion by fourth-century sculptors must be attributed to their recognition that numerical formulas failed of natural truth; for Polykleitos to hold that his canon should be tempered out of its exact prescriptions would have been to take the first step toward discarding it.

However all this may prove to be, ancient testimony to the arithmetical nature of Polykleitos' thinking and working is too precise and unambiguous to be rejected. Even though uniformly late, it can scarcely be posthumous ascription without adequate warrant in fact.

Thus, as just remarked, Polykleitos is quoted by Philo Mechanicus as having expressed himself to the effect that success comes close to being a matter of *many numbers;* and Galen, the great practical physician and writer on medicine, states specifically:

Beauty does not reside in the overall ratios of the body, but in the commensurability of their individual parts, as for instance of finger to finger and of all the fingers to the metacarpus and carpus, and of these to the forearm, and of the forearm to the entire limb, *precisely as is written in the "Canon" of Polykleitos*, who supported his theory by producing a statue consonant with its prescriptions. The statue itself, like the written summary, he called by the same name of Canon [i.e., measuring rule].

Again, the same author wrote in another treatise: "The so-called Canon of Polykleitos is a statue deriving its name and fame from the exact commensurability of every one of its constituent parts." (In the light of comments such as these we may interpret Plato's reference to "the body's numbers and the location of each of its parts" as contemporary testimony to a concept of an arithmetical canon for human anatomy.)

Even with its canonic formula of modular measurement, its system of *symmetria*, still hidden from us, the *Doryphoros* remains a stylistic landmark in Greek sculpture by virtue of other and more instantly discernible qualities; for in addition to its obscurely calculated proportions it embodies an almost academic demonstration of perfection in its studied pose and carefully pondered compositional balance. Like the application of integral numbers, this too was no novel invention by Polykleitos. Its previous history takes us back once more to earlier times.

In the archaic *kouroi* a peculiar stilted angularity in the carriage of the torso becomes apparent in lateral profile view. This is not due to the sculptor's technical incompetence or anatomical misunderstanding but to the material restriction of the shape of the block of marble, which obliged the sculptor to align the shoulder blades and the calf of the right leg in the same plane with the tip of the buttocks. An exaggerated pelvic angle and a tilted spine resulted from this procedure. The only feasible remedy was to start with an ampler depth of blank marble (or a less strictly symmetrical block) in order

to permit a more natural carriage for the human body imprisoned within the stone. The *Kritios Boy* does not yet show this straightening of the spine but still exhibits a strongly curved torso in lateral view. However, the two other cardinal aspects of the statue, full-front and rear, indicate an even more vital adjustment of pose, which could be contrived without material hindrance from the quarry-block.

It is not clear whether the *kouroi* were supposed to be walking or standing still. The Egyptian prototype presumably signified the power rather than the actual activity of locomotion, an abstract magic power imparted to an inanimate image by the sculptor's ritual formula. The Greeks, accepting the formula but interpreting it realistically, must have been disturbed by its lifelessness; yet through more than a hundred years of unquestioning repetition they made no effort to devise a remedy. Their striving for mimetic fidelity was at first directed toward the detail structure of the human body, which they sought to reproduce, part for part and feature for feature, in stone. But it was inevitable that any notable success in capturing the living appearance of the parts only made the more apparent the unliving rigidity of the whole. Whether the *kouros* was imagined to be standing at rest or to be stepping out to move forward, there was something in the symmetrical immobility of his attitude which did not suggest a living being.

In every waking moment that we are erect upon our feet, whether walking or running or leaping or standing idle, our bodies respond to and counter the force of terrestrial gravitation. All unconsciously we exert an accurately timed and minutely controlled muscular adjustment which might fitly be termed a "living balance." We are prone to believe that when we walk we do no more than put one foot in front of the other, unaware that the act of walking is a constant stumbling checked to prevent our falling. Even in our moments of inaction we keep ourselves poised in swaying equilibrium. Until sculpture can reproduce some plausible moment in this unceasing

maintenance of corporeal balance, its erect human figures not merely will not seem to be moving but will not seem to be properly standing still. A piece of sculpture, accordingly, must observe a twofold state of balance—one of the physical mass of its inert material, to keep it from overturning, and one of the living creature it portrays, to make it seem anatomically stable and alive. The two demands are not necessarily coincident. In archaic sculpture the *kouros* effectively balanced its mass of solid stone but gave no evidence of balancing himself as a living creature.

Our earliest instance of "living balance" in a Greek statue is, I suppose, the nude adolescent male from the Acropolis entered in the Acropolis Museum catalogue as item 692 and well illustrated on Plate 108 of Payne-Young's photographic commentary to that collection. But this statue is not very satisfactory for our purpose because the lower legs are missing and the pose must be inferred from the rendering of the buttocks and hip muscles. (Payne has certainly misdated it in claiming it to be "rather before than after the end of the sixth century"; it is appreciably later than the "*Theseus*" of his Plates 105–6, which belongs in the last decade of the sixth century.) More advanced and somewhat better preserved is the elegant *Kritios Boy*, whose head has already been considered—a widely known and justly admired embodiment of the Boy Beautiful of ancient erotic attention, the παῖς καλός so often celebrated on early red-figure Attic vases. Despite the loss of both feet and one lower leg, it is evident that the even rigidity of the archaic *kouros* has been altered to a new imbalance by setting one foot firmly on the ground and raising the other upon its toes. In response to the uneven load, one leg is relaxed and its knee bent, while the other remains taut. This differentiation between tense and relaxed support is necessarily transmitted to the torso. Under pressure of the uneven strain, the hips are no longer level; the buttocks and inguinal boundary and heavy hip muscles are no longer shown as symmetrical mirror images, left and

right, but are distinguished for muscular tension and release. In the accepted terminology, "weight leg" and "free leg" have been introduced; but this vitalizing change in pose does not yet extend above the waist level to produce axial asymmetry in the torso. It was reserved for the next generation of sculptors to involve the thorax, chest, and shoulders, the upper back, neck, and tilt of head in the continuous swaying movement of living balance. With the *Doryphoros* of Polykleitos the formula was to be perfected and raised to canonic status as the accepted pose for the freestanding figure.

Viewed frontally the *Doryphoros* dispels the rigid axial symmetry of the archaic *kouros* by introducing "chiastic" contrast between physical left and right. Not only does a bent knee and raised heel oppose a knee kept taut and a foot set flat, and a bent forearm and lifted hand oppose an arm hanging idle along the other flank; but these unsymmetrical dispositions are themselves set in opposition by associating the raised arm with the lowered knee, and the lowered arm and its lightly drooping shoulder with the taut leg and its raised hip. By this symmetrical asymmetry a visible differentiation between tension and relaxation, between muscular contraction and expansion, is introduced into each bodily feature in contrast with its opposite counterpart; and a gently swaying curve expressive of the erect body's living balance replaces the straightly vertical axis of the unliving archaic stance.

Comparison with Myron's *Diskobolos* is illuminating. In the earlier statue (to judge from a confrontation of the various copies extant), despite the attitude of extreme muscular strain, the torso presented only static muscles without apparent response to the actions in which they were engaged. The active arm, straining backward with discus poised for the throw, differs hardly at all from its uninvolved pendant counterpart. Neither the thigh muscles nor the calf muscles show any abnormal projection under the extreme tension of flexed support. In the torso the schematic musculation of the inactively erect *kouros* has

been adapted with the least possible modification of its structural pattern; were it not for the curvature, the entire torso above the navel could be mounted on the abdomen and lower limbs of a *kouros* standing at rest. While the copies differ among themselves in their indication of these particulars, unquestionably the original statue showed no attempt to reproduce the dependence of bodily action on muscular contraction and control. Herein, presumably, is to be found the reason for Cicero's comment that Myron's statues, unlike those of Polykleitos, were "not yet sufficiently close to natural truth" (*nondum Myronis* [*sc. signa*] *satis ad veritatem adducta . . . Polycleti et iam plane perfecta*).

Polykleitos' closer approach *ad veritatem* was an advance from inert to living anatomy, dependent on stricter observation and more accurate reproduction of muscular behavior. What this involved in terms of technical accomplishment could not be described more concisely or more vividly than Xenophon has done in a memorable passage of his *Memoirs of Sokrates*, wherein he recounts a conversation between the philosopher and a sculptor called Kleiton, in whom we may plausibly discern our master:

> On one occasion, having turned in at Kleiton the sculptor's and engaging with him in talk, "Kleiton," said he, "I am aware, through having seen them, that the runners and wrestlers and boxers and pankratiasts that you make are very fine; but what most attracts men's attention, their lifelike appearance—how do you produce this in these statues?" When Kleiton was at a loss for a prompt reply, "Is it not," said Sokrates, "by likening your work to living appearances that you make the statues seem alive?" "It is indeed," said he. "Then, is it not by reproducing the various elements as they are drawn up or down by the pose of the body, those that are compressed and those that are extended, those that are contracted and those that are relaxed, you cause them to seem more like the true appearances and make them more plausible?" "Quite so!" said he.

Photographic illustration of the *Doryphoros* is almost invariably confined to the frontal view, perhaps because of the widespread mod-

ern impression that Polykleitos' interest in perfecting chiastic balance involved only this single aspect of the human figure. Nothing could be more mistaken, since such an assumption overlooks the origin and century-long development of the *kouros* type as an interpenetration of *four* cardinal profiles. The *Doryphoros* in lateral view is even more adroitly balanced, and the contour even more effectively combined in overlapping pattern. A charming, small-scale stēlē from the sculptor's native town of Argos, carved in low relief and showing the *Doryphoros* leading a horse by the bridle, should be sufficient testimony to antiquity's better appreciation of the statue's lateral view. However, as in the archaic *kouroi*, the four cardinal aspects still control the entire composition. As the statue is revolved, or the spectator moves around it, it becomes evident that intermediate viewpoints have no independent status or interest of their own but are purely incidental to the exchange of one cardinal silhouette for another. If Pliny was to record Varro's criticism that the Polykleitan statues were all "four-square" (*quadrata*), the complaint was based on the entirely accurate observation that only the four cardinal aspects had been the sculptor's concern.

If Pliny recorded the further complaint that Polykleitan figures were too much alike (*paene ad unum exemplum*), this was the inevitable price of a fixed canon of proportions with its inelastic prescription of harmonic perfection. In Greek philosophic thought the generic form was single, while its material embodiments were manifold; and if art insisted on presenting the ideated form rather than its individualized variety, it could hardly fail to favor the One over the Many. Yet herein was its ultimate virtue, even as Pliny's authority understood and phrased it with startling conciseness in the familiar passage:

> He made also the statue that sculptors call the Canon, from which they derive art's precepts as though from a code of law; for he, alone of mankind, is deemed to have put Art's very self into a work of art.

Here, then, was embodied in enduring shape the Polykleitan conception of chiastic balance and studied muscular response, of tempered proportion and harmonious outline, of expressive pose for the body at rest in a moment of suspended action, of the athletic nude in heroic strength. And here, perhaps more starkly than in any other work, may be detected the essential qualities of Greek sculpture in its fully evolved formal state, uncontaminated by any un-Hellenic trait. Quite possibly it was the recognition of this claim which made the "Canon" throughout the imperial Roman epoch the best-known statue of classic times.

# V

## Temple Pediments
## Classic Drapery

IN ANCIENT GREECE as in later Europe during the Romanesque
and Gothic period and, for that matter, in any age when the major
contribution to building was the stonemason's concern, sculpture
and architecture were intimately allied. In Greece, both arts em-
ployed the same material medium of white finely crystaled marble,
trimmed and carved with the same tools, finished in equally exact
precision, and with brightly colored detail added in the same wax-
base pigments. The Greek architect conceived his task in the same
visual terms and aimed at the same artistic effects as did his sculptural
fellow. Indeed, sculptors and architects were often one--Skopas and
the younger Polykleitos being conspicuous examples of this dual
role. In consequence, it is not far wide of the truth to say that a
Greek temple such as the Parthenon, with its perfection of jointing
and coherence of contour and organic unity of structural form,
would have seemed not so much assembled out of separate blocks as
carved in a single huge mass of marble. It is not surprising that Greek
architecture (again like Romanesque and Gothic) relied greatly on
sculpture for decorative aid.

Apart from the carved and colored moldings which were intro-
duced to crown and separate the various structural elements, the
sculptural adjuncts to the Greek orders had their origin in two un-

related types of ornamentation. One of these was painted design applied to blank surfaces; the other was modeled clay for finial plaques and figurines along gutters and gabled ridges. Since roofs were covered in terracotta tile, their decoration with terracotta figurines or modeled plaques along their eaves and against the sky line was a wholly appropriate invention. In another category, the smooth surfaces of the marble walls and the various other blank elements incident to a temple structure presented panels to attract the painter's art. But glyptic monumental sculpture in-the-round, such as we have been reviewing, had originally no congenial place on a Greek building. Here, as has already been noted in another connection, it was carving in relief which acted as the intermediary in converting the painter's contribution into sculptural enterprise.

In timber construction, a framework of parallel beams laid horizontally carries the ceilings, and sloping (or "raking") beams are set as rafters to support the roof. In the horizontal rack, the open intervals at the outer end of the ceiling beams could be closed with thin slabs to keep out the weather. These slabs might be made either of thin wooden plank or of terracotta when that material was in use for sheathing exposed woodwork. On either of these the application of a whitewash slip would provide a suitable ground for painted design. It was from such painted panels that the carved metopes of the Doric order were evolved.

Along the flanks, where the horizontal ceiling beams and the sloping rafters converge, there were only the overhanging eaves above the metopes; but at the narrow ends of the building the sloping rafters, rising from either side to a central ridgepole, formed a large gaping triangle above the ceiling level. Since this opening, too, needed to be closed against the weather, a screen wall was inserted—the *tympanon* of Greek architectural parlance—and this presented an attractive field for painted design. It was not the open space under the sloping roof but the closing wall behind it, not the pedimental gable

but the tympanon screen, which at first received decoration. From the reinforcement of such tympanon designs by carving them in relief, pedimental sculpture was initiated on the Doric temple. But it was not until relief gave place to fully detached statuary that the shallow shelf in front of the closing wall was utilized. In this manner the Greek tradition for pedimental sculpture was evolved.

This is not a theoretical reconstruction of an assumed series of events; for the earliest pedimental sculpture which has survived is all relief-work; and the earlier its date, the shallower is its carving and the more dependent is it on drawn outline and flat, colored surfaces. The tiny pediment showing Herakles' combat with the Hydra, from the Athenian acropolis, is very faithfully a carved-out Attic black-figure vase design. And the transition from tympanon relief to detached sculpture in-the-round is convincingly demonstrated on the Siphnian Treasury at Delphi, where the upper half of the various pedimental figures is fully cut away from the ground while their lower portion remains imbedded in it, carved only in relief.

By all odds, the most spectacular relief-pediment to survive is the well-preserved series of tympanon blocks from an early sixth-century temple to the local Artemis of Corcyra, the island today generally known as Corfu. In utter disregard of consistent scale, the carved figures swell from tiny prostrate or seated figures in the corners of the gable to huge spotted leopards flanking an enormous, hideous-faced Gorgon at the center. The available height of wall under the sloping roof has alone determined the varying sizes of the occupants of a common spatial frame. The artist's mind was seemingly undisturbed by any suspicion that such a loftily set and sharply isolated situation demarcated a spatial world of its own, which imposed a self-contained orderliness of coherent size, pertinent action, and relevant meaning. All this the Greek sense of artistic fitness might be expected to reason out fully and find for all its problems of scale and composition and subject matter their appropriate solutions—not

abruptly and at a single cast, but only after repeated trial and effort.

What explanation can be offered for the substitution of sculptural for pictorial decoration on the Greek temple?

On the blank rear walls of public colonnades such as lined the open plaza (or *agora*) of a typical Greek city or enclosed a sheltered porch (or *lesche*), paintings were often executed in wax pigment upon the polished or stuccoed marble surface. This tradition was not altered in favor of adornment in carved relief for such a location, nor were statues set to embellish such a background wall. Similarly, within the temples and public buildings, painted designs were applied to the stone screens and perhaps to the interior faces of the walls (as seems to have been the original intent for the Hephaisteion in Athens). Was it merely the danger of impairment by sunlight, wind, and rain which deterred a similar pictorial treatment of the exposed exterior surfaces of a building? Such an explanation would hardly apply to a tympanon, where heavy eaves offered adequate protection for painted decoration. In order to explain the shift from pictorial to sculptural decoration in Greek architecture, which produced the carved metopes and the pedimental statuary of the classic temple norm, we must postulate a powerful, though perhaps not wholly conscious, preference for sculpture as against pictorial representation, the very reverse of the condition in Renaissance Italy when painting was the favored art, with sculpture by and large a poor second. In Greek appraisal, painting was more appropriate to interiors with low illumination, sculpture in-the-round to the full light of out-of-doors, while relief (the intermediary between the two arts) was cut in greater salience when intended to be seen in strong daylight and more weakly limned where the light was less. So, on the Parthenon, the figures on the exterior metopes were as completely detached from their ground as the medium permitted, whereas the sheltered frieze within the colonnade, dimmed by the ceiling above it, was carved in much slighter projection (Plate XXI). The technical

reasoning here is sound. The higher the protrusion of relief carving, the deeper will be the shadow cast by and upon the figures and the greater will be the illumination required to dispel it. *Per contra*, where diffused shade prevails and daylight is dimmed, relief must avoid adding to the obscurity and must therefore use only low-projecting masses devoid of heavy shadow. For the harsh, sun-struck reality of a Greek temple standing in the open against a Grecian sky, although flat color could profitably be added to clarify the individual structural members, any painted composition spread flat upon an exposed surface would have possessed insufficient spatial actuality, in contrast with the vividly real structure of the building. Here only solid sculpture had adequate material existence. Likewise, a carved and colored relief upon a tympanon, viewed from far below and at a considerable distance, would appear scarcely more than a painting on a shadowed screen, too weak for the heavy frame of roof and cornice.

Yet the introduction of solidly substantial figures in the niche of built-in space between entablature and roof, while it better suited the architectural environment of sharply defined structural shapes, entailed an esthetic objection of a different order. Whereas painted representations were only visual evocations as unreal as the incidents in a storyteller's tale, statues in their full and firmly solid actuality must seem as real as the temple on which they were stationed. The Aeginetan warriors, fighting and stumbling and lying wounded on their corniced shelf high up above unclimbable columns within a starkly uncomfortable triangle beneath an irrelevant roof, could hardly fail to suggest something illogical and even ludicrous in their embattled presence, encamped on a temple front.

We have no way of knowing whether the irrationality of thus representing convincingly human beings in a setting manifestly impossible to them ever disturbed the Greek artist or his public. But it raises the interesting query whether the Greeks' insistence on visual realism had not here led them astray. And it is perhaps pertinent

that the architects addicted to the Ionic order, though they ultimately accepted the Attic practice of setting between epistyle and cornice a frieze of sculptured figures in relief, resolutely resisted the introduction *more Dorico* of statues in their pediments.

Because the roofs of temples were carried on central ridgepoles running the length of the building to form symmetrical gables at either end, sculptors were confronted with the task of filling two triangular fields of identical shape and size. For this reason, Greek pedimental sculpture was produced in twin sets of closely contemporary execution and hence, it is to be expected, of comparable style and similar composition.

This being the norm, it was extremely surprising and no less bewildering to discover on closer study of the remains of the early fifth-century sanctuary of the deity Aphaia on the island of Aegina opposite the Attic shore that not two but *three* series of pedimental figures were represented, with no other possible source than the one isolated Doric temple. The most plausible explanation for this anomaly assumes that, during the Persian invasion and at the time of the enemy's naval blockade of the Saronic Gulf before Salamis, a hostile landing party severely damaged the statuary on the eastern front of the newly erected temple but did no harm to the western gable, whose figures may not yet have been set in place. After the Persian defeat, the Aeginetans would have replaced the damaged statues with a new set of figures and buried the discarded series within the sanctuary, just as the Athenians at that time interred the shattered dedications on their acropolis. Such an explanation, if correct, lends new importance to the Aegina statues. Despite the havoc which Persian rage, the indifference of time, and the oversanguine restorations of Thorwaldsen have inflicted on them, their contribution to the chronology of stylistic development during a crucial phase goes far to compensate for the disappointments attendant on a visit to the famous *Aeginetensaal* in Munich.

Although the correct restoration of many of the figures is debatable and their arrangement within their respective pediments is still by no means entirely certain, there is much to be learned from them. Compared with any known marble work from the period (even if that period is a decade later than the handbooks on sculpture assume), the variety of poses is surprisingly great. This richness of compositional resource must have been derived from the Aeginetan bronze-casters' experimentation with piece-cast figures. There is abundant evidence for an important school of sculpture in bronze on Aegina by the close of the sixth century, but little or nothing to suggest a flourishing industry in marble. Yet for the sculptural adornment of a marble temple there was no other choice than marble, since it was seemingly unthinkable to the Greek mind that bronze should be employed. The compulsion to essay a branch of the sculptor's art with which the Aeginetans were not conversant explains their adherence to technical procedures from working in metal. This is revealed not only by the highly active poses such as could with difficulty be cut from single blocks or kept in balance or insured from breakage when made of solid stone, but also by the abundant recourse to metal accessories for the statues. Spears and shields, bows and arrows, helmets and plumed crests, all occur as separately cast additions to the marble hands and heads of the warriors. A further borrowing from bronze technique, which greatly affected the stylistic quality of the work, is the sharp, shallow engraving for the hair of head and beard and for the detailed elaboration of such costume and armor as had not been supplied in metal.

It should be remarked that this intrusion of actual armor and weapons into a make-believe company of stone was entirely consonant with the realistic ambition of the Greek sculptors, whether archaic or not, who saw no logical objection to putting genuine swords and spears in the hands and helmets on the heads of figures intended to be seen so accoutered. The resultant "mixed metaphor,"

which confused physical reality with artistic imagery, was greatly mitigated where the addition of bronze, whether left blank, artificially patinated, or gilded over, produced no further visual effect than that of an extra color in the palette of bright hues habitual to Greek marble sculpture.

A significant advantage in borrowing from the bronze-caster's more extensive repertory of poses was the unity of scale and subject matter which could be achieved—probably for the first time in sculptural history—within the awkward spatial limitations of a full-size temple gable. By judicious choice of attitudes—reclining, kneeling, stooping, falling, lunging, striding, or standing erect—the designer could meet all the exigencies of pedimental headroom without introducing any discrepant size in the figures. It was of course incumbent to choose some applicable theme to justify the simultaneous occurrence of so many different postures. But such a theme was ready at hand in the combat scenes of contemporary pictorial tradition. The melee of battle included every moment for such a scene. That the arrangement which resulted was wholly impossible in actual combat hardly weighed against the sculptural coherence and visual harmony attained. Whatever else might be said against such a carefully ordered display of arbitrary action in conflict, at least it solved the formal problem of pedimental composition with exemplary consistency and without any surrender of artistic sense or fitness.

It is hardly sound esthetic criticism to object that in such a situation it is the pre-established external frame which has supplied the unifying bond to the composition; for the frame belongs to the architecture, and if this dominates the sculpture, it correctly emphasizes the subordination of decoration to structural design. Even so, it must be the sculptor's task to compose so adroitly that the figures seem to determine the shape of the frame rather than to allow it to be apparent that, in fact, the reverse is the case. Herein the Aeginetan masters signally succeeded.

Greek temples faced the sunrise, toward which the cult statue of the enshrined divinity looked out through a great doorway and the eastern row of exterior columns. In consequence, the eastern pediment crowned the open entrance front while the western pediment adorned the rear of the god's dwelling. At Aphaia's temple on Aegina the absorbed interest of the sculptors in their new formula of composition seems to have precluded any thought of distinguishing sculpturally between the two façades. But at Olympia, with the next great commission for temple pediment statues only a decade later than the last of the Aegina triad, east and west were emphatically and brilliantly contrasted. This finely conceived distinction might well have become an accepted tradition for the Doric temple; yet it seems to have been an isolated trait of Greek artistic inventiveness. No comparable difference of mode between front and rear pediment is discernible in the later temples, whether in the Parthenon at Athens or the rebuilt shrines for Apollo at Delphi and Athena Alea at Tegea in Arcadia. However, since the last two are known to us by little more than a description of their statues, no dogmatic statement may be made.

In Elis beside the river Alpheus, where the foremost of the Greek athletic festival contests was ceremoniously celebrated every fourth summer, Zeus, lord of the games, had long held his sanctuary yet possessed no proper temple of his own. He shared with his wife Hera an old-fashioned, squat-columned, but in no sense mean or unworthy building. The god's share in the booty from the richly caparisoned Persian host in the great defeat at Platea provided the funds, as the tremendous victory provided the moral incentive, for building an ambitious new temple. (At Athens, where a sadly ruined town had first to be rebuilt and adequately fortified with encompassing walls, the city goddess' new temple had to wait forty years for its dedication; the Parthenon, following at an appreciable interval the temple of Zeus, is the next great sculptural undertaking.) At Olympia the funds seem to have been exhausted before crowning statues

had been set against the sky line for acroteria above the pediments or a worthily rich and duly impressive cult statute of the god could be placed in the interior chamber. In consequence, the completion of the sculpture for the temple lagged for more than thirty years. The twelve metope reliefs for the front and rear vestibules—the exterior order was left blank—were the first to be finished; next, the two pediments were filled with statuary by masters unidentified; thereafter, but not immediately, the enormous gold and ivory cult statue of the seated Zeus was fashioned by Pheidias and installed within the temple; and, last of all, the acroterial figures of Victory were carved by Paionios, an Ionian-born sculptor resident in Athens. Of this splendor of sculptural adornment, several of the metopes and most of the pediment statues have survived in intelligible condition; but of the acroteria and the great chryselephantine statue no fragments remain. Thanks to the clean river sand in which the marble has lain embedded, whatever has been recovered preserves a surface texture such as few ancient statues can rival. Most of the classical marbles now on display in museums were found encrusted with a lime deposit or otherwise discolored and damaged from century-long repose under rain-soaked soil. Because they were thoroughly cleaned, often with acid to loosen the crust, scoured, and burnished without pity during the Renaissance and in even quite recent times without due regard, the original texture is usually lost. But from this misfortune the marbles from the Zeus temple at Olympia are exempt. Broken as they are, whatever remains has lost nothing save its coloring in wax and still shows the original touch of the stone-cutters' hands. And since these pediments mark the highest surviving achievement of a particularly inventive phase in stylistic progress and self-conscious artistry, a pilgrimage to Olympia today is as obligatory on the lover of Greek art as ever it was in the past on the enthusiast for athletic contests.

As immediate successors to the artists of Aphaia's temple on

Aegina, the sculptors at Olympia might be expected to have followed the excellent Aeginetan formula for pedimental composition, but in fact it would be difficult to imagine nearly contemporaneous productions more profoundly different in mood and manner than those which adorned the two sanctuaries.

It is completely uncertain who were the masters charged with the metopes and pediments at Olympia or even from what part of Greece they and their helpers were called to Elis. To be sure, Pausanias in describing the famous temple, still standing undamaged in his day six centuries after it was erected, records two familiar names of the Attic school, Alkamenes and Paionios, as masters of the two pediments. But the proven date and apparent style of these sculptors render his testimony unacceptable. Yet he may have correctly indicated the home land of the sculptural school responsible for the work. It is mistaken to suppose that there were a great many important centers of sculptural activity in Greece at this time or many workshops equipped and experienced to execute so great a commission in marble (just as, in this same period, statues in bronze were probably being produced at only a comparatively small number of foundries —at Samos, Aegina, Argos, Athens, and perhaps Chalkis, as well as at Rhegion on the Sicilian strait, to name those for which we have most certain evidence). Of this much at least we may feel convinced, that the artists who carved the statues for the Olympia pediments had been apprenticed and schooled to work in marble, not bronze, and that they were intimately familiar with the Attic sculpture of their day. The head of the huge Apollo who stood protectingly in the center of the western pediment has often been likened to that of the *Blond Boy* of Athens; the heroic nudes on either side of the god, striding with weapons raised, are reminiscent of the Attic *Tyrannicides*, the famous bronze pair made to replace Antenor's figures carried off by the Persians; beyond these, the centaurs assaulting Lapith women and boys resemble those of the earlier metopes which were

119

(perhaps) even then being carved at Athens to await emplacement on the great new temple projected for Athena Parthenos; and finally some of the attendant figures in the east pediment show contracted poses of much the same silhouetted character as Myron's *Diskobolos*.

At Olympia the two pediments are deliberately and dramatically contrasted one with the other. On the entrance façade the ordering of the figures is calm and tranquil with each statue set openly apart from its neighbors, whereas the rear gable is filled with a remarkably agitated arrangement of symmetrically balanced groups tightly interlocked. It is presumably an accidental result of such a disposition of the figures rather than the deliberate intent of a geometrically minded artist that, when projected, the axes of all the major figures in the east gable run vertically parallel without intersecting or converging, while in the west the projected axes converge toward two rather vaguely defined areas situated about forty feet above and below the pedimental floor level (the latter convergence agreeing, by coincidence, perhaps, with the location of a spectator standing before the temple front). When examining Greek art, and most especially that of the fifth century, it is difficult to decide how many of its geometrical and other mathematical qualities were deliberately introduced by the artist; for, as already noted, there can be no question that the sculptors and architects of the period were highly sensitive to numerical and geometrical relationships of form and much concerned to employ them in their work.

Certainly, there is a deliberately contrived contrast in mood and manner between the two pediments at Olympia. In the ceremonially aloof poses of the east gable the central statues continue the *kouros* tradition of the motionless pier-hewn figure, while the attendants crouch or otherwise contract themselves into immobile blocks, humanly articulated rectangles surmounted by slumbering heads; and in the corners, recumbent youths, interpreted by Pausanias as divinities of the two nearby rivers, emerge from tightly wrapped sheaths of

clothing, as slow-moving as mollusks in their shells. A local legend fraught with violence and threat of murderous disaster—the tale of the chariot pursuit of Pelops by his grim, unwilling father-in-law— has been drained of all incident and action in order to transmute it into changeless statuary. It is as though, before acting out a drama of deceit and flight and lovers' triumph, a company of players had aligned themselves at the footlights to bow to their audience. Those who incline to esthetic dogma in the spirit of Lessing may detect herein a fundamental aversion to pictorial narrative which properly distinguishes the sculptor's from the painter's art. But to conclude that Greek sculpture avoided the immediate representation of dramatic action is to overlook the rear pediment of the same temple where all is turmoil and impassioned strife.

Perhaps it will be objected that here, in this astonishing array of interlaced bodies, sculpture has become pictorial narrative; but if so, it constitutes a peculiarly Greek sort of pictured presentation, since there is no indication of scenery or setting, of spatial or material environment, but only living actors upon an empty stage, set side by side against a common ground. It is true that Greek painters might have portrayed a centauromachy in similar terms of vivid silhouettes against a blank background; but this would suggest either that Greek painting had a strong sculptural bias or that Greek sculpture drew on graphic precedent, but not that Greek sculpture had here transcended its proper domain and trespassed on painting's legitimate preserve. If in the east pediment all action has dropped from the myth and no story is being told, and in the west the incidents of a drama of violent struggle are displayed in vivid detail, in neither case is there transgression beyond the representation of sculptural themes in sculptural terms. Architectural space—the solid triangle on the shallow shelf between horizontal and raking cornice—has been accepted and utilized as sculptural space without conversion into pictorial illusion of inactual depth and distance. It is the supreme logic of Greek sculp-

ture and the best proof of its sound artistic sense that it confines itself to sculptural space.

If it be inquired what may be meant by "sculptural space" and what warrant there is for its existence, a straightforward answer can be given:

Whenever we concentrate our attention on a piece of sculpture, we deliberately segregate it mentally (and hence visually) from its objective environment. Amid the depth and distance in which our visual world extends, a sufficient amount of these commodities will accrue to the sculptured solid; and, in addition, it will attract to itself enough of the surrounding aerial vacancy to insulate itself from the rest of the visual scene. It demands adequate living-room for its activities. According as it is seen to be thin or thick, flat or cylindrical, cubical or otherwise constituted, it will occupy varying amounts of visual space; and according as it presents motion or implies any similar reaching-out beyond itself, it will assimilate sufficient enveloping space for action. There is thus a subjective factor in sculptural space which differentiates it from the measurable volume which a physicist would assign to the configured material mass of a statue. The material mass is never identical with the apparent volume as seen—and still less so if we add the sculpture's attracted environment, its spatial "aura." Sculptural space is accordingly definable in terms of apparent volume and assimilated surrounding "aura," and hence is not fully identical with physical or (as we are apt to call it) "real" space.

On inquiry it will be found that architectural space has a similar subjective character; but it is sufficient for our present understanding to note that sculptural space may coincide with architectural space accurately enough to prevent any sensible discrepancy; whereas pictorial space, because it is created through the substitution of an artificial visual field with its own presentation of depth and distance, cannot be made coextensive with either architectural or sculptural space, both of which partake of the spatial world of our normal waking

sense-experience. There is nothing recondite in such a formulation, which corresponds to everyone's awareness that buildings and statues are spatially real while that which we see in a painting is spatially illusionary. But it is less generally appreciated that the spatial structure of sculptural representation depends primarily on vision and not on physical measurements. It is what it is *seen* to be; and since it is also seen as something other than its material self—being, for instance, the god Apollo as well as a nine-foot mass of marble—how it seems to be shaped is greatly affected by visual presentation and suggestion. It is this distinction between the carved block and the seen statue which the fifth-century sculptors were beginning to appreciate. At Olympia we may see them working their way to an optically effective solution to an extremely subtle visual problem.

On this problem—if we are not to misapprehend or miss completely one of the most extraordinary properties of Greek sculptural art—we must concentrate our attention.

The Greeks understood sculpture as an art of direct visual presentation; what one saw, when one looked attentively and intelligently, was the entire intent. Statues were not meant to be symbolic suggestions of something other than themselves, illusive and allusive in their impact on the imagination of the spectator. They were fully objectified existants in the same world of sense as the rest of the spectator's sensuous experience (even if some mental concession had to be made to explain their immobile presence out-of-doors in a temple precinct or a public market place). This should not be construed to imply that the Greeks had no recognition of a statue's independent status as a work of art or were unaware of its essential unreality as a block of carved marble or a piece of cast bronze; they cannot be accused of thus confusing subject matter with esthetic experience. But it serves to justify the struggle for mimetic truth which through six centuries of seldom-diverted effort determined the course of their sculpture's stylistic development.

Objection may be taken to all archaic statues that, visually ana-
lyzed, they are faulty. Since their linear contours and schematic sur-
face detail were derived from fixations of the visual field (comparable
to the flat projections visible in the finder of a camera), the spectator's
eye, however sympathetic to the artistic intention, must see them
for what they are, constructions in the flat and on the flat. Their
formal devices do not record all the conversions of solid shape which
tridimensional objects assume on our retinal screen; if they did so,
we should behold them as pictures and not as fully solid; but rather,
they present to us secondhand projections of these pictorial conver-
sions, incomplete and hence only partially effective. Therefore, ar-
chaic statues, however solid they may be when considered as masses
of stone or wood or metal, do not convey fully spatial illusions of
depth and volume, but present incorrectly the third dimension of
depth along the spectator's line of sight. It must always be kept in
mind that a glyptic art cannot dispense with linear mediation because
the sculptor's cutting tool must follow some sort of guideline, with-
out which it would have no directed path. The phrase "hewing to
the line" reflects the need of a line to which to hew. The popular
assumption that the accomplished sculptor hacks away stone in
random chips and splinters until the desired form emerges shows an
ignorance of the slow precision of the Greek tradition for working
marble and the vivid exactness of Greek visual conception. Further,
the modern critic will only confuse himself and mislead others if he
envisages Greek sculpture in terms of a plastic medium formed by
tactual pressure and thereby removed from linear control. How,
then, if archaic work suffered from excess of linear guidance and
could not dispense with its aid, could line be used and yet not betray
itself and mislead its master? Here was the crux of the problem—to
discover linear devices which would make statues appear as solid and
correctly modeled shapes instead of as flat projections. Whoever
carves stone must cut to a pattern; and the only pattern that can be

laid out on a working surface is a linear construct. But what pattern can be conceived that will work against its own nature and while lying flat upon a surface produce an appearance of solid depth?!

At this point it will be helpful to turn momentarily from sculpture to Greek architectural practice; for the architects, confronted with the same problem, had discovered a solution.

The classical orders are conventionally established sequences of characteristic structural parts, such as columns surmounted by capitals, architraves, friezes, and cornices. It was traditional to distinguish and set apart these various structural elements from one another by inserting between them narrow crowning strips, or stringcourses, carved and colored to some running pattern, usually a conventionalized vegetabiliar design. These ancient Greek architectural moldings, widely imitated, should be familiar to all, since it is impossible to walk abroad in Europe or elsewhere in the Western world without encountering them—egg and dart, bead and reel, Lesbian leaf, meander, to name some of the most common. Perhaps a little better than casual acquaintance with them will add the realization that each of the various patterns invariably adheres to a characteristically profiled ground—the meander with its straight lines and right angles appearing only upon a flat ribbon cut at right angles to its background; the *ovolo*, or egg of parabolic curve, adorning a molded strip which projects in just such a curving profile; the spherical bead gracing a circular roundel; and (most intricate imagining!) the Lesbian cymation, or ogival leaf, presenting an endless alternation of convex and concave curves in precise step with the identical rise and fall of the ground over which it travels.

Logically, this situation (which must have been deliberately created) may be summarized by saying that the pattern repeats the profile section by exhibiting it in the plane of sight; or psychologically, the pattern on the visual field interprets the unintelligible profile in the axis of depth. It becomes easier to see that the Lesbian cymation is

cut to an S-curve when precisely such an S-curve is displayed to us in the horizontal running pattern. We see no curvature of surface, no illusions of projecting and receding stone, where the meander lays its rigid T-square over all. We see that the roundel is circular when we see the circle of the beads which it carries.

It might be anticipated that, in point of time, the painted pattern preceded its carved echo; but, in point of fact, there seems to have been a gradual convergence between decorative theme and molded profile, culminating in a geometrically concise concordance before the fifth century, considerably earlier than the sculptors' adoption of a comparable solution for their own art. It is therefore quite possible that sculpture learned from architecture the device of the "modeling line" (as for convenience we shall designate this extremely intelligent resolution of a basic technical difficulty).

If the empiric rule that the cross section of a molding shall determine the geometry of the running pattern on its surface has been understood and its purpose appreciated, it should not be difficult to realize that the same device can serve the sculptor to overcome the inevitably troublesome obstacle of vision in depth, which alone can make solid form directly comprehensible. Gradients of illumination are known to the painter as chiaroscuro, the tonal range from high light into shadow upon an object's surface, supplemented by the extraneous shadow which the object casts beyond its boundaries. In normal vision gradients of illumination assist us to see stereomorphically. But Greek marble becomes so inundated with the strong Mediterranean sun that the shadows on its surface are invaded by lateral illumination and much of the tonal contrast is destroyed, while the shadow cast by the whole statue is seldom helpful to its visual comprehension. The sculptor working in Greek marble was accordingly confronted by an exaggeration of the ever-present sculptural obstacle of presenting tridimensional form. Of course, it is always possible to an artist working in a solid medium to content himself

with a two-dimensional effect—as, indeed, the master of the *Disko-bolos* had perforce limited himself to frontal presentation, and as every sculptor does who emphasizes contour and areal shape and surface pattern at the expense of solidly modeled, substantial form. One might imagine that a comparable restriction would have satisfied the designer of pedimental sculpture for the temple, since his figures were displayed against a fixed ground and could be seen from only a very limited arc of their circumference. But, as we have seen, Greek pedimental sculpture had been moving away from relief and toward solid statuary under pressure of the Greek conception of sculpture as an imitation of living shapes. By the middle of the fifth century it had become Greek conviction that temple pediments, if they contained sculpture, should carry fully rounded statues of the same type and appearance as other glyptic works of art wherever set up and dedicated. Precisely because in their lofty isolation along a tympanon they were likely to be seen as flattened silhouettes, unusual attention had to be given to pedimental statues to avoid this misapprehension. At Aegina the figures were still largely effective as animated contours deployed against a unifying background; on the Parthenon the pediment statues are already solid shapes, independent sculptural entities arranged in sequent order on a common shelf as on a pedestal. Between these two extremes, the Olympia statues are silhouettes struggling to materialize as solids, occasionally succeeding, occasionally failing to do so, in either event with little or no detriment to their success as glyptic art.

That the statues at Olympia were still not fully emancipated from the category of relief carvings is especially clear in the west pediment with its violently active figures, many of which resemble Myron's *Diskobolos* in crowding their intelligible presentation into a frontal silhouette with no regard for other aspects. A few do not fully exist in the round; others are abbreviated in depth. Thus, the horses in the east pediment have no thither flanks but are sliced lengthwise, parallel

to the tympanon; and in the west pediment the centaur who bites the Lapith youth's arm has no equine hindparts but simply ceases to exist, like a figure in high relief which disappears into the background from which it springs. In the Parthenon pediments, in striking contrast to Olympia, the surviving statues are completely worked in the round, with no distinction between front and rear save a slightly less finished rendering of the back surfaces. And though the exigencies of space usually determine the statues' orientation, the seated goddesses from the east pediment show no controlling silhouette but are equally intelligible and effective from a great many angles.

To believe (as many have sentimentally asserted) that Greek pedimental statues were thus dutifully completed, even in those aspects never afterward visible to mortal eyes, because the all-seeing, temple-dwelling god would behold and resent imperfection, is to impugn the eyesight of Olympian Zeus and to impute to Athena less critical discrimination than an attentive visitor to the Elgin marbles will evince. Such an explanation for the care with which pedimental statues may be worked in the round overlooks the nature of glyptic sculpture and the manner of its production. If some of the Olympia statues violate the mature tradition that glyptic statues are created by attacking a solid block not merely from front and rear but from every other intelligible viewpoint until a total figure emerges from the enveloping mantle of meaningless stone, this violation is to be explained by recalling that pedimental statuary had been developed out of relief and that Olympia marks the transition from the linear control which archaism shares with relief design to a more fully stereomorphic approach to statuary form.

This sense for solid form, and the ambition to impart it to their work, had already matured in two or three of the group of sculptors collaborating in the Olympia pediments. Perhaps younger in years, certainly younger in artistic outlook, these pupils of the great (but for us, nameless) master in charge of the project were experimenting

to discover a new formula. The very nature of glyptic art made it impossible to emancipate themselves from the use of line to establish the contours and interior detail of their work; but this did not preclude the possibility of diverting and adapting line to a new purpose in order to make the figures seem spatially complete in depth. Throughout the archaic phase, linear form had held appearances to the visual plane. The problem was to make a different application of linear form counteract this impression by imparting a visual sense of modeled depth. The drapery, they realized gradually, gave them their opportunity.

Vivid illumination, as we have remarked, floods the exposed surface of the highly crystalline Greek marble and prevents highlight and shadow from forming except where the block has been deeply grooved or undercut. Anatomic detail was in general too shallow to meet this requirement; but drapery ridges and hollows, without  much falsification of natural appearance, could be cut deeply enough to penetrate through the luminous rind of the marble into the shadowy depth beneath. The task accordingly must be to use this shadow to make the directional shifts of surface visible and intelligible. It was, in short, the same problem of suggesting movement in depth along the axis of sight which the architects had solved for their carved and colored moldings. How any surface extends toward right and left or upward and downward across the visual field is apparent enough because in these directions, while the retinal picture dwindles everything upon its tiny screen of colored dots, it does not alter these spatial relations of the external world. But the third dimension (by which must be meant in such a connection the dimension of depth and distance directly away from the spectator) cannot appear in vision except as it has been converted into intelligible pictorial gradients. If extension in this dimension of depth were entirely suppressed on the two-dimensional network of the retina, it would vanish from sight and the objective world would be seen only as a flat panel. But

since it is not eliminated and is, instead, converted into intricate equivalents, reappearing as a complex system of gradients, this equivalent appearance is available to the pictorial artist and, with sufficient practice and experience, may be reproduced in his work. Were this not so, no pictures could be painted. (And were not the conversions extremely complex and difficult for pragmatic vision to analyze and isolate, it would not have taken the painters of western Europe six hundred years to master them.) But what the application of these essentially pictorial forms may be to *sculptural* representation is manifestly a subtle question and proves to be a confusingly paradoxical study. All of the visual indices of depth appertain to pictorial projection in *two* dimensions; yet sculpture makes its representations physically actual in *three*.

*Solvitur ambulando:* In the Olympia pediments we surprise the ancient sculptors thinking out their geometrical thoughts. But we must have the patience to examine them closely or we shall miss them utterly.

In the kneeling Lapith woman of the west pediment (Plate XV) the profile contour sharply defines the protruded leg with its raised knee. Equally emphatic is the outline of the other leg at haunch and thigh and bend of the grounded knee. But within these vividly intelligible outlines the supplementary interior lines have caused the sculptor considerable perplexity. Upon the farther leg, instead of indicating the interior contours of thigh and calf, he has spread a fan of drapery radiating from the kneecap. For the nearer leg he has tried a different device, or rather, two different devices. As far as the turn of the knee he has paralleled the contours with ridges and grooves that repeat the profile over the interior area. Below the knee all comparable anatomic suggestion disappears under an irrelevant pattern of loops and eyes. Here, then, in the lower part of a single figure, are three very different suggestions for the sculptural representation of costume, ranging from a wholly abstract surface pattern (loops and eyes)

2 .

through a derived geometric pattern (the fan spreading out from the point of the bent knee) to a completely functional use achieved by matching the contours of the nude with echoing, interior lines of identical curvature. It is a curious confrontation of three mutually intolerant solutions, only one of which can be claimed to be entirely tolerable to the Greek artistic sense, since it is only when the drapery lines reinforce the bodily profile that the costume subserves the form behind it, with the animate made visible in terms of the inanimate, and the living form vitalizing the unliving matter.

If the corresponding group in the opposite wing of the pediment (Plate XVI) was the work of the same master, as seems very probable, he was not long in making up his mind on the relevant merits of the three modes of presenting sculptural drapery. On the woman struggling against the centaur's grasp, drapery parallel to the contours and body lines has been more consistently applied and with more consequent success. Yet, attractive as the scheme was, it was not destined to prevail; it contained a peculiar weakness. The repetitious stream of contours reinforced the linear element and clarified the design, but it failed to explain or suggest extension in depth, without which the drawing remained flat and the figure failed to overcome the effect of an animated relief. A different solution was demanded. And here, in the same group of striving figures, a way to that solution was sighted.

The centaur assaulting the woman is himself being attacked by a Lapith youth who drives a knife into his chest. The youth is nude save for a slip of garment that has caught and clings over one sharply bent leg. And here, instead of carrying the drapery folds parallel to the outlines of the limb, the strongly shadowed folds of overlapping cloth run across it *at right angle* to the contour. Not much has been gained hereby because the sculptor has not grasped the visual working of this device. But it is nonetheless of inestimable significance for the further evolution of his art that he has solved his problem, even

though he does not concentrate his solution in a straightforward and self-consistent formula. Yet such a formulation was to come.

In the east pediment there is a male figure (Plate XVII) attendant on one of the teams of horses, in the same crouching pose as the Lapith maiden first considered. And here, instead of tentative experimentation with alternative solutions, the formula has been consistently applied and with full comprehension of its purpose. A simple test will show what has been attained. In the flat projection upon the plane surface of the photograph the drapery ridges and grooves appear as *curving* lines, and the curves which they show very fairly approximate the *profile in depth* of the anatomic part which they conceal. Solid form has been made visually intelligible.

It is easy, if one is not geometrically minded, to misunderstand the situation. If drapery grooves merely follow the rise and fall, the in and out, of a sculptured form, they will not necessarily serve to model it. On the contrary, when viewed at a considerable distance under frontal illumination they become foreshortened to the same degree as the mass upon which they have been carved. If this latter appears flat, they will seem to be straight, no matter what their actual curvature may be. Thus, to provide a cogent demonstration, the sculptor of the *Stumbling Niobid* (Plate XVIII) has contented himself with carving a continuous flow of ridged drapery over the extended leg. The drapery must be closely coincident with the cylindrical form of the limb which it is imagined to cover, since it wraps it closely round; but in the photograph the lines do not curve appreciably; hence they do not round the form but flatten it. This is not true of the seated goddess from the east pediment of the Parthenon (Plate XIX, left), on which the sharply cut and hence strongly contrasted ridges and grooves of the drapery at times follow the rounding of the bodily form, being immediately adherent to it, but more frequently add to it their own curved career in a different visual plane—their own career, but not in an independent or irrelevant course, since each

curvature reflects foreshortened movement in depth, which it rescues from misapprehension by restoring it to the visual field.

The actual career in tridimensional space, for so subtle a system of modeling lines as this, would be too baffling for a sculptor's chisel were it not the result of two separate stages in the process of cutting. In the first stage the bodily forms are fixed in the rough; in the second stage the curvature of these forms is noted on the roughly blocked out surface as guidelines for the drapery. The extremely complex stereometric interplay of these two processes thus takes care of its own complexity—much as the schoolboy may be vexed by the geometrical problem of plotting the journey through air, relative to the pavement, of the fly which crawls along the spoke of a turning wheel of a cart in motion; yet the revolving of a wheel and the crawling of a fly are both very simple geometric events which cause no trouble when taken separately.

A peculiar convention observed by drapery of this early formal period is well illustrated in two of the statues under present study, the lunging youth from Olympia (Plate XVI) and the *Stumbling Niobid*. Both are derived from temple pediments, as may be deduced from the low plinths, or flat bases, on which the figures are mounted. It is not the plinth which is the peculiar convention but the treatment of the drapery which spreads out over it, losing all material life and substance as it passes from the living body to the inert ground, somewhat as a crested wave rolls in upon a beach and abruptly collapses into a thin line of writhing foam. Though the comparison is fanciful, it reflects a visible actuality—the midfifth-century conception of drapery as something in itself inert, to which the living body imparts vitality and substance. Without the human form to inform it, together with the pull of gravity to shape its pendant folds, it reverts to helpless inanition. The immediate explanation for such a phenomenon is obvious. The sculptors are thinking of what is behind the cloth, rather than of the cloth itself; and since the ground is an ab-

straction and of no moment except as a basal support, the costume loses substantiality as it trails over it.

Such a convention was logically intelligible and artistically defensible. Yet it was not destined to establish itself as an enduring mannerism. On the contrary, its career was so brief and so uniquely restricted to a transitory phase that its occurrence on a statue may be taken as conclusive evidence of mid-fifth-century origin. For this reason (although only Waldhauer seems to have been convinced of the attribution), Myron's *Drunken Hag*, famous in antiquity, may be identified in copies familiar to every visitor to the museums in Rome and Munich (Plate XX). The pose is derived from the potential of a compact cubical block, as were the crouched and kneeling attendants in the east pediment at Olympia. As on the kneeling Lapith woman of the west pediment (Plate XV), a fan of drapery spreads from a point of contact on the nude form. Elsewhere, on the lower limbs, the drapery lines hesitate between two contradictory manners, simple parallel streams crossing the thigh and looped modeling lines articulating the shin. These latter follow the more fully developed formula which evolved out of experimentation at Olympia. The writhing ends of grounded drapery echo the abstract ornamental crimping beneath the *Stumbling Niobid*. The "pedimental plinth" is a curious borrowing for a freestanding statue, but serves to make even closer the resemblance to these nearly contemporary works. The head and neck, and especially the grimacing face of the hag, have presumably been tampered with by the copyist and to a lesser degree by the modern restorer, anxious to emphasize the crass stupor of the figure; but otherwise the two copies, having been produced by mechanical means, do not distort or alter the lost original by Myron.

It is not my intent to debate disputable, or seek to correct erroneous, ascriptions of extant works except as they may serve to illustrate the contention that the stylistic phases through which Greek glyptic art evolved are clear and reliable guides for the reconstruction of

Greek sculptural history. Where so much is due (to quote Wald-hauer) to "prejudices and premature summaries which tend to color ensuing discussions," with "many a theory which had the value merely of a working hypothesis . . . in time come to be adopted as an axiom, . . . scepticism ought to be a cardinal principle for all research in ancient sculpture." The modern student's basic tool must be a well-grounded appreciation of the formal evolution of Greek sculptural style in that succession of phases and manners which occurred because, physiologically and logically, it could not have followed a different order. If such a position is as sound as I suppose, the *Marsyas* of the Lateran (Plate XXXI B) cannot have been sired by the Myron of the *Diskobolos*, nor, *per contra,* could the *Drunken Hag* have proceeded from any other period than his.

It may be well to summarize this involved discussion, without comprehension of which much of the formalism of fifth-century sculpture must remain unclear and may even pass unnoticed:

The device of the modeling line depends on the same geometric formula as that displayed by Greek architectural moldings. As in these, movement or extension in depth is made visually intelligible by repeating it in the plane of the retinal image. By duplicating the curvature of the nude form over which they move, drapery ridges and grooves, carrying highlight and shadow across the undulating surface of a solid, can make visible by suggestion the configurations of depth which otherwise would elude apprehension. So starkly mathematical a principle may be uncongenial to modern minds because it seems abstract and intellectual, without artistic emotion or sensuous imagination; yet there can be no dispute that it was deliberately employed by the fifth-century sculptors for a concrete and perfectly understood purpose. Beholding it in a rudimentary stage at Olympia, where it is only vaguely understood and hesitatingly applied, whoever judges that its effect was an accident of unintentional variety need only look a generation later to see it fully elaborated in

the Elgin marbles or, after still another generation, exploited into manneristic exaggeration on the reliefs of the Nike temple parapet and the circular pedestal of the *Maenad Base*.

Each of the pediments of the Zeus temple at Olympia possessed a unity of compositional pattern; but neither can be said to have displayed any uniformity of sculptural style. The vagaries must be due to variation in the formal interests and accomplishments of the contributing artists, some of whom were attentive to the new study of stereomorphic drapery, others chiefly concerned with the problem of cutting figures in violent action out of single blocks. It is very generally assumed that the severely quiet statues of the eastern pediment were earlier work than their agitated counterparts on the west. But the sequence of experimental modification and final comprehension of stereomorphic presentation by means of drapery, which begins on the western pediment and leads back to the eastern pediment, suggests a flaw in this commonly accepted opinion. It is more probable that a company of skilled marble workers was simultaneously engaged in supplying all the statues destined to fill both gables of the temple. The only chronological sequence was that in which each master completed his assignments. It has been estimated that a single life-size marble statue must have required many months of continuous labor; if so extensive a commission was to be ready for installation within the construction time of the building, a considerable number of masters must have been at work. In the two pediments there were thirty-four figures in addition to the horses and cars—a task which would have represented the occupation of half a lifetime of a single sculptor and his apprentice helpers. Consequently, there could have been no such person as "*the* master of the east (or west) pediment," except in the sense that every composition demands a planning mind in general control. The same consideration applies to all major pedimental sculpture, such as that of the Parthenon and, a century later, the Tegean temple of Athena Alea (for which the

sculptor Skopas was reputedly the architect; he may therefore have *supervised* the sculptural adornment of the building, but the sculpture itself would not have been his work).

The Parthenon displays in its pedimental sculpture even greater disparities of style and an even greater recourse to stylistic experimentation than does the Zeus temple at Olympia. Therefore, one cannot speak of *a* "Parthenon style" or *a* "Pheidian manner" in connection with this assembly of brilliantly variegated figures, for which every sculptural device known to the period has been exploited. Because the themes dealt with the gods and with legendary dynasties without reference to the battlefield or athletic contest, there was comparatively little occasion for nude figures; but among those that occur there are the two superb reclining male figures from the left wings of either gable—the fully recumbent river-god Kephissos (often compared, to his advantage, with the reclining corner figures from the Aegina pediments and the west gable at Olympia) and the more erect, reclining god who fronts the rising horses of the Sun in the east pediment and who, having long been known as "Theseus," has been renamed Dionysos but probably should be identified as Ares, the war-god. Ares thus sits aloof and turns his back on his fellow Olympians in the conclave of gods on the front frieze of the Siphnian treasury at Delphi; here, on the Parthenon, he is deliberately far-removed from his compositional counterpart, Aphrodite, in the opposite wing of the gable. He is characterized as Ares by being couched on a panther skin such as Thracians used in combat in lieu of a shield; presumably he held a slanting spear in his right hand; the unworked hair on his head suggests that he wore a bronze helmet. If one inquires wherein the artistic greatness of such a statue lies, grandeur and breadth of treatment are obvious terms from which to frame an answer. More technically considered, it could be said that the trend toward naturalism has here progressed so far that not only has every significant anatomical detail been given due attention, but

distinctions have been drawn to indicate bone, tendon, muscle, and fat beneath the covering skin. To an extraordinary degree, the invisible vital structure of the fully mature male body has been expressed in terms of the clearly silhouetted outline of its ordered elements and an enveloping surface deftly modulated to suggest the functioning of its hidden mechanism. Nevertheless naturalism has not yet proceeded so far as to eliminate the tectonic differentiation of each of the structural parts of the body, but still tolerates their articulation as typical and separate shapes without destructive blurring and fusing under the illumination of highlight blending into shadow, which may be pictorially true to visual appearances but is fatal to vitalizing integration in sculptural terms.

The acceptance of a common formula for anatomic structure imparts stylistic coherence to the nude male figures in the two pediments. Upon closer examination it will be evident that there is much individual difference of manner. The long slow surface movement of the colossal Poseidon at the center of the west pediment contrasts markedly with the brisk vigor of the bodily forms of the "Hermes" behind Athena's horses, the almost slovenly inarticulate, seated Kekrops near the left corner, and the genially casual, kneeling boy near the right. These differences of treatment are not due to the scale at which the various figures are taken, because the reclining Kephissos, relegated to the cramped corner of the gable, displays a truly Michelangelesque greatness in its heavily mobile fleshy masses within the rigid framework of the skeleton, which transcends its little more than normal human size. Yet on none of the nudes has there been any drastic departure from the established anatomical tradition. It is in the feminine figures, whether striding, standing, leaning, seated, or reclining, that the great stylistic range of the Parthenon masters found full scope. For no anatomic fixity of accepted formula restrained them in rendering the loosely fitting Grecian costume. Nonetheless, the available supply of sculptural devices for this purpose was neither

unrestrained nor numerous. Instead of losing themselves in a disorder of uncontrolled variety, the fifth-century sculptors systematized the sculptural problem of feminine costume by establishing four categorically distinct geometric modes of representation, each calculated to perform a different formal function. The modeling line, the catenary, the motion line, and illusionary transparency—out of this restricted series of formal devices all later fifth-century drapery was evolved. The modeling line has already been discussed. It remains to deal with the other three as briefly as their intelligible exposition may permit.

The last of the four, by which an illusion of diaphanous texture was imparted to clothing, was a favorite among Attic marble workers of the three closing decades of the fifth century (although it seems to have had less vogue in bronze where the medium was unfavorable to its effective use). Although exploited by the sculptural school which succeeded Pheidias, it was in no sense that school's discovery. More than a century before Paionios carved his floating Victory with its masterful display of transparent drapery (Plate XXIV), the sculptor of the mid-archaic *Lyons Korē* (Plate IV) had cut drapery directly on the nude form in much the same ambition, though without the same bravura and skill. Many of the succeeding makers of Attic *korai* had followed this artistically tempting tradition; but the results were always somewhat clumsy and never entirely persuasive, since they failed to distinguish adequately between the textural substance of the nude flesh and the cloth which was supposed to adhere to it (though it must be remembered that the addition of color greatly enhanced the illusionary effect). A completely successful rendering of the device had to await an understanding of the use of the modeling line and, what was even more essential, the *substitution of raised ridges for incised grooves* in the drapery. Further than that there was no mystery in the marble cutter's trick. All that was necessary was to shape and polish the surface to the human form and interrupt its con-

139

tinuous smoothness judiciously with thin running ridges interpretable only as gathered cloth. If a uniform color was spread over all, such as a dyed costume might show, our desire to make sense of sensuous appearance will force us to see nude flesh behind a colored film of cloth, much as we peer beneath the surface of a pool of water to descry the deeper things within. Among the statues of the Parthenon pediments the attendant striding beside Poseidon's chariot (Plate XIX, right), long known as Nike and through some error in the records associated with the figures of the east pediment, most deftly combines modeling ridges with nude passages between to produce a delicacy of surface tracery "*qu'on ne peut pas assez admirer*" (as Lusieri, who gathered up the Parthenon sculptures for Lord Elgin, wrote on extricating this lovely fragment from the accumulated soil at the temple's west front). Between these two formal devices—the running ridge which echoes the modeled form and the spaced gathering of cloth which produces diaphanous illusion—there is no inherent conflict or contradiction. The reclining Aphrodite of the Parthenon's east pediment, with its astonishing envelopment of modeling folds and ridges, interrupts the densely gathered stream around the breasts, over the abdomen, and again above and below the knees to add transparency where it is most needed to articulate the anatomic structure. (In passing, it may be noted as an unwritten law of fifth-century sculptural tradition that, except in the standing pose at rest in which one of the knees may be completely hidden under vertical folds of drapery, the knees—as likewise the elbows—of every figure must be made visible; without their clear articulation the anatomic order would be destroyed.)

Less immediately concerned with making visible the bodily form within the costume, the catenary was used to stabilize the pose and add unifying pattern to the drapery. Like transparency, this device was no new discovery but descended from archaic times when (again like transparency) its possibilities had not been fully understood or

effectively applied. Where costume hung free from the wearer, without further contact than its initial support from arm or shoulder or neck, archaic tradition had been content with motionless pendant folds running vertically down to a zigzag hem line. But very exceptionally the archaic masters took cognizance of the wholly different linear scheme which results when pendant cloth has more than a single point of suspension from the wearer, as, for example, when it is hung from both shoulders and droops in U-shaped loops across the back. The earliest Attic record of this state is the statue of the Acropolis maiden 594 (Payne-Young plates 47 and 48) who wears an unusual shawl on top of her normal costume. The shawl is decorated behind with evenly spaced, rigidly parallel, incised catenaries spread awkwardly from one shoulder to the opposite upper arm, while on the front of the figure the shawl forms an extraordinary pool of catenaries contracted to a narrow neck of drapery compressed behind the elbow. Such an elevation of the catenary to a compound system of related curves foreshadows in an uncanny way the exploitation in the fifth century of the artistically profitable realm of curvilinear patterns.

To penetrate this geometric world of abstract form, one has only to pick up a length of cord or a flexible metal chain, hold it by both ends, and allow it to dangle free in the air. The downward pull of earthly gravity will invariably produce a U-shaped arc whose trace will constantly but consistently vary according as the cord is drawn tighter or relaxed and, again, as either hand is raised or lowered. The entire series of looping lines thus generated belongs in geometric theory to a single and unique class of variable curves which take the name "catenaries" from the *catena* (or chain) which forms them. Since the precise course and character of the curve is always a function of the relative location of its two terminal points, it follows that loosely shaped costume attached to the wearer at any two suspensory points must ideally (and actually, insofar as it is otherwise free and

yielding) droop into a series of catenary ridges and folds symmetrically cohering. The finest early example of its deliberate use to stabilize a pose and create a compositional pattern is the main relief of the Ludovisi "Throne" in the Terme Museum in Rome. Another and even more striking instance is the Parthenon metope numbered 316 in the British Museum. Here the nude body of a Lapith youth projects in high relief before a catenary curtain-fall of drapery caught momentarily upon his widely extended arms. Sunlight penetrating the smooth marble to illumine the naked form against the glaring contrast of the cloak—in brilliant red, perhaps—must have heightened the impression to an astonishing degree.

It is remarkable that, although the formal properties and artistic effectiveness of catenary lines had been correctly appreciated by the sculptor of this metope and are to be seen in some few other metopes as well as, more sparingly, on the Parthenon frieze (Plate XXI), the masters of the pedimental statues of the temple seem to have made no use of them. Perhaps the explanation may lie in the apparent lack of concord between the two-dimensional effect of a suspended curtain of folds, such as a catenary system necessarily presents, and the completely three-dimensional function of the modeling lines which was the major interest of the sculptors of these pediments. It would have been a logical decision to restrict catenaries to relief sculpture and debar them from statuary in-the-round as inimicable to stereomorphic representation; and such a decision seems actually to have been reached and to have been scrupulously observed for several decades. In any case, it was in relief sculpture that catenary drapery found its fullest evolution.

But that catenaries, when judiciously employed, may serve as modeling lines and be integrated into their ever-changing curvature is beautifully illustrated on the grave relief of Dexileos (Plate XXII) from the opening decade of the fourth century. How powerfully, how magically, a pattern of suspended catenaries may stabilize a pose

and unify a bodily form is most strikingly evidenced by the famous Nike who reaches to loosen her sandal before entering Athena's shrine (Plate XXIII, left). In the undraped nude such a pose, especially when compacted into the single plane of a relief, would be ungainly to the point of awkwardness. But the streaming fan of lines which diverge from the shoulder at the highest central point of the figure, to merge and disappear within the profusion of adroitly suspended catenaries, superposes a stable symmetry which transmutes clumsiness into balanced grace. And the careful precision with which the bodily forms are revealed as points of attachment for the hanging drapery subordinates the cloth to the animate shape beneath. The twin devices of transparency and attached catenaries have been combined with supreme skill by employing transparency to construct the suggested solid shape of the figure and catenaries to hold it poised in balance. Modeling lines, whose more extensive use would have destroyed the catenary patterns, have been introduced with the utmost caution.

The master of this most rightly famous fragment from the Nike temple's lofty parapet may have been responsible for devising a scheme for utilizing such patterned catenaries on statues in-the-round. It has long been realized that the master of the *"Sandal-binder"* relief must have carved the standing figure of Aphrodite familiar to us in several copies and most notably in the elegant *Vénus de Fréjus* of the Louvre. For the front and lateral aspects, transparency has here been combined with raised modeling lines with a skilfulness and delicacy of touch quite equal to that which distinguishes the *"Sandal-binder."* Seemingly, the original work was intended for a niche or some similar setting which made its rear view of minor import; for, as one passes from the fully modeled front and lateral view to the rear face, a flat pattern of catenaries interposes a concealing curtain over the back. Some fifty years later, Kephisodotos employed the same device for his Eirene in the bronze group of *Peace Fostering In-*

*fant Wealth;* and there are, in addition, a number of such "panel backs" among the draped figures of the High Classical period. These do no violence to the two-dimensional nature of catenary pattern but, on the contrary, turn it intelligently to use.

The fourth and last of the devices for formal control of drapery concerned itself with the clothed figure in motion. The sixth-century *korai,* like the *kouroi,* had been cut from quadrangular piers which precluded any other than a completely static pose. Their costume, concordantly, hung vertically straight and as limply lifeless as a flag in windless weather. But the animated poses which the bronze-casters introduced for the unclothed male in sudden action suggested a comparable innovation for the draped woman demanding a wholly new type of drapery pattern. The central figure in the east pediment on Aegina, an armed Athena eager but unable to join in the melee of fighting warriors, proves by her clumsily stretched garment that the archaic sculptors had no schematic devices immediately available to fit a moving form.

The famous relief of the *"Mourning Athena"*—famous chiefly because it has been misinterpreted by the romantic mind—shows the severely simple manner of the post-archaic "transitional" period at its height and the introduction of motion into drapery at its most helpless inception. The monument is probably a *horos,* or boundary stone, for Athena's precinct on the Acropolis. Its design in low relief shows the goddess leaning on a spear with which she has traced the borders of her sacred territory to the terminal stone; before this she now pauses with her task accomplished. The technical interest lies in the curious slant of the rigidly parallel drapery lines which all lean slightly out of the vertical and are seemingly intended—like the dragging hinder foot—to indicate that the figure has been moving and is only just now coming to rest. The vertical flutings of the traditional static pose permitted no better suggestion of action.

The *Pitcairn Nike* in Philadelphia has been identified as a full-size

copy of the chryselephantine Victory alighted on the outstretched hand of the colossal gold-and-ivory cult statue in the Parthenon, the Athena Parthenos by Pheidias. Seen from directly in front, the quiet catenaries covering the torso and the vertical stream of close-set ridges below the girdle and along the thighs give no suggestion of a moving figure. But the lateral view has been differently treated. Here, in order to show past motion persisting in a figure as it comes to rest (the problem which the *"Mourning Athena"* relief could not solve), the vertical ridges and valleys of the static norm have been swung backward and outward in a long curve and countercurve, to terminate in the involved in-and-out of a horizontal serpentine hem. Those interested in the geometric cast of Greek sculptural thought should observe that in this much-used formula the ogival alternation of concave with convex in the vertical plane repeats itself in the horizontal plane in the equally complex serpentine movement of the hem. This abstract concordance remains characteristic of the "motion line" throughout its subsequent career.

Only a few years after the *Nike Parthenos* was finished, the more difficult problem of representing a draped figure in motion rather than coming to rest was courageously attacked in one of the statues for the east pediment of the temple. In the running Eileithuia, or divinity presiding over birth (the "Iris" of popular parlance and the "Statue G, East" of the British Museum inventory), the pose is not much more than the fencer's lunge of the stock fifth-century repertory. All further effect of visible motion is due to the wind-blown drapery. The modeling of the nude is not visualized in terms of running ridges, since the modeling line, which must cling to the figure, has been replaced by the sweeping ogival motion line, which imposes its own freer pattern. The sculptor has had to rely on transparency to bring out the bodily form, boldly supplemented by a fully nude passage in which the left flank, thigh, and lower leg emerge from the parted cloth. Elsewhere, long ogival curves predominate—monoto-

nously repeated on the once invisible right flank against the backing wall of the gable, deeply cut away into heavy shadow between the striding legs in frontal view, and broken into long lappets of overfolded cloth across the left waist and along the bared thigh. So different are these three aspects of the statue that no one, seeing only their photographic record, would imagine that they were views of one and the same piece of work. It is no impertinence to a great master to say that the device of the ogival motion line is here in an experimental stage and not yet fully under formal control. In particular, the failure to co-ordinate its free-fluttering career with the geometrically unrelated and closely applied modeling line leaves the figure stereomorphically incoherent.

To model a moving form by means of its drapery without destroying the suggestion of movement through space which sweeping ogival curves could impart; or, the reverse of this proposition, to add swinging motion lines to a figure without destroying the modeling power of its drapery—this problem was the major obstacle to the integrated use of these formal devices for sculptural costume. For a time it seemed as though the sculptor was obliged to choose between them and must dispense with either the modeling line or the motion line, since both could not be employed together. It was perhaps no great inconvenience that a fully modeled figure could not be shown in motion since, as in the case of the "*Sandal-binder*," she could remain so elegantly poised at rest. But it was extremely awkward if a moving figure could not be modeled. Another relief from the same series as the "*Sandal-binder*," but from the hand of a different master, is a case in point.

On the only unbroken slab from the entire parapet, with little more than the heads of the figures destroyed, a Nike with wings outspread (Plate XXIII, right) runs ahead of a rearing sacrificial heifer which a second Nike tries to restrain. The latter figure, which may be the work of the master of the *Stumbling Niobid*, does not immedi-

ately concern us. But the running Nike is an interesting study in for-
mal drapery. Although she appears to be moving rapidly, her pose
is not that of a runner but of a fencer lunging in place; and, as such,
she would be rigidly immobilized were it not for the flaunting ogival
curves in her drapery. It is the wavelike crests and troughs of the
fluttering pennant which hangs from her raised arm, and the free
swirling end of her mantle which runs down between her legs, that
produce an illusion of rapid movement in which the figure seems to
participate. It is important to realize that the suggestion of visible
movement is not due to its pictorial representation or to our under-
standing of the subject matter but is induced by an abstract linear
device. It is a problem which might interest the experimental psy-
chologist—to determine whether it is mental association with our
past experience of seeing the motion of waves over water and the
flutter of garments in the wind that gives the undulant ogival line
this peculiar property or whether, with our gaze mechanically led to
glide rapidly along its guiding curve, we confuse our own muscular
retinal motion with external movement of the object across our
visual field. Whatever the explanation may be, it is a matter of direct
personal experience that a stationary figure thus may seem to move
before our eyes. It is an interesting commentary on the alertness of
the Greek artistic intelligence that it discerned this particular property
in this particular type of curve and, having observed it, accepted it
as a formal instrument in the sculptor's art, set apart for this specific
function. For considerably more than a century after the Nike para-
pet was carved, the ogival motion line continued to be the stock in
trade for draped figures in active motion, especially for sculpture in
relief. Still later, in revived "baroque" form, it was employed time
and again for the striving figures of the great altar frieze at Pergamon.

The discovery of the ogival motion line supplied an elegant and
attractive solution to the problem presented by drapery freed from
close attachment to the human figure. Previous to its use, masses of

cloth had lost all animate character as they dropped away from the wearer. But with its introduction they became intensely alive with an energy which they could communicate to the living form on which they depended. On the running Nike of the parapet the trailing ends of cloth between the limbs move briskly along the ground instead of collapsing upon it; and where the long streamer of cloak hangs from the raised arm, an accompaniment that in archaic work would have immobilized the figure in parallel ridges and folds now curls and curvets in forward-straining onset. All this is a paradigm of artifice, since woolen cloth as it might be blown free from a costumed figure so engaged would not assume even a remotely similar appearance. The natural behavior of the garment is as faultily recorded as the physical action of the wearer. Nonetheless, though a camera cannot record such an event, no appreciative eye can behold, unenthralled, its sculptural presentation.

That the effect of motion taking place before our eyes is due to linear suggestion will become apparent if we here imagine the drapery absent and examine only the figure beneath. The lunging pose stops short the straining body. Similarly, in a passage of the west frieze of the Parthenon (Plate XXI A), a rearing horse gains forward speed from the backward rush of ogival folds in the billowing cloak of the dismounted attendant, although horse and man are balanced stiffly in place. The animal supports itself stolidly on one hind leg yet seems to be plunging forward as its flowing tail joins in the stream of curves and countercurves behind it. So also the rider who precedes him gains impetus from the ogival flutter of his pantherskin cloak.

In the pedimental statues of the same temple the device of the ogival motion line has been used for all the draped figures intended to be shown in powerful action—the two colossal statues of Athena near the central axes of the gables, the two charioteers and one of their attendants in the west pediment (Plate XIX, right), the rapidly-

moving Eileithuia, and (on the evidence of the Madrid altar) the floating central Nike and the half-clothed Hephaistos departing behind the enthroned Zeus. But the difficulty of combining motion lines with modeling lines has clearly irked the sculptors, who have not yet discovered a satisfactory formula for simultaneous use. The generic uncongeniality between the long flowing motion line, which overrides the model, and the short and changeful modeling line, which tends to hold the figure firm, was evidently very difficult to reconcile; to overcome it completely would have been impossible. The celebrated floating *Nike of Paionios* (Plate XXIV) in Olympia, carved a little more than a decade after the Parthenon's completion, shows an effective and widely adopted escape from this technical impasse. The statue is today an extraordinarily effective monument, though much of the drama of a flier in billowing cloak suspended high in air and drifting down has been destroyed by breakage and loss. The three major formal devices of transparency, modeling line, and motion line have been applied and combined with consummate skill. The bare breast and thigh on one side of the body are matched against their draped counterparts on the other, in a demonstration almost too striking of the power of linear suggestion to model the nude more clearly within a veil of diaphanous cloth than when the body is left fully exposed. To left and right the garment streams off in long ogival motion lines; but a strange and unnatural transformation in its weight and texture has occurred. One and the same piece of costume inexplicably and abruptly transmutes itself from a lightly clinging, transparent accompaniment of the nude body, whose form it models, to masses of deep-shadowed material that hang in a wind-blown, heavy curtain behind the limbs.

Drapery "on the body" and drapery "off the body" are, therefore, in sculpture of the late fifth and early fourth centuries two strikingly distinct idioms of plastic form. Considered as realistic representations of human clothing, the two could not be combined easily because

they were dictated by different formal needs and designed for completely divergent functions. But as long as sculpture continued to be accepted as an artistic presentation possessing its own, often arbitrary, visual qualities and material properties, the inherent discord seems to have passed, if not unnoticed, at least unresented and uncensored.

Once the functional behavior of the modeling line had been apprehended and the device had been put into extensive operation, as on the seated goddesses of the Parthenon's east pediment, an interesting formal corollary was evolved to make fifth-century sculptural costume still more artificial even while it heightened its artistic effectiveness. This was an entirely logical outcome of a very simple principle of solid geometry. Because the peripheral surface of a solid is a continuous expanse without proper beginning or ending, any system of modeling lines employed to define such a solid and make its structure visible should display a similar uninterrupted career. It is for this reason—that is to say, to insure a consistent and unbroken modeling of the solid form— that the draped goddesses of the pediment are enveloped in long running lines of light and shadow which, as far as the exigencies of an actual Greek costume permit, move without break or interruption across their thighs, into their laps and out of them, around their waists, or over their shoulders and across their backs, as continuous as a spider's thread. Cloth on a living wearer will not submit itself to such intellectualized geometry; but the remark is a cogent objection only if sculpture be denied its right to apply its own devices of visual presentation and be required to conform exactly to actuality. It has frequently, and very correctly, been remarked of the human figures on fifth-century Attic vases that their keenly expressive outlines do not waver or break or pause but run in a continuous flow of even strength from crown to heel and back again. And the interior drapery lines often show a similar unbroken flow from upper to lower edge of the silhouetted body. In late fifth-

century formal sculpture the same appreciative sense of organic unity has been applied to the depiction of solid structural form. The vitalizing relationship between Wearer and Worn is the open secret of the High Classical norm for drapery.

It remains to mention one other formal device for the sculptural representation of the draped feminine figure which was occasionally employed and, seemingly, invented in the expectation of combining transparency and the modeling line in a single, over-all formula. Instead of the alternation of thin ridges of gathered cloth with open glimpses of the fully shaped nude which was the standard procedure in the presentation of a chiton-clad figure, the raised ridges were flattened into shallow ribbons running contiguously to cover the otherwise fully shaped torso. The mannerism may be seen used on the kneeling figure of Kekrops' daughter in the group which, of all the statuary of the Parthenon pediments, is the only important remnant still in place on the temple. A few other examples of such "ribbon drapery" have survived in copies from freestanding marbles of the late fifth and early fourth centuries. But the manner was not widely favored, presumably because it was not an entirely successful answer to the formal problem it was meant to solve. It is a cogent objection to say that it fails to distinguish the body beneath the drapery because it smothers the nude without adding sufficient highlight and shadow to re-create its modeling. Because of this inherent defect, ribbon drapery, though it does not appear to have been discarded outright, won no lasting place in Greek sculpture.

Out of these few formulas—none of which is entirely consonant with physical truth—all the marvelous variety of late fifth-century drapery has been compounded.

# VI

## High Classic

THE STYLISTIC DIFFERENCE between the *Doryphoros* and the *Ares Borghese*, difficult though it may be to express in words, distinguishes the Formal from the High Classic manner. It is the change from objective acceptance to subjective control of formula, from prescriptive theory to significant emotional use. Among feminine themes it is the difference between the severe correctness of the *Mattei Amazon* (which might be Polykleitan) and the studied grace of the *Lansdowne Amazon* with her calculated elegance of pose and sophisticated formal drapery. In relief it is the difference between the staidly seated gods of the Parthenon frieze and the delicately exquisite *gravestone of Hegeso*.

In art, at any time and in any phase, artifice is a perilous commodity; and, as must by now be abundantly evident, Classic form in sculpture was an extremely artificial substitute for natural appearances. As a remedy for the optical inadequacies of the archaic approach and the limited range and rigor of Early Formal invention it was an unqualified success. But its opportune power to substitute artistic construction for mimetic truth, to take the sensuous world as it appears and convert it into something with special appeal to esthetic sensibilities, was a dangerous seduction, apt to intrigue the artist for whom its ways were still novel, its possibilities not yet exhausted. In little more than two generations of practitioners, Formal Classic moved through uncertain experimentation to assured control

of its devices, only to be lured into an exaggerated exploitation beyond all realistic plausibility.

Specific example will serve better than general exposition to illustrate this change in technical capacity and artistic mood.

Among its many Hellenic treasures the Boston Museum of Fine Arts includes two outstanding versions of High Classic sculpture in-the-round. One of these—to be considered first because of earlier date—has the attributes, the pose and superhuman size, of a cult statue such as would be appropriate to a shrine or small temple (Plate XXV). With the missing head and neck restored, the seated figure would have measured slightly over ten feet in height.

A matronly but still youthful woman, elaborately costumed, is seated on a lofty throne. She once supported a large tambourine beneath her left arm and presumably was attended by a lion couched or seated at her right. The identification as the goddess Cybele is certain. No less clear is the magnificent correctness of the formal drapery in High Classic style. Beneath the raised girdle and over the lower torso looped catenaries have been applied as shallow modeling lines upon transparent surfaces. Other catenaries, cut deep to shape strongly shadowed pockets, have been attached to either side of the protruding left leg, which is shown in full transparency. Elsewhere upon the figure, modeling lines in long career of emphatic light and shadow envelop the limbs and descend into the lap, to be interrupted by a densely gathered pendant of garment below the knees (a detail now unclear; a separate piece of marble once cemented here is no longer in place). On the left, where the foot is set forward, the deep pockets of shadow on either side of the leg and the transparent modeling from thigh to ankle vividly articulate the nude. On the right, where the foot is sharply drawn back, the thighs are emphatically defined with modeling lines, the kneecap is left unencumbered and the hidden course of the lower leg is suggested by slanting parallel grooves of heavily shadowed cloth. The downward tilt of the

thighs is an optical adjustment against over-abrupt foreshortening from a viewpoint well below the statue (implying its original elevation on a pedestal within a shrine of no great size). The rigid frontality of pose has been softened by turning the upper torso slightly on the axis of the lower body. Throughout, variety in the spacing of the drapery ridges and in the depth and width of their accompanying troughs gives life to their carefully calculated course and avoids any semblance of academic rigor. The clarified anatomical structure with its accompanying commentary, the uninterrupted movement of light and shadow playing upon a human figure of more than human size, produces an impression of extraordinary grandeur and power.

Sculpture so impeccably designed and so faultlessly executed cannot be derived from any minor source. There is only one plausible prototype for a colossal cult statue of Cybele carved, as is this, of native Attic marble in the apogee of the High Classic style, and that is the Cybele in the market place of Athens, according to some ancient authors the work of Pheidias, according to others, the work of his favorite assistant, Agorakritos. The thoroughgoing control over all the classic drapery devices puts Pheidias out of question as master of the statue in Boston. But the close stylistic connection with certain of the seated figures of the Parthenon pediments (notably "U" of the west gable) makes Agorakritos an entirely feasible ascription. It is tempting to believe that this statue, which has none of the characteristic features of an imperial Roman copy and at the time of its acquisition by the museum was held by a very gifted judge of such matters to be "unmistakably a Greek original," is actually the Cybele of Agorakritos. Its size and pose are right for the little Metroon shrine in the Athenian agora. It is at least conceivable that the cult image was carried off to Rome at Sulla's instigation after his sack of Athens in 86 B.C. and that, later, it came into the possession of the rich, art-loving historian Sallust and was presented to his native town of Sabine Amiternum, high in the mountainous Abruzzi.

For the most surprising feature of the statue is its reputed discovery in this most unlikely find-spot for a huge Greek fifth-century master-piece in Pentelic marble. (In Athens the stolen image would neces-sarily have been replaced by another.) If it be objected that it is quite unthinkable that a famed Greek cult statue should turn up in a remote part of central Italy, it may be pointed out that in any case, being of Attic manufacture, the colossal marble had to be shipped overseas and transported to Amiternum, and that it was much simpler for a victorious Roman commander to help himself to whatever took his fancy than to trouble to arrange for a replica to be made. Roman plundering of Greek works of art during late Republican and early Imperial times is too well attested to require comment.

However uncertain (and, to the thinking of many, fantastic) all this may seem, the colossal *Cybele* in Boston ranks next to the seated goddesses of the Elgin marbles in London as our finest surviving ex-ample of draped feminine sculpture of the late fifth-century Attic school.

Item 22 in L. D. Caskey's exemplary *Catalogue of Greek and Roman Sculpture* in the Boston museum is a somewhat less than life-size, headless and broken-limbed, but for the rest finely preserved marble figure of *Leda protecting the Swan* (Plate XXVI). The half-crouching, nude body is partly exposed and partly draped. The widely spaced folds of her clinging and intermittently transparent chiton have been gathered into high narrow ridges with sharp edges and smooth walls, in a manner wholly impossible to actual cloth. Natural truth has been sacrificed to formal effect in a brilliantly-calculated play of light and shadow, carrying ogival and catenary modeling lines over the transparent form and adding sweeping motion lines as a foil for the uncovered body. By these ingenious, concurrent devices an im-mobile pose has been stimulated into action even while its movement has been restrained within a two-dimensional design. Even the "anatomic inaccuracies" which have been noted in the bodily pro-

portions may have been intentional transgressions for optical effect.

Remarkable as the craftsmanship is, it would be a hazardous opinion to assert that in such obvious artifice the spectacular end justifies the dubiously plausible means by which it is attained. As Caskey pointed out, the highly mannerist style of the Boston *Leda* is directly descended from that of the Nike parapet. (More specifically, "Master F," who was not among the most expert of the sculptors collaborating on the parapet, might have produced this relief-like figure in-the-round if he profited from association with the "Sandal-binder" master and improved his technical accomplishments.) But what on the parapet was a harmonious blend of representational meaning and abstract formal device now became an overemphatic display of sculptural device for the sake of optical effect—a magic idiom, if you like, but one that leans too heavily upon the magician's skill and lingers too much over the abracadabra of linear suggestion.

This euphuistic delight in the distractions of artifice at the expense of significant content was destined to increase its hold on the Attic temper and lead to a veritable frenzy of decorative dissipation. In the High Classic idiom of drapery there lurked an ever-present temptation to overstep its proper function of heightening visual intelligibility and divert it to decorative design and visual illusion. This peril beset the very masters who, on the Nike parapet, had still held (as Plato might have phrased it) a strict rein over sensuous beauty's unruly steed. As workers in relief they were peculiarly exposed to this risk; in relief the linear design is more prominent, less fully embodied in materially solid shape. By decreasing the recession in depth and making the linear patterns upon the panel more assertive, the devices of the classic formulas for drapery became pictorially intensified and lost their spatial reality. A peculiar circumstance contributed to this effect in a famous sequence of so-called neo-Attic reliefs.

Only a few years after the Nike parapet had been erected, several of its collaborating sculptors again worked together to carve reliefs

for a large circular pedestal some twenty feet in circumference and tall enough to accommodate figures considerably larger than those of the parapet, being only slightly less than life-size. Nine slabs were cut, and these, when assembled, formed a company of nine ecstatic maenads engaged in a dancing revel, of unsurpassable virtuosity of draped design. It has been suggested that this large and richly decorated drum served as base for a cult statue of Dionysos, the maenads' patron god. If this is correct, by all odds the most logical location for so splendid and costly a pedestal would be to support the chryselephantine image by Alkamenes, made for the new shrine of the god behind the scene building of the great theater of Athens and (to judge from a reference in Plutarch) a gift of munificent piety from the wealthy Athenian Nikias, either during his lifetime or by legacy upon his death in 413 as a general on the ill-fated Sicilian expedition.

None of the nine original reliefs has survived; but their extraordinary reputation in later centuries caused them to be copied or otherwise reproduced so many times that they may claim to share with the Polykleitan *Doryphoros* the title of the most widely known work of Greek art during the imperial Roman age. As favorites in the repertory of modern neo-classic imitations, they turn up in the most unexpected places. In antiquity, they were widely used, in considerably reduced scale, to ornament marble candelabra bases, urns, household altars, and the like; but on occasion they were very accurately rendered at full-size on flat plaques, presumably for insertion in villa or palace walls. And here there resulted an unusual and unavoidable deformation from their transference from a curved to a flat surface. By employing the copyist's normal instrument for pointing-off, the *linear design* of the original reliefs could be exactly reproduced on a plaque; but the cutting in depth had to be supplied at the copyist's discretion; if the correct depth within the stone had been recorded for every point, an exact replica and hence a curved instead of a flat piece of work would have resulted. Through economy of labor—

though also, perhaps, to suit the decorative taste of the times—the carving was skimped in depth, the plastic effect was lost, and a more superficial pictorial run of line produced. A striking illustration of this phenomenon is afforded by two versions of the same original, one now in Madrid (Plate XXVII B), the other in New York. Both are flat plaques; and both reproduce to identical scale the thyrsus-bearing maenad which the Italians have nicknamed "The Weary" (*La Stanca*) because of the exaggerated droop in her "free leg" (a trait characteristic of figures attributed to the "Sandal-binder" master of the parapet). Line for line, the two versions are the same; yet they differ greatly in plastic rendering because the depth of relief on the Metropolitan copy averages only half that of the Madrid version. Unaware of this distorting factor, some modern critics maintained that the flamboyantly decorative and exaggeratedly linear manner of the maenad reliefs could not possibly be authentic fifth-century Classic but must be an invention of later times, the product of the same artificial classicistic movement which produced the affected travesties of archaic to which the term "archaistic" is applied. Fortunately for our better understanding of late fifth-century Attic sculpture, other copies from the *Maenad Base* at full-scale and on correctly curved panels have survived, notably the "*Kid-slayer*" of the Conservatori Museum in Rome and a much damaged but almost complete series more recently discovered on the site of the Hellenistic city of Ptolemais on the North African coast and said to be now in Rome. From these it has been possible to identify the sculptors of the original reliefs as members of the company of artists collaborating on the Nike parapet. The *Maenads*, therefore, except for the altered effect of shallow bas-relief on the flat panels, are truly High Classic creations, more spectacular than the winged Nikes of the parapet in their waving lines and woven patterns, but fashioned from the same devices of modeling lines curving over transparent forms and motion lines fluttering out to serpentine hems. One may

be reminded of Jean Goujon's bas-reliefs from the Fountain of the Innocents in Paris; but a better comparison would be to the contemporary vases painted by Meidias, whose florid drapery lacks the strength of the carved ridges and the beauty of the flowing patterns of the *Maenads* but depends on the same fascination for transforming significant draftsmanship into purely sensuous charm. Under the lure of ornate decoration, the evolutionary cycle of style had come full circle on its spiral ascent, to produce "florid formal" as a century-later counterpart to "florid archaic." In both epochs the subsequent reaction was the same—a rejection of unreal ornamentational abstractions and a reversion to a more faithful reproduction of visual reality.

Unless we understand the underlying trends which made and as quickly unmade these gaudy styles, just as it is impossible to explain the severely simple style growing out of the archaic, so it must remain inexplicable that the generation of subtle craftsmen which produced the exquisite statue known to us through the *Vénus de Fréjus* of the Louvre (and reproduced in mirror image, by a device familiar to the Roman copyist, in the even lovelier torso from the Palatine in the Terme), to say nothing of the inimitably brilliant reliefs of the flutter-lined *Maenads*, should have been succeeded by a sculptor who could be acclaimed for memorializing Athens' recovery from the economic collapse of the disastrous Peloponnesian War with a statue of *Peace Nurturing Newborn Wealth* that was not only a frigid allegory but a severe and unseductive study of the impenetrably draped feminine form.

But that was in the year 376. Meanwhile, and until that epoch, the flamboyant High Classic style continued to be popular. For marble statuary in-the-round we know the name of one of its chief exponents, Timotheos; and in the pedimental sculpture surviving from the new temple of Asklepios at Epidauros from about the year 380 we have excellent proof of its continuing vitality. Athens itself, the

center for the style, has little of the kind to show for the first quarter of the new century. Economic and political disaster had exacted their toll on all artistic enterprise. Unable to find commissions for their livelihood at home, the Athenian sculptors scattered far and wide through the Greek lands and even crossed barbarian frontiers. We can trace this great Attic *diaspora* eastward to Rhodes and nearby Lycia and farther Cilicia and most distant Phoenician Sidon; while westward—for the minor arts, at least—we have evidence of Attic artists at work in the Greek towns of southern Italy and Sicily. Upon these far shores, like spent waves over distant beaches, the lovely Attic style dissipated its energies; in the Grecian homeland, Peloponnesian sculptors replaced it with their still vigorous athletic tradition, substituting Argive and Sikyonian bronze for Attic marble—cogent and purely material reasons why so little original work has survived from the opening decades of the fourth century.

The fourth century is generally treated by the historian of Greek sculpture as a galaxy of famous masters, a golden age of individual geniuses of unsurpassed accomplishment. Certainly, the leading names are well known to us, with Skopas, Praxiteles, and Lysippos as the major constellations and Bryaxis, Leochares, Euphranor, Kephisodotos, Silanion, and Timotheos as lesser luminaries. But, except for Praxiteles and possibly Lysippos, the written record of achievement sadly lacks any sure documentation for want of original pieces of their work. I have preferred, therefore, to ignore the individual masters except in the case of the two just mentioned. Rather than review the long array of conjectured identifications and dubious ascriptions and attempt to derive from these a hypothetical reconstruction of personal styles and distinguishable traits, it is the better wisdom to examine critically whatever has survived from the wreckage of time and, disregarding authorship, to concentrate attention on scuptural art and evolutionary sequence.

In order to acquire a profitable conception of these phenomena

during the first, obscure decades of the century while Attic art was in abeyance, we must win some sort of glimpse of the activity of the Polykleitan school. The names of most of its members are known to us from Pausanias and from inscribed but plundered pedestals unearthed at Delphi, Olympia, and other sites; but its artistic character is elusive and its attainments hard to evaluate. Any attempt to trace a path through this twilight must revert to the mid-fifth-century transformation of the *kouros* into the victor-athlete, and begin with Polykleitos himself.

The *Doryphoros*, the *Diadumenos*, the *Herakles*, and other athletic nudes by the master must have exerted enormous influence upon the output of his school and held its stylistic character in strict leading strings to his preceptorial example. Yet except for such sporadic attributions as the *Oil-pourer* of the Pitti Palace or the *Standing Diskobolos* of the Vatican and Conservatori museums (claimed with fair plausibility to have been copied from a bronze by Naukydes, brother to a sculptor bearing the same name as the master Polykleitos, and evidently his linear descendant in the second generation), we are hard put to it to identify any of the work of the Polykleitan school. The original bronzes whose titles are known have inevitably perished, and modern scholarship has had only indifferent success in sorting out their Roman copies in marble. (It is conceivable that few of them were popular enough in later times to have found their way into the workshops of the copyists.)

Very fortunately, and most opportunely, there seems to be a signal exception to this mournful catalogue of vanished work.

A monumental bronze was recovered in many broken and corroded fragments from a sunken cargo ship in deep water off a small island below Cythera in the south Aegean and skilfully (yet not quite correctly) reassembled. After the last Great War it was dismantled and more accurately restored and is now on exhibition in the National Museum in Athens (Plates XXVIII and XXIX). As the only

original monumental bronze from the first quarter of the fourth century, it deserves our most respectful attention.

Except for the tilt of the head and the more sharply raised and outthrust arm, the pose is the mirror image of the *Doryphoros*. But the quadrifrontality and axial tenseness of the "Canon" have been replaced by a more swaying balance in which the body leans lightly outward in more than one direction. The head is dissimilar, at least in frontal view: the face is rounder, with fuller cheeks and less tightly stretched surface; there is a more natural set and expression to the eyes; and the hair shows more plastic movement over deeper shadow. But the bodily anatomy differs hardly at all from its canonic prototype except that the asperity of the Polykleitan rendering of the muscles with its lingering survival of severely linear definition by deeply grooved boundaries has been softened to a more undulant rise and fall of continuous shifting surfaces. The structural shapes are still the same, and each is still clearly defined and set apart; but light and shadow have begun to mold what was previously left to graphic outline to establish. The change is, of course, like every other crucial advance in the formal evolution of Greek sculpture, an advance toward visual truth by correction of mimetic inadequacy. Classic abstract formalism is becoming modified into formalized naturalism. But the past is still strong upon it and within it, to give it stylistic character and structural power.

Out of this slowly evolving tradition was to emerge a new formulation in the mature genius of the greatest of the master's followers, Lysippos, the incredibly productive director of the bronze foundry at Sikyon, neighboring town to the famous metallurgic center of Corinth on the inland gulf separating the Peloponnese from central Greece. That this most celebrated of all ancient makers of hollow-cast bronzes was indeed a direct product of the Polykleitan school is evidenced by the marble *Agias* of Delphi, a mediocre copy of a powerful bronze from Lysippos' early period, showing close depend-

ence on Polykleitan anatomic tradition, chiastic balance, and four-sided silhouette, but differing (like the *Ballplayer*) in the shape of the head and (unlike the *Ballplayer*) in its slenderer bodily proportions and in a significant change of stance. This latter feature may have been borrowed from Attic usage. In any event it demands some further comment at this stage of our study if we are not to lose the continuity of Greek sculptural style.

There are a number of marble statues harking back to late fifth-century, predominantly Attic, prototypes which observe the accepted distinction between "weight-leg" and "free-leg" with chiastic contrast in the torso and yet display a very different compositional rhythm from the closed ponderation of the Polykleitan norm. As an example of highest artistic attainment (not always appreciated as such by modern writers on Greek sculpture) may be cited the *Ares Borghese* in the Louvre. On no very compelling grounds save those of inherent plausibility, this statue has been considered a reduction to life-size of the cult statue made by Alkamenes for the Ares temple adjoining the Athenian agora. (Stylistic kinship with the *Ares-Dionysos* of the Parthenon's east pediment has further been noted; if valid, this would help toward distinguishing Alkamenes' contributions to the pediments.)

The statue's stance and ponderation deserve particular attention. Instead of trailing the foot of the "free-leg" behind the other and raising its heel to produce a sharply bent knee, as do the *Doryphoros*, the *Diadumenos*, and others of the Polykleitan family, the *Ares* very lightly relaxes his weight by setting one foot forward and outward with sole planted flat and firm. The contours resulting from this distribution of the body's weight lack the enharmonic unity and poised grace of the Polykleitan scheme but are far more expressive of static strength and restrained power. More important, this "Attic" pose replaces hesitant motion with decisive rest and thereby resolves the long-persisting ambiguity of the Egyptian hieratic pose in which the

figure seemed at one and the same moment to be walking and to be standing still.

Even so, this strikingly apt solution of the problem of immobile vital balance failed to dispose of the old defect of quadrifacial frontality, with which it made no attempt to deal. Being deeply involved in the technique of glyptic sculpture, four-sided composition was an extremely persistent characteristic of early Classic statuary. As long as the four cardinal profiles were used as initial guide in shaping the blank pier to human form it was inevitable that these four master-contours should act as inclosing planes limiting the solid structure of the statue. To say that an archaic *kouros* is a solidified four-sided relief would be to exaggerate the situation unduly; and yet the shallow incision of linear detail within the four major contours of the figure imparts much of the quality of relief to archaic work. And even after the body's stereomorphic structure had been fully released from archaic trammels in the Formal Classic phase, the ease with which the sculptor of the Argos *stēlē* has converted the *Doryphoros* into a relief proves how much of the innate character of relief projection adheres to classic quadrifacial composition.

Seen as a problem in solid geometry—and visualization in geometric terms was congenial to the Hellenic mind—the readiest device for overcoming quadrifacial composition would be the gradual rotation of the erect figure on its vertical axis to make it face different directions at various levels. It is a surprising proof of the intellectual bias of Greek artistic sensibility that the sculptor's ultimate resolution of the inherent obstacle to stereomorphic composition conformed exactly to this strictly theoretical geometrical formula, as though in spite of its emotional appeal art was to be ruled and guided by rational thought undisturbed by sentiment; very possibly this is the quality in classicism which the modern mentality least comprehends and most deeply disapproves.

The process of axial rotation was very tentatively initiated and

very slowly carried to its logical consummation. Indeed, it may seem incredible to us that one hundred and fifty years should have separated the tentative, extremely limited dissolution of quadrifacial frontality (first rotating the figure's vertical axis only at its lowest horizontal level) and the final, completely consistent application of the formula to the entire body from heel to head. Yet such is demonstrably the fact.

The first stage is particularly characteristic of Attic work from the end of the fifth century. But its initiation began considerably earlier. Some slight attempt at introducing torsion is evident in the *Tyrannicides*, in which the lunging pose has been lightly modified by turning the rear foot outward without releasing the body from the flat compositional plane. Myron's *Diskobolos* from the same period shows no actual torsion (despite Quintilian's "*quid tam distortum!*"), but merely a superposition of bodily members in a continuous plane. No advance in stereomorphic composition is evinced in the magnificent bronze salvaged some thirty years ago from the sea off the northernmost headland of the island of Euboea and now skilfully reconditioned and superbly displayed in the Athens National Museum (Plate XXX). Variously known as the *Poseidon* or *Zeus of Artemision*, this slightly-over-life-size striding figure of a heroic nude poised in the act of hurling a trident or a thunderbolt shows, like the *Diskobolos*, violent action immanent in a moment of rest and, like the *Diskobolos*, depends on construction along a single plane of composition as a vividly outlined silhouette. The anatomy is static with no differentiation between contracted and expanded muscles; and the torso shows no response to the spreading arms or the straddled legs. The statue does not owe its extraordinary effect of concentrated energy to the physically accurate reproduction of a living model thus engaged but to the restriction of all significant appearance within a single aspect, a silhouetted form in overwhelmingly eloquent outline. Despite the extreme, almost polar, difference in the two

poses, it is the vivid and vital graphic delineation which makes these masterpieces so instantly intelligible and emotionally so persuasive; yet it leaves them stereomorphically immature.

In contrast with these earlier works, a marked advance toward spatial freedom in composition and vital balance of pose characterizes the statue identified as a Protesilaos, representing a spearman in action on a ship's prow and protected only by helmet and shield, with a scarf-like, crumpled chlamys across one shoulder. This unusual theme has been preserved for us in the restorable fragments of a marble copy of fair quality, now in the Metropolitan Museum (Plate XXXI A) and an isolated torso of considerably better workmanship in the British Museum. Like the bronze god from Artemision, the warrior is poised in the act of hurling a weapon; but here all resemblance ceases. *Protesilaos* leans sharply back out of the vertical, with his main weight over a bent leg with outturned foot and his spear arm drawn back on the opposite side from the leg thrust forward, thereby breaking frontality. The contrast between the raised spear arm and the lowered shield arm, in conjunction with the compressed and the relaxed hip, is reflected in chiastic musculature in the torso, front and back. Though the bodily torsion is not continuous but confined to the shoulders above and the lower legs below, a wholly new movement in space has been introduced, imparting visual solidarity to the figure in lieu of the earlier flat projection in single silhouette. If, as I have argued elsewhere, we have in the *Protesilaos* marble copies of an original bronze (by Deinomenes of the Polykleitan school) dedicated by the Spartans from the proceeds of the Athenian naval disaster at Aigospotamoi, a date very close to the year 400 is established for the prototype.

In the *Marsyas* of the Lateran (Plate XXXI B) there is the same backward tilt of the bodily axis and the same support of the main weight on a bent leg with outturned foot, the other leg being set well forward, and the same distinction between a raised and a lowered

arm, each sharply bent at the elbow. But in the *Marsyas* the true Polykleitan chiasmus obtains, with the lowered shoulder on the same side as the raised hip; and the muscular response to the ponderated pose is thoroughgoing and complete. Had the *Protesilaos* been broken just above the knee, no modern restorer would have correctly inferred the position of the lower limbs; whereas a good anatomist, confronted with a similar situation for the *Marsyas*, would have had no difficulty in completing the pose.

Unhappily, the Lateran *Marsyas* has been ascribed in modern times to the elder Myron, author of the *Diskobolos*, even though the pirouetting pose, the spatial complexity of compositional planes, the chiastic musculature, and the advanced knowledge of anatomical detail combine to make such an ascription completely untenable. Puzzled by the abnormal pirouetting pose, the early nineteenth-century restorer of the statue interpreted the satyr as a dancing faun and put castanets in his hands. Later, the castanets were removed (as were the modern arms) when the satyr was identified as Marsyas approaching stealthily to "pick up the flutes which the goddess wished discarded," as Pausanias describes a group of Marsyas and Athena on the acropolis of Athens. If this is indeed the proper explanation, and if Pliny's reference to a "satyr gazing at flutes and Athena" among the works of Myron identifies the same group, then we are obliged to hold that Pliny failed to distinguish between the elder Myron of Eleutherai, creator of the *Diskobolos*, and a younger Myron of Thebes, presumably a grandson, who is known to us only from inscriptions. The original of the Lateran *Marsyas*, if only because it expanded the Polykleitan muscular chiasmus to a body *in action* (instead of at comparative rest, as in the *Doryphoros* and *Diadumenos* and *Herakles* of the master), must be of an appreciably later date than the *Diskobolos*, which does not make use of these anatomic distinctions. The interval should be, at the least, two sculptural generations.

I like to imagine that the bronze group on the Acropolis by Myron

of Thebes was dedicated by Thrasyboulos and his partisans in appreciative commemoration of Theban support and shelter after their native town had cast them out during the evil days after the final disaster of the Peloponnesian War, and that this would explain the choice of theme, in transparent allusion to a contemporary political event (the Thebans being much addicted to flute-playing and hence readily recognizable in the satyr of the myth). The Greek concept of the purpose and meaning of sculpture, where it was not a purely decorative adjunct to architecture, was averse to unmotivated representations possessing no further excuse for being than their innate esthetic interest. Grave reliefs, victor statues, *korai* and *kouroi* dedicated to patron deities, cult statues of the gods, images of personages of political or literary renown, all justified themselves by significant reference of subject matter to an identifiable purpose or need.

In the marble *Nereids*, which once were stationed between the Ionic columns of a Lycian prince's tower tomb in Xanthos but now are domiciled in the British Museum, the pirouetting pose has been carried to an almost extravagant extreme. With axial revolution still confined to the lower limbs and the torso still presented frontally, an almost dislocating strain results between hips and waist.

It is unfortunate that the chronology of these three paradigms of the pirouetting pose has been so diversely and even perversely argued. On the architectural evidence, the Nereid tomb cannot be earlier than the end of the fifth century and may well belong to the early decades of the fourth century. Its Attic connections are firmly established. The *Protesilaos* and the *Marsyas* should belong to the same span of years. In addition, the outturned foot and the leaning pose with weight supported over a bent knee recur in other nude athlete statues ascribable to the Polykleitan school, such as the *Standing Diskobolos* of the Vatican. But the pose marks a transitional stage in the evolution of stereomorphic representation.

This brings us back to Lysippos—not to his early work, the *Agias*,

which is still quadrifrontal, but to his later masterpiece, the bronze *Apoxyomenos*, familiar to us from the finely executed marble copy in the Vatican. Lysippos has accepted the "Attic" stance with the out-turned foot set flat below a bent leg but has carried the consequent torsion into the upper body by bringing one arm horizontally across the torso toward the other arm, which is held extended laterally forward. The strigil in hand supplies justification for the pose; but the artistic purpose was very accurately and concisely stated by Pliny when he recorded of Lysippos that he introduced a "new and hitherto untried motive for converting the four-sided poses of the older masters."

If we set the mirror image of the Conservatori *Runner* (from a fifth-century bronze original) side by side with the *Standing Boxer* of the Dresden Gallery (Plate XXXII), the Lysippan consummation of the process initiated by the Polykleitan school becomes instantly and eloquently apparent. Concomitantly, the enormous increase in anatomic observation is equally important and equally symptomatic of the Lysippan contribution to fourth-century sculpture.

While these notable advances toward tridimensional composition and anatomical fidelity were being made in the Polykleitan and Lysippan circle of bronze-casters, sculpture had been actively resumed at Athens and under Kephisodotos and his (presumed) son Praxiteles had once more come conspicuously to the fore. After the final Hellenic settlement with Persia, known as the Peace of Antalkidas, the fortunes of Athens were on the mend. By the third decade of the fourth century the city had regained sufficient economic prosperity to keep its sculptors occupied at home. But the lacuna in Athenian art had been deep and lasting. The direct link had been broken with the great masters who succeeded Pheidias—such as Agorakritos, Alkamenes, and Kallimachos, to name the most famous of a very considerable company.

The Attic foundries having stilled their furnaces, it is very probable

that the youthful Praxiteles had to go to Sikyon or Argos to learn monumental bronze casting and the technique of contemporary sculptural fashion. To this acquired Peloponnesian lore in metal he added a native Attic gift for hewing marble, with the result that he attained to almost equal distinction as sculptor in bronze and in stone. If today we think of him as outstanding in the latter medium only, we are overlooking his ancient reputation as recorded by Pliny and neglecting the technical perfection and remarkably skilful artistry of the bronze boy fished up from Marathon Bay, a masterpiece which almost certainly originated in his workshop.

Another very general misconception holds to the opinion that Praxiteles ceased to follow the structural tenets of the classic formal style, having broken with them in order to devote himself to a sensuous illusionism of imprecisely defined shapes in an exquisite softness of surface produced by polishing the marble into luster. Such a judgment imputes a structural formlessness to Praxitelean work and a dissolution of sculptural into pictorial modes which would be wholly out of harmony with the evolutionary phase in which he lived. The situation more probably was this:

If Praxiteles had been instructed at Sikyon or Argos in the anatomic rendering of the nude as exemplified by the *Ballplayer,* and proceeded to reproduce this in marble, he would have discovered that the sensible effect of such a manner had been strikingly altered with the change in material medium. Burnished metal reflects light from its immediate surface, while marble absorbs and diffuses it to produce a vaguely luminous layer of appreciable density. In consequence, while the least incision in burnished bronze will occasion shadow, the same incision in marble will not do so. What is apparent in bronze as engraved line or retreating surface will not be visible as more than a slight disturbance of luminosity when reproduced in marble. If Athenian Praxiteles acquired the technical manner of the bronze-casters of the current Peloponnesian school and applied this

to a work in Parian marble he would have seen much of its structural precision and anatomic definition disappear, dissolved in the luminous radiance of finely crystaled stone. No doubt the result would not have been displeasing to him. Instead of rejecting such a technique of modeling, he took advantage of the softly radiant quality which it engendered in marble. Instead of altering the manner to conform to the physical properties of the medium, he exploited the medium to yield a hitherto unfamiliar manner.

If this description fits the event, it follows that Praxiteles was not attempting to work marble to reproduce the hard highlights and abrupt shadows of bronze; it may be doubted that he ever sought to reproduce the mirrorlike surface of burnished metal by reducing the stone surface to a glassy coat with abrasive powder. Such a procedure was practiced by copyists in the time of Hadrian and the Antonines in order to give marble reproductions some of the strong reflections and brilliant lights of bronze originals. But for Praxiteles to have adopted such a technique would have been to destroy the very quality of luminously delicate and sensuous bodily texture which he delighted in creating. If the *Hermes with Infant Dionysos*, unearthed at Olympia and still displayed there, has been polished to reflect rather than to absorb light, this is one of several indications that the statue is a copy made in Roman times to replace an original bronze deported to Italy.

Where by rarest chance such a bronze by Praxiteles has survived— as seems to be the case in the *Boy from Marathon Bay*—anatomical construction has not been dissolved into continuous surface movement devoid of articulate shape and distinguishable pattern, but, with due allowance for the boyish immaturity of muscular development, observes much the same formal definition of an anatomic Order as the *Ballplayer*. No competent copy of a Praxitelean original, whether taken from a bronze or a marble work of the master, should be misinterpreted as a "morbid" study in graded light and

shadow without solid support of tectonic design and articulate construction. In short, Praxiteles was no ancient Rodin born before his proper time, convinced that sculptural form is entirely an optical problem, a presentation not of physical substance but of reflected light. Praxiteles was no revolutionary at odds with his heritage but a gifted craftsman who saw how to make the most of a technical opportunity. Nor can it be claimed that Praxiteles diverted the course of Greek sculpture toward a new goal by ignoring the structural formulas of canonic proportion and schematic anatomical division, blending the whole into a continuous rhythm of shifting surfaces in closer agreement with natural appearances. The trend toward mimetic fidelity to objective appearance had dominated Greek sculpture from its inception; and any technical change which furthered that trend could not be contrary to its ordered evolution. If the Praxitelean style in marble was more naturalistic than any which preceded it, naturalism was in any case a predetermined goal for the sculptor's art. Not the event itself, but its happening as early as the mid fourth century, should be matter for surprise. "Naturalism" is the appropriate label for the stylistic phase through which Greek sculpture passed in the course of the third century; and there is no good reason for supposing that, if Praxiteles had never lived, the development of Greek sculptural style would have been other than it was. So great a craftsman exerted an unmistakable influence on his successors; but they were mannerisms of personal style rather than fundamental diversions of artistic judgment or aim which memorialized Praxiteles to later generations. Most notable was the Praxitelean norm for the feminine head, which no succeeding sculptor seems to have supplanted or been able to ignore. The late second-century master from Antioch-on-the-Maeander who carved an Aphrodite for the island town of Melos seems to have felt no compunction in giving the goddess the same head which Praxiteles had given her predecessor of Knidos (Plate XXXIX). And it is the vivid reminiscence of the

*Knidia* in the head of the *Seated Demeter* from the same Knidian sanctuary which has overridden the evidence of the archaizing pose and the early first-century drapery and hair to induce Furtwängler to declare (with the concurrence of most others of his profession) that the *Seated Demeter* is "a Greek original, not only of the time but actually of the artistic circle of the great masters of the fourth century, Scopas and Praxiteles."

In one regard, however, Praxiteles left no heritage. He was outmoded by other masters who moved toward a more highly evolved phase of stereographic understanding of sculptural form than that which he attained. The notorious Praxitelean pose of langurous imbalance may have been much admired by contemporaries and again in later times; but it was an immature and incorrect solution of the sculptor's cardinal problem of tridimensional composition.

To rehearse our observations briefly, the Polykleitan formula for static balance presented potential rather than actual bodily movement. It concentrated upon the four cardinal aspects and the consequent suggestion of motion and muscular action by animated contours in four silhouettes only, without further attention to the complex spatial orientation of the moving body in shifting balance. The much more violent displacements incident to vigorous action, such as hurling a discus or trident or striding to attack with weapon raised, had been given sculptural embodiment in bronze in the *Diskobolos*, the *Tyrannicides*, and the *"Poseidon" from Cape Artemision;* but in every instance the sculptor's control of spatial displacement was restricted to significant outline of the silhouetted form in its four aspects. The *Ballplayer* shows an initial realization of the fundamental proposition that all bodily action affects the solid mass in three dimensions and cannot be recorded only locally or by simple change of contour. The Vatican *Apoxyomenos* employs a much.more effective formula by distributing profile appearances over intermediate aspects instead of restricting them to the four significant silhouettes.

An increased perception of solid shape results; from whatever stand-point we view the statue some elements now present themselves foreshortened. Our apperceptive acceptance of foreshortened shape as extension in depth is largely responsible for our perception of three-dimensional solidity. In an isolated optical appearance such as a statue, if it be so displayed as to appear foreshortened in some part of its structure from every point of view, it will seem to occupy space solidly instead of being merely projected flatly against a spatial background.

Praxiteles had no share in this eminently logical sequence of technical advance from the four-sided pier of archaism toward the free suspension in space of the spirally rotated figure. Inheriting the Polykleitan quadrifacial formula which the Polykleitan school tended to perpetuate, Praxiteles confined himself to an exaggeration of its chiastic rhythm, with little appreciation of its immanent conversion into more complex spatial setting. The *Knidian Aphrodite* makes the pose of the *Doryphoros* more supple, yielding, and unathletic by stooping the torso forward and dropping the lowered shoulder still farther, thereby increasing the chiastic contrast of short curvilinear compression and long-drawn relaxation. This languid devitalization of the male victor-athlete into an equivalent feminine canon was the result of modifications introduced into the four cardinal profiles with little effect on any intervening aspect. The result in frontal or close-to-frontal view is masterly. It would be entirely proper to claim that the *Knidia* occupies for the nude feminine form the canonic rank of exemplary perfection which antiquity accorded to the *Doryphoros* for the male nude. But the anecdote in Lucian's travelogue, from which we gather that the *Knidia* was so displayed in her shrine at Knidos that she could be viewed from front or back but could not be examined from other angles suggests that the ancients were well aware that the pose had been conceived frontally without regard for polyfacial composition. It is worth noting that the *Hermes* is (at

present writing) displayed in the Olympia museum with much the same insistence that the visitor confront the statue and not move around it. In various other works of the master the Polykleitan chiastic displacement has been carried much farther—so far indeed, that the "living balance" which it was originally intended to convey has been corrupted into disequilibrium. With the copyist's obbligato of supporting marble drapery omitted, the *Hermes* of Olympia barely keeps in balance; and the statue of the *Boy from Marathon Bay* has caused the Athens museum authorities considerable perplexity: Should it be mounted as far out of plumb as it seems to demand? In both the *Lizard-slayer* and the *Capitoline Satyr* (which depends in some way on a Praxitelean original) the chiastic lateral displacement has been carried to such an extreme that the body requires an extraneous physical support to keep it on its feet.

All this was novel at the time; but it marked a departure from earlier interest in athletic vigor and hale vitality, which Praxiteles' slurring of the tectonic structure of the human body made all the more emphatic. Perhaps on this very account, and because he threatened to divert Greek sculpture into pictorial byways of sensuous illusion, Praxiteles may be the most individual of all Greek sculptors—without deserving on that account to rank as the greatest.

Meanwhile, as sculpture in-the-round attained technical maturity, sculpture in relief followed as though magnetically attracted to its lead. Throughout the fifth century the graphic fluency achieved by the painter had more than once tempted the carver of reliefs to borrow his precocious repertory of linear design. The frieze from the interior of Apollo's lonely temple in-the-Glens (*"Bassai"*) of southern Arcadia has proved troublesome to place in a chronicle of fifth-century sculptural style because much of it is little more than carved wallpainting. But by the close of the century the tombstone for the Athenian Hegeso shows how completely relief could rely on the purely sculptural devices of monumental statuary and how marvel-

ously the formal idiom for drapery could be refined to suit the shallow depth and diffused light of delicate carving. Equally illuminating is a comparison of the mounted Amazons of the Bassai frieze and the charging horseman on the *tombstone of Dexileos* (Plate XXII) from the opening decade of the fourth century, where light and shadow, line and surface and solid shape are conceived and executed in glyptic sculptural terms, even when, as in the rider's fluttering mantle, the carving is so shallow that the design may seem drawn rather than modeled.

Unfortunately, most of the Attic gravestones, though preserved in remarkable abundance and in general much admired by the modern world, are not on the artistic and technical level of the *Hegeso* and *Dexileos* reliefs but seem only a commercial by-product of a great period. There are exceptions to this stricture—for example, the somewhat later gravestone from the Ilissos on which a pensive standing athlete and his glooming father have been cut after the manner of the Peloponnesian bronze worker's statuary tradition. But in general, fourth-century Attic funereal sculpture is far below the level of the great masters. How much it falls short becomes apparent when one turns to such first-class work as the carved base (Plate XXXIII) from one of the columns of the vast temple of Ephesian Artemis, rebuilt in greater splendor after the fire of 356. Here there is no pictorial suggestion, no echo from the painter's copybook, but a treatment of relief so fully sculptural that the only adequate comparison of the figures would be to statues in-the-round which have not yet fully emerged from the marble mantle out of which they were being cut. It would be arbitrary, and false, to speak here of a frontal and a background plane between which the carved figures have been compressed (though this is the way some critics have described the technical structure of Greek relief). Nor can the figures be rightly characterized as half-round statues evenly attached to a common ground. If a precisely circular strip of plastic material were fitted closely to

the drum, it would touch the carved figures at many points along their surface; but this would indicate merely that the drum had been lathe-turned and smoothly finished before the figured design was drawn upon it. The sculptor was not concerned to make this continuity of the original surface contributory to the artistic effect; on the contrary, he has destroyed its insistence lest it seem to flatten his figures. And the empty ground between the figures has not been kept to an accurately measured and even depth; the sculptor had no interest in it except as it served as a uniformly colored curtain of indeterminate depth and distance against which the figures may seem to resemble pedestaled statues standing against the open sky.

A word or two should be added on fourth-century drapery. The Ephesian column drum, commended as an emulation of solid sculpture in terms of relief, may serve to illustrate the mid fourth-century interpretation of the formal drapery of late fifth-century tradition. On the youthful Hermes (a Polykleitan boy-victor equipped with caduceus and traveler's cloak but with petasos omitted), the skilfully interpolated drapery is composed of interlocking catenaries, vertical free-hanging folds ending in swallowtail hem line, and a few but effective modeling and parallel contour lines carried in semitransparency over the arm and hand. All this is strict classic formalism. The "Alkestis," who stands beside Hermes in full feminine costume, shows, in contrast, how the fifth-century formal idiom could be modified to a more natural appearance by interrupting the continuity of the ridges and their accompanying hollows and by "irregularizing" their formal precision with a casual informality of linear direction, spacing, and depth, such as a garment on a living model might show. Such a treatment involves a contradiction in terms. One must choose between representing garments as they are seen in everyday life and delineating sculptural drapery after the formulas which serve artistic purposes. It is difficult to imagine that both of these effects could be obtained at once. Yet the fourth-century masters

displayed considerable success in reconciling the paradox and making the inherent contradiction plausible.

It is a simple matter to foretell the outcome of this attempt to yield to two mutually contradictory compulsions, the one derived from precept and training, the other from the ever-present world of visual experience. The mimetic trend toward accurate imitation of visible shapes and appearances, which had always exerted a decisive formative pressure on Greek glyptic style, was certain to force sculptors to abandon classic formalism in favor of mimetic naturalism. The exquisite *Artemis from Gabii* in the Louvre shows how deftly and with how much grace and charm they succeeded in chiseled marble in making this shift of allegiance. The *Artemis of Versailles* in the same collection suggests that the transition was not so easily made in bronze.

On the fourth-century Attic grave reliefs there may be traced a gradual degradation of the strictly formal idiom of late fifth-century classicism under the impact of an uneasy conscience that rebelled against representing Attic citizens—specific persons whose names were recorded above their carved heads—in non-existent costume of artistic invention. This intrusion of textural realism, which broke the long-running drapery lines into discontinuous ridges and interrupting folds, disturbing their geometrically calculated curves with haphazard wrinkles and irrelevant shifts of surface, is very marked on some of the later fourth-century gravestones; but it encountered a more enduring resistance at the loftier and less mundane levels of divine and heroic theme. Patently, there was less incentive to imitate the realistic detail of everyday costume where Amazons were being carved for temple friezes, or to transfer the wrinkled disarray of the market place to the stately himatia of the gods or the flying cloaks of the heroes. On one of the Maussoleion friezes the charioteer who presses one knee against the rail of his car as he guides it onward, delineates with his cramped body a single long ogival curve overlaid

and reinforced with parallel streaming motion lines in his trailing gown. Yet this is probably a work contemporary with Attic grave reliefs on which every running fold of cloth has been interrupted and every ridge cut across in ineffectual triviality.

Yet the lesser manner was destined to prevail over the greater. When we look to the contesting warriors and hunters dressed in close-fitting Persian costume on the *Alexander Sarcophagus*, carved at the century's close, we see that the episodic texture line has invaded the abstractly formal patterns to effect an unstable compromise between the artistically imagined and the everyday actual. In this tacit surrender to the unsculptured world of visual reality the High Classic gives portent of its own demise.

# VII

## Sculpture in the Third Century

COINCIDENT WITH THE DEATH of Alexander the Great in 323, Greek civilization entered a new phase marked by the abrupt transformation of the self-contained city-state of the classical era into the larger and more loosely organized realms of the Hellenistic kings. Greek political rule was established and Greek cities were founded far beyond the former eastern boundaries of Hellenism, with a consequent diffusion of Greek speech, science, and art. Yet, as far as we can judge, the history of Greek sculpture is distinguished by no remarkable break or change during the closing decades of the fourth century. The process of consistent formal evolution traced in the preceding chapter seems to have continued its course undisturbed by the tremendous political and social upheaval. The building of great new capital cities such as Alexandria in Egypt and Antioch on the Syrian frontier must have occasioned many new commissions for the sculptors and painters of the old-established centers of these arts. But the stimulus of increased opportunity did not perceptibly alter the quality or character of their work. Art, like everything else of human creation, is subject to economic control and must accommodate itself to social factors and prevailing tastes; but, like religion, it possesses within itself the obstinate vitality of a self-contained organism. Just as the incidence of the Persian War was not responsible for

the shift from archaism to functional formalism, so the emergence of Hellenistic empire exerted no directly apparent influence on Greek sculptural history.

During the opening decades of the third century the reputation of the Attic workshops was effectively maintained by two sons of Praxiteles, Kephisodotos and Timarchos, who are recorded as collaborating on various commissions in Attica, Kos, and elsewhere. They seem to have worked mainly in marble; but the inscribed empty pedestal of a bronze statue which they made, representing in seated pose the poet Menander, who died in 291, may still be seen near the great theater in Athens. However, to judge from the Alexandrian "theater ticket" of bone engraved with the poet's name and profile head, and the Marbury Hall portrait medallion similarly adorned, we have not succeeded as yet in identifying Menander's features in any bust.

The traditions of Attic bronze casting were continued also by Polyeuktos, known to us from several good marble copies of his bronze statue of Demosthenes, erected forty-two years after the death of that erstwhile discredited but later rehabilitated patriot. More active—and by all accounts extremely productive—were the Peloponnesian foundries maintained by the lineal and collateral descendants of Lysippos. Some nine or ten artists' names are recorded from their company, along with mention of a number of their works, but none of these has survived in the original and very few have been identified in copies. There is a statuette in the Vatican reproducing in miniature the seated *Fortune of Antioch* by Eutychides; and the bronze *Epithyusa* of Phanis, listed by Pliny, has very probably yielded us in marble copy the attractive *Fanciulla d'Anzio* of the Terme Museum. In both statues the Lysippan pose of partial torsion has been employed, with one hand carried across the body toward the other to interrupt the frontal plane. The *Seated Girl* of the Conservatori Museum is clearly a companion piece to the *Tyche of Antioch* in com-

positional theme; and some of the seated philosophers show related poses. The bronze *Praying Boy* in the Berlin museum has often been equated with Pliny's *Adorans* by Lysippos' son Boidas; but the sophisticatedly simple pose, without trace of axial torsion, together with the untectonic blending of the anatomic divisions into a naturalistic continuity of surface, make hazardous any attribution to the immediate Lysippan school. And since the bent arms with the outstretched suppliant hands are modern additions, even the identification as an adorant is uncertain.

Undoubtedly the most spectacular production of this gifted company of artists was the great *Colossus of Rhodes* by Chares of Lindos, the hundred-foot-high statue of the island's patron deity, Helios the sun-god, which stood for only eighty years before an earthquake shook it to the ground, to lie unrepaired throughout ancient times. This tremendous image of a giant captivated later minds through the mistaken belief that it once bestrode the harbor entrance so that ships could pass between its legs. The shattered marvel was made enduringly picturesque by the fate which overtook it in A.D. 1360, when its fragments were sold as junk, loaded on 980 camels, and passed over the Asia Minor caravan roads into oblivion.

The Lysippan pose of partial torsion, though effective, did not constitute a complete resolution of quadrifacial frontality; but it must have suggested the device of continuous axial rotation which is displayed by a number of brilliantly conceived bronze statues recovered from the buried houses of Pompeii and Herculaneum. There is no reason to suppose that these are original pieces; but they are careful and presumably accurate reproductions (some at reduced scale) of important earlier masterpieces. That these originated in the school of Lysippos is pure hypothesis and yet, for a variety of reasons, probably the case.

If the bronze *Seated Hermes* from Herculaneum (Plate XXXIV), now in the Naples Museum, is compared with the seated *Ares Ludo-*

*visi* of the Terme Museum in Rome, the similarity of pose is striking, but equally so the difference. While the *Ares* departs from uniform frontal orientation only in the upper torso and the head, the figure of the *Hermes* moves consistently through an arc of some ninety degrees from the direction in which the sandaled left foot is pointed to that toward which his gaze is directed. The series of imaginary horizontal axes which pass through the two ankles, through the knees, the hips, the shoulders, and the ears, turns like a revolving compass needle through a full quadrant of the circle, bringing the uppermost axis at right angle to the lowermost. All frontality of pose is thus destroyed by confronting the entire circuit of possible viewpoints with simultaneous silhouetted and foreshortened aspects, always in coherent relation. In consequence, the spatial configuration of the presented object remains visually intelligible as solid form from every point of view. The Polykleitan restriction to four cardinal profiles has given place to omnifacial stereomorphic presentation. Where four different photographs will suffice to illustrate an archaic *kouros* or a mid-fifth-century statue, and an almost equally limited number of views will adequately present the *Ares Ludovisi*, an unrestricted series may profitably be taken of a spirally posed figure such as the *Seated Hermes*.

A similar comparison may be drawn between the partial torsion of the *Fanciulla d'Anzio* and the complete spiral revolution of the *Dancing Satyr* from the "House of the Faun" in Pompeii; or again, between the *Silenus Nursing the Infant Dionysos* in the Vatican and the *Listening Dionysos* from Pompeii.

To this restricted company of statues distinguished by a pose which, however ingenious and esthetically effective, can hardly fail to seem forced and unnatural, belongs the imaginatively conceived *Hypnos*, known to us through a marble copy in Madrid and a fine recast of the head discovered in Perugia and now in the British Museum. Almost like a stumbling sleepwalker, the youthful god leans

forward in a turning spiral with arm and hand outstretched to spread abroad his gift of sleep.

Apparently sensitive to the artificiality of the formula of spiral torsion, sculptors sought to justify the pose by inventing plausible motivations for it. The satyrs pirouette because they are dancing. More ingeniously, the *Aphrodite Kallipygos* is engaged in contemplating that portion of her well-formed body normally more apparent to others than to herself; and (perhaps in good-humored caricature of this invention) there is the youthful satyr who fixes a fascinated gaze upon his stubby caprine tail. In this not fully serious display of mastery over the sculptor's art, the incidence of a playful "genre" theme marks a broadening of interest (and a decline in taste) symptomatic of Hellenistic Hellenism.

The *Seated Hermes* and the *Dancing Faun* show bodily proportions and anatomical detail in close agreement with the Lysippan norm. And the formula to which their poses conform is too strictly applied as an abstract, intellectualized theorem to be a casual discovery of later Hellenistic times. There is good reason, therefore, to ascribe it to the Lysippan school and assign its use to the early years of the third century. It must rank as the last of the significant formal devices which distinguish classic Greek sculpture and set it apart as an abnormally intellectualized genus of representational art. That the other formal inventions of the classic phase appeared on the scene at a considerably earlier date (most of them being introduced during the course of the fifth century) is due to the different category of visual apprehension to which they belong. There is a consistent shift of esthetic level from the incised linear notation of archaism through the modified surface conformations of the classic phase to the fully stereomorphic conception of poses in spiral torsion. With tridimensional spatial presentation, such as the *Seated Hermes* exemplifies, the long process of stylistic evolution from pictorial vision to stereomorphic reproduction of material structure reaches its culmination,

beyond which the only further formal development possible is the tempering of theoretic formulas with a more thoroughgoing mimicry of objective reality. The great era of formal development ends after three and a half centuries with the Lysippan school of the early Hellenistic age. It is somewhat startling to find that at just this point in history Pliny sets a term to Greek sculptural activity with the comment, "Thereafter the art came to a full stop" (*cessavit deinde ars*), not to resume its life until the mid-second century, some 140 years later (*et rursus olympiade clvi revixit*).

There can be no doubt that in making such a statement the Roman encyclopedist was seriously at fault. For although there are not many sculptors and very few pieces of sculpture that can be securely dated to Pliny's empty interval, there are enough of both to make it certain that enthusiasm for the major art of classical Greece did not suddenly evaporate or sink into inanition.

Modern scholarship has surmised the source of Pliny's error. In the second generation after Lysippos there was among his followers a certain Xenokrates, "*qui de sua arte composuit volumina*"; and it was from his book that Pliny derived information about the sculptors of the period. Perforce, Xenokrates' account could not have extended beyond his own lifetime; so that Xenokrates himself, not the practice of casting bronze statues, *deinde cessavit*. It is not equally apparent what prompted Pliny to set resumption of the art at the year 156 B.C. (an inappropriate date on his own showing, since he makes mention of Pergamene artists who "did the battles of Attalos and Eumenes against the Gauls"). But whatever the explanation, the intervening lacuna marks a gap in Pliny's knowledge rather than in the progress of sculpture.

It is generally assumed that the matter may be dismissed therewith. But if a considerable amount of fine sculpture had been produced throughout the third century and sculptors of outstanding reputation had been active, could Pliny have remained totally unaware of

the fact? Does not the gap in Pliny's information imply at least some diminution in sculptural enterprise or a drop in artistic quality in early Hellenstic times? For lack of specific evidence, we can only surmise that this may have been the case. Yet the general character of third-century sculpture does not remain entirely obscure to us. And perhaps what we can discern of its stylistic trend may throw some light on its failure to have made sufficient impression on subsequent times to have attracted Pliny's attention.

In the British Museum there is a headless and armless marble from Athens, a seated Dionysos which once adorned a choregic monument high above the topmost tier of seats of the god's theater. The monument was erected by a certain Thrasyllos for a choral victory in 320 and was crowned by a tripod, the prize of the contest. Fifty years later his son Thrasykles added two bases to commemorate choregic successes of his own. Presumably these bases supported two additional tripods awarded to him as prizes. At some later time the statue now in the British Museum replaced one of the tripods. There it was seen in modern times by Stuart and Revett, and thence it was removed to England. Of what date was this statue? Did Thrasyllos dedicate it in 320 or Thrasykles in 271? Or was it brought from elsewhere in Roman times when the tripods were removed? If this is the case, it may be a work of some other period. I cite these details as typical of the obstacles encountered in establishing a secure chronology of Hellenistic sculpture. Judged on its own merits, by its stylistic character alone, the *Dionysos* should be a product of the second quarter of the third century (and hence contributed by Thrasykles to enrich his father's memorial).

In this severely quiet but impressive work, pose and drapery alike have been directly inspired by the pedimental sculpture of the Parthenon; yet an entirely different effect has been produced by more faithful reproduction of the heavy substance and languid surface of thick woolen garments. The result is symptomatic of the growing

conflict between esthetic form and physical reality. There is still a judicious compromise between the two antagonistic interests, with natural truth imposing a simplifying restraint upon patterned invention. A lack in complex movement of line and surface is compensated by an increased massiveness and sober dignity. Above all, there is more abrupt contrast between light and shadow, a more conscious control of these elements in order to set out solid structural shape. The modeling lines have themselves been modeled for material volume in their own right. These are important developments, quite sufficient to belie Pliny's report that the art of sculpture had ceased.

The central decades of the third century comprise the most obscure period in the whole of Greek sculptural history. What glimpses we have of it from datable documents consist almost entirely of portrait statuary. Notable among these are the portrait heads of the Ptolemaic Egyptian queens, exhibiting a style of extreme simplicity and calm and unostentatious loveliness, with clear foreheads and cheeks and features smaller than those of the Classic tradition. The fine bronze head of Arsinoe III preserved in the Ducal Palace at Mantua, the serene marble head of Berenice of Cyrene in the little museum of Libyan Benghazi and the bronze head of this same queen in Naples, the rather vacuous marble heads of Ptolemy IV and his wife Arsinoe in the Boston Museum of Fine Arts, are outstanding examples of the third-century manner of tempered formalism. The identifications have been made through comparison with heads on coins; and these not only reproduce the same countenances but display the same quiet and serenely lovely style. To their company should be added the portrait head of Queen Philistis on the silver coins of Syracuse; and among the as-yet-unidentified sculptured portraits should be listed the exquisite bronze head of a girl, one of the treasures of the Boston Museum, and the equally excellent bronze head of a young woman from Perinthos on the Sea of Marmora (Plate XXXV) on display in the Athens National Museum.

If the *Seated Poseidippos* of the Vatican is correctly labeled—the inscription on the base is not modern—the statue should be a copy of an early third-century original, since the successor to the great Menander was hardly so prominent as to have inspired posthumous portrayal. The little man with the troubled face sits hunched upon his chair, head and body constricted within the boundaries of the geometrically simple block from which the figure has been cut.

A use of "closed" or centrally massed composition is manifest also in the seated statue of the Stoic philosopher Chrysippos. The lost original has been identified as a work by Euboulides and ascribed on grounds of the sitter's age and the sculptor's presumed period of activity to the final decade of the century. Here the drapery makes no pretense to model or do more than suggest the bodily form but hangs in blank panels or is sparsely gathered to patternless folds. A natural pose, a lifelike costume, a physical likeness without pretension to sculptural grandeur—here, at length, is the technique of mimetic fidelity triumphing over the artificialities of the Classic tradition.

That so much of the sculpture identified as of the third century should be individual portraiture is only partly due to the difficulty of establishing a chronological status for statuary representing other than historically attested persons. It was not until a fully naturalistic technique had been evolved and become generally available that the sculptural presentation of specific individuals, rather than ideated types, became feasible. With its widespread popularity such a branch of the sculptor's art had the inestimable advantage of adding a limitless subject matter with prospect of lucrative reward. *Quot homines tot statuae!* Clearly, the response to this new outlet for sculptural activity was tremendous—most of all, as far as we can judge, in Athens, once more the intellectual and artistic center of mainland Greece. In addition to statues of statesmen such as Demosthenes and his bitter opponent Aeschines (both posthumous creations) we have evidence

for third-century portrait statues of Menander and Poseidippos among the poets, and of Aristotle, Theophrastos, Epicurus (but *not* the much-copied, wax model version, which must have been of later origin), Metrodoros, Hermarchos, and Chrysippos among the philosophers. Elsewhere, the powerful new dynasts of the Hellenic principalities were commemorated at home and abroad in flattering abundance.

From what has been said it should not be inferred that portraiture was in any sense an exclusive accomplishment of the third-century sculptors. Quite the contrary! We know of a considerable number of fourth-century, and even of some fifth-century, portrait statues of contemporaries; and it was the second and not the third century which brought this branch of the sculptor's art to its highest artistic triumphs, thanks to the substitution of a plastic for the earlier glyptic technique. But during the third century, due to the emphasis on naturalism and the exploitation of the ability to reproduce individual physiognomy, the production of portrait statues of living contemporaries had a special appeal which insured its ascendance over other sculptural themes. We hear of no ambitious pedimental sculpture, no great reliefs for temple friezes or other monuments of the period. It is true, of course, that the temples in the newly founded Hellenistic centers required cult statues. Thus, we know that when Nikomedia was founded in 264, to become the capital city of the kingdom of Bithynia opposite Byzantium, a cult image of Zeus Stratios was made by Doidalsas; it is reproduced on the coins of King Prusias, and thus the statue and its maker are securely dated around the midmark of the century. But, by and large, sculpture had by then come to earth from its ideal empyrean; and the likeness of living people had become its favorite theme. (The shift of interest is comparable to the shift from fifth-century heroic drama to third-century comedy of contemporary manners.)

But toward the century's close a great change occurred, apparent-

ly inspired by the politico-cultural ambitions of Attalos, the reigning king of Pergamon, an Asia Minor city of considerable antiquity but with no previous prominence in art.

Attalos I, who ruled from 241 until his death in 197, would seem to have been primarily interested in war and politics. Soon after his accession he distinguished himself by turning back the Galatian invasion; thereafter he extended his territory greatly by defeating Antiochos Hierax, at that time lord of most of Asia Minor. But by 222 Pergamenian power had been greatly reduced; whereupon, whether by shrewd military foresight or political opportunism, Attalos joined his fortunes and the destiny of Pergamon to the rising power of Republican Rome. This collaboration led to a curious division of the spoils of war. When the island of Aegina was enslaved by Roman arms in 210, Rome removed much of the population but agreed to sell the land with its remaining goods and chattels to Attalos for a sum of thirty talents. What benefit the king gained thereby is suggested by Pausanias' remark that a colossal Apollo by the Aeginetan bronze-caster Onatas stood in Pergamon in his day. And when the citadel of Pergamon was explored by modern excavation, there came to light the marble veneering slabs of pedestals which once supported bronze statues; and on one of these was inscribed the name "Onatas" and on others "From Aegina." So also, when the town of Oreos on the northern tip of Euboea was captured in the year 200, "Rome took the people, Pergamon the town" (to paraphrase Livy's brutally brief phrase, *urbs regi, captiva corpora Romanis*)—which illuminates the inscription "From Oreos" on another marble slab in Pergamon. Still other inscriptions record famous names such as Myron of Thebes, Demetrios, and Praxiteles. Here was the start of that plundering of the sculptural treasury of Greece, in which Rome was somewhat later to indulge so lavishly after her taste and understanding had been aroused (as Cicero put it) for "those things which you Greeks prize so highly but for which we Romans care little."

If the citadel of Pergamon was to become a statuary museum of works from the Classic age, now long since ended, it is not surprising that the Pergamenian rulers conceived the ambition to bring that golden period to life by summoning sculptors from Athens and elsewhere to their great and growing center of arts and letters.

Athens itself was not plundered like Aegina and Oreos, partly because there was no pretext for military assault but chiefly because Attalos revered the "eye of Hellas" too greatly and sincerely to pluck it out. He contented himself with commanding copies to be made of several Athenian masterpieces; and of these one at least has survived.

It is a matter of considerable interest and much importance for the technical history of sculpture to determine by what process such copies were made at this stage. There is no recorded information on the matter; but the replicas themselves permit some insight into the probable procedure.

An exact copy of a given statue may be made in either of two ways. By taking piece molds and consolidating them in a single casting form a plaster reproduction may be cast. But if a replica is desired in a rigid medium such as marble, the problem is far less simple. A blank block of sufficient size and over-all dimensions must somehow have recorded upon it—or rather, *within* it—the precise, relative location of every shift of surface of the original statue; then the superfluous mass may be removed accurately, leaving neither too much nor too little stone. Such a transference of topical information from a formed original to an unformed marble block may be accomplished by taking precise measurements for drilling "points" into the interior of the blank. Those familiar with the $x$, $y$, $z$ co-ordinates of Cartesian geometry are aware that any point in tridimensional space may be located in terms of three fixed axes of reference. In less formal language, the measured vertical height from the ground, the distance to right or left of a central vertical line, and the horizontal displacement toward the interior will give the exact position in space

of any chosen point on the surface of a statue. If the same measurements of height, lateral displacement, and distance in depth recorded on the original can be applied to an unformed blank, the relative location of every portion of the original statue's surface can be recorded in the replica. But since this duplicated record will lie *inside* the unshaped mass of marble, a drill must be used to locate its depth within the stone.

Ideally, if every measurable point on the surface of the original were thus re-established by a corresponding point in the interior of the blank, all superfluous stone would have been removed by drilling and an exact replica would have emerged. In actual practice, so thoroughgoing a point-for-point transference could be accomplished only by a power-driven machine designed for this purpose. Where manual execution with the sculptor's tools is responsible for the work, a greatly restricted number of points, selected for their crucial relevance to the surface conformation, are made to serve as guide to the stonecutter who reduces the blank. Logically, the greater the number of points taken on the original and transferred to the blank, the less the stonecutter's individual contribution in shaping the block —and also, the more mechanical and impersonal the copy.

On considerate scrutiny the Pergamenian copies will be found to depend on a restricted use of measurement for the size and proportion of the major features, with most of the detail completed by an eye and hand thoroughly schooled in the stylistic character of the period being reproduced. A copy so executed is not strictly a replica but a re-creation of an already existent model. We may account for this characteristic of Hellenistic copies by assuming either that the sculptors were too self-conscious of their role and dignity as artists to be mere copyists, or rather (on purely technological grounds) no device had yet been invented for transferring the host of accurate measurements requisite for completely exact duplication. Judging by the soulless and dreary mechanical routine of so many of the copyists at work in later Roman times, this may have been just as well.

It should be remarked in this connection that a technical knowledge of a method for taking piece molds from a statue and assembling these to cast a plaster replica—and an equivalent accomplishment, the making of plaster casts from the living model, is recorded for the early third-century Lysippan school—would have been of no assistance in itself to a copyist, because the difficulty of reproducing a plaster cast in solid marble is precisely the same as that of making such a replica directly from the original statue.

It may be taken for granted as an inevitable consequence of a heightened interest in sculpture that Attalos I—and, still more, his culturally ambitious successor Eumenes, who reigned in Pergamon from 197 until his death in 159—should have supplemented his collection of earlier masterpieces and freehand copies with work by living sculptors to enrich his city and glorify himself. How much of the great renascence of sculptural activity in the second century was immediately due to Pergamenian stimulation is difficult to appraise. But a sense of emulation of Athens' earlier pre-eminence in art and an ambition to create a new Periclean Age seems to have possessed the rulers of Pergamon. What fifth-century Greece had achieved in its heroic defeat of the Persian invader, Attalos and Eumenes were eager to believe they had equaled in repelling the Galatian mercenaries who had threatened Asia Minor with a worse than Persian barbarism. And no doubt the defeat of Antiochos Hierax in 228, and success against Seleukos of Syria, followed in 189 by victory over Antiochos the Great in open battle, were great achievements and had far-reaching consequences. Of the sculptural glorification of these events the extant remains are sufficient to make Pergamon a landmark in Hellenistic art. The series is familiar to every visitor to the Italian museums, ranging from the *Dying Trumpeter* of misinterpreted gladiatorial renown, and the pathetic defiant suicide with his slain wife, to the concourse of less than life-size marbles of fighting and expiring combatants. These latter pose many unsolved problems to the modern student. Several appear to be copies of bronzes which

were not displayed in Pergamon but presented to Athens by Attalos to be set among the dedications on the Acropolis. Unfortunately for the chronology, it may be queried whether the dedicant was Attalos the First, on the occasion of a visit to Athens at the close of the third century, or Attalos the Second, who succeeded Eumenes toward the middle of the following century and manifested even greater interest in Athens by presenting it with the magnificent stoa, now once again a glittering landmark of the city. Apart from their style, the diminutive scale of these statues may help to settle the thorny problem of their date.

In Greek artistic tradition, terracotta figurines belonged to a diminutive world of visual pretence where actual size was as unreal and as irrelevant as in a vase painting; whereas monumental sculpture purported to reproduce objective reality to scale. When, under inspiration of Egyptian precedent, the scale was superhuman, colossi usually were devoted to Olympian and other more-than-mortal themes. But statues at half life-size constituted a confusion of categories. They were common enough in Roman times but should not be taken for a normal product of the Classic period. The major art of monumental sculpture strongly affected the minor art of terracotta figurines; so strongly, indeed, that coroplastic imitation of monumental fashions of poses, composition, drapery, and anatomic style was responsible for the emergence of a distinct art of mold-cast terracotta statuettes—the "Tanagrettes" and other miniature figures in baked clay which throng the showcases of the world's museums. But there was no opposite attraction exerted by the figurines upon monumental statuary to induce a reduction of scale toward the Lilliputian world of the Tanagrettes.

Perhaps a bronze figurine such as the remarkable *Dancing Girl* in Walter Baker's collection in New York will throw light on the origin of half-size statuary. This hollow-cast bronze measures only eight inches in height; but its every detail has been worked with the

same care and the same consummate artistry that would have been given a monumental figure. Ordinary figurines of baked clay, made of a material of little intrinsic value and pulled from molds which were used over and over, were a commercial item of mass production; but such a figurine expertly cast in bronze and finely tooled and finished was a unique piece of work with full claim to the highest artistic status. Productions such as this could bridge the gap between the minor and the major art, since there was no apparent hindrance to prevent a still closer assimilation to monumental tradition by increasing the scale. Figures intermediate in size between the terracotta figurines and the monumental statues could have resulted.

Some indication of such an eventuality reaches us in a passage in Pliny. In connection with two Roman officials who had been sent to put down piracy on the Illyrian coast across the Adriatic and had there been captured and put to death by "Teuta, the Illyrian Queen," Pliny comments,

> I should not neglect to mention that the Annals record that *three-foot statues* to these men were set up in the Forum. *It seems that this size was in favor at that time.* [N.H., XXXIV. 24.]

The time in question was 230 B.C., which is not only the period to which Mrs. Homer Thompson assigns the Baker *Dancer* in her publication of the statuette, but is likewise the period at which the earliest Attalid dedications seemingly were set up. This does not prove that the originals of all the small Pergamenian statues must have been late third-century productions; but it does prove that they well might have been. And if Pliny's *"tunc"* is at all restrictive, the balance of probabilities strongly favors Attalos the First and the closing decades of the third century for these unusual productions.

Their series includes a wounded Gallic warrior which clearly is blood relative to the *Dying Trumpeter* of the Capitoline Museum, whose theme it closely echoes and whose pose it reproduces in reverse image. It is impossible to determine which of the two was the

prior work; but both may be nearly contemporary, since both—however sentimentally dramatic in conception—are extremely naturalistic in execution.

In the fully life-size figure of the *Dying Trumpeter* in the Capitoline Museum in Rome barely a trace of the traditional formal anatomy of the classic canon survives in the slow-moving surfaces and indefinite boundaries of the nude torso, front and back. Accurate reproduction of the epidermous patterns and texture has displaced the formalized delineation of the subcutaneous muscular structure. The resultant "leather-thick hide," which effectively conceals any muscle, sinew, and bone beneath, has been accounted a realistic touch in imitation of the weathered bodies of the uncivilized northerners from the wild wet woods of central Europe. But an equally deliberate suppression of the muscular divisions and interior bodily structure distinguishes the *Praying Boy* in Berlin, who is certainly intended for a palaestra-trained and Mediterranean sun-tanned Greek; while a yet more drastic instance of heavily inelastic skin without muscular anatomic indications occurs in the *Bathing Aphrodite* attributed to Doidalsas, as she appears in the much-commended copy found in Vienne in southern France and now in the Louvre. We cannot suppose that Doidalsas, for all his un-Greek Pontic name, intended the body of a Gallic barbarian for the Cyprian goddess.

On the testimony of the polished surface of the marble and the crudely cut drapery cast over the conventionally impossible dolphin, the lovely *Aphrodite from Cyrene* (Plate XXXVI), now in the Terme, should be a copy made in advanced imperial Roman times from an earlier Greek bronze original. (The emperor Septimius Severus, who ruled Rome from A.D. 194 to 211, was born at Leptis Magna on the North African shore; and sentimental concern for his native land led to the remarkable architectural and sculptural enrichment of many of the Libyan coastal cities during his brief but energetic reign.) Because of the extremely simple, self-contained, but unrigid and lightly

elastic pose, closely comparable to that of the *Praying Boy*, and because of the naturalistic coherence of the surface structure without use of traditional canonic formulas—in contrast with which the *Knidia* of Praxiteles makes an enlightening comparison—the original from which the *Aphrodite of Cyrene* was copied probably stems from the third quarter of the third century B.C. As such, it embodies in the guise of effortless composure a supremely self-conscious artistry of skill, combining sensitive naturalistic discrimination with profound technical understanding. If that much-abused phrase, "the art which conceals art," may find, for once, an accurate application, it is here, where all exuberant ostentation, all dramatic diversion, all calculated display of technical capacity, have been avoided by an artist who, in the conviction of his own perfected vision, has relied on only the subtlest elements of sculptural appeal to engage a public capable of their due appreciation. Perhaps this marks a culmination in Greek sculptural art, even though, like Attic drama at its best, it requires the enlightened sympathy of an audience such as cannot always be assembled.

# VIII

## The Renascence of
## Classic Form

AS A NEW CENTURY (according to our calendar reckoning) got under way, the self-sufficing calm of the third-century naturalistic style was abruptly broken by a return to earlier formal traditions. The crucial objection to naturalistic art is in the danger it incurs of seeming to be little more than a duplication of an already existent world of visual experience which the artist has recorded without materially transforming it by contributions of his own. In the sense that color photography makes the greater part of the painter's normal activity seem superfluous, naturalistic sculpture can threaten to turn the sculptor's enterprise into a pointlessly repetitious act of uncreative imitation. There is the further danger that art which conceals art may run the risk of not being esteemed as art at all. In addition, every established manner palls through re-use and grows stale with habit. Finally, while subjects and topics may variously abound, style shapes them all—and style may not stagnate if the arts (and the artists) are to live. For reasons such as these, the naturalistic phase in Hellenistic Greece was an unenduring stage of stylistic evolution. And since the attainment of a perfected technique of naturalism seemed to debar further progress on the century-old path of mimetic realism, and no wholly new style could be imagined, the only apparent recourse was a return to earlier formalism—but with a new way of envisaging its esthetic possibilities.

At Pergamon, the open-air museum of imported masterpieces of earlier sculpture must have engendered renewed interest and led to a greater understanding for bygone styles; and this could not have failed to induce critical comparison of the abstractly constructed beauty of classic formal art with the facile but rather unemphatic gentleness of the contemporary naturalistic style. The resulting impact on Pergamenian taste stimulated a classic revival, the repercussions of which are plainly apparent in the tremendously ambitious sculptural decoration of the great altar erected by Eumenes on one of the artificial terraces of the long sloping ridge of the city's acropolis. Around the flanks of this monumental structure there ran at eye-level a grandiose frieze of slightly more than life-size figures in extremely high and occasionally even fully detached relief, representing all the gods and lesser deities of the Hellenic pantheon in hand-to-hand combat with an equal host of demonic giants. The melee of striving figures in frenetic contest, thrown together without any formal regard for controlling patterns or rhythmic sequence, succeeds in imparting an impression of a titanic superworld of physical power in confusion and of sculptural splendor run wild. But variety of detail has destroyed coherence of design. The result is a masterpiece of overwhelming dramatic elaboration, which takes everything into account except the spectator's need for logical order and intelligible plan. There is too much to see and too little formal help to seeing it.

"*Je prends mon bien où je le trouve*" might well have been the motto of these sagacious but rapacious artists. All the fifth-century formal devices recur; but they are combined with acquired Hellenistic traits —naturalistic rendering of textural surfaces, torsion and other spatially complex poses, exaggeratedly modeled muscular anatomy, arbitrary drapery patterns, and purely ornamental diversions of detail. Dominating these are the revived classical motifs—sweeping motion lines running out to serpentine hems, modeling lines over torso and thigh, coherent folds and parallel ridges, frontal poses in significant contour, striding and lunging profiles; in short, all the idiomatic

formulas of late fifth-century Attic art. Even the Athena of the Parthenon's east pediment and the Poseidon of the west gable reappear as the running Athena and the thunderbolt-hurling Zeus of the central plaques of the frieze; and there are very immediate echoes of other Athenian work which the Pergamenian artists must have examined closely and either recorded directly or recalled from memory. But there is this difference, that solid form on the altar frieze is rendered literally instead of through optical suggestion; the classic devices do not have to function spatially but attach themselves as decorative additions to bodily forms already fully shaped without their aid.

If we turn back to the frieze of the Parthenon (Plate XXI), we see that it is a linear design to which material substance has been given by carving in relief. The graphic original remains intact, held as though in floating suspension on a panel ground. But in the Pergamene frieze of the Altar of Zeus the linear design has been sacrificed to solid statuary form; deep penetration of the original panel ground has destroyed all continuity of surface; and the violent and haphazard contrasts between highlight and shadow have reduced the patterns to confusion. Mere reproduction of the classic idiom, without further consideration of the purposes which it was intended to serve, might respect the outward appearance of fifth-century style but could not bring back its vitality or recapture its emotional concentration on intellectualized yet sensuous loveliness. It would be unfair on this account to stigmatize the frieze as a gigantic failure and complain that it is a wearisome display of extraordinary technical skill artistically mis-exerted. But it affords a striking demonstration that the fifth-century devices of sculptural style are abstract artifices of a very subtle sort which, like the equally subtle formulas of poetry, cannot be mixed indifferently with the idioms of normal speech. Stylized naturalism is a contradiction in terms, producing an emotional incoherence in art. But to dismiss this and other Pergamene sculpture as

a pretentiously inflated and turgid mélange of mimetic realism and classic formalism is to show scant sympathy for its enormous vigor and its remarkable success in experimenting with old forms to produce new effects.

Perhaps the complex theme of violence on the altar frieze did not offer the best opportunity to show what could be done. Many of the figures would be far more effective if seen in isolation from their fellows. Single statues worked in such a style of emotional excitation might be less exhausting, because less exacting if so complicated an appeal were confined within formally intelligible boundaries. The *Victory from Samothrace* (Plate XXXVII) is a case in point.

In this justly much-admired statue the traditional striding pose of earlier periods has been converted stereomorphically by introducing counter-torsion in the body and a complex, carefully calculated pattern in the drapery to produce a spatial structure of extreme diversity with an astonishing sense of movement. Frontality of profile has been destroyed by torsion; but the torsion follows a hitherto unfamiliar formula. Instead of spiraling in continuous revolution about a vertical axis, the turning movement is checked at the waist in mid-career, to be resumed in reverse direction in the upper body, thereby returning the shoulders and head to the same orientation as the lower limbs. This is a distinct improvement over the studied artificiality of the continuous spiral of the Lysippan school, since it interrupts frontality yet permits the figure to maintain its cardinal profiles. The Italian cinquecento was to rediscover this device of counter-torsion and put it to effective use, as did Michelangelo in his superb *Captive Slaves*, now in the Louvre. In the *Victory* the efficacy of such a pose has been greatly heightened by introducing torsional movement in the massed and twisted drapery, by emphasizing the backward stream of the wings, and by adding a flowing panel of cloth which flares behind the Nike like a rudder to her airborne flight.

In abrupt contrast to the linear flow of drapery masses in collision,

which swirl over the lower half of the figure, the splendidly ample upper body is shown in frontal view in full transparency. For the lateral view, however, the disposition is precisely the contrary, with the upper part of the figure concealed within a veil of downward streaming motion lines, disposed to accentuate the body's contour as far as the thigh; thereafter, finely linear transparent drapery uncovers the lower limb to the ankle. (The purpose of this reversal of structural pattern in the two major aspects of the statue is examined below.) In either view, the heavily rounded hip is an unclassical feature, being characteristic of a widely-favored, second-century mannerism. Otherwise, the bodily proportions are soundly traditional—an observation which warns us not to set the date of the statue later than the century's second quarter. As in other work of this period, the marble in places has been deeply hollowed out for heavy shadow to set off the bodily form from the complex drapery which threatens to obscure its structure. Classical drapery, being strictly functional to the bodily form it reveals, does not employ such cavernous penetration of the solid block—if only because it has no need to do so.

The pedestal for the Nike was shaped to the likeness of the prow of a naval vessel. This in turn was raised upon a stone foundation set hard against a steeply sloping hillside across a small (and usually dry) stream bed from the main temple of the sanctuary in which the Nike was dedicated. From the terrace of the temple the statue was clearly visible but could not be more closely approached; nor could it be viewed from the temple in any other than its frontal aspect. But there was also a long colonnade which extended parallel to the stream bed, on the same side of it as the Nike and at about the same level. From this much closer viewpoint the statue could be examined in greater detail; but here it was presented in lateral view, from full profile to three-quarter obliquity, according to the spectator's station along the stoa's front. The almost startling difference in the statue's appear-

ance as it is viewed from the front or from the flank is to be explained by consideration of its local setting in the rugged terrain of the sanctuary, with the boldly contrasted light and shadow and emphatic structural pattern of the frontal view calculated for distant sight from a fixed standpoint and the more uniformly graded drapery lines on the flank designed for view at closer range. From the statue's right side and from the rear the Nike was not overlooked by any building and was not intended to be viewed by visitors to the sanctuary precinct; and to this must be ascribed the sculptor's otherwise inexplicable neglect of finished detail in these portions of his work. The inner faces of the wings have been left smooth, without indication of feathers; and much of the drapery at the right rear of the statue has been worked only sketchily.

Such calculated heed of optical effect, and such diversion of classicism's traditional devices in order to make dramatic appeal to emotional response, are traits peculiarly typical of second-century sculptural mentality. A comparison with the *Nike of Paionios* (Plate XXIV) brilliantly illuminates this distinction between the purely functional use of modeling lines, motion lines, and textural transparency, for which functional need the fifth-century sculptors invented them, and their re-employment as emotionally suggestive stimulants for dramatic effect, to which second-century sculpture converted them.

On what seems very inconclusive evidence, the *Victory* has been claimed as a Rhodian dedication and its sculptor identified as Rhodian Pythokritos. Whatever the truth may be, the artist was certainly one of the Pergamenian group (which included others than native Pergamenes), not far removed in time or in training from the masters who collaborated on the great altar frieze, where wings may be seen with precisely the same disordered feathering as on the Nike and many of the same mannered adaptations of classic formulas occur. But in the Nike the style has evolved toward a "free emotive" use of classic idiom; and for that reason it should be dated somewhat

later than the altar. If the period between 180 and 160 is a plausible ascription, it may be remarked that there was no outstanding Rhodian naval success during that span of time and that it was precisely to the Samothracian sanctuary that Perseus, last of the Macedonian kings, fled from the Roman forces in 168. Thence he surrendered himself and his kingdom to the enemy. Since it was the Pergamenian fleet which barred Perseus' further escape and by confining him to Samothrace compelled his submission to the Roman commander, the Nike may well have been Pergamon's memorial to its share in extinguishing the hitherto mighty power of Macedon. (The Roman commander's monument celebrating his earlier defeat of Perseus on the battlefield at Pydna was erected in Apollo's sanctuary at Delphi, where its lofty pedestal survives.)

Another work of the Pergamene school from much the same period as the *Victory* is possibly its technical equal for sculptural expertness, although its far less sensational mastery of an emotionally expressive use of the classical formal style will probably never win it a large circle of admirers. Headless and lacking the raised right arm, but otherwise remarkably well preserved, the heroic statue of a semi-draped man (Plate XXXVIII) was exhumed in the temple of Hera at Pergamon and is now exhibited in the Istanbul museum. Whether this was a companion piece to the vanished cult-statue of Hera, and as such should be labelled "Zeus," or represents a heroized Pergamene ruler such as Attalos the Warrior, matters very little. In either case the stylistic manner remains the same; and it is this for which the statue deserves attention. The pose is conventional early fourth-century. The nude torso shows canonic, if somewhat heroic, structure. The arrangement of the single garment is entirely traditional. Yet no one familiar with fourth-century sculpture could possibly mistake this for a fourth-century original or an immediate copy thereof. It is worth a moment's effort to discover why this is so.

From the black-and-white illustration it is apparent that the distri-

bution and tonal range of light and shadow in the drapery are un-classical. The ridges are too salient; and there are extremely deep pockets of shadow produced by cutting cavernous hollows into the marble. These hollows have not been introduced haphazardly but were carved along and between the limbs for better visual articulation of the bodily form within the obscuring, solid drapery. It was a matter of indifference to the sculptor whether actual cloth in daily wear could assume such abrupt shapes and patterns. For him, the cord-sharp ridges and guttered edges, the fretted furrows and deep-clinging cavities, were so many sculptural forms to be used at discretion for their sculptural effect. Unlike the third-century rendering of costume, they do not conform to the dictates of everyday objective appearance but deliberately transcend it in adapting the unnatural classical formulas to artistic ends. Yet these are all so adroitly held within the bounds of stylistic coherence that they do not strike us as fantastic or unreal, except insofar as any man of marble dressed in stone clothing can exist for us only as artistic pretense.

However, such a remark signally fails to apply to most of the draped statuary carved only a decade or two later in Pergamon and other Greek towns along the Asia Minor shore—whether this be the Pergamene *Tragoidia* with slanting girdles of twisted and crumpled cloth, the varied company of Muses with their spider-web outer garments, the weirdly patterned creations from Magnesia, or half a dozen costumed *fantasias* from Pergamon. Yet it cannot be said of these that a wholly new style has suddenly intruded itself. On the contrary, the sculptors of the *Nike of Samothrace* and the *Hero* from Hera's shrine in Pergamon, despite their parade of classic mannerisms, had already taken the crucial initial step which was to lead to this most unclassical confusion.

In their use of the revived classical formulas for drapery, second-century sculptors assumed for themselves a privilege that their fifth-century predecessors would never have countenanced or even im-

agined. The archaic sculptors had imposed schematic pattern on their statues because they could not otherwise derive artistic advantage from the linear abstractions which served them as carvable equivalents for seen appearances. In much the same way, the sculptors of the succeeding period of classic form had exploited the lovely curvilinear patterns which could be constructed from their still rather superficial devices for making the draped human body's solid shape and structure visually apprehensible. But by the second century, Greek sculptors had learned how to reproduce and represent solid forms correctly and effectively; they no longer had need of the classic devices for modeling and molding the figure within its costume. Instead, appraising the classical idiom of drapery for its powers of visual suggestion rather than for the functional purposes for which it was invented, they dissociated it from its original and legitimate application and considered its formulas as purely esthetic resources which the artist could rearrange and recombine in whatever way he chose, without reference to the human form or deference to natural truth of textural substance, material behavior, or normal appearance.

In deliberately re-employing the old-fashioned repertory of the classic style, these later artists were seeking an escape from naturalism, not unlike that which, after the recrudescence of a realistic phase in the evolutionary cycle of style, occasioned the archaistic mannerists and self-elected primitives of our own century. But the mid-Hellenistic return to classic tradition must not be mistaken for an academic revival. That was to come later. Neither did second-century sculptors take refuge in the past to evade the present. They saw (more clearly perhaps than Greek artists had ever seen before) that the artist's province was not the imitation of nature but a re-creation of the visible in terms of esthetic apprehension and emotional response. And for this end there was in classic sculptural form a congenial (because inherently Greek) and unrivaled (because hitherto untried) opportunity. It proved to be, indeed, a revelation of unsuspected possibilities.

It will be recalled that in drapery of the classic formal phase the modeling lines, the motion lines, and the structural-pattern lines combine to cover the outspread surface of the garment and thereby constitute its entire visible structure. The resulting complex of ridges and valleys purports to be an actual manipulation of woolen or linen cloth as it might attach itself to the human form. In later second-century usage this presumption was disregarded. Ridges and valleys run wherever the sculptor chooses to lead them, intersecting, fusing, colliding, and re-grouping themselves, without consideration of the inherent logic of textile behavior. Pockets and indentations are formed, shelves and serrated edges range themselves, complex geometric designs are created over which the eye is led from point to point and pattern to pattern at the sculptor's discretion.

Such, at least, was the ultimate phase of this "free emotive" style after several decades of unchecked experimentation, wherein, as happens in human affairs, what begins as liberty ends in ungoverned license. The vagaries of the manner are innumerable. Precisely because precedent was disregarded and novelty was prized, the aberrant variety of mid second-century handling of draped female statues is so great that the present study can give no more than a summary of its range and versatility. At times the interest is wholly linear. Aware that the eye must follow the lead of running lines, the sculptor took delight in interrupting the flowing contour of the human figure by diverting attention to some gathering-point of drapery pulled wide of the body's boundaries. (Already in the *Victory from Samothrace* the artist had ventured to introduce this classically improper trait into his frontal pattern.) On other statues, crisscross and zigzag movement adds inextricable confusion to anatomic structure; on still others, a vertical flood of rigidly regular flutings smothers the curves natural to the feminine form. Or again, in a wholly different preoccupation with the potential suggestions of massed and crumpled woolen garments, twisted spirals of fretted folds are carried across the waist, accompanied above or below with kaleidoscopic splinters

of dissolving geometric patterns. Under the blanketing of such distorting cover, tectonic anatomy is ignored or deliberately misrepresented.

To most classicists, who commend classicism precisely because it is "classic," this is the *cacoethes sculpendi* of the ancient world, the malignant sore in the otherwise healthy body of Greek artistry, to be excoriated from the Hellenic ideal by dismissing it as "Hellenistic." More recent students, differently oriented, have found in it a peculiar fascination precisely because it presumes to violate every precept of classic probity. Quite correctly, these less scornful critics see its resemblance to European baroque architecture, as a release of traditional devices to "free emotive" use. But because (as in baroque and in still more recent modern art) novelty of invention only too often becomes a criterion of success, and departure from precedent a prerequisite to popular attention, the outcome (then as now) could not fail to be chaotic and undisciplined. The most valid objection to this Hellenistic style of sensational expressionism was not for its lack of restraint or its restless search for variety; its fault was that it contravened the innate Greek sense of sculpture as a revitalization of the human body without distortion of its physical reality. In consequence, the duration of this esthetically fallacious manneristic phase— fallacious, be it understood, because subversive of the Greek conception of the sculptor's proper function in his task—was necessarily brief. And, as in European baroque, the inevitable reaction to its overwrought imaginings took the form of a repentant (and hence thoroughly unimaginative) return to older ways. In arresting its own forward movement along a path discovered to be no longer profitable, a "baroque" or "free emotive" phase is almost necessarily succeeded by an academic renascence of earlier traditions.

The chronology of this surprisingly violent incidence of "baroquism" in Greek sculpture may be fairly accurately established by noting its tentative appearance on the freestanding figures at-

tached to the altar of the Athena temple in Priene plausibly ascribed to the decade following 160, its emphatic occurrence in the statue of the Delian *Cleopatra* (almost certainly from the year 137), its presence in extreme elaboration at Pergamon where sculptural activity was apparently brought to an abrupt end by Rome's acquisition of the kingdom in 133, and its total absence from any work that can be confidently ascribed to the following century. Seemingly, therefore, the entire movement was confined to little more than a single generation of sculptors.

The critic familiar with the much more restricted and self-consistent earlier styles of Greek sculptural drapery is at first quite pardonably bewildered by the complexity of mid second-century patterns. On closer scrutiny, however, he will see that these are by no means as random and undisciplined extravagances of individual invention as he had supposed, but favor certain types of surface structure and repeat certain unitary traits of style. Thus, there is a "rope" or "corded" style, which wraps a heavier costume in thin-spun filaments of ridges without accompanying valleys. There is a "maze pattern" style, which sets short ridges in opposition to one another to form a linear network of intricate design. There is a widely used mannerism of carving serrated edges or similar fretwork along the ridges to alter the tubular section of classic tradition, or ending their running career abruptly in cul-de-sac depressions, or converging with other ridges to form spearheads and jagged lightning-flashes. A curious hallmark of the period is a pattern of colliding ridges disposed to shape themselves into the semblance of the letter *alpha* with ⅴ-shaped crossbar, thus: ⋏. Most of these manneristic devices of abstract invention correspond only vaguely to natural observations of textile patterns such as cloth may assume when it serves as human costume. Yet two, though unknown to earlier art, must be classed as extremely realistic imitations of material actuality.

One such device is a rendering of textual transparency to make the

folds of a heavier garment visible through a thin outer covering of silk. Delicate cloth with this diaphanous quality was being woven of vegetable silk from at least the early decades of the third century, to be worn as veils and shawls and light "wrap-arounds" by Hellenistic ladies of pretension. Its transference to the sculptor's repertory of drapery devices was not difficult, in view of the familiar technique of carving diaphanous linen over the nude form. Inasmuch as it reproduced a visual effect which must have been a commonplace experience in Hellenistic days, the sculptural indication of "drapery through drapery" should properly have been an innovation of the latter half of the third century, with its paramount interest in truth to visual reality. And the claim has been advanced that there are terracotta figurines of indubitable late third-century provenance which show this illusionist mannerism. But the great vogue of this, in itself not particularly edifying, trick of craftsmanship clearly belongs not to the third but to the advanced second-century Asiatic school, in whose eyes the complex linear formations occasioned by the intersection of the vertical folds of the heavier undergarment with the more erratic run of horizontal and diagonal ridges in the lighter cover gave unrivaled opportunity for creating the broken light-and-shadow and intricate movement of line congenial to mid second-century taste.

The other naturalistic device which reproduced a feature characteristic of contemporary dress is, to the modern eye, peculiar and most unexpected. It seems to apply only to masculine dress. The usual Greek male costume, the one-piece himation, being untailored and unshaped to the body, was not hung up like our garments of today in wardrobe closets when unworn, but folded and stacked in chests, as modern blankets or quilts might be, thereby escaping fortuitous crumpling and wrinkling but acquiring under pressure the imprint of its own over-folded edges. It is these "press folds" which the Hellenistic sculptors recorded by adding their imprint in lightly

engraved parallel lines intersecting at wide intervals at right angles, somewhat suggesting a checkering of over-large squares. So precise and minute an observation of a natural occurrence might be expected to have been, like the diaphanous indication of drapery folds through silk, an innovation of the mimetically punctilious, late third-century sculptors; but, again like silken transparency, it seems to be a mannerism much more prevalent in the advanced second-century style of male portrait statuary. The matter would be too trivial to deserve attention were it not that just such trivialities may be turned to account as chronological criteria. If we hold, as I think we should, that no ancient statue which shows these faintly delicate "press folds" incised upon its drapery can have been carved earlier than the mid-Hellenistic period, something may have been gained toward helping us to discriminate between classic and classicizing styles—at present a very weak spot in connoisseurship—though it may be thought that we need not depend on such picayune rules of *expertise* in sorting the two periods but should rely on more fundamental differentia of style to discriminate between the restricted classic idiom and its broader adaptation to the Hellenistic conception of sculptural form. Since the classic devices were re-applied for wholly new ends and esthetic purposes by second-century sculptors, it should not be permissible to mistake their productions for work of the classic phase. Yet this mistake has been made time and time again, and its issue still heavily beclouds our understanding of Hellenistic achievement.

From a discouragingly large number of such errors of judgment I select a few conspicuous instances:

The first of these has been recognized long since as a mistaken ascription to the classic period of the "great masters" and duly corrected in the handbooks; but for many years after the marble Aphrodite was discovered in 1820 on the island of Melos and transported to France to become world-famous as the *Vénus de Milo* of the Louvre it was acclaimed as a fourth-century original from the imme-

diate circle of Praxiteles. That master's influence is certainly apparent in the statue's head (Plate XXXIX B), which is almost a plagiarism, so reminiscent is it of his *Knidia* (Plate XXXIX A). But the pose is taken in counter-torsion, the long hip line and high waist are unclassic, and the drapery is functionally incoherent, with the telltale v-barred *alpha* among its discordant patterns. The date must therefore be 150 or a few years later. Fortunately, a block with the artist's signature—"[—]ANDROS, son of [M?]ENIDES, of Antioch-on-the-Maeander, made [it]"—accompanied the statue to Paris. Unfortunately, the block with the inscription has since disappeared. It was not deliberately suppressed, as has sometimes been intimated, but certainly was disassociated from the statue. It seemed incredible that someone from an unimportant Hellenistic town who carved his name in letter forms of the advanced second century could have been the sculptor of a masterpiece from the classic Golden Age. It is an interesting commentary on inherited prejudice that the reallocation of the *Aphrodite* to late Hellenistic times has tended to dampen public enthusiasm for the statue as a work of art.

Half a century later, on the same Aegean island, a second Hellenistic cult statue came to light, the finely preserved and imposing *Poseidon* now in the Athens National Museum. Like the *Aphrodite*, this is a half-draped figure; and, as on the *Aphrodite*, the unfunctional drapery betrays the Hellenistic date. It was fortunate for the statue's appraisal that the huge fretted spearhead of drapery-folds flashing obliquely across the main panel of the garment made it impossible for long to mistake the mid-second-century origin, since in other respects the *Poseidon* conforms much more closely to classic prototype than does the *Aphrodite*. Apparently both statues were contemporary commissions to Asia Minor workshops, to enrich an island not otherwise conspicuous for its art in Hellenistic times.

The *Nike from Samothrace* was not as immediately recognized as a second-century work, but for many years was dated with entire con-

fidence to the end of the fourth century on the authority of an assumed resemblance to a ship-borne Nike on silver coins minted for Demetrios Poliorketes. It is a disheartening indication of widespread blindness to stylistic criteria that so much argument was necessary before this paradigmatically typical mid-Hellenistic statue was accepted as such in professional circles.

A fourth-century classic origin, and proximity to the work of such masters as Skopas, Praxiteles, and Leochares, is stoutly maintained for the *Demeter from Knidos* (Plate XL) now in the British Museum. Yet, sooner or later, with the previously mentioned statues, it must join the Hellenistic company of major masterpieces of later Greek sculpture—be it hoped without consequent detriment to its mondial reputation. As in the Melian *Aphrodite*, the head presents an extremely misleading criterion for the date. It might be mentioned that our habit of recognizing individuals by their facial features tempts us to look too exclusively at the head and to neglect the rest of Greek statuary appearance. Had the head of the *Demeter* been lost (as was at first supposed by its discoverer), it is very doubtful whether a fourth-century date would have been suggested for the body of the statue. The pose is strictly frontal, with precise dependence on the four cardinal aspects, wholly comparable to the late-archaic *Seated Goddess* in Berlin. With all due allowance for hieratic conservatism in cult statues, this is an archaizing trait alien to fourth-century representation of the deities. In the lower half of the figure the drapery pattern derives from the fifth-century Attic tradition as it occurs in the Parthenon pediments; but the drapery enveloping the torso is completely unclassical because its unfunctional run of line is destructive of the modeled form beneath. The ridges and valleys, instead of closely accompanying each other, are worked separately to produce highlight and shadow and, in a significant passage below the left shoulder, are interwoven with one another in complete disregard of material actuality. In extreme contrast with the harshly

broken texture of the upper garment, the neck and face are luminous-
ly clear. The perfectly classic (and classically perfect) features of the
face are surrounded by smoothly polished surfaces without indica-
tion of an underlying muscular structure, relying on the gradation
of reflected light rather than on the modeling of the planes to make
solid shape intelligible. In the hair there is similar dependence on
luminosity rather than on fully articulate glyptic shape; but here it is
the play of light over finely disturbed surfaces which the sculptor
has invoked for a more pictorial than sculptural presentation of the
texture. Finally, the deeply cut interstice between the pallid highlight
of the flesh and the hanging tresses of hair and the screening veil
serves to outline the neck with a black line of shadow; and this is a
dramatic expedient highly characteristic of the second century with
its heightened sense for chiaroscuro in marble.

The so-called *Maussolos* (Plate XLI) in the British Museum, dis-
covered at the site of King Maussolos' magnificent tomb in Hali-
karnassos, is typical mid-Hellenistic work. As such it should date
from somewhere about the year 160 and hence should represent
some Carian ruler of that time (when Rome had restored independ-
ence to Halikarnassos) rather than the titular occupant of the mid-
fourth-century monument. The draped woman associated with him
as Artemisia, Maussolos' widow, also belongs to the Hellenistic pe-
riod, but is stylistically of somewhat later date. It has long been rec-
ognized that these statues cannot have been mounted upon the great
four-horse chariot recorded as crowning the pyramidal roof of the
tomb and very probably surviving in the impressive fragments ex-
hibited in the British Museum. It has been shown that "Maussolos"
once carried scepter and sword; and neither he nor the woman can
be equipped with reins. The rear of both statues would have been
exposed on a chariot, while the lower half of the figures would other-
wise have been concealed by the framework of the car. Yet the backs
of the statues have been very negligently worked, suggesting that
they were intended for an alcove or for position in front of a wall.

The further inference that, if these two figures were not mounted upon a chariot, there is no compelling reason to identify them·as Maussolos and Artemisia does not seem to have appealed to scholars; yet such an inference is mandatory on grounds of sculptural style.

To consider only the "Maussolos," the enormous cavity behind the drapery looped from the left knee to the right ankle, and the unlinear massive panel which accompanies it, relate the statue stylistically to the "Hero" of the Pergamenian Hera sanctuary (Plate XXXVIII), which displays the same pose. Deeply cut hollow furrows in this location have been specifically identified as characteristic of the second century by German scholars, who speak of *"tiefeingegrabene Furchen unterhalb der Beinstellung"* as *"charakteristisch für das zweite Jahrhundert."* In the upper garment the indication of the drapery in terms of flat ledges instead of running ridges is unclassical; in the heavy gathering of crumpled folds across the waist the disorderly intrusion of solid masses upon linear pattern, with violently contrasted light and shadow erratically distributed, departs from the classic conception of draped modeling. "Press folds" (page 210) have been emphatically cut into the fabric. The mass of long hair has been deeply undercut on either side along the vertical contour of the neck and, in front view, the tangled strands are lined with darkness. With a different use of pictorial resources for back and lateral view, the texture of unkempt hair is rendered elsewhere in terms of broken light and patternless color instead of by glyptic definition of separate strands—a manner which can hardly be explained as negligence or as a sign of unfinished work. The beard is similarly carved with more regard for optic impression than for material structure.

How differently the mid-fourth-century sculptors rendered hair and beard, with what precision they carved the features and defined the muscular structure of the face, is finely demonstrated in an otherwise unplaced head, now in the British Museum, and also from the Maussoleion site.

The superficially rather striking resemblance to the head of *"Maus-*

*solos*" afforded by the portrait heads of Persian satraps on early fourth-century coins results from the die-engravers' use of hard wax for their designs, whose negative impression they copied on their dies. That a piece of glyptic statuary in-the-round should look like a study in modeled wax is precisely what should *not* be anticipated of fourth-century marble sculpture. But such a head, stylistically comparable to that of *"Maussolos,"* may be seen on the *"Walking Hero"* (perhaps a Poseidon or Asklepios) from Pergamon, now in Berlin, of assured second-century date. In distinction to this statue and to the other *"Hero"* from Pergamon (Plate XXXVIII) the *"Maussolos"* shows in its disordered drapery patterns that the process of disintegration of classic formula has already set in, presaging the extravagant vagaries of the century's later decades. The date of the *"Maussolos"* should therefore lie closer to the century's mid-point, almost precisely two hundred years *after* the death of Maussolos, the great Carian king for whom the ambitious grave monument at Halikarnassos was erected.

Since the diversion of formal drapery devices from functional need to freely inventive use is a drastic and easily recognizable step, wherever drapery is present the advanced Hellenistic should be distinguishable from earlier classic productions by appeal to critical criteria of style which are specific, unambiguous, and dependable. But where drapery is not employed and only the anatomy of the nude confronts the critic, it might be imagined that the task of discriminating between the two periods would not be so simply resolved. Obviously, anatomic structure cannot be extensively altered into appearances other than those which nature itself has prescribed. In the case of the feminine nude, however, historical accident intervened in the creation of an anatomic canon which serves to diversify fourth-, third-, and second-century styles.

It will be recalled that the naked feminine body was not a permis-

sible theme for Greek sculptors during the period in which the male anatomic canon was evolved. In the course of the fifth century, occasional half-draped representations were essayed, with due concession to the social proprieties by plausible motivation of the abnormal state as, for example, incident to assault in the case of the Lapith women in the Olympia pediment or to a mortal arrow in the *Stumbling Niobid*. Even in the fourth century, when prejudice had become relaxed, Praxiteles felt obliged to justify the nudity of the *Knidia* by the suggestion that she was preparing to bathe. In consequence of this enforced delay in attention to the feminine form, the sculptors of the late classic phase were led to apply to it the technical understanding gained from long familiarity with male proportions; as a result they were inclined to treat the feminine figure in rather too masculine terms. Not only is the *Stumbling Niobid* from the third quarter of the fifth century over-masculine, but the vaunted *Knidia*, prized as the ideal embodiment of feminine loveliness, is not truly feminine throughout. The *Aphrodite of the Capitoline* and the *Vénus de Medici* (see the excellent and slightly more naturalistic replica in New York—Plate XLII) derive too directly from Praxiteles to have succeeded in completely feminizing the type, though their closer approximation to natural truth testifies to a third-century origin for the statues from which they were copied. In the *Aphrodite from Cyrene* (Plate XXXVI), for the first time of which we have direct knowledge, nothing of the *kouros* lingers, either in the proportions and scale of the parts or in the patternization of the now scarcely distinguishable underlying muscular structure.

Broader hips and higher waist and narrower shoulders, now recorded correctly and sympathetically, were accepted by the second-century sculptors, only to be exaggerated into a new canon so different as to be instantly recognizable as vehemently unclassic. In its extreme embodiments, the rounded hip line is swelled to unprecedented amplitude, the waistline is lengthened to bring the greatest nar-

rowing of the body close beneath the breasts, and the shoulders are even more narrowly restricted by folding the arms in a veiled self-embrace which so shrinks the upper torso that the entire figure, from the flaring garment at the ground to the small and cylindrical head, suggests to modern eyes an old-fashioned handbell rather than a properly formed human being. Since most of the examples of this misshapen manner are heavily draped, the exaggeration can hardly have been intended to increase sensual appeal but may reflect contemporary social fashion and transient aberrations of taste. Perhaps also there was some measure of deliberate reaction against the masculine bias of the earlier feminine statuary.

While it was readily apparent that the loosely wrapped and un-tailored Grecian costumes gave the Hellenistic artists almost limitless opportunity to indulge their fancy for "emotive" pattern and stereographic suggestion, and (rather more unexpectedly) the naturalistically perfected feminine form could be exaggerated into baroque extravagance, it was not equally clear what could be done with the male canon of the nude with its fixed proportions and clearly articulated muscular divisions. At first approach there would seem to be nothing that could be done to convert the classic idiom of anatomic form, or its more subtle but in no sense vague or undisciplined third-century tempering, into a more dramatic, more sensational mode of expression. One could do what one wished to deform the pliable texture of crumpled and pendant cloth, especially if one were allowed to transgress natural truth in the interest of artistic effect; but the anatomy of the athletic male body was too precisely preformed in nature to tolerate extensive reconversions in art.

There would seem, therefore, to be an unavoidable stylistic dichotomy in second-century sculpture between the baroque drapery of the costumed figure and the classic formulation of the male nude. It may be suggested that the revived classic canon could have been fused with a more scrupulously exact study of muscular anatomy and

epidermal texture to yield a novel style of strongly realistic representation without destroying the older formal tradition; but it may be doubted whether such a reconciliation of two diametrically contrary practices was possible of accomplishment. The guidance of either a realistic or a formalistic approach to the representation of the nude may be profitably followed; but it is difficult to see how both courses can be pursued simultaneously with any advantage. It is a widely accepted opinion that the mid-Hellenistic sculptors, confronted by these alternatives, chose the course which the stylistic development of their craft had always preferred. Having accepted third-century naturalism as the established manner of their day, they are supposed to have modified it still further in the direction of outright physical realism. Indeed, the suggestion has more than once been advanced that the anatomical knowledge displayed by such works as the *Borghese Fighter* or the *Uffizi Wrestlers* is so all-inclusive and so minutely accurate that their creators must have attended classroom demonstrations in the dissection of corpses by Alexandrian or other Hellenistic surgeons in order to have acquired so thoroughgoing an understanding of subcutaneous muscular structure. But even if a plaster cast of Agasias' *Warrior* (that is to say, the *"Borghese Fighter"*) has been used to demonstrate to nineteenth-century art students the essentials of artistic anatomy, it does not necessarily follow that Agasias must have acquired his spectacular sense for athletic surface structure from subcutaneous study. Agasias' rendering of the human body in violent action has been termed "a factual result of anatomical research"; but it might equally well be characterized as a direct derivative of the unfactual classic tradition of formal linear analysis. As in successful drama for the stage, so for effective emotional evocation in art, it will be found that "realism" is not so much a mechanically faithful reproduction of the objective world as it is an artistic re-creation thereof in exaggeratedly vivid terms. Perhaps Agasias' *Warrior* was so useful to nineteenth-century instruction in artistic anatomy not

so much because it was physiologically correct as because it was artistically convincing; and it may be significant that it has been the student of art rather than the neophyte in medicine and surgery whose anatomic perception has been quickened by its contemplation. So vivid is the muscular articulation of the tensely straining figure that the *Warrior* has been stigmatized as representing a flayed body rather than a living form. On the purely technical side, I believe that the "flayed" effect is due solely to the deeply grooved demarcation of the muscular divisions which makes them preternaturally salient. By emphasizing their outline with broad incision and heightening the swelling of surface between their boundaries, an impression of enormous physical tension and power in terms of seeming physiological accuracy has been attained. But the structural pattern thus scored out is essentially that of the classic canon of the nude as Lysippos might have formulated it. I submit, therefore, that it would be a more accurate appraisal of this late-Hellenistic mannerism to say that Agasias has applied to the nude the same conversion of classic formula into dramatic emotionalism which is so conspicuous a characteristic of the drapery styles of his day. The realistic factor is, of course, a very potent element. Since Greek sculptors had always understood their art as a mimetic reconstitution of physical actuality, however profoundly affected by technical precept, it would be absurd to minimize the late-Hellenistic ability to observe and reproduce physiologic structure. But just as the *Warrior's* pose, while physically possible, is stretched and strained into a sensational deployment of the human body as a centrifugal explosion into space, so the anatomical pattern, while founded on natural truth, has been intensified beyond natural limits in the interest of a dynamic expression of strength of body, agility of action, and vehemence of will.

It has occasionally been suggested (presumably because of the Lysippan echoes in the bodily structure, the schematic, linear hair without plastic depth, and the supporting tree trunk so often added

by copyists in reproducing bronze in marble) that in signing himself
as author of this work Agasias of Ephesos meant only that he was re-
sponsible for carving it, not that it was his own creation. But the
theme of the lunging warrior defending himself against an attacking
cavalryman who threatens him from his higher vantage had long
been a commonplace in Greek art; and if it was the embodiment of
the theme in the greatest possible freedom of spatial composition
and heightened anatomical presentation which gave this work its in-
dividual status, no other date than the advanced second century may
be assigned to it. Whether Agasias copied in marble another mas-
ter's work in bronze or, alternatively, transmuted some earlier (e.g.,
Lysippan) statue into second-century form, the *Warrior* remains a
second-century creation; and it is of no great moment whether we
have this creation at first or second hand.

Much the same conclusion on the degree of physiological veracity
which attaches to second-century rendering of the nude may be
reached by examining another well-known late-Hellenistic master-
piece which treats the seemingly contrary theme of corporeal relaxa-
tion instead of extreme muscular tension. The huge marble of the
*Drunken Satyr* who has fallen asleep on a ledge of rock, more general-
ly known as the *Barberini Faun*, produces an impression of closely
studied and realistically rendered anatomic structure—an impression
which, however unfounded, pays unconscious homage to the artist's
control of the sources of emotional effect in sculptural presentation.
Such a comment is particularly applicable to the superbly executed
musculation of the back, seldom shown in photographic illustration.
To be sure, it may be objected that there are passages which cannot
be termed a restatement of classic formula but are a strictly mimetic
reproduction of natural observation; such is the needlessly detailed
anatomization of the veins which trace their vivid course over the
satyr's idly hanging and heavily knuckled hand—but this, together
with much else of similar nature, is due to restorations by Bernini

in the seventeenth century and is not part of the original work. Indeed, there can hardly be a better demonstration of the stylistic difference between academic realism and formal expressionism than that provided by the modern contributions to this extensively restored ancient marble.

The anatomic rendering of the three nude male figures composing the *Laokoon* group may be cited as a similarly calculated heightening of classic formula for dramatic effect. Baccio Bandinelli's realistically "edited" copy in the Uffizi once more illustrates the distinction between anatomic imitation and emotively expressive form.

The almost equally sensational group in the Terme Museum, the Gaul who has killed his wife and makes ready to kill himself, is a copy in marble from a lost Pergamenian original in bronze. The violently centrifugal pose and muscular tension ally the nude with Agasias' *Warrior;* there are hardly less obvious anatomic similarities to the *Barberini Faun*. If any chronological coherence is to be presumed for second-century sculptural style, all three of these works must be brought together into plausibly close association, with Agasias' *Warrior* presumably the latest (because in anatomic manner the most developed) and the *Suicidal Gaul* probably the earliest in the series. But on no discoverable ground may this second work be assigned to so early a place as to make it contemporaneous with the *Dying Trumpeter*. Between these two memorials to Gallic defeat there must have intervened all the considerable span of years needed for developing second-century dramatic classicism out of late third-century naturalism. It may be recalled that the signal repulse of the Galatians by Attalos the First did not put an end to Pergamon's trouble with these formidable invaders, against whom Eumenes later directed several expeditions, even penetrating the interior uplands in which they had been permitted to fix their abode. It is extremely unlikely that the mercenary bands which the first Attalos defeated in pitched battle were accompanied by their families, where-

as the destruction of the Galatian settlements by Eumenes' general, the second Attalos, might very naturally have occasioned the tragic episode which the *Suicidal Gaul* immortalizes. Pliny expressly states that the Pergamenian artists celebrated the battles of Attalos *and* Eumenes with the Galatians. There is thus entire justification for the opinion of the German critics who distinguish a first and second Pergamenian school of sculpture—except that to split Pergamene art into only two phases is to simplify too drastically a far more complex sequence of events.

Nowhere else in surviving ancient sculpture, save in the *Laokoon*, has sensationalism been attuned to such a pitch of emotional tension as in the group of the *Suicidal Gaul*. Perhaps the contrasts between the energetic living and the insensate drooping body, between defiance and death, between the male nude and the fully clothed feminine form, are somewhat too obvious, too strident, to produce an unrestrained emotional response in the spectator. But melodrama differs from legitimate drama only in leaving its mechanism more openly exposed to view, relying on a less perceptive audience. If the *Laokoon* has succeeded in satisfying a more sophisticated taste than the *Suicidal Gaul*, it is largely because it diverts our critical perception of melodrama's overt artifices by working on our instinctive fear and horror of huge serpents. The mechanism for emotional excitation is the same. There is the same juxtaposition of the living body in violent tension and the relaxedly sagging corpse, a contrasting of adult physical strength and adolescent physique; while the introduction of a third figure into the *Laokoon* group makes possible an even more complex emotional contrast in the simultaneous representation of the agony of hopeless struggle, the eager prospect of immanent escape, and the insensate submission to disaster.

This dramatic device of poignant juxtaposition of the living and the dead, as also of the maturely formed and the adolescent physique, had already been introduced into group composition in another il-

lustration of epic theme in which Menelaos is shown dragging the dead Patroklos from the battlefield. This work is widely known in the much reconstituted version exhibited in the portico off the public square in Florence but is more correctly accessible in a considerable number of marble replicas in varying states of mutilation.

Once more, if any degree of stylistic coherence is to be attributed to late-Hellenistic sculpture, these three dramatic groups should not be very widely spaced in time, with the *Menelaos and Patroklos* set in prior place because of its strictly frontal composition in graphic pyramidal pattern and its unexaggerated rendering of anatomic form, the *Suicidal Gaul* assigned to the reign of Eumenes, not much later than the Altar of Zeus of Pergamon, and the *Laokoon* probably placed last in the series, but still within the chronological limits of Pergamenian "baroque." (To be specific at the risk of being arbitrary, the half century between 190 and 140 would satisfy these requirements.)

The Pergamenian elements of style in the *Laokoon*, in particular the similarities to the great altar frieze, have long been noted. Even the cardinal theme of the twining and attacking serpents recurs on the frieze in the coiling serpentine limbs of the giants—an invention which might have suggested the Laokoon legend as a feasible subject for sculpture. But because of inscriptional evidence from Rhodian Lindos, recording two names identical with those mentioned by Pliny in connection with the masterpiece which he set above all other work in marble, it has been persuasively maintained that the *Laokoon* cannot have been produced earlier than the year 50 B.C.

Such a displacement of the date, an entire century later than its stylistic context requires, was not welcome news to students of Hellenistic sculpture, who made the best of it, nonetheless, by remarking that the frontal and relief-like composition of the group in a flatly graphic pattern might well be an indication of lateness, a lapse from the mid-Hellenistic stereomorphic control of sculptural

form. Against this concession it may be pointed out that familiarity with the great altar frieze at Pergamon could very well have inspired a relief-like conception for figures in consecutive arrangement even when fully detached from their ground, especially if the work was intended to be seen against a screen such as an enclosure wall or the framework of a niche. But in a very recent study of the problem, the frontal composition of the *Laokoon* has been ascribed to the pictorial notions of sculptural form current in sixteenth-century Italy when the dismembered fragments of the group were reassembled as we now see them, but not as they were originally disposed. Here the claim is made that "the elder son was displaced as much as ninety degrees out of his original position, and the axis of the group shifted about forty-five degrees. . . . Freed from the relief-like composition imposed on it by its sixteenth-century restorer, the group now regains an extraordinary three-dimensional character."

However this finding may be judged, we shall perhaps do best, in view of the stylistic evidence, to take the priests of Athena Lindia documented for 22 and 21 B.C. as lineal descendants of the Athenodoros and Agesandros of the triad which carved the *Laokoon* a century earlier. Such a solution leaves Hellenistic "baroque" (and the *Laokoon* has all of its essential qualities) a comparatively short-lived phase without recrudescence in after days, as might reasonably be expected of an artistic *stella nova* of sudden appearance, remarkable brilliance, but little permanence. A "Pergamenian revival" around the middle of the first century would prove embarrassingly out of step with the trend of Greek sculptural style as we otherwise establish it. The mid-first-century reversion to classic precedent, as it may be studied in the work of Apollonios Nestoros in the marble *Belvedere Torso*, the bronze *Seated Boxer*, and the so-called *Hellenistic Ruler* (Plate XLVII A), indicate an attention concentrated on the late fifth-century heroic manner of the Polykleitan and Pheidian circles with an almost total disregard of the Hellenistic interlude. Even in por-

traiture the truly admirable second-century technique was largely re-
placed by a more classicizing manner, which by mid-Augustan times
gained complete ascendancy in the imperial court at Rome.

This "truly admirable" attainment in sculptured portraiture which,
in itself alone, would have conferred greatness on second-century
Greek art, was in no sense a "renascence of classic form." It con-
stitutes a topic for separate discussion devoted to the emergence of
plastic technique as a final phase of pre-Roman statuary art.

Meanwhile it remains to make some mention of sculptural relief in
late-Hellenistic times. The treatment can afford to be brief since its
theme is singularly unrewarding. The architectural friezes are par-
ticularly disappointing, being of inferior artistry and giving an im-
pression of perfunctory attention, vapid and repetitious design, and
inelegant and careless execution. A considerable amount of such
work has survived in the Artemis temple frieze from Magnesia, now
in the Louvre, and the Hecate temple frieze from Carian Lagina,
now in Istanbul, conspicuous among the longer pieces, and among
briefer examples the pedestal crown-relief of Aemilius Paullus' mon-
ument to his victory over Perseus at Pydna in 168, still at Delphi,
and the wind-gods of the octagonal *Horologion* in Athens, of con-
siderably later date and remarkably good preservation. Otherwise,
with the notable exception of the brilliantly carved *Gigantomachy* re-
liefs on the exterior socle and the more pictorially narrative *Telephos
frieze* on an interior wall of the Pergamenian Altar of Zeus, there is
little deserving even passing mention. The single slab of the *Dancing
Girl* from Pergamon, now in the Istanbul museum, alone suggests
that work of great distinction and beauty may have been made
and lost.

It is difficult to say why most of this work should be so mediocre,
unless it was that professional and public interest had shifted to dis-
play pieces in-the-round, which afforded opportunities in tridimen-
sional composition of solid structural form inevitably denied to uni-

facial relief. The painter's art, which had maintained a copybook of linear designs accessible to the carvers of relief and readily adaptable to their use, by this time had so perfected its devices for reproducing physical shapes in terms of their retinal conversions that the sculptor could no longer make use of its illusionary projections of spatial extension, its graded color tones—in a word, its purely pictorial ambience. And while relief no longer had the means to mimic painting, the glyptic art on which it had relied even more directly was now so deeply engaged in the presentation of the multifacial aspects of solid shapes, that it, too, had attained a technical level inaccessible to relief's single-surface panel rigidly attached to its ground. Relief was paying the penalty for being a *Zwitterwesen*, for attempting a twofold existence which could not be simultaneously pursued.

The Pergamon altar had made a brilliant attempt to revitalize classic relief by adapting the technical devices for statuary-in-the-round to deeply undercut and partially detached figures arranged in sequence along a uniform background plane; but no subsequent effort seems to have been made to adapt so linear, so unescapably two-dimensional a means of sculptural presentation to the flamboyant second-century taste. Its advanced conception of sculpture as an art of poised living forms freely occupying isolated space left no opportunity for relief. Despite this loss, the difficult task of stereomorphic presentation had been so completely mastered in free-standing statuary that the second-century achievement is sufficiently spectacular to win it a place among the great periods of universal sculptural history—especially in view of its new interest and unprecedented technical progress in the art of portraiture.

# IX

## *The Intrusion of*
## *Plastic Form*

IT WOULD BE EXTREMELY UNWISE, in a survey of such large scope
and so little bulk, to attempt to do more with Greek portrait sculp-
ture than to fit it into the general framework of the evolution of
sculptural style. Viewed in perspective, it must be self-evident that,
if we define a portrait as the recognizably faithful likeness of an in-
dividual, the technical limitations incident to the archaic phase pre-
vented the creation of sculptural portraits during that period. Of
course there can be no dispute that every archaic representation of a
human being is an individualized, recognizably distinct representa-
tion, possessing a unique "personality" of its own. The "Apollo"
from Tenea and the Youth from Volomandra are distinctly individu-
al beings; but they are people of the sculptural world of the archaic
*kouroi*, and all that makes them uniquely different from their fellows
is incidental to their creation by a sculptor who could not, even if he
chose, exactly duplicate a previous production, much less a living
person. Certainly there is no ground for the belief that there was
anyone alive at the time, in the Peloponnesian town of Tenea or in
the Attic district now known as Volomandra, who bore the least
resemblance to either of these two inhabitants of the statuary realm
of marble. We may take it for certain that the technical status of
archaic craftsmanship excluded the glyptic reproduction of such an

intricately modeled and complexly illuminated geometric structure as the human countenance.

It should be equally clear that as long as a canon of simple arithmetical proportions was applied to the sculptured features of head and body, the result must be an abstraction of physical reality and never an exactly faithful duplication. On this account, as long as sculptors continued to lay out their work canonically—and this would be equivalent to the entire period of classic form—a fully individualized portrait would involve a complete departure from traditional techniques. A "portrait" herm of Perikles is extant in several copies. It is generally agreed that the copies must be derived from an original contemporary work by the sculptor Kresilas, produced some time before the great Athenian leader's death in the terrible plague of 429. Since all the features of the head are linear patterns in strictly balanced symmetry, with the flat bridge of the nose continuing the plane of the forehead and the arch of the eyebrows sharply edged to a geometrically simple curve, there seems little warrant for imagining that anyone familiar only with Kresilas' rendering would have been able to identify the living Perikles by sight. The "aged seer" from the east pediment at Olympia is much more persuasively an individual person than is this helmeted, short-bearded, but otherwise characterless head which purports to be that of Perikles. The "aged seer" has individuality because mid-fifth-century sculpture had begun to differentiate generic types within the generic formula of the *kouros*. Here the bald forehead, the heavier beard, the fleshy cheeks, and the flabbily muscled torso distinguished the male of advanced middle age as a separate sculptural theme, without thought of any specific likeness to an actual person, the whole representation being based on legend. If an imagined character derived from legend can impress us as more real than the purported likeness of a contemporary, it would strain credulity to claim

that this latter work nevertheless bore faithful resemblance to a specific person.

Just thirty years after Perikles' demise, Sokrates was put to death in Athens. There is no reason to believe that during that period there had matured a sculptural technique of accurate portraiture in fully detailed agreement with individual facial appearance. If several of the extant heads and statuettes of Sokrates conform to the descriptions in Plato and Xenophon, and even confirm Alkibiades' bantering parody of his physical peculiarities as given in the *Symposium*, should we not suspect that it was these vivid passages which determined a later sculptor's rendering rather than visual memory of the man himself? There is no intrinsic probability that a portrait statue of Sokrates was made during his lifetime. (What reasonable purpose or occasion was there for making one? And what would have been done with it, if it were made?) If Athens, in later repentance for having so undeservedly put to death one of its most remarkable citizens, erected a public statue to his memory, the literary tradition of his physical appearance would have offered more to the sculptor than he could have derived from any iconographic source. Since it may be claimed that there are several distinct types discernible in the surviving representations of Sokrates, there is no great probability that any of these types reproduced its subject *in propria persona*.

Forty years, or thereabouts, after Sokrates' death, a Persian nobleman who had sought instruction in Plato's Academy commissioned the Athenian sculptor Silanion to make a statue of the great philosopher who had founded this center of learning. Since Plato was still living and active at the time of the statue's creation, and since the extant and authenticated heads of Plato are versions of a single type with distinctive fourth-century characteristics of style, there is every reason to claim that Silanion's sculptural portrait has survived in copy and that in it we have proof that lifelike representations of specific individuals were being made in Greece before the middle of the fourth

century. Certainly, the head is a forceful and persuasive representation of an ancient Greek philosopher. The difficulty is to discover how closely its lineaments resemble those of Plato himself, and, alternatively, how much of sculptural invention and artistic transformation attends this portrayal of a rather morose, highly intelligent, and deeply thoughtful middle-aged man. Where no realistic technique of sculptural mimicry is current, "portraits" are judged for different merits and will strive for quite other qualities than strict material resemblance. We are only too prone to overlook this fact.

In Silanion's case it should be considered that this master is also recorded as having made statues of the two great feminine poets, Sappho and Corinna, who had died generations before Silanion was born. In one of these companion pieces (to judge from the replica of the statuette now in Compiègne and labeled "Korinna") the subject is shown wearing her hair in fourth-century fashion, and her garments are treated in the fourth-century sculptural manner. One must therefore make due allowance for artistic convention and technical tradition and avoid the assumption that a portrait head which appeals to us as genuine cannot be wholly inexact as a portrait.

Nor should we place a modern interpretation on ancient *dicta* lauding veridicity in sculpture where perhaps we should discern only verisimilitude. Such remarks must first be set in their appropriate context of time, place, and cultural convention. When we read of the Attic sculptor, Demetrios of Alopeke (who must have been active at least as early as Silanion), that he dealt "not in gods but in men" and preferred "truth and likeness to beauty," and that his statue of a Corinthian general named Pelichos was "the very image of the man himself," with fat belly, bald forehead, disheveled beard, and protruding veins, it might be wise to reflect that Lucian—to whom we owe this description of the statue—was describing the statue and had never seen the man. A "Pelichos" could have been evolved out of the "Aged Seer" of the Olympia pediment without drastic change

of style. As far as any fourth-century sculpture has survived for our critical examination, there is nothing in its technical means and methods to lead us to suppose that such a thing as a mimetically exact and correctly differentiated reproduction of an individual's physical appearance was produced or even attempted.

It will perhaps be objected that this verdict demonstrably fails to consider the material evidence. Portrait statues of Alexander the Great (who died in 323) are known to have been made by contemporary artists, notably by Lysippos, who is recorded as having also made statues of Krateros, Kassander, and Seleukos—all earlier than the year 300; and portrait heads of Alexander have survived from antiquity in considerable number. There is no reason to doubt that some of these go back to originals made in Alexander's lifetime, though it is equally indisputable that many are Hellenistic versions or later reworkings of presumptive contemporary renderings. It still remains to determine, if we can, whether these fourth-century "portraits" of Alexander are true likenesses or sculptural mutations. Admittedly, the wonderfully fine marble head found on the Athenian Acropolis (Plate XLIII B) portrays Alexander as we would like to imagine him. Nevertheless, all the features and measured proportions are strictly classical—from which it must follow that they are ideated abstractions of physical shapes. Bernard Ashmole has published, side by side, two photographs, one of the nostrils and lips of the Alexander head, the other of the nostrils and lips of the *Demeter of Knidos*, aiming to prove that both were from the hand of the same fourth-century sculptor, but perhaps more adequately demonstrating how conventionally fixed were the classic sculptural norms and how far from everyday mortality was their transcendental loveliness.

Much has been made of the passage in Pliny, previously cited in reference to Lysistratos, as warrant for the assertion that even if fourth-century portraits are set aside as glyptic ideations, and thus physically unreal, nonetheless mimetically faithful portrait heads

were produced at the start of the following century. So crucial a statement, on which so much may depend for our understanding of the technical behavior of Greek sculpture in its later periods, cannot be passed over without comment or accepted without closer scrutiny of Pliny's text.

Pliny has been interpreted as saying that Lysistratos, brother of Lysippos, invented a procedure for taking casts from the living face and that he used these to produce portrait likenesses. Were this correct, we should expect to see a very sudden change in Greek portraiture by the opening decades of the third century, since any sculptured head based on a life mask of its subject would necessarily differ fundamentally from all previous Greek work. But no such sudden alteration in style is discernible (cf. Plates XLIII C–D). It is the textural structure of the body, rather than of the facial features, which underwent change in this period and developed a novel character as a result of the disguise of the formal linear divisions under a more fluid continuity of surface without sharply defined patterns. This is the very result which might be anticipated from comparing casts of parts of the living body with their traditional canonic rendering and revising the canon in light of the anatomic information thus gained. And this is what Pliny intended to record.

When translated in conformity with the sculptural practice of the period to which it refers, the passage in Pliny should read as follows:

Sicyonian Lysistratus, brother of the Lysippus of whom we have been speaking, introduced the practice of taking impressions of the human form in plaster from the living model and by pouring wax into the plaster mold correcting its rendition (*sc.* in sculpture).

He also introduced the practice of making true likenesses, where the interest previously had been in the greatest possible beauty.

This same artist likewise invented a process for making casts of statues, which came to be so generally employed that no statuary was made without clay.

One could wish that Pliny had gone into greater detail on these matters. But there is no reason to doubt the accuracy of his information or justification for deriving from his statement other meaning than their literal wording offers. Accepting this as it stands, we gain three important pieces of information:

First, at the beginning of the third century anatomic naturalism was furthered by reference to piece-casts taken from the living form. There is no mention of life masks; and death masks being no more probable, Lysistratos' innovation had no bearing on sculptural portraiture.

Second, the trend toward mimetic fidelity affected the rendering of the features so that "likenesses" replaced the impersonal ideations of previous work. When Pliny comments that earlier sculptors had sought to make portrait heads "as beautiful as possible," his *quam pulcherrimas* has nothing to do with the beauty of comeliness or similar sensuous attraction, but echoes the Greek *kalon*, for which neither Latin nor English has a just equivalent. Where Pliny wrote *quam pulcherrimas*, we best convey the intent of his Greek source by saying that earlier sculptors had "idealized" human features. Lysistratos' improvement would have been an attainment of closer resemblance to individual countenance by irregularizing the established formula of canonic shapes and measured proportions in the interest of those departures from the geometrically simplified norm which make one person's features recognizably different from another's. Pliny was correct in asserting that this had not greatly interested Lysistratos' predecessors. But whether this neglect should be charged to an innate Greek sense for abstractly intellectualized form in art or to the material and psychological exigencies of a purely glyptic technique, or to a combination of both of these, exceeds my critical competence to decide and would not at all have interested Pliny.

Third, we are told that Lysistratos, having devised a process for taking molds and making casts from the human body, extended this

invention to the production of casts of statues. Unfortunately, this does not inform us whether, as in his casts from the living model, he contented himself with piece molds or whether (as is done today) he was able to assemble a set of piece molds to a master form from which to extract an entire figure in a single casting. If the latter interpretation seems probable (there being little point in casting, piecemeal, fragments of a statue), the first essential step had been taken toward making possible the mechanical reproduction of older masterpieces, an enterprise that by imperial Roman times had developed into a great industry.

Yet there still remains the crux of Pliny's account. His preceding reference to casts from the living form concerned *plaster* molds and *wax* castings; he now epitomizes the outcome of taking casts from statuary in the slogan *nulla signa sine argilla*—"without clay, no statues"—failing to explain how *clay* has been introduced into the procedure. It might be tempting to assume that, the whole passage being part of an account of the sculptural history of bronze and not marble, it applies solely to bronze statuary and means that the existence of a process for making molds from entire figures enabled sculptors to model their work in clay, leaving it to the foundry to make the final casting mold from a replica in plaster of the clay model—in a word, that our present procedure for casting bronze statuary was in use in late classical antiquity. This would mean, of course, that for bronze statues the glyptic tradition had been replaced by plastic art. But Pliny does not say all this. And even if it should be thought to be a valid inference, so fundamental a revolution in sculptural practice cannot be ascribed to Lysistratos but must be understood only as an eventual outcome of his innovation. Whether this occurred after a prolonged or an inconsiderable lapse of time Pliny omits to state, confining himself to the vague indication that "the practice increased so greatly" (*crevit res in tantum*). For lack of any more specific information from written sources, reliance must be placed on surviving

sculptural work to tell us, if it will and if we listen, how it was and when it was that a plastic technique was substituted for the century-old glyptic tradition. On this, the only truly dependable evidence, it would appear that it was specifically in portrait sculpture that the revolutionary change was first made. Presumably this was due to a realization that if "likenesses" were to be achieved only a plastic technique could produce them.

The introduction of such a technique must have been due to the bronze-casters (since the making of a preliminary model in wax or clay would hardly have profited the cutting of a head from a solid block of marble). The method may at first have been employed only for the heads of statues and perhaps been further restricted to heads intended as individual portraits. The plastic medium employed was wax rather than clay. All this is purely a matter of observation and inference but need not on that account be dismissed as mere conjecture.

From the earliest days, Greek metallurgists must have used wax (probably in a state hard enough to permit cutting, paring, and engraving) in order to fashion models from which *solid* castings in molten metal could be made for objects of comparatively minor magnitude. Bronze mirrors; tableware in bronze and silver; the rigid parts of couches, tables, chests, and chairs; metal ornaments for attachment to armor, to doors, to coffered ceilings; jewelry and other articles of goldsmithing, where these were not beaten out of thin sheets of gold—the list of objects normally cast from modeled wax is a long one. But none of these objects approached in measurement or in any way suggested in structural appearance a life-size human head. Monumental sculpture, as we have seen, relied on other resources for producing its hollow-cast bronzes.

There was, however, an important artistic industry, widespread in its activity and notable for its products, in which both the shaping of wax models and the representation of individualized portrait heads

in metal were practiced several generations before the time of Lysistratos. The reference will be apparent to those who have taken note of the exquisite artistry of late fifth- and early fourth-century Greek coins and observed that occasionally the profile heads which they show are intended to represent living individuals. These heads seem to be directly based on preliminary studies made at exact scale in hard wax.

Greek coins had not always been made in such a manner. Through the sixth century the designs stamped on the coinage of the various Greek communities were token marks or badges to distinguish the issuing polity. These were drawn from the early artists' repertory of simple types. Among these were included turtles, fish, flowers, fruit, and various quadrupeds; but human heads, representing local divinities or half-gods such as nymphs and satyrs, came to be especial favorites, not only because of their humanized theme, but also because they were peculiarly suitable in shape and scale and pattern for profile setting in the small circular field of a coin.

Apparently it did not occur to any of the local dictators who had political control of early centers of commerce that the head stamped upon their coins might be their own. Whatever the reason may be, portrait heads did not appear as identifying badges for any of the Greek communities until Hellenistic times, when the deified rulers arrogated this right. But the Persian empire, with its provincial governors, or "satraps," was subject to no such sentiment of restraint; and where, as in western Asia Minor, Greek cities were subject to their rule, Greek artists were employed to engrave dies and local mints were empowered to strike gold and silver coinage with the local satrap's likeness in a profile portrait head. The finest examples date from the end of the fifth and the first half of the fourth centuries. The dies from which they were struck had been engraved by a technical procedure essentially different from that employed at an earlier date.

The coins struck during the sixth and early fifth centuries carry linear designs in characteristically archaic terms. The outlines of the object to be represented in raised relief on the coin were engraved on the smooth surface of the die; within the area thus circumscribed, the metal was scooped out to form a shallow pan; and on the floor of this depression the interior detail of the design was engraved, beginning with the major features and sinking into these the more minute and subsidiary detail. When a metal blank was struck by such a die, the sunken design was reversed so that the deepest linear detail stood out as thin raised dikes above the rest. Such an art was both graphic and glyptic, a sort of negative of archaic relief, without recourse to modeling or any nonrigid medium such as clay or wax. Greek numismatic art, in fact, is a by-form of Greek relief sculpture, reflecting its phases and its characteristic qualities. For that reason it cannot be passed over in the present study. But there is another reason for its inclusion at this point in the critical narrative.

On late fifth-century coinage of superior artistry, produced notably for the Sicilian and South Italian cities, it is apparent that, for the most part, the process of progressive accumulation of a design by building up its graphic structure successively in depth within the die has been abandoned for a different method. The coins are still struck in hot metal, not cast in a mold (a process inapplicable to the production of many specimens of the same design, since a technique for repeated casting from a single matrix was apparently unknown to antiquity). But a technique for solid casting very generally employed for other art work in metal gave the die-engravers the clue to a method by which they could overcome the linear rigidity of archaism and attain more modeled solidity of mass correctly ranged in depth.

By forming the design in hard wax, not worked entirely freehand like modeling clay but shaped by paring and graving, a finished model for a coin could be made in positive relief; and from this a negative impression could be taken in finely levigated clay. From

such a mold a molten metal cast could conceivably have been made —but only with the destruction of the mold itself. Instead, a different use was made of it. Because it presented a perfect negative impression of the finished design, it could serve the engraver as a fully formed model which he need but reproduce exactly in his die without alteration or correction of any kind.

Coins struck from such a die would present their designs in strongly modeled relief. The minor detail of this relief would have been produced by paring, gouging, and graving the wax, and thence would derive a markedly glyptic quality; but in the unlinear spread of surface and the welling massiveness of the underlying structural shape an equally marked plastic component would be apparent. Greek coins of the so-called fine period of the late fifth and early fourth centuries are unlike those struck by any other people; they are imbued with sculptural form divorced from all pictorial suggestion. But they also differ from contemporary statuary work in hollow-cast metal by their greater reliance on the mobile structure of the wax in which they were first given shape. In short, they exemplify a more plastic rendering in their representations than can be found in monumental sculpture of the period. The coiners employed by the Persian satraps took advantage of this release from linear control, conferred by working in a plastic medium, to venture upon Greek art's earliest efforts in realistic portraiture. By working in wax, the artist could reproduce the rise and fall of undulant surfaces possessing no definable boundaries except as these were made and unmade by the shifting incidence of light and shadow. Thereby he could faithfully record those minute deviations from the canonic norm which make each individual appear a person apart, uniquely different in looks from his fellows.

It seems a rational suggestion that neither Greek nor any other sculptors could have produced glyptically, by direct attack upon a solid block without aid of any plastic model or preliminary study, a

realistic portrait in our modern sense of the term. Until the technique of wax modeling, which existed in numismatic art but which was there restricted to profile relief on a miniature scale, could be adapted for use in life-size sculpture in-the-round, realistic portraiture of monumental size could hardly occur in Greek art. Conceivably, such a technical adaptation from numismatic to major sculptural practice might have taken place at any time; however, those aspects of art which are matters of acquired craftsmanship prove themselves to be extraordinarily tenacious and resist obstinately any sudden substitution of new working methods. It was not until the continued trend of sculpture toward mimetic fidelity had undermined the classic tradition of ideated linear form by a more naturalistic treatment that Greek artists sensed the need of a fundamentally different approach to the problem of representing human features in marble or bronze. On the testimony of the coins (though some of the immediate successors of Alexander were represented by heads powerfully modeled and strikingly plastic) it was thereafter the major art which exerted the greater influence, paying no heed to the remarkable technical opportunity which the minor art held out to it. The mid-third-century die-engravers seem to have been content to follow the lead of contemporary sculptural fashions and reproduce very successfully the placid surfaces and flaccid modeling of the naturalistic phase. But at some time close to the year 200, at the very period when a dramatic change is discernible in monumental sculpture, there is a sudden and equally dramatic turn of style in the heads of the Hellenistic rulers on coins. Instead of relying on sharply simple profile drawing and a smoothly clear run of surface, the heads now look as though they were copies in high relief from fully modeled, life-size prototypes in-the-round. Universally recognized as masterpieces of numismatic art, these second-century coins should also be taken as proof that the contemporaneous art of monumental sculpture had evolved and put into effective use a new technique for portraiture.

Necessarily this new technique—which can only have been that of making *preliminary full scale models in wax* for reproduction in the more durable medium—had been introduced by the bronze-casters (since it is difficult to imagine any use that the marble cutters could have made of such work). A head modeled in wax, whether shaped from a solid lump or worked upon a wax-coated interior core or supporting metal framework as clay heads are modeled today, could be utilized to produce a clay mold in which bronze could be poured in the usual procedure to make a hollow replica. Accordingly, we are entitled to assume that all the wax-based, mid-Hellenistic portraits were bronzes and that when we meet with one carved in marble it can only be a copy of some lost bronze original.

The previously cited portrait heads from the third century—those of the Ptolemaic queens and the young woman of Perinthos—exhibit the undisturbed curvilinear planes of cheek and forehead and the generically patterned features of a formalized glyptic technique (Plate XLIII C). However lifelike their effect of quiet, youthful beauty, they are derivative of the older sculptural tradition. Their resemblance to those whom they purport to portray is more allusive than actual; they are sculptural re-creations of reality, not images in a mirror which have been caught and solidified in bronze.

Even in photographic reproduction it must be instantly apparent that the bronze heads of the middle-aged man from Delos and the embittered old man from the sea (Plates XLIV and XLV) are not of this order of being but belong, technically and esthetically, to a wholly different domain. One need not revert to fifth-century heads such as those of the Delphi *Charioteer* or the *"Poseidon" of Artemision;* even so late a work as the *"Berenice"* in Naples (Plate XLIII C) belongs to a wholly different world of sculptural creation.

In the case of the head from Delos, the model from which an impression was taken for the casting mold was not made by laying out linear boundaries for the features in a canonic pattern and trimming away whatever was extraneous to these demarcations. Nose and

mouth and chin have here been built up by addition of freely formable matter, not reached by subtraction of already present environing mass. The highly complex movement in and out and along the surface of forehead, temples, cheeks, chin, and neck will be recognized by every practicing student of art as the work of a modeling hand using its fingertips to form and re-form a softly solid substance. Similarly, the hair has been given a moving surface structure by modeling; and on this has been imposed a linear definition of strands by use of some slightly blunted tool, the grooved imprints of which were later to be reinforced in the cast replica by graving the cold metal, much as the eyebrows were indicated by incision after the casting. It is undeniable that the openings of the nostrils and mouth have been cut and edged with some sharp instrument, much as the strands of hair have been separated, and that this had taken place in the preliminary wax model; but such intrusion of glyptic work is wholly incidental. Perhaps the wax was worked in a softer state in modeling the solid structure and then allowed to harden before glyptic retouching of contours and linear details.

I would say that it is completely impossible that the model from which this head was cast could have been worked in clay; its material medium can only have been wax. The head of the *Old Man from the Sea* (Plate XLV), which was recovered from the same deep-water wreck that yielded the *Ballplayer*, is even more visibly a product of plastic modeling; but the present texture of the surface is somewhat misleading in showing a waxlike or claylike quality, the result of heavy impregnation with paraffin to prevent the corroded surface from further flaking or scaling after the head's recovery from the Aegean. To the rather ambiguous effect thus produced may be ascribed any hesitation that one may have in deciding between wax and clay as the medium in which the head was originally modeled. Point-by-point comparison with the head from Delos should dispel any doubt that this, too, was worked in wax.

Some technical details may prove of interest. On the head from Delos the lead jacket which holds the eyeballs correctly oriented and firmly lodged is plainly visible; but if eyelashes once were clipped in the protruding ends of these soft metal plates, they have been broken off or have worn away. In the eyes themselves the pupil is a circular cavity drilled in the center of an iris made of an appropriately colored stone. This effective use of empty shadow to represent a material part can scarcely represent the sculptor's intention; more probably the cavity once held a glass pupil—with which modern taste might be willing to dispense, but which any realistic imitation of nature would surely require. In the head of the old man, the raised edge of metal which outlines the lower lip once served for lapping over and keeping in place a thin sheet of beaten copper or some metallic alloy of ruddy hue, veneering the lip with a more natural color. The eyes, which seem to reverse the proper sequence of colors for their parts, are damaged. Close-set behind narrowed lids in a battered face, their present state may exaggerate the impression of restrained ferocity. But the patternless tangle of shadow in hair and beard prove that this was always a dramatically expressive, even a romantic, and certainly not a merely imitative, study in portraiture. I know of nothing more masterly in surviving sculpture.

Admittedly, we have no means of knowing how well in either head the sculptor has caught a living likeness. Neither can we be certain that complete fidelity to physical actuality was desired or attempted. Our doubts on this score should be much increased by the observation that several of the second-century heads which are most strikingly individualized, and therefore seem most surely to present us with realistic likenesses of living men, prove to be wholly imaginary exercises in an ingenious art of sculptural improvisation for bringing visibly to life the famous and long since dead. This was indeed no Hellenistic innovation in sculpture. As noted, Silanion in the fourth century made statues of Sappho and Corinna, of whose pre-

cise appearance he could have known nothing. And I have already suggested that the Sokrates of our sculptural collections is an imaginary creation based on descriptions in Plato and Xenophon. Accordingly, if among second-century portraits we encounter heads of Homer and Hesiod, it is not their indisputably fictitious nature which gives us pause but the incomparable plausibility which the new technique of working in wax has made possible. It is conceivable that the portraits of living persons of this period are similarly imaginative interpretations rather than realistically imitative creations. Comparison with Roman portrait heads of the late Republic or the Flavian period of the Empire, when fidelity was the primary interest, should caution us against underestimating the pure artistry of mid-Hellenistic sculptural portraiture.

It is a curious observation that whereas our ancient marble statues with conspicuous frequency have been deprived of their heads, there is a considerable series of bronze heads which have survived without their bodies. Such are the two now under consideration, as well as the *Boxer's Head* from Olympia (Plate XLVI A), the *Arsinoe* in Mantua, the *Berenice* in Naples (Plate XLIII C), and the young woman from Perinthos (Plate XXXV), to name only those which this study includes. One might imagine that since heads without bodies had long been familiar appearances on coins, and heads with only vestigial reminders of the bodily parts were traditional for the pillar shafts called hermae, disembodied portrait heads, resembling the busts of imperial Roman times, might have become an accepted convention in the Hellenistic age. Yet such an abbreviation of the human form to a disembodied head seems incongruous when we consider the coherent unity of the living organism which is so conspicuously manifest in the Greek conception of sculpture from its very inception. It is virtually certain that these heads were torn from complete statues: most of them, having been cast separately, could the more easily be detached.

Nevertheless, although there seems to be no sure evidence that por-

trait heads were isolated productions forming a separate category in Hellenistic sculptural art and distinguished by a peculiar technique of their own, there was no compelling reason to extend to the entire statue the method of modeling a positive image in wax, which had so revolutionized facial portraiture. Since the heads were cast separately from the bodies (as the insertion of the eyes from within certifies), each statuary part presented its own technical problem; and the bulk of torso and limbs would have militated against their construction in beeswax, while the less intricate configuration of their surfaces would have afforded no particular inducement for shaping them plastically. In consequence of this specifically technical consideration, it was virtually inevitable that portraiture should develop into a specialized art applicable only to the heads of statues, while the other bodily parts continued to be formed in the traditional manner.

However improbable such a mingling of plastic with glyptic art within a single figure may seem to the modern craftsman, it offers a thoroughly plausible explanation for a peculiar practice recorded by Pliny of late-Republican Roman times—that is to say, for the period immediately succeeding that now under consideration. A passage in the section of his encyclopedia of natural science devoted to sculpture asserts that, prior to the dictatorship of Julius Caesar, distinguished Romans caused themselves to be represented in the nude and that statues of this kind were known as "Achillean," intimating that their physical type was athletic-heroic and classical. It is easy to see what an enormous saving of time and energy such statues would allow the Greek artists who filled these commissions. Only the head, modeled apart in likeness of the "sitter," would be the sculptor's creative and personal contribution. All the rest could be taken bodily from some earlier classic masterpiece—in the case of a work in bronze, by taking molds directly from some prototype. Except for the modeled head, an "Achilles statue" was a matter of routine, foundry craftsmanship.

Our finest surviving example of such a portrait pastiche is the so-

called *"Hellenistic Ruler"* (Plate XLVII A) of the Terme Museum, in which a life-size and very lifelike portrait head (Plate XLVI B) has been combined with an heroic (and hence slightly out of scale) body, whose anatomic detail so strongly resembles the *Herakles* of Polykleitos, as this work has been transmitted in marble copies, that one may reasonably suspect that the body may be little more than a recasting from some such work of the High Classic phase. As a piece of bronze casting the statue is an impressive demonstration of technological accomplishment; but judged as sculptural portraiture the head shows far less subtle artistry than the mid-Hellenistic heads previously discussed, with less intricate modeling of surface and little of interest in the play of light and shadow.

It is not apparent that sculptors who worked in marble could have taken advantage of this convenient way of filling their commissions for portrait statues. Unless they were in possession of some device for making copies in marble of pre-existing statues (for the bodies) and of plaster casts of wax heads (for the crowning portrait likeness), an "Achilles statue" in marble was no easier to make than any other kind. Yet such a statue has been found on Delos, with an individual head of distinctively Roman countenance set upon an exaggeratedly athletic, nude body in pseudoclassic style. Perhaps we should conclude that a practice which had arisen out of mere technical convenience in the foundry by late-Republican times had become an obligatory convention, to be followed in marble as well and for no better reason than public demand. In the *"Pseudo-athlete"* (as he has been nicknamed) from Delos, the body does not seem to be a purely mechanical copy of a recognizable classic masterpiece, and the head shows none of the subtle surface movement or plastic conformations characteristic of the modeled portrait.

It is true that second-century Hellenistic portraits based on wax models turn up in marble as well as in bronze. But these are commercial copies of bronze originals and were made in imperial Roman

times. Such, notably, is the *Homer*, most famous of all imaginary portraits, which so admirably envisages the tradition of an aged and sightless mastersinger of epic. Such also is the equally expressive head of a far less genial and bitterly disappointed old poet who has been given many names in modern times—among them, and most suited to the evidence, that of Hesiod. A bronze recasting of this head, now in Naples, demonstrates how much better modeled wax is suited to reproduction in metal than in stone.

Among the marble heads which by their style show that they have been copied from bronze cast from a wax model, it is somewhat embarassing to encounter portraits of men who lived earlier than the second century, yet not at so remote a date as to justify their inclusion among the imaginary inventions of storied tradition. Thus, Epicurus, who died early in the third century, is represented by a much-repeated type of portrait head that on stylistic grounds should be a work of the advanced second century. However, the fact that Epicurus' contemporary, Metrodoros, and his immediate successor, Hermarchos, survive in portrait heads executed in the linear glyptic manner appropriate to their lifetime suggests an escape from the stylistic dilemma. As founder of the school to which innumerable educated men adhered throughout the pagan centuries, Epicurus was an object of especial reverence, and sculptural likenesses of him were continuingly in demand. A modeled portrait with all the dramatic appeal of second-century art could easily have replaced in popular esteem any earlier rendering. The situation is the same with the heads of Alexander the Great, which prove by their varying styles that "likenesses" of Alexander, the enduring idol of the ancient world, continued to be made in every century according to whatever sculptural manner was in vogue. We have only to think of modern analogies to realize that the more famous the subject, the less surely authentic and the less probably contemporary its representation in art may be.

The repercussion of the wax-model portraits in bronze upon the style of sculptors working in marble would hardly have led them to attempt to reproduce in stone the soft plasticity of wax or the shifting brilliance of surface that modeled wax imparts to burnished bronze. The glassy polish given to marble surfaces by copyists during the Roman period—most frequently to be encountered in the Greek Renaissance under Hadrian and the Antonine emperors—was intended to reproduce the metallic reflection of highlights in the bronze originals which they were duplicating. Any smoothing and abrading of marble which the Hellenistic sculptors may have undertaken would have been of a different nature and for a wholly other purpose. In obscuring linear boundaries and blending formal anatomic divisions, they would concern themselves with imparting surface continuity of modeling in order to give coherence and unity to the nude figure.

There is a marble head of a young woman, sometimes nicknamed "*The Beautiful Head*," found at Pergamon and at present in Berlin, on which some of the abrasion and smoothing of surface, which blurs and softens the linear demarcation of the facial features and the strands of the hair, may be original and deliberate, as though in emulation of the vague definition and grainless texture of wax that has been gently heated in the final stage before taking its mold impression. But it is difficult to distinguish the contributions which the eventualities of time and of modern cleaning have made to ancient workmanship and original appearance.

This remark applies with even greater cogency to the yet more famous and lovely head of the *Maid of Chios* in the Boston Museum of Fine Arts. The claim has been made that all of its lucent vagueness is ancient and original, that none is due to the acid bath used to remove earthy incrustations or to any subsequent scouring and smoothing of its lightly pitted surface. If the present condition is accepted as the unaltered state in which the marble left the sculptor's workshop,

the very decided blurring of linear definition, which considerably exceeds that of the *"Beautiful Head"* from Pergamon, coupled with the presumable rendering of the missing portions of the hair in molded and tooled stucco, make it tempting to hazard a late second-century date for this "Praxiteleanizing work" with its classicizing reminiscences of modular canon.

It is regrettable that for neither head can we be sure of the antiquity of their seeming appeal to optical appearance as the final determinant of sculptural form. In the *Maid of Chios* as we behold her today it is not the tangible, measurable, materially actual shape of a block of marble, but the visual impression which our eyes receive from it when light is reflected from its surface, that determines it as a work of sculptural art. When the ultimate material in which the sculptor embodies his theme is comprehended—not as marble but as light, not as the physical object which he has fashioned but the visual construct which forms on our retina and dwells in our mind—then the final evolutionary phase of sculptural style has been attained. It is singularly unfortunate that we cannot decide for certain whether Greek sculpture ever reached this phase.

In quite another branch of sculptural activity recourse to a freely plastic medium that could be shaped and altered without material restraint permitted the Hellenistic artists still at work under glyptic discipline to achieve hitherto unattempted sculptural compositions of great spatial complexity. Unless the previous absence of unitary groups in classical Greek sculpture is understood as a natural concomitant of a glyptic technique devoted to canonically envisaged single figures, this lack must seem an extraordinary and quite inexplicable phenomenon.

During the fifth century, individual statues were often assembled to form a series or company or similar gathering related by some common theme or purpose, as when at Delphi the legendary kings of

# GREEK SCULPTURE

Argos, or the captains of the galleys victorious over the Athenian ships at Aigospotamoi, were stationed on a common pedestal. But there seems to have been no sense for true statuary groups in which the component figures merged their individual shapes in the larger unity of an inclusive total compositional pattern. Little advance in this regard seems to have been made during the fourth and third centuries; but with the second century, fully evolved and maturely constructed sculptural groups appear and become highly popular.

It might have been anticipated of a race so highly endowed with visual sensibility and so inclined to geometric thinking that it would be intrigued by the spatial intricacies of group composition and would make notable contributions to this advanced aspect of sculptural art. Several concordant explanations may be advanced for the failure to do so until mid-Hellenistic times.

Greek sculpture isolated the human body as a self-contained and self-sufficient unit. Insistence on coherent contour and canonic proportion was symptomatic of a concentration of attention on the organic singleness of the living creature. In *kouros* and athlete, the anatomic order was as much a closed system of shapes and forms as was the architectural order of a colonnaded building. The same disinclination to violate inherent structural unity that made composite constructional invention in architecture impossible (and restricted the Greek temple to an unmodifiable static form) exercised its restraint on sculpture and prevented the expansion of the single figure into the complex statuary group. At Selinos, in Sicily, the clustered temples were an aggregate of unconnected individual buildings, each complete in itself and, because it was complete in itself, resisting any fusion with its fellows. The lack of compositional planning in the sanctuaries at Delphi, Olympia, and elsewhere was due to the stark individualism which made every building, every dedication, every memorial a thing to itself, to be seen and appraised for what it was, without reference to its neighbors and surroundings. This same re-

spect for the self-subsisting individual prevented the sculptor from conceiving of statues as anything but isolated human figures. They could be set side by side, like the two *Tyrannicides*, or made to confront one another, like *Athena and Marsyas*, or gathered to a concourse, like the kings of Argos or the heroes of Marathon and Aigospotamoi, very much as citizens of a Greek town might assemble in a market place without resigning their discrete existence as separate persons.

Two further reasons for the absence of true statuary groups in pre-Hellenistic sculpture are technical rather than ideological:

As long as sculpture was created by direct attack upon an amorphous solid block, structural form depended upon linear contour. But a nexus of more than one figure can only be visualized stereometrically with great difficulty and never with much accuracy; and it cannot be recorded graphically. At most, it will be little more than a pictorial projection, as though viewed against a background plane, so that it cannot advance beyond the graphic state of a metope composition. Such a visual projection of interrelated shapes might yield a perfectly satisfactory relief but not a fully three-dimensional design. It would, of course, be entirely possible to give such a relief solid statuary form by cutting away the ground to which the figures were attached and giving the dimension of depth its full value. But the result would resemble Myron's *Diskobolos* and remain a freestanding metope composition. It would not be a tridimensional presentation, structurally intelligible from every point of view.

German critics call such a freestanding metope composition an *einansichtige Gruppe*. Perhaps an equivalent, or better term, would be "pictorial group," in contrast to the "sculptural group" possessing tridimensional value. When one recalls the long-protracted development from the quadrifrontal *kouros* to the tridimensional structure in multifacial pattern, as such a work as the *Seated Hermes* from Herculaneum (Plate XXXIV) may be termed, it should not be a matter

for surprise if the advance from the *einansichtige Gruppe* to the tri-dimensional *vielansichtige* complex was a step long delayed and not easily taken.

Because a "pictorial" group is adequately visualized in the imagination of the artist and may be graphically delineated before it is carved, a composition of this nature presents none of the difficulty which distinguishes the combination of more than one figure in a new solid shape sculpturally significant for every angle of view. But because a stereographic complex cannot be visualized or recorded graphically, it is well-nigh impossible to reproduce it glyptically in a single block without guidance from a preliminary model. Such a "consulting model" for a nexus of figures could be constructed plastically in clay or soft wax. By adding and subtracting, by forming and reforming, to correct the pose and relative positions and fuse the shapes and contours—in brief, by free spatial control of solid masses in fluid plastic state—the visual obstacles to tridimensional composition can be overcome. And only then can they be mastered glyptically, by transference from the plastic state to the enduring solid medium. Therefore, it may be assumed with confidence that no true sculptural group, combining two or more figures in unified, tridimensionally effective design, could have been produced by Greek craftsmanship without the aid of a plastic model.

As a matter of fact, statuary groups on a miniature scale were produced throughout classical times; but they were not glyptic work in stone but freehand modeling in soft clay made firm by firing. Such terracotta groups, in which two or more figures are intimately combined, are often difficult to date because of the unpretentiousness of their stylistic treatment; but a great many must certainly be earlier than the Hellenistic age. Had sculptors elected to adapt this humble form of art to their more ambitious needs, they might have worked out complex groups on a miniature scale and used these to inform

themselves on spatial structure and voluminous configuration for life-size versions. Whether such studies, or *proplasmata*, would have sufficed them, is difficult to determine. It would certainly have been far more helpful if they constructed full-size models from which measurably exact replicas could be made. The well-known *sympleg-mata*, in which two struggling figures are interlaced in solid open-work in a close-knit stereomorph of great complexity, as in the in-tertwined *Wrestlers* in the Uffizi or the much-exploited theme of the attacking satyr and the uncomplaisant nymph, are inexplicable except as glyptic reproductions of a preliminary plastic model in clay or wax. Such a work as the interlocked nymph and satyr in the Museo Nuovo in Rome, by the obviously hand-modeled character of the nude, confirms the judgment that such groups are derived from plas-tic prototypes. It does not follow that they were produced, like mod-ern sculptures in marble, by mechanical transference from a full-scale model preformed in clay and using a plaster cast as interme-diary. The *Laokoon*, for example, does not appear to have been so made. Yet here the coiled snakes cannot possibly be glyptic improvi-sations cut freehand out of the block but have every appearance of being plastic superimpositions upon the three separately constructed figures in their coils. Perhaps it is reasonable to conjecture that, since three sculptors worked on the group, each of the three was respon-sible for one of the figures, whereas the arrangement and assemblage of these figures in a single group, with twining snakes drawing them together within a single pattern, must have been the outcome of ex-perimentation with a plastic model. Such a procedure would explain Pliny's much discussed phrase "*de consili sententia*" as a reference to the common agreement which had to be reached by the collaborat-ing artists before three figures could be cut and a unified composi-tion result.

With this procedure Greek sculpture would still retain the quality

of a glyptic art and remain the immediate product of glyptic crafts-manship even while it surrendered some of its traditional conceptions of sculptural form to the new device of plastic invention. That this crucial development took place in Hellenistic times, and specifically during the second century, underscores our previous finding, how-ever modern taste may inveigh against it, that, technically, before its submission to Roman patronage, the final creative phase of Greek sculpture was its most mature achievement.

# Bibliography of Sources

## I. TO THE TEXT

A complete bibliography of everything that has been written about Greek sculpture, were its compilation possible, would fill many volumes such as the present. What is here attempted is to list a few of the standard works of reference and to add, under appropriate chapter and page, such indications as may serviceably supplement the discussion in the text.

For those who read German, Georg Rodenwaldt's Die Kunst der Antike (Vol. III of the Propyläen-Kunstgeschichte [Propyläen-Verlag, 1927]) offers the best summary view of Greek sculpture. The most fully documented and scholarly German treatise is that by Georg Lippold, Die griechische Plastik (Vol. III, Part I, of Otto-Herbig, Handbuch der Archaeologie [Munich, 1950]). In French, Charles Picard's Manuel d'archéologie grecque: La sculpture antique (4 vols; Paris, 1935-48), which thus far has been brought down to the late fourth century B.C., is extremely readable and informative. Each succeeding volume is noticeably more discursive than its predecessor. There are no works in English comparable to the foregoing; but Bernard Ashmole's contribution on sculpture to Beazley-Ashmole, Greek Sculpture and Painting to the End of the Hellenistic Period (Cambridge: Cambridge University Press, 1932) gives an excellent brief account, which may profitably be supplemented by Gisela Richter's The Sculpture and Sculptors of the Greeks (rev. ed.; New Haven: Yale University Press, 1950). The same authority's A Handbook of Greek Art (London: Phaidon Press, 1959) contains a lengthy chapter on sculpture, which is concise, up-to-date, and exceptionally well illustrated. For the fourth century and the Hellenistic period, Margarete Bieber has collected the monumental material and has summarized German scholarship in the field in her recent The Sculpture of the Hellenistic Age (New York: Columbia University Press, 1955) with thorough combing of the professional literature and the best compilation of photographic material to be found. These studies concern themselves mainly with the historical career of Greek sculpture and incline to neglect its stylistic character and esthetic worth.

The ancient literary sources, both Greek and Latin, are collected in Johann Overbeck's Die antiken Schriftquellen zur Geschichte der bildenden Künste bei den Griechen (Leipzig, 1868) with critical comment but without translation of the texts. The excerpts which are to be found accompanied by an English translation in H. Stuart Jones's Select Passages from Ancient Writers Illustrative of the History of Greek Sculpture (Oxford, 1895) are useful but insufficient for serious study. The passages in Pliny dealing with Greek art have been compiled separately, together with an English translation, archaeological commentary, and extensive

critical introduction by K. Jex-Blake and Eugénie Sellers in The Elder Pliny's Chapters on the History of Art (London, 1896), which in spite of its antiquated date remains an important work.

The ancient inscriptions on statues and statuary bases, which supply many names of sculptors and often important indication of the nature and purpose of their works, were accurately reproduced and competently evaluated by Emmanuel Loewy in 1885 in his Inschriften griechischer Bildhauer; but the great increase of material resulting from more recent archaeological excavation has made this compilation distressingly incomplete. The lacunae will be filled by Jean Marcadé, whose Recueil des signatures de sculpteurs grecs is in course of publication (Paris: E. de Boccard, Livr. I, 1953; Livr. II, 1957).

On the technical side there are several outstanding treatises. From Stanley Casson's The Technique of Early Greek Sculpture (Oxford: Clarendon Press, 1933) and more especially Carl Blümel's Griechische Bildhauerarbeit (Jahrbuch des deutschen archäologischen Instituts, Ergänzungsheft XI [Berlin: de Gruyter, 1927]), more briefly presented in English in his Greek Sculptors at Work (1955), we may learn how Greek marbles were carved; from Volume I of Fr. Kluge and K. F. Hartleben, Die antiken Grossbronzen (3 vols.; Berlin: de Gruyter, 1927), we may learn how monumental Greek bronzes were cast; and from Alessandro della Seta's Il Nudo nell' Arte we may derive unparalleled understanding of anatomical rendering in Greek art.

Monographs on individual sculptors and specific sculptural works will be found listed below under the heading of the chapters in which they are discussed in the text.

### Chapter I

Page 3 The "menhir herm" is illustrated and discussed by Dorothy Burr (Thompson) in American Journal of Archaeology, XXXI (1927), 169–76.

Page 4 On the origin of Greek monumental sculpture cf. also Homann-Wedeking, Die Anfänge der griechischen Grossplastik.

Page 5 On Daedalid figurines consult R. J. H. Jenkins, Dedalica (Cambridge: Cambridge University Press, 1936).

Page 12 The New York kouros has been magnificently published by Gisela Richter in Brunn-Bruckmann-Arndt, Denkmäler griechischer Skulptur, Nos. 751–55.

### Chapter II

Page 30 On stereoscopic vision consult James J. Gibson, The Perception of the Visual World, pp. 12–76. My use of the terms "visual field" and "visual world" is borrowed from Gibson.

Page 36 The rendering of the ear in archaic sculpture is exhaustively considered by Gisela Richter in the course of her study of the kouroi.

Page 51 The Maidens of the Acropolis have been brilliantly evaluated and finely illustrated in Payne-Young, Archaic Sculpture of the Acropolis (2d ed., 1950) and given extraordinarily minute examination in the monumental collaboration, Schrader-Langlotz-Schuchardt, Die archaischen Marmorbildwerke der Akropolis (1939).

### Chapter III

Pages 61 ff. For Attic reliefs consult for the archaic period Gisela Richter, Archaic Attic Gravestones; and for the late fifth and fourth centuries Hans Diepolder, Die at-

tischen Grabreliefs (1931), and above all the monumental publication by Conze, Die attischen Grabreliefs (4 vols.; Berlin, 1893–1922).

Page 70 The leading work on the technical processes of ancient bronze casting for monumental sculpture is Volume I of Kluge-Hartleben, Die antiken Grossbronzen. There is a good brief discussion in Charbonneaux, Les bronzes grecs (Paris, 1955), chap. I. Most of the handbooks treat the technical aspect too summarily.

## Chapter IV

Page 100 For Polykleitos the monograph by R. Bianchi-Bandinelli in the series Quaderni per lo Studio dell'Archeologia, I. Policleto (Florence, 1938) collects everything of moment for the study of this master.

## Chapter V

Page 117 The material for the Zeus temple at Olympia is most conveniently accessible in the great publication of the German excavation of the site, Curtius-Adler, Olympia: Die Ergebnisse, etc., Vol. III, Georg Treu, Die Bildwerke (1897).

Page 125 On Greek architectural moldings consult the definitive treatise by Lucy T. Shoe, Profiles of Greek Mouldings (Cambridge, Mass.: Harvard University Press, 1936).

Page 135 I have discussed the authorship of the Lateran Marsyas in Observations on Familiar Statuary in Rome, Memoirs of the American Academy in Rome, XVIII (1941), 5–18.

Page 143 The sculpture of the Nike temple parapet, as much as had been recovered up to 1930, is illustrated and analyzed in my pamphlet under that title (Cambridge, Mass.: Harvard University Press, 1929). For the Maenad Base see p. 262, note to p. 136.

Page 145 The Pitcairn Nike is published in the second memorial volume to Oikonomos of the Athens Archaeological Society (Archaeologikē Ephēmeris, 1953–54, Rhys Carpenter, The Nike of Athena Parthenos, pp. 43–55), and more briefly in *Expedition* (Bul. of the University Museum of the University of Pennsylvania, II.1 [1959]), 34–37.

## Chapter VI

The most serviceable monographs on the leading fourth-century masters are:
for Praxiteles, G. E. Rizzo, Prassitele (Milan: Frat. Treves, 1932), and for individual works, Ch. Blinkenberg, Knidia (Copenhagen, 1933); Rhomaios, Der Knabe von Marathon (Antike Denkmäler IV, pp. 54–56 with plates 30–37); the literature on the Hermes of Olympia is too vast to be summarized here;
for Skopas, P. E. Arias, Skopas (Quaderni e guide di archeologia, 1 [Rome: Bretschneider, 1952]);
for Lypsippos, F. P. Johnson, Lysippos (Durham, N.C.: Duke University Press, 1927).

## Chapter VII

Page 181 On Kephisodotos and Timarchos consult M. Bieber, Die Söhne des Praxiteles, in Jahrbuch des Instituts, XXXVIII-IX (1923–24), 242 ff.

Page 181 On the school of Lysippos see M. Bieber, The Sculpture of the Hellenistic Age, pp. 39-42, 57, 72-73.

Page 182 A study by Herbert Maryon of the mechanical problems incident to the construction of the Colossus of Rhodes will be found in Volume LXXVI (1956) of the *Journal of Hellenic Studies*, pp. 68-86.

Page 185 For the passage in Pliny and for Xenokrates cf. Jex-Blake and Sellers, The Elder Pliny's Chapters on the History of Art, XXXV.153, and pp. xx-xxxvi.

Page 186 The best critical account of the choregic monument of Thrasyllos occurs in Ida T. Hill, The Ancient City of Athens; its Topography and Monuments (London: Methuen, 1953), pp. 108-10, with notes 7-9, pp. 234-35.

## Chapter VIII

Page 199 The sculpture discovered at Pergamon has been superbly published in volumes III.2 and VII, Altertümer von Pergamon (Königliche Museen zu Berlin): III.2, H. Winnefeld, Die Friese des groszen Altars; text in quarto, plates in folio (1906); VII, Franz Winter, Die Skulpturen, mit Ausnahme der Altarreliefs; 2 vols., text in quarto, 1 vol. plates in folio (1908). For the frieze of the Zeus altar, H. Kähler, Der grosse Fries von Pergamon (Berlin: Geb. Mann, 1948), is very satisfactory.

Page 203 On the date of the Victory from Samothrace cf. especially H. Thiersch, Die Nike von Samothrake, in Nachrichten der Ges. der Wissensch. zu Göttingen (Ph.-H. Klasse, 1931), pp. 336-78.

Page 207 Baroque feminine drapery has been studied and illustrated by Rudolf Horn in his monograph, Stehende weibliche Gewandstatuen in der hellenistischen Plastik (Ergänzungsheft II to Mitteilungen des deutschen archaeologischen Instituts, Römische Abteilung [Munich: Bruckmann, 1931]).

Page 212 The inscribed basis of the Aphrodite of Melos was published and discussed, together with much else pertinent to the statue, by Adolf Furtwängler in his chapter on the Venus of Milo in Masterpieces of Greek Sculpture (trans. Eugénie Sellers; London: Heinemann, 1895), pp. 367-401. Cf. also J. Charbonneaux, La Vénus de Milo (Opus Nobile, 6; Paris, 1958).

Page 213 Demeter from Knidos: the arguments for a fourth-century date are presented by Bernard Ashmole in *Journal of Hellenic Studies*, LXXI (1951), 13-28.

Pages 214 f. Maussolos: not mounted on a chariot: J. B. K. Preedy, in *Journal of Hellenic Studies*, XXX (1910), 133-62; to be restored with scepter and sword: Fr. v. Lorentz, "Maussollos" und die Quadriga auf dem Maussolleion zu Halikarnass (Ph.D. dissertation, University of Leipzig, 1931). For a stylistically correct mid-fourth-century portrait statue of a standing man cf. Lullies-Hirmer, Greek sculpture, plates 252-53, the so-called Hippocrates from Cos.

Page 217 On anatomical characteristics of the feminine nude in Greek sculpture consult the analyses under the various examples in Alessandro della Seta, Il Nudo nell' Arte (Milan, 1930). Della Seta's exposition of the *Borghese Warrior* is extremely professional.

Pages 224 f. The case for a second-century date for the *Laokoon* has been most recently advocated by Gisela Richter in Three Critical Periods in Greek Sculpture (Oxford: Clarendon Press, 1951), pp. 67-70. The quotation anent the original tridimensional composition of the group is taken from Seymour Howard's article On the Re-

construction of the Vatican Laokoon Group, in *American Journal of Archaeology*, 63 (1959), 365–69.

## Chapter IX

The literature on Greek portrait sculpture is very extensive. Among the leading handbooks may be mentioned:

A. Hekler, Greek and Roman Portraits (London: Heinemann, 1912);

——, Bildnisse Berühmter Griechen (2d ed.; Berlin, 1942);

R. P. Hinks, Greek and Roman Portrait-sculpture (London: British Museum, 1935);

L. Laurenzi, Ritratti greci (Florence: Sansoni, 1941);

K. Schefold, Die Bildnisse der antiken Dichter, Redner, und Denker (Basel: Schwabe, 1943); and the monumental series of annotated photographic reproductions, Arndt-Lippold, Griechische und römische Porträts (Munich: Bruckmann, 1891–1942).

Among the more important monographs may be listed:

Plato: R. Boehringer, Platon, Bildnisse und Nachweise (Breslau: F. Hirt, 1935);

Alexander the Great: Margarete Bieber, The Portraits of Alexander the Great, in *Proceedings of the American Philosophical Society*, XCIII (1949), 373–427;

"Menander"-Vergil: J. F. Crome, Das Bildnis Vergils (R. Accademia Virgiliana di Mantova. Atti e Memorie, 1935);

Homer: E. and R. Boehringer, Homer, Bildnisse und Nachweise (Breslau: F. Hirt, 1939);

late Hellenistic portraits: C. Michalowski, in Volume XIII, Exploration archéologique de Délos (École Française d'Athènes, 1932).

For Sokrates consult M. Bieber, The Sculpture of the Hellenistic Age, pp. 44–46, with accompanying notes.

For portraits on Greek coins: Kurt Lange, Herrscherköpfe des Altertums im Münzbild ihrer Zeit (Zurich: Atlantis-Verlag, 1938); G. H. Hill, l'Art dans les monnaies grecques (published with English text as Select Greek Coins [Paris: Vanoest, 1927]).

Page 235   For plastic as opposed to glyptic portraits cf. Memoirs of the American Academy in Rome, XVIII (1941), 75–79.

Page 248   The Maid of Chios: L. D. Caskey, Catalogue of Greek and Roman Sculpture in the Museum of Fine Arts, Boston (Cambridge, Mass.: Harvard University Press, 1925), 71–77; Antike Denkmäler II, text to plate 59.

## II. ILLUSTRATIVE MATERIAL

The purpose of the following bibliography is to supply references to easily accessible illustrations of good quality for the sculpture referred to in the text but not reproduced in the plates.

The following abbreviations have been employed:

Ant. Dnk.   Antike Denkmäler, Kaiserlich Deutsches Archaeologisches Institut (Berlin, 1891–1931).

Bieber   Margarete Bieber, The Sculpture of the Hellenistic Age (New York: Columbia University Press, 1955).

Br.Br.   Brunn-Bruckmann-Arndt-Lippold, Denkmäler griechischer und römischer Skulptur (Munich, 1888–1947).

Bu.   Ernest Buschor, Die Plastik der Griechen (rev. ed., Munich, 1958).

# GREEK SCULPTURE

Ch.A.      Jean Charbonneaux, La sculpture grecque archaique (Paris: Editions de Cluny, n.d.).

Ch.Cl.I    Jean Charbonneaux, La sculpture grecque classique, Vol. I (Paris: Editions de Cluny, 1943).

Ch.Cl.II   the same, Vol. II (Lausanne: Guilde du Livre, n.d.).

Diep.      Hans Diepolder, Die attischen Grabreliefs des 5. und 4. Jahrhunderts v. Chr. (Berlin, 1931).

Hdbk.      G. M. A. Richter, A Handbook of Greek Art (London: Phaidon Press, 1959).

Hekler     Anton Hekler, Greek and Roman Portraits (London: Heinemann, 1912).

Horn       Rudolf Horn, Stehende weibliche Gewandstatuen in der hellenistischen Plastik (Ergänzungsheft II to Mitteilungen des deutschen archaeologischen Instituts, Römische Abteilung [Munich: Bruckmann, 1931]).

Kouroi     G. M. A. Richter, Kouroi (New York: Oxford University Press, 1942).

Laur.      L. Laurenzi, Ritratti greci (Florence: Sansoni, 1941).

Lawrence   A. W. Lawrence, Later Greek Sculpture (New York: Harcourt, Brace & Co., 1927).

Lullies    Lullies-Hirmer, Greek Sculpture (New York: Abrams, 1957).

Matz       Matz, Geschichte der griechischen Kunst I: Die geometrische und die früharchaische Form (Frankfurt a/M., 1950).

Payne      Humfry Payne and Gerard Mackworth-Young, Archaic Marble Sculpture from the Acropolis (New York: Wm. Morrow & Co., 1950). An earlier edition with somewhat better reproduction of the plates was published by the Cresset Press, London, in 1936.

Perg. VII  Altertümer von Pergamon, Königliche Museen zu Berlin, Vol. VII, Franz Winter, Die Skulpturen, mit Ausnahme der Altarreliefs (Berlin, 1908).

Schefold   Kurt Schefold, Die Bildnisse der antiken Dichter, Redner, und Denker (Basel: Schwabe, 1943).

sw '50'    J. Sieveking and K. Weickert, Fünfzig Meisterwerke der Glyptothek König Ludwigs I (Munich, 1928).

TEL III    Encyclopédie Photographique de l'Art, Vol. III, the Louvre (Paris: Editions "TEL," 1938).

Zervos     Zervos, l'Art en Grèce (Paris: Edition Cahiers d'Art, 1946).

It should be noted that archaic Attic sculpture has been exceptionally well published by Payne and by Schrader, Langlotz, and Lippold, Die archaischen Marmorbildwerke der Akropolis (1939); cf. also Langlotz-Schuchardt, Archaische Plastik auf der Akropolis (1943). In general, the best miscellanies of illustrations of well-known pieces are to be found in Lullies, TEL III, Zervos, and the chapter on sculpture in Richter's Handbook.

PAGE

5   Nikandre: Br.Br. 57a; Matz pl. 78; Hdbk. fig. 54.
    "Lady from Auxerre": Lullies pl. 6; TEL III, p. 133; Matz pl. 79; Hdbk. fig. 55.
14  The Dipylon Head: Matz pls. 96–98; Zervos figs. 132–34; Ch.A. pl. 6; Hdbk. fig. 50.
15  Branchidai: Br.Br. 141–43.
16  Colossus of Delos: Matz pls. 112–13; Kouroi pl. XXII; (the inscription, ibid., p. 85).
19  Hera of Samos: Br.Br. 56; TEL III p. 144; Lullies pls. 30–31; Ch.A. pl. 28; Hdbk. fig. 65.
24  The Calf-bearer: Br.Br. 6; Payne pls. 2–4; Lullies pls. 22–23; Ch.A. pls. 12–13; Hdbk. figs. 68–69.

# Bibliography of Sources

PAGE

25  Horsemen from the Acropolis: Payne pls. 133–40.

34  Zeus with Ganymede: Lullies pls. 102 and (in color) 103; Hdbk. fig. 111.

44  Apoxyomenos of the Vatican: Br.Br. 281, 487; Hdbk. fig. 200; Bieber figs. 74–75.

48  Sunium Twins: Ant. Dnk. IV pls. 47–56; Kouroi pls. IX–XI; Matz pls. 105–9; Ch.A. pl. 7.

Theran *kouros:* Br.Br. 77c; Kouroi pls. XXXVI–XXXVIII.

*Kouros* from Volomandra: Kouroi pls. XLIII–XLV; Hdbk. fig. 61; Bu. p. 33.

Tenean *kouros:* sw '50' pls. 4–5; Lullies pls. 34–36; Hdbk. fig. 60; Br.Br. 1.

*Kouros* from Keos: Kouroi pls. XCIV f.

"Theseus" of the Acropolis: Payne pls. 105–6.

"Later" *kouroi:* Payne pls. 97–98, 108.

53  "Peplos *korē*": Payne pls. 29–33; Lullies pls. 41–43; Hdbk. figs. 86–88; Ch.A. pls. 26–27.

The "Samian Women": Payne pls. 18–20.

54  Furtwängler's Athena Lemnia: Br.Br. 793–94; Ch.Cl.I pls. 37, 40; Furtwängler, Masterpieces of Greek Sculpture, frontispiece and pls. II, II*, III.

Dancing Women from Herculaneum: Br.Br. 294–95; Ch.A. pl. 109.

"Aspasia," Hdbk. fig. 122.

54 f.  Rampin Head and Horseman: Payne pls. 11a–11c, 133; Lullies pls. 28–29; TEL III pp. 138–39; Ch.A. pls. 16–19.

55  Antenor's *korē*: Payne pls. 51–53; Bu. p. 45; Zervos fig. 261; Hdbk. fig. 89.

59  "metope" fragments from Mycenae: Lullies pl. 7; Bu.p. 21; Ch.A. pl. 21.

early metopes from Poseidonia: P. Zancani-Montuoro and U. Zanotti-Bianco, Heraion alla foce del Sele (Rome, 1951–54).

61  Painted metopes from Thermon: Ant. Dnk. II pls. 50–52; Matz pls. 157–59.

68  Dreros bronzes: Matz pl. 80a; Kouroi pl. IV, fig. 11.

80  Tyrannicides: Br.Br. 326–28; Ch.A. pl. 86; Hdbk. fig. 117.

89  The "Pouting Girl": for other views of the statue see especially Payne pls. 84–88 and Zervos pls. 267–68.

90  The blond "Brother": for other views of this head see especially Payne pls. 113–15 and Zervos pls. 282–84.

95  Kritios Boy: for the entire statue see Payne pls. 109–12; Lullies pls. 85–87; Ch.A. pls. 84–85.

100  "Omphalos" Apollo: Br.Br. 42; Zervos pl. 309; Hdbk. figs. 115–16.

102  Doryphoros of Polykleitos: extensive illustrative material in Bianchi-Bandinelli, Policleto (Quaderni I).

107  The relief from Argos: *ibid.*, pl. V, fig. 31.

111  Herakles and Hydra pediment: Br.Br. 16.

Siphnian Treasury pediment: Zervos pls. 163, 165–67; Ch.A. pls. 38–39; Hdbk. fig. 104.

Corfu pediment: Lullies pls 14–17; Zervos pls. 135–42; G. Rodenwaldt, Korkyra II.

114  Aegina Pediments: Furtwängler, Aegina; sw '50' pls. 7–14; Lullies pls. 69–73, 78–83.

117  Zeus temple at Olympia: E. Curtius and F. Adler, Olympia: Die Ergebnisse, III (Treu); E. Buschor and Hamann, Die Skulpturen des Zeustempels zu Olympia (Marburg); G. Rodenwaldt and Hege, Olympia (2d ed.; Berlin: Deutscher Kunstverlag, 1937); Lullies pls. 105–23; Zervos pls. 290–98; Ch.A. pls. 100–8.

# GREEK SCULPTURE

PAGE

125 For Greek architectural moldings consult any handbook of Greek architecture, but more particularly Lucy T. Shoe, Profiles of Greek Mouldings.

135 Lateran Marsyas: Arias, Mirone figs. 17–24; Memoirs of the American Academy in Rome, XVIII (1941), pls. 2–3, 5–6; Hdbk. fig. 134.

136 Nike temple parapet: Rhys Carpenter, The Sculpture of the Nike Temple Parapet; Ch. Picard, L'Acropole: l'Enceinte, etc. (Paris: Morancé, 1929).
Maenad Base: G. Caputo, Lo scultore del grande bassorilievo con la danza delle menadi (Rome: L'Erma, 1948); A. Rizzo, Thiasos: Ch.Cl.II pl. 29; Lawrence pl. 84; Hdbk fig. 157.

137 Parthenon pediments: A. H. Smith, The Sculptures of the Parthenon (London: British Museum, 1910); Lullies pls. 140–69; Ch.Cl.I pl. 88, 90–91, 93–94, 96–99.

142 Ludovisi "Throne": Ant. Dnk. II pls. 6–7; Lullies pls. 132–35; Ch.A. pls. 95–97; Hdbk. figs. 124–25.

143 Vénus de Fréjus: Hans Schrader, Phidias, figs. 283, 285, 287, 299, 301, 311; TEL III p. 176; Ch.Cl.II pl. 18; Br.Br. 473.
Eirene of Kephisodotos: sw '50' pl. 20; Hdbk. fig. 184; Br.Br. 43.

144 Mourning Athena relief: Br.Br. 783; Lullies pl. 137; Ch.A. pl. 94; Hdbk. fig. 127.
Pitcairn Nike: Archaeologikē Ephēmeris, (1953–54), II, 41–54, pls. I–II; Expedition (Bul. University Museum, University of Pennsylvania), II.1 (1959), 34–36.

152 Ares Borghese: TEL III p. 179; Ch.Cl.II pl. 19; Br.Br. 63.
Mattei Amazon: Br.Br. 350.
Lansdowne Amazon: Hdbk. fig. 160; the Berlin version: Br.Br. 348; Ch.Cl.II pl. 8.
Gravestone of Hegeso: Br.Br. 436; Lullies pl. 185; Ch.Cl.II pl. 57; Bu. p. 78; Diep. pl. 20.

156 Maenad reliefs: see above, under p. 136.

159 Pedimental sculpture from Epidauros: J. F. Crome, Die Skulpturen des Asklepiostempels von Epidauros (Berlin: de Gruyter, 1951); Br.Br. 19–20; Ch.Cl.II pls. 62, 63, 75; Hdbk. figs. 182–83.

161 Polykleitan statues: Bianchi-Bandinelli, Policleto, pls. V–XII.
Standing Diskobolos: Br.Br. 682–85; cf. TEL III p. 178.

162 Agias: Hdbk. fig. 201; Bieber fig. 76; Laur. no. 37, pl. XIII.

163 Ares Borghese: see above, under p. 152.

165 Poseidon of Artemision: for other views cf. Lullies pls. 128–31; Ch.A. pls. 111–12; Hdbk. figs. 118–19.

166 Lateran Marsyas: for other views cf. above, under p. 135.

168 Nereids: Br.Br. 211–13; Ch.Cl.II pls. 38–40.

169 Apoxyomenos by Lysippos: Br.Br. 281, 487; Bieber figs. 74–75; Hdbk. fig. 200.

171 Hermes of Olympia: reproductions are legion. Among the best—Rodenwaldt-Hege, Olympia, pls. 85–91; Lullies pls. 220–23.
Boy from Marathon Bay: Ant. Dnk. IV pls. 30–37; Lullies pls. 210–12.

173 Demeter from Knidos: see below, under p. 213.

174 Knidian Aphrodite: Blinkenberg, Knidia; Bieber figs. 24, 25, 29; Ch.Cl.II pls. 98–99; Hdbk. fig. 187.

175 "Lizard-slayer" (Sauroktonos): Br.Br. 234; TEL III p. 190; Ch.Cl.II pls. 95–96; Bieber fig. 18; Hdbk. fig. 185.

PAGE

Capitoline Satyr: Br.Br. 377; the torso in the Louvre—Br.Br. 126–27; TEL III p. 191; Bieber fig. 16.

176 Stele from the Ilissos: Lullies pl. 218; Diep. pl. 48; Br.Br. 469; Bieber fig. 69; Hdbk. fig. 217.

178 Artemis from Gabii: Ch.Cl.II pls. 101, 103; TEL III p. 187; Br.Br. 59; Hdbk. fig. 186. Artemis of Versailles: TEL III pp. 198–99; Br.Br. 420; Bieber fig. 201.

179 Alexander sarcophagus: O. Hamdy-Bey and T. Reinach, Une nécropole royale à Sidon (Paris: Leroux, 1892).

181 Demosthenes of Polyeuktos: Bieber figs. 214–29; Hekler pls. 56–57; Hinks fig. 6b; Schefold p. 107. Fortune of Antioch (Tyche by Eutychides): Br.Br. 154; Bieber fig. 102; Hdbk. fig. 222. Fanciulla d'Anzio: Br.Br. 583–84; Lullies pls. 232–33; Bieber figs. 97–100. Conservatori Seated Girl: Bieber fig. 101; Lawrence pl. 23a; H. Stuart-Jones, Sculptures of the Palazzo dei Conservatori, pl. 53.

182 Praying Boy: Br.Br. 283; Bieber fig. 93.

183 Ares Ludovisi: Br.Br. 388; Ch.Cl.II pl. 83; Bieber fig. 103. Dancing Satyr: Br.Br. 769; Bieber figs. 95–96. Silenus with Infant Dionysos: sw '50' pl. 26; TEL III pls. 232–33; Br.Br. 64. Listening Dionysos: Br.Br. 384. Hypnos: Br.Br. 529 (the British Museum head, Br.Br. 235).

184 Aphrodite Kallipygos: Br.Br. 578.

186 Dionysos of Thrasyllos: Br.Br. 119; Bieber fig. 213.

187 Head of Arsinoe in Mantua: Bieber figs. 354–55. Berenice of Cyrene: Bieber figs. 346–47; Laur. no. 71, pl. XXV–XXVI. Head of Berenice in Naples: Br.Br. 385. Ptolemy and Arsinoe: L. D. Caskey, Catalogue of Greek and Roman Sculpture in the Museum of Fine Arts, Boston, pp. 121, 123. Bronze head of a girl: Caskey, Catalogue, pp. 118–19.

188 Seated Poseidippos: Hekler pls. 110a, 111a; Laur. No. 107, pls. XLII–XLIII; Schefold p. 111. Seated Chrysippos: Bieber figs. 238–42; Schefold p. 127.

191 Pergamenian copies of Attic sculpture: Perg. VII pls. 2–9.

193 Dying Trumpeter: Br.Br. 421; Bieber figs. 426–27; Hdbk. fig. 231; cf. fig. 232 for the similar Dying Gaul. Suicidal Gaul and Wife: Br.Br. 422; Bieber figs. 281–83, 424; Hdbk. fig. 230.

194 Baker Dancer: American Journal of Archaeology, 54 (1950), 372, 373, 378; Bieber figs. 378–79; Bu. p. 104.

196 Aphrodite by Doidalsas: Br.Br. 434; TEL III pp. 228–29; Bieber figs. 290–93; Hdbk. fig. 224.

199 The Gigantomachy frieze from the altar of Zeus in Pergamon: Perg.III.2; Heinz Kähler, Der grosse Fries von Pergamon (Berlin, 1948); Lullies pls. 238–47; Bieber figs. 458–70.

205 Tragoidia: Perg.VII pls. XIV–XV; Horn pl. 18². Muses: Bieber figs. 497–502; Hdbk. fig. 249.

# GREEK SCULPTURE

PAGE

Draped Statues from Magnesia: Humann-Kohte-Watzinger, Magnesia am Maeander (Berlin: Königl. Museen zu Berlin, 1904).

Baroque draped women from Pergamon and elsewhere: Horn pls. 19, 21, 28, 29, 31, 38; Perg.VII pls. XX–XXI, Beiblatt 9, 10, 11, 13; Bieber figs. 510–15, 519–21.

209 Priene altar relief: Horn pl. 26[1].

Delian Cleopatra: Bieber fig. 511; Explor. arch. de Délos, VIII, fig. 95; Bu. p. 114.

210 "Drapery through drapery": Laur. nos. 98–99, pl. XXXIX.

211 Aphrodite of Melos: Lullies pls. 254–55; TEL III pp. 200–3; Bieber figs. 673–77; Hdbk. fig. 229.

212 Poseidon of Melos: Br.Br. 550; Bieber fig. 684; Hdbk. fig. 228.

213 Demeter from Knidos: a series of excellent photographs in *Journal of Hellenic Studies*, LXXI (1951), pls. I–VII, XI; also Lullies pls. 216–17; Hdbk. fig. 209.

Seated Goddess in Berlin: Ant. Dnk. III pls. 37–44; Lullies pls. 93–97; Hdbk. fig. 96.

214 "Artemisia": Br.Br. 242; Bieber fig. 249. For a comparable drapery style cf. Perg.VII, Beiblatt 14 (early first century B.C.?).

215 Head from Maussoleion site: Bieber fig. 73.

216 Portrait heads of Persian satraps: Bieber figs. 243–44, 247–48.

"Walking Hero": Perg.VII pl. 35; Horn pl. 20[1].

218 "Bell-shaped" draped women: Bieber figs. 511, 521; Horn pl. 41.

219 Agasias' Warrior: TEL III pp. 263–65; Bieber figs. 686, 688–89; Br.Br. 75.

Uffizi Wrestlers: Br.Br. 431; Bieber fig. 267.

221 Barberini Faun: sw '50' pls. 38–39; Lullies pls. 234–35; Bieber figs. 450–51; Br.Br. 4.

222 Suicidal Gaul: see above under p. 193.

223 Laokoon: Bieber, Laocoon: The Influence of the Group since its Rediscovery (New York: Columbia University Press, 1942), contains a series of fine photographs by Ernest Nash (not too well reproduced); Lullies pls. 262–63; Bieber figs. 530–33. Bandinelli's copy: Bieber, Laocoon, pl. 4.

224 Menelaos and Patroklos: Br.Br. 346; Bieber figs. 272–77.

225 Belvedere Torso: Br.Br. 240; Hdbk. fig. 236.

Seated Boxer: Ant. Dnk. I pl. 4; Lullies pls. 259–61; Br.Br. 248; Hekler pls. 85–86.

"Hellenistic Ruler": Ant. Dnk. I pl. 5; Lullies pls. 250–51; Bieber figs. 682–83, 685; Hekler pls. 82–84; Br.Br. 246.

226 Frieze of Artemis temple in Magnesia: TEL III pp. 250–51; Bieber figs. 702–3; E. Herkenrath, Der Fries des Artemisions von Magnesia (Berlin, 1902). Cf. also the altar reliefs: A. v. Gerkan, Der Altar des Artemis-Tempels in Magnesia (1929).

Frieze from Lagina: A. Schober, Der Fries des Hekateions von Lagina (Baden bei Wien, 1933); some specimen slabs in Bieber figs. 704–7.

Horologion in Athens: I know no adequate publication of the frieze.

Telephos frieze: Perg.III.2 pls. XXXI–XXXVI.

Dancing Girl relief: Perg.VII pl. XXXVIII; Ant. Dnk. II pl. 35; Bieber fig. 479.

229 Herm of Perikles: Ch.Cl.II pl. 7; Hekler pl. 4; Laur. no 11, pl. III; Hinks, Greek and Roman Portrait-sculpture (London: British Museum, 1935), fig. 1; Hdbk. fig. 155.

230 Sokrates: Bieber figs. 125–39; Hekler pls. 19–21; Laur. no. 16, pl. V; no. 39, pl. XV; Schefold pp. 69, 83, 85.

# Bibliography of Sources

PAGE

Silanion's Plato: R. Boehringer, Platon, Bildnisse und Nachweise; Bieber figs. 112–19; Hekler pls. 22–23; Laur. nos. 20, 21, pl. VI; Schefold p. 75.

231 Corinna in Compiègne: Bieber figs. 120–22.

232 Alexander the Great: Bieber, The Portraits of Alexander the Great, in *Proceedings of the American Philosophical Society*, XCIII (1949), 373–427; *Journal of Hellenic Studies*, LXXI (1951), pls. XIa, XIb, XIIa, XIIc; Perg.VII pl. XXXIII; Hekler pls. 59–64; Laur. nos. 38, 40, 41, 85, 86, 87.

244 Head of Arsinoe in Mantua: Bieber figs. 354–55.

246 "Pseudo-athlete": Exploration archéologique de Délos, XIII, pls. XIV–XIX, figs. 11 f.; Lawrence pls. 57, 58a; Hekler pl. 127b.

247 Homer: E. and R. Boehringer, Homer, Bildnisse und Nachweise; Schefold pp. 143, 145; Laur. no. 113, pl. XLV; TEL III p. 247; Bieber figs. 598–99; Hdbk. fig. 242.

"Hesiod": Hekler pls. 119–20; Schefold pp. 135, 137; TEL III p. 246; Bieber figs. 596–97.

Epicurus: Hekler pls. 100–1; Laur. no. 65, pl. XXIV; Bieber figs. 159–66, 171; Schefold p. 119.

248 The "Beautiful Head": Perg.VII pl. XXV, Beiblatt 15; Br.Br. 159; Lawrence pl. 44; Bieber fig. 475.

Maid of Chios: Ant. Dnk. II pl. 59; Lullies pls. 228–29; Hdbk. fig. 195; Caskey, Catalogue, pp. 72, 73, 75.

253 Nymph and Satyr: Br.Br. 731–32; Bieber figs. 626–27; TEL III p. 239.

Uffizi Wrestlers: see above, under p. 219.

# Topical Index

*(Unless otherwise noted, references are to page numbers)*

Achillean statues, 245 f.

Aegina: early relations with Egypt, 15; not addicted to sculpture in marble, 15; important bronze foundry in, 15, 115, 119; pedimental sculpture from Aphaia temple in, 113, 114–16, 117, 119; statuary plundered by Pergamon, 190

Agasias' Warrior ("Borghese Fighter"), 219–21

Agias. *See* Lysippos

Alexander sarcophagus, 179

Anatomy of the feminine nude, 216–18, 258 (n. to p. 217)

Anatomy of the male nude: in the archaic phase, 40, 42–44, 46–48, 137 f., 256; in fifth-century canonic form, 43 f., 138; in fourth century, tempered to naturalism, 44 f.; in third-century naturalistic style, 182, 184, 196; in second-century "realism," 219–22; in first-century "neo-Polykleitan" style, 225

Anavysos. *See* Kouroi

Aphrodite: of Cyrene, Pl. XXXVI, 196 f., 217; Kallipygos, 184; of Knidos, Pl. XXXIX A, 172, 174, 197, 212, 217; Medici, Pl. XLII, 217; of Melos, Pl. XXXIX B, 172, 211 f., 258 (n. to p. 212)

Apoxyomenos. *See* Lysippos

ARCHAIC SCULPTURE: archaic phase, Chap. II, 27–58

quadrifrontality, source of, 11 f., 37 f.

realistic ambitions in, 23 f., 46–48, 87 f.; *vs.* unrealistic attainments in, 13, 27, 46

linear, without spatial depth, 12, 46, 47, 54, 124

schematic patterns: their superficial application in, 36–38, 98; their mutual isolation in, 40; their importance for style in, 45; in drapery, 20 f., 37, 51–54; in representation of hair, 48–50

decorative effect: source of, 39, 54; emphasis on, 54 f.; decline of interest in, 55

diffusion of archaic technique, 14–17

dissolution of archaism, 56–58, 86–91

survivals in later styles, 98

Architecture: architectural *vs.* sculptural space, 121; close connection with sculpture, 109; moldings, relation of profile to pattern in, 125 f., 257 (n. to p. 125); tectonic appeal: in the Greek orders, 41; in Greek sculpture, 41, 44; in Greek vases, 42 f.

Ares Borghese, 152, 163

Ares Ludovisi, 183 f.

Ares of the Parthenon east pediment, 137, 163

Aristion, stēlē of, Pl. VIII, 61 f., 63–65

"Artemisia," a late-Hellenistic work, 214 f., 264 (n. to p. 214)

Artemision, bronze statue from, Pl. XXX, 165, 173

Auxerre, "Lady" from, 5

axial rotation, 164 f.

Balance: "living balance" *vs.* material equilibrium, 82, 103 f.; its inception in the early fifth century, 104; its perfection in the Doryphoros, 105; responsible for chiastic composition, 106–8; so-called Attic stance, 163

Ballplayer, Pls. XXVIII–XXIX, 44, 161 f., 163, 170 f., 173

Barberini Faun, 221 f.

Baroque, in second-century styles, 208 ff.

Bassai, frieze from, 175 f.

Blond Boy: head of, Pl. XII A, 90–92; numerical canon, 94 f.; compared to Apollo of Olympia pediment, 119

Branchidai, 15

BRONZE:

Greek monumental bronzes: not a primary sculptural form in Greece, 66 f.; at first hammer-beaten, 67 f.; not dependent on clay models, 66, 75, 79; but glyptic in essential character, 67; being derived from wooden models, 68 ff., 70, 73 f., 78 f.; assembled from piece-castings, 70, 73 f., 78 f.; similarity to statues in marble, 79; differences, 66 f., 79, 97; freedom of pose, 80 f.; adaptation of pictorial themes, 81 f.

specific bronze statues discussed: *see* Ballplayer, Delphi Charioteer, Diskobolos, Marathon Bay, Marsyas, Praying Boy, Hermes (Seated)

fourth-century bronze-casters, 161, 170 f.; Polyeuktos, 181; sons of Praxiteles, 181; school of Lysippos, 181–84

technique of bronze-casting, 71–79, 257 (n. to p. 70); cast work *vs.* cold work, 69; bronze accessories to marble sculpture, 115 f., 137

location of leading foundries, 15, 119

Calf-bearer, 24

Canon (*see also* Symmetria): of the male nude, 44; in early fifth-century heads, 93–96; in entire statues, 99; of Polykleitos, 100–2, 107, 162

Catenary, 140–44, 177

Charioteer. *See* Delphi

Cheramyes. *See* "Hera of Samos" under Samos

Chiasmus: in static pose, not in the Diskobolos, 105 f.; fully developed in the Doryphoros, 105 f.; in dynamic poses, 167

Chios, Maid of, 248 f., 259 (n. to p. 248)

CLASSICISM:

the classic manner, 43–45, 108, 135, 162, 208

in anatomy, 43 f.

in drapery, 151. *See also* Drapery

as idealism, 98

High Classic: compared with Formal Classic, 152; examples cited: Ares Borghese, 152; Hegeso, 152; Lansdowne Amazon, 152; Boston Cybele, 153–55; Boston Leda, 155 f.; Maenad Base, 157–59; flamboyant or florid phase, 158 f.

subversion to naturalism during third century, 182, 184, 188 f., 196

renascence of classic formal devices in second century, 198–200, 203, 205–7

Color in Greek sculpture: applied by wax stain on marble, 50 f., 54, 56 f., 62 f., 97; by metal inlay and gilding on bronze, 74; by adding bronze accessories to marble statues, 115 f., 137

Colossi, 16, 194

Composition: archaic, 111; fifth-century formal, 249 f.; centrifugal, 220; chiastic, 105 f., 167; closed, 188; torsional, 182–84, 201, 212; pedimental, 111, 115 f., 119–21, 127 f. *See also* Groups

Copies of Greek statues: at Pergamon, 191; how made, 191 f.; from plaster casts, 192 f.; character in Roman times, 66, 192

Cybele ("Colossal"), in Boston, Pl. XXV, 153–55

Daedalid figurines, 5; hammer-driven in bronze, 68; influence on earliest korē type, 22

Delphi Charioteer, Pl. X, 76, 85, 97
Demeter of Knidos, Pl. XL, 173, 213 f., 258 (n. to p. 213)
Dexileos grave-relief, Pl. XXII, 142, 176
Didyma, statues along Sacred Way, 15, 19
Diffusion of archaic sculpture, 16
Dionysos of Thrasyllos, 186, 258 (n. to p. 186)
Dioskuros of Monte Cavallo, Pl. XLVII B, 44
Dipylon head, 14
Diskobolos of Myron, Pl. IX, 82–85, 105, 165, 167, 173, 251
Doidalsas, 196
Doryphoros of Polykleitos, Pls. XIII–XIV, 10, 100, 102, 105–8, 157, 161–64, 167
DRAPERY:
    archaic, evolved out of Daedalid proto-types, 22; stylistic character of, 20 f., 51–55, 89 f.
    in the Olympia pediments, 130–32; line-ar vs. solid forms, 124, 127 f., 128 ff.
    on Myron's Drunken Hag, 134 f.
    on the Stumbling Niobid, 132–34
    in the Parthenon pediments, 138, 140, 142, 145 f., 148 f., 151
    fifth-century formal devices: catenaries, 140–44; modeling lines, 132, 135, 150 f.; motion lines, 144–50, 178; ribbon drapery, 151; transparency, 139 f.
    fourth-century mannerisms, 177–79
    second-century styles, 205–11, 216, 217 f., 258 (n. to p. 207); determination of date, 208 f.

Egypt: Greek contact with, 7, 10, 11 f., 13; source of Greek technical knowledge of statuary, 7, 10 f., 13, 15 f., 18, 21; relief, its pictorial character, 60; stone statuary: its religious function, 7, 19; its technique of manufacture, 9, 12, 13, 20
Eyes in Greek statuary art: in bronze heads, inserted from within 73 f.; in marble heads, indicated in wax paint, 97; occasionally inserted as in bronzes, 97

Figurines: solid, in clay or bronze, modeled freehand, 6; influence on monumental sculpture, 22, 24; hammer-beaten, 68; hollow, in clay, from molds, 6, 194; in-fluenced by monumental sculpture, 6, 210; hollow-cast bronze, in monumental style, 194 f.
Frontality: frontal aspects recorded by ar-chaic sculpture, 36. See also Quadrifacial-ity

Gauls, statues of. See Pergamon
Grave-reliefs. See Relief
Groups in Greek sculpture: composition by mere juxtaposition, 249 f.; "metope" compositions of freestanding statues, 251; no unitary stereomorphic composi-tion until the second century, 252; sym-plegmata, 253; various Hellenistic groups, 219, 223 f., 253

Hegeso grave-relief, 152, 175
"Hellenistic Ruler," Pls. XLVI B, XLVII A, 225, 246
"Hera of Samos." See Samos
Hermes of Praxiteles, 171, 175; Seated Hermes, from Herculaneum, Pl. XXXIV, 182 f., 184, 251
Herodotus, on Egypt, 11 f., 15
Homer, portrait of, 247
Horsemen, statues of, 25 f., 55
Horses, in Greek sculpture, 25 f.
Horse-tamers of Monte Cavallo, Pl. XLVII B, 44

Idealism in Greek sculpture: its origin in technical procedure, 98 f; its connection with integral ratios, 99 f. See also Canon

Knidian Aphrodite. See Praxiteles
Knidos, Seated Demeter from: a fourth-century original, 172 f.; an early first-century creation, 213 f.
KORAI:
    at first, stylistically less advanced than the kouroi, 20–22

KORAI—*Continued*
as dedications to divinities, 19, 22, 51
treatment of drapery, 20 f., 50–54, 55
Antenor's *korē*, 55
Euthydikos *korē* ("Little Pouting Girl"),
Pl. XI, 51 f., 89
Lyons *korē*, Pl. IV, 21, 51 f., 139
other *korai*, 89
KOUROI:
Egyptian connections. *See* "Egypt"
archaic, as grave-markers, 19, 22
adapted to athletic and religious themes
19 f.
specific examples studied: Anavysos, Pls.
V–VI, 46 f.; Blond Boy, Pl. XII A,
90–92, 94 f., 119; Kritios Boy, Pl.
XII B, 67, 95–97, 103 ff.; New York
*kouros*, Pls. II–III, 12–14, 22, 46 f.;
Volomandra, 48, 50; other *kouroi*
briefly characterized, 48, 104

Laokoon group, 222, 223; its Pergamenian
style and probable second-century date,
224 f., 258 (n. to p. 224)
Leda with the Swan, Pl. XXVI, 155 f.
Lyons *korē*. *See* Korai
Lysippan School, 181–85, 258 (n. to p.
181); Xenokrates records its history, 185,
258 (n. to p. 185)
Lysippos: Agias, 162 f.; Apoxyomenos, 44,
169, 173 f.; anatomic canon, 163, 184;
torsional poses, 169, 183

Maenad Base, Pl. XXVII, 156–59
Maid of Chios, 248 f., 259 (n. to p. 248)
Maidens of the Acropolis. *See* Korai
Marathon Bay, Bronze Boy from, 170, 171,
175
Marsyas of Myron, Pl. XXXI B, 166–68;
not by the master of the Diskobolos, 135,
167, 257 (n. to p. 135); but by Myron of
Thebes, 167; possible occasion of its
dedication, 168
"Maussolos," a second-century work, Pl.
XLI, 214–16, 258 (n. to p. 214); other
statuary from the Maussoleum, 178, 215

Mechanism of human vision, 27–35; of
prime importance for understanding se-
quence of sculptural styles, 23; distinc-
tion between pictorial and sculptural
form, 23, 30–34
Metopes: with painted decoration, 60 f.;
origin of the carved metope, 61, 110;
from Temple of Zeus at Olympia, 118;
from Parthenon, 112, 142
Miletos, 15 f.; Milesians in the Delta, 15
Mimetic fidelity, of paramount influence
on the evolution of sculptural style, 53,
56, 172
Minoan art, 4 f., 17, 59
Modeling lines, 132, 135, 150 f., 177, 199
Motion lines, 144–50, 179, 199, 202
Mycenaean art, without influence on classi-
cal Greek sculpture, 5, 17, 59
Myron (*see also* Diskobolos, Marsyas):
Drunken Hag, Pl. XX, 134; "Myronic
moment" of suspended action, 83 f.; lack
of natural fidelity criticized by Cicero,
106
Myron the Younger (of Thebes), 167, 190

Naxos, 16
Nereid tomb: Attic connections, 168; free-
standing statues from, 168
New York *kouros*. *See* Kouroi
Nikandre, 5, 22, 53
Nike: by Paionios, Pl. XXIV, 139, 149,
203; Pitcairn, 145, 257 (n. to p. 145);
from Samothrace, Pl. XXXVII, 201–4,
207, 212 f., 258 (n. to p. 203)
Nike Parapet, Pl. XXIII, 136, 143, 146 f.,
156, 257 (n. to p. 143)
Niobid ("Stumbling"), Pl. XVIII; treat-
ment of drapery, 132 f.; related to Nike
Parapet? 146; partial nudity, 217; un-
feminine anatomy, 217
Nudity in Greek sculpture, 10 f., 20; ban on
feminine nude partially evaded in fifth
century, 217; fully lifted in fourth century,
217; formulation of the male nude can-
on, 43; influenced the subsequent femi-
nine canon, 217

Olympia: for Temple of Zeus, *see* Pedimental Sculpture *and* Metopes; for Nike by Paionios, *see* Nike

Parthenon, 109; frieze, Pl. XXI, 112, 142, 148, 200; metopes, 112, 142; for pediments, *see* Pedimental Sculpture

Pattern in archaic sculpture, 36, 49 f.; its two-dimensional nature, 39

PEDIMENTAL SCULPTURE:
its origin in tympanon designs carved in relief, 110 f.
early relief-pediments at Athens, Corfu, and Delphi, 111
substitution of statues in-the-round for relief, 111–14, 127
from Aegina, 113–16, 117, 119
at Olympia, Pls. XV–XVII, 117–21, 127–32, 136, 257 (n. to p. 117)
on the Parthenon, Pl. XIX, 127 f., 132, 137 f., 148 f., 151, 163
elsewhere, 117, 136

PERGAMON:
under Attalos I, 190; who collected sculptural masterpieces of earlier masters, 190; had copies of Attic work made, 191; and patronized contemporary artists to commemorate his exploits, 185, 193; presented similar works to Athens, 194 f.; was succeeded by Eumenes, who was even more addicted to art, 199; inducing a revival of classic styles, 199
altar of Zeus, 199–201, 226, 258 (n. to p. 199)
works by Pergamenian artists: "Beautiful Head," 248; Dancing Girl relief, 226; draped feminine statuary, 205 f.; dying combatants, half life-size, 194 f.; Dying Trumpeter, 193, 196; Nike from Samothrace, Pl. XXXVII, 201–4, 207, 212 f.; Suicidal Gaul and wife, 222–24; "Zeus-Hero" from sanctuary of Hera, Pl. XXXVIII, 204 f., 216

Perspective in Greek art, 29 f.

*Petite Boudeuse* ("Little Pouting Girl"). *See* Korai

Polykleitos, 100–2, 105–8, 163; School of, 161; his technical aphorisms, 72, 101; works by: *see* Doryphoros; other works mentioned, 161, 163, 167, 246, 257 (n. to p. 100)

Ponderation. *See* Balance, Pose

PORTRAIT SCULPTURE:
technically unachievable during archaic and formal periods, 228–32
fourth-century portraiture, 230–32, 247; portraits of Alexander, 232
popularity of sculptural portraits in third century, 188 f., 241
characteristics of third-century portraits, 234, 241
life masks *not* recorded for Lysistratos, and highly improbable, 233
portrait heads on coins, 237–39, 240
introduction of wax models and a plastic technique, 236–41
second-century plastic portrait heads in bronze, 241–45; head from Delos, Pl. XLIV, 241–43; "Old Man from the Sea," Pl. XLV, 242
imaginary portraits of famous persons: Sokrates, 230, 244; Corinna and Sappho, by Silanion, 231, 243; Homer and Hesiod, 244, 247
Achillean portrait statues, 245 f.
plastic portrait heads in marble copies, 246 f.
modern literature on Greek portrait sculpture, 259

POSE:
"Egyptianizing," in early *kouroi*, 10
gradually modified in Anavysos *kouros*, 46 f.; and Kritios Boy, 103–5
Polykleitan chiastic pose, 10, 105
"Attic" stance, 163 f.
dynamic poses first attempted in bronze: Diskobolos, 80–83; Tyrannicides, 119, 165; "Poseidon" of Artemision, 165; Protesilaos, 166; Marsyas, 166 f.
translated in marble: in Aegina pediments, 113, 115; in Nereids, 168

Pose—*Continued*
axial rotation introduced by Lysippos: Apoxyomenos, 173 f.; Ares Ludovisi, 183 f.
complete spiral torsion in Lysippan school, 182–84
counter-torsion, a second-century innovation, 201, 212
Poseidon: from Artemision, Pl. XXX, 165, 173; from Melos, 212
"Pouting Girl." *See* Korai
Praxiteles, 44 f., 50, 169–75; Knidian Aphrodite, 172, 174, 197, 212, 217; Olympia, Hermes with Infant Dionysos, 171, 175; other works, 171, 175; sons of, 181, 257 (n. to p. 181)
Praying Boy, bronze, 182, 197
Primitive sculpture: in-the-round, none in Greece, with one possible exception, 3 f.; in relief, in southern Italy and Sicily, 59; traces of primitivism in early archaic work, 13

Quadrifaciality: an essential characteristic of all archaic statuary, 11 f., 38; still preserved in Polykleitan works, 107; gradually dissipated during fourth century 164 ff., 173; entirely overcome by Lysippan School, 182 f.

Ram-bearer of Thasos, Pl. I, 11 f., 14, 24
Rampin Head, 54 f.
Reflected Light, contrast between marble and bronze, 67, 126, 129
Relief: Chap. III, 59–65
of greater antiquity than monumental sculpture in Greece, 4, 59
originates in pictorial graphic art, 60 f.
funereal relief, in Egypt, 60; in Attica: stēlē of Aristion, Pl. VIII, 61 f., 63–65; gravestone of Hegeso, 152, 175; fourth-century gravestones, 176, 178
in architecture: as frieze of the order (Parthenon), 122, 200; at Bassai, 175 f.; as socle frieze (Pergamon altar), 199 f.; for column drums (Ephesos), 176 f.

attraction to monumental sculpture, 61 f.
technical characteristics: 62–65; depth of cutting, 62–64; high *vs.* low relief, 112 f.
specimens analyzed or described: stēlē of Aristion, Pl. VIII, 61, 63–65; "Mourning Athena," 144; gravestone: of Hegeso, 152, 175; of Dexileos, Pl. XXII, 142, 176; from the Ilissos, 176; column drum from Ephesos, Pl. XXXIII, 176 f.
second-century reliefs, 226 f.
Romanesque and Gothic sculpture, contrasted with Greek, 21, 51, 53, 109

Samos: in contact with Egypt, 15; an important early center for bronze work, 69, 119; "Hera of Samos," 19, 21, 53, 85; "Samian Women" of the Acropolis at Athens, 53
Samothrace. *See* Nike
Schematic patterns, 36; in hair, 49 f.
Schematic structure of archaic statuary, 40
Sculpture:
an art of direct visual presentation, 123, 206; revitalizing the living form, 51, 208; not a tactile art, 34 f.; concerned with the exterior world beyond the retinal image, 32 f., 35 f., 38, 56 f.
not dependent on clay models, 33, 35; a purely glyptic discipline, originating in limestone and marble, 34; with bronze a later venture, 66
monumental terracottas, 34
stylistic evolution directly dependent on the mechanism of human vision, 48; and governed by a constant trend toward mimetic fidelity, 46 f., 56, 58, 172; little affected by political events, 55, 180
Shadow: stereoscopic effect of, 129, 135, 202; use of in marble statues, 113, 126, 129, 205, 215. *See also* Reflected Light
Space, in sculptural art, 122 f.
Stereoscopic vision, 28–31, 33; its application to sculpture, 40, 128–33, 164 f., 183, 201 f.

SUBJECT MATTER OF GREEK SCULPTURE:
restricted range in early period, 19 f., 22,
24–26; Oriental themes derived from
minor arts, 24; original Greek inven-
tions, 25
Greek statuary always motivated by spe-
cific purpose or meaning, 168; fune-
rary statues, 19, 22; grave-reliefs, 19;
*kouros* type converted to other themes,
20, 22, 104; athletic victor statues, 20,
100, 105; Apollo, 100, 119; gods and
heroes, 19
themes from pictorial art converted to
sculptural form, 81 f., 111; centaurs
and satyrs, 26, 119, 131, 167
*See also* Portrait Sculpture
*Symmetria* not to be translated "symme-
try," but integral numerical propor-
tion, 92; how determined, 93 f.; re-
sponsible for sculptural canons, 99

Tanagrettes: influenced by monumental
types, 6, 194; without influence upon
monumental sculpture, 194

Tectonic appeal, 41 ff.; in architecture, 41;
in ceramic design, 42; in sculptural
anatomy, 43 f.
Thasos, 11, 14. *See also* Ram-bearer
Torsion, 164–69, 182–84; counter-torsion,
201, 212
Transparency: archaic origin of the device,
52 f.; fifth-century exploitation of,
139 f.; Hellenistic revival of, 202, 203,
209 f.
Tyrannicides, by Kritios and Nesiotes, 97,
119, 165, 173

Venus. *See* Aphrodite
Victory. *See* Nike

Writing: its introduction into Greece,
17 f.; comparison with introduction of
monumental sculpture, 17 f.

*Xoana*, 20

# PLATES

*Plate I.* KRIOPHOROS OF THASOS. Photograph by courtesy of École Française d'Athènes.

*Plate II.* ARCHAIC KOUROS IN NEW YORK: FRONT AND REAR. Courtesy, The Metropolitan Museum of Art (Fletcher Fund, 1932).

*Plate III.* ARCHAIC KOUROS IN NEW YORK: LATERAL VIEWS. Courtesy, The Metropolitan Museum of Art (Fletcher Fund, 1932).

*Plate IV.* LYONS KORĒ; TWO VIEWS. Acropolis Museum, Athens, Photographs by courtesy of the German Archaeological Institute in Athens.

*Plate V.* ANAVYSOS KOUROS: HEAD. Athens National Museum. Photograph by courtesy of the German Archaeological Institute in Athens.

*Plate VI.* ANAVYSOS KOUROS: TWO VIEWS. Athens National Museum. Photographs by courtesy of the German Archaeological Institute in Athens.

*Plate VII.* HEAD OF THESEUS FROM ARCHAIC PEDIMENT. Chalkis Museum, Greece. Photograph by Alison Frantz, Athens.

*Plate VIII.* STELE OF ARISTION: DETAIL. Athens National Museum. Photograph by Alinari, Rome.

*Plate IX.* MYRON'S DISKOBOLOS: RECONSTRUCTION AND BRONZE STATUETTE. National Museum, Rome. Photograph by Anderson, Rome.

*Plate X.* BRONZE CHARIOTEER OF DELPHI: TWO VIEWS. Delphi Museum.

*Plate XI.* EUTHYDIKOS KORĒ. Acropolis Museum. Photograph by courtesy of the German Archaeological Institute in Athens.

*Plate XII.* (A) HEAD OF "BLOND BOY." Acropolis Museum. (B) HEAD OF "KRITIOS BOY." Athens National Museum. Photographs by G. Mackworth-Young. Courtesy of the Cresset Press, London.

*Plate XIII.* DORYPHOROS OF POLYKLEITOS: RECONSTRUCTION. Munich, Archäologisches Seminar.

*Plate XIV.* DORYPHOROS OF POLYKLEITOS: TORSO. National Museum, Rome.

*Plate XV.* OLYMPIA, TEMPLE OF ZEUS, WEST PEDIMENT: KNEELING LAPITH. Olympia Museum. Photograph by Alison Frantz.

*Plate XVI.* OLYMPIA, TEMPLE OF ZEUS, WEST PEDIMENT: GROUP OF LAPITHS AND CENTAUR. Olympia Museum. Photograph by Alinari.

*Plate XVII.* OLYMPIA, TEMPLE OF ZEUS, EAST PEDIMENT: KNEELING ATTENDANT. Olympia Museum. Photograph by Walter Hege.

# GREEK SCULPTURE

*Plate XVIII.* STUMBLING NIOBID. National Museum, Rome.

*Plate XIX.* (A) PARTHENON EAST PEDIMENT: SEATED GODDESS. British Museum, London. (B) PARTHENON WEST PEDIMENT: "IRIS." British Museum.

*Plate XX.* MYRON'S DRUNKEN OLD WOMAN. Munich, Glyptothek.

*Plate XXI.* PARTHENON WEST FRIEZE: TWO SECTORS. Photographs by Alison Frantz.

*Plate XXII.* GRAVE RELIEF OF DEXILEOS: DETAIL. Athens National Museum. Photograph by Alison Frantz.

*Plate XXIII.* NIKE PARAPET: TWO FIGURES. Acropolis Museum.

*Plate XXIV.* NIKE OF PAIONIOS. Olympia Museum. Photograph by Walter Hege, by courtesy of the German Archaeological Institute in Athens.

*Plate XXV.* COLOSSAL CYBELE. Photograph by courtesy of the Museum of Fine Arts, Boston.

*Plate XXVI.* LEDA WITH THE SWAN: TWO VIEWS. Photographs by courtesy of the Museum of Fine Arts, Boston.

*Plate XXVII.* MAENAD RELIEFS: TWO FIGURES. National Museum, Madrid.

*Plate XXVIII.* BRONZE BALLPLAYER. Athens National Museum. Photograph by Alison Frantz.

*Plate XXIX.* BRONZE BALLPLAYER: DETAIL. Athens National Museum. Photograph by Alison Frantz.

*Plate XXX.* BRONZE "ZEUS" OF ARTEMISION. Athens National Museum.

*Plate XXXI.* (A) PROTESILAOS. Metropolitan Museum of Art, New York. Courtesy, The Metropolitan Museum of Art (Hewitt Fund, 1925). (B) LATERAN MARSYAS. Lateran Museum, Rome. Photograph from the Photographic Archives of the Vatican.

*Plate XXXII.* (A) CAPITOLINE RUNNER. Conservatori Museum, Rome. (B) DRESDEN BOXER. Albertinum, Dresden.

*Plate XXXIII.* COLUMN DRUM FROM EPHESOS. British Museum.

*Plate XXXIV.* BRONZE SEATED HERMES FROM HERCULANEUM. Naples Museum.

*Plate XXXV.* BRONZE HEAD FROM PERINTHOS. Athens National Museum.

*Plate XXXVI.* APHRODITE FROM CYRENE. National Museum, Rome. Photograph by Anderson.

*Plate XXXVII.* NIKE FROM SAMOTHRACE: TWO VIEWS. Louvre, Paris. Photographs by Alinari.

*Plate XXXVIII.* "ZEUS-HERO" FROM PERGAMON. Istanbul Museum.

*Plate XXXIX.* (A) KNIDIA OF PRAXITELES: HEAD. Vatican Museum. (B) APHRODITE OF MELOS: HEAD. Louvre.

*Plate XL.* DEMETER OF KNIDOS. British Museum. Photograph by courtesy of Hirmer Verlag, Munich.

*Plate XLI.* "MAUSSOLOS." British Museum.

*Plate XLII.* MEDICI VENUS AND NEW YORK REPLICA. Capitoline Museum, Rome. Metropolitan Museum of Art, New York. Courtesy, The Metropolitan Museum of Art (Fletcher Fund, 1952).

*Plate XLIII.* FOUR HEADS: FIFTH, FOURTH, AND THIRD CENTURIES. (A) Bronze Head. Glyptothek, Munich. (B) Head of Alexander. Acropolis Museum. (C) Bronze Head. National Museum, Naples. (D) Marble Head. Archaeological Museum, Venice.

*Plate XLIV.* BRONZE PORTRAIT HEAD FROM DELOS. Athens National Museum. Photograph by Alison Frantz.

*Plate XLV.* BRONZE HEAD OF OLD MAN FROM THE SEA. Athens National Museum. Photograph by Alison Frantz.

*Plate XLVI.* (A) BRONZE HEAD OF BOXER FROM OLYMPIA. Athens National Museum. Photograph by Hermann Wagner. (B) "HELLENISTIC RULER": HEAD. National Museum, Rome.

*Plate XLVII.* (A) BRONZE "HELLENISTIC RULER." National Museum, Rome. Photograph by Anderson. (B) COLOSSAL DIOSKUROS OF MONTE CAVALLO. Rome. Photograph by Anderson.

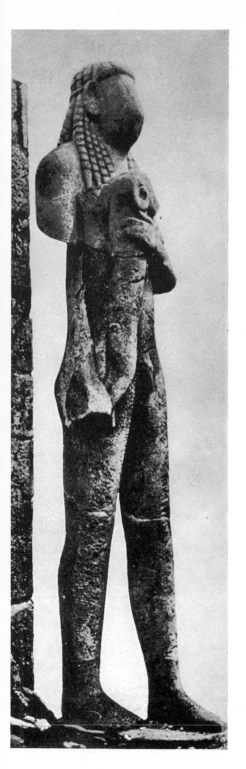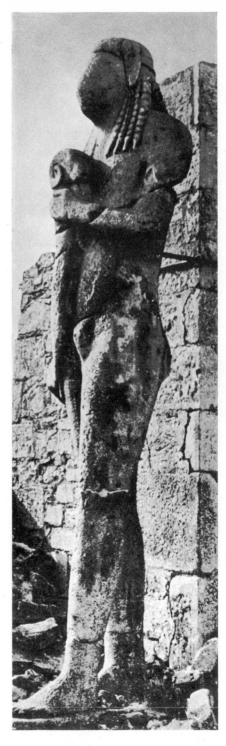

PLATE I

KRIOPHOROS OF THASOS

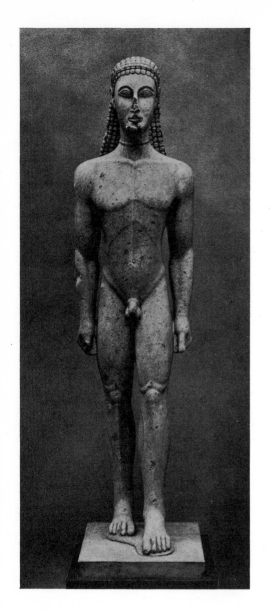
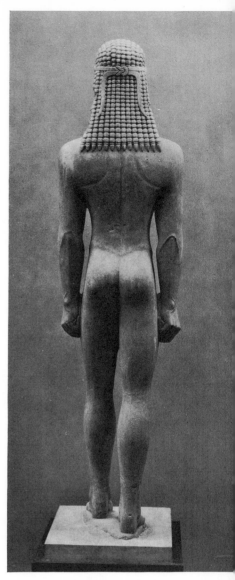

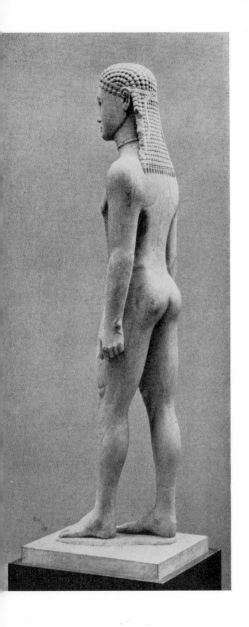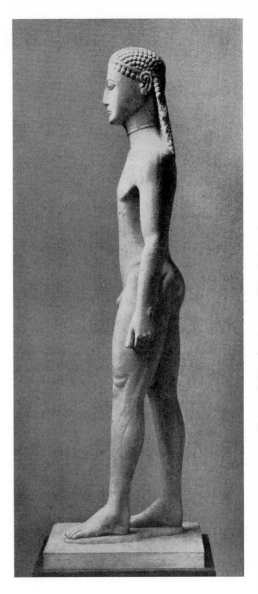

PLATE III
ARCHAIC KOUROS IN NEW YORK: LATERAL VIEWS

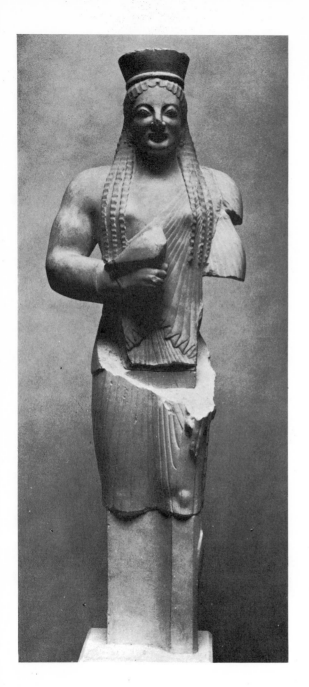
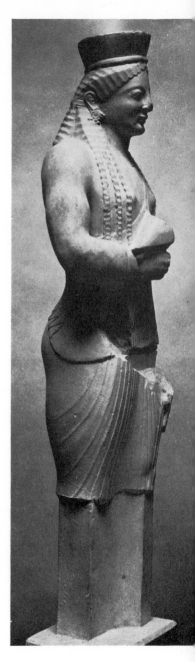

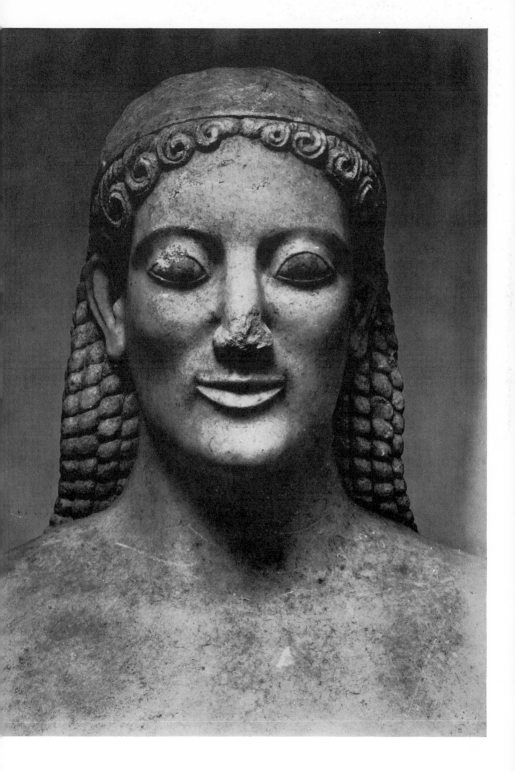

PLATE V
ANAVYSOS KOUROS: HEAD

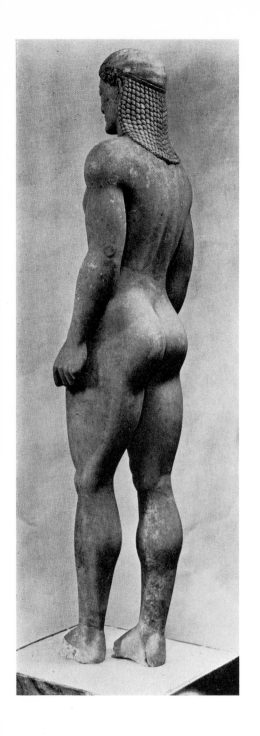
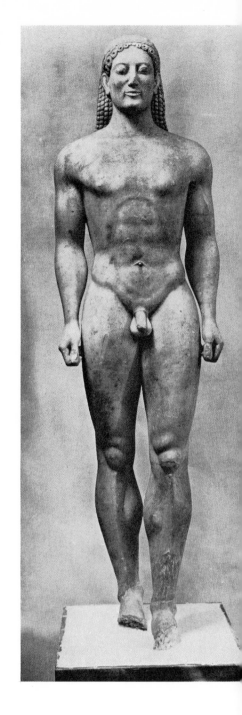

PLATE V

ANAVYSOS KOUROS: TWO VIEW

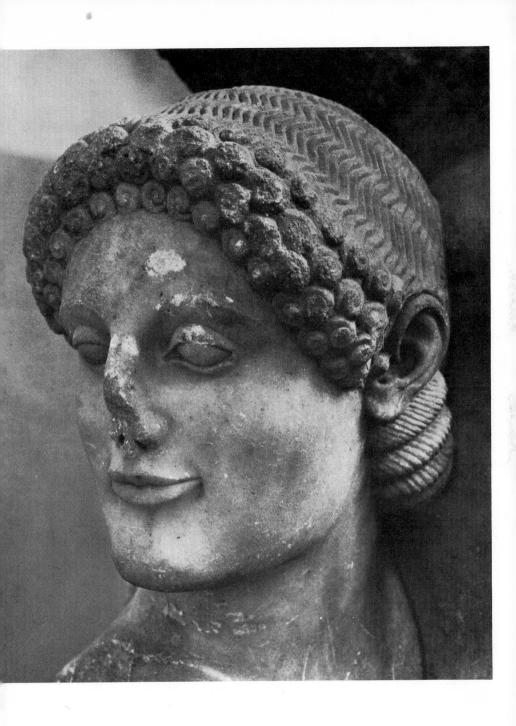

PLATE VII

HEAD OF THESEUS FROM ARCHAIC PEDIMENT

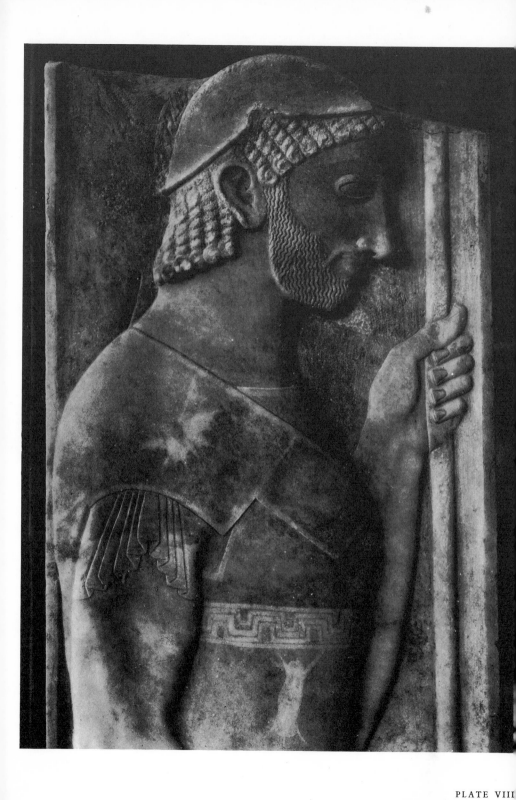

PLATE VIII

STELE OF ARISTION: DETAIL

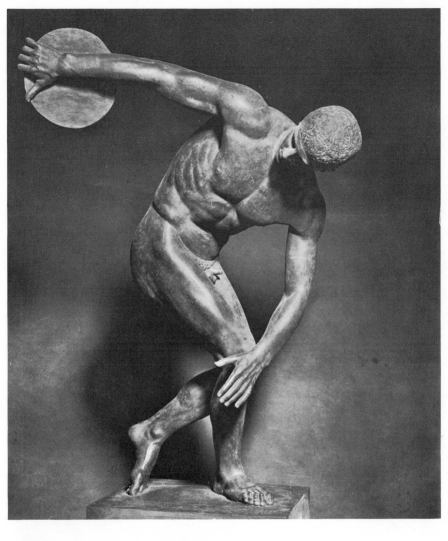

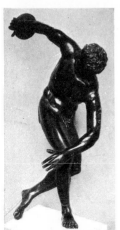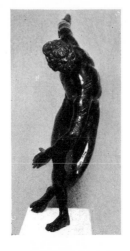

PLATE IX
MYRON'S DISKOBOLOS:
RECONSTRUCTION
AND BRONZE STATUETTE

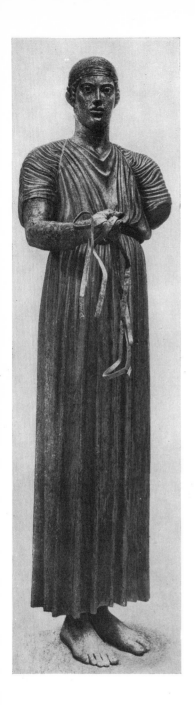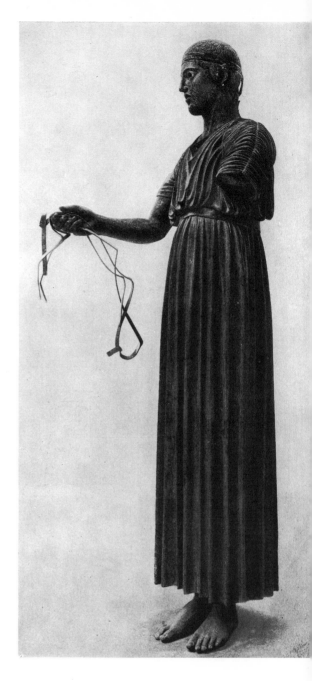

PLATE X

BRONZE CHARIOTEER OF DELPHI: TWO VIEWS

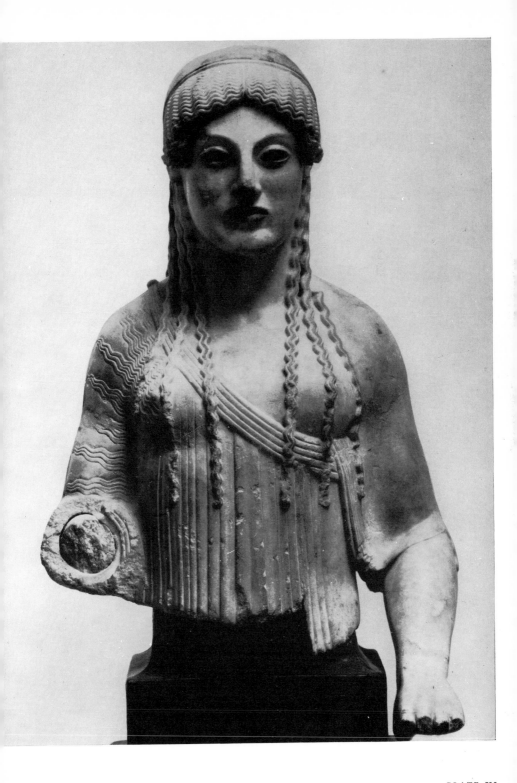

PLATE XI
EUTHYDIKOS KORĒ

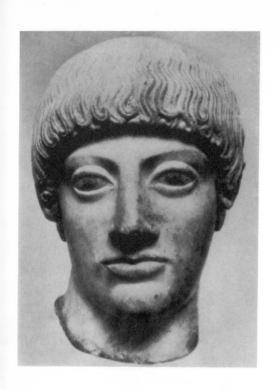

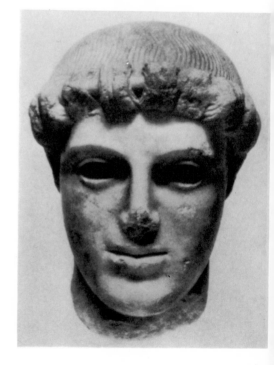

PLATE XII
(A) HEAD OF "BLOND BOY"
(B) HEAD OF "KRITIOS BOY"

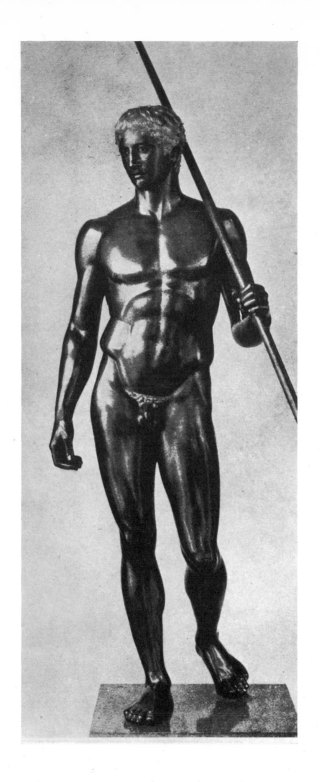

PLATE XIII

DORYPHOROS OF POLYKLEITOS: RECONSTRUCTION

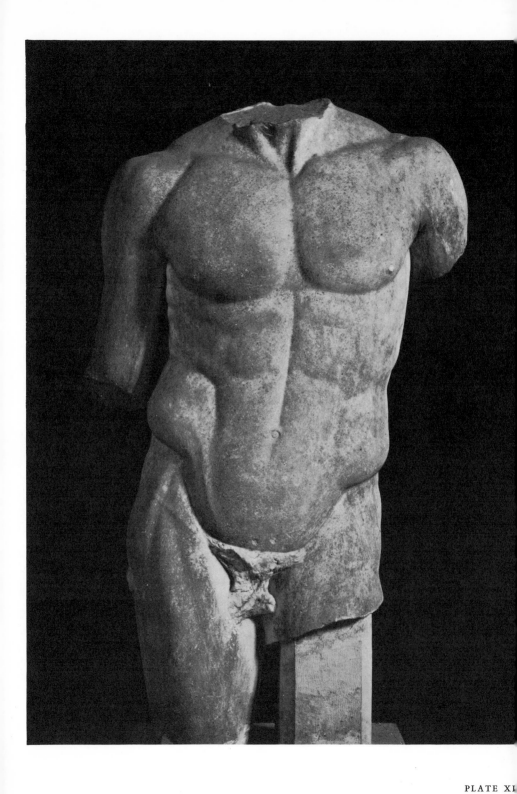

PLATE XI

DORYPHOROS OF POLYKLEITOS: TORS

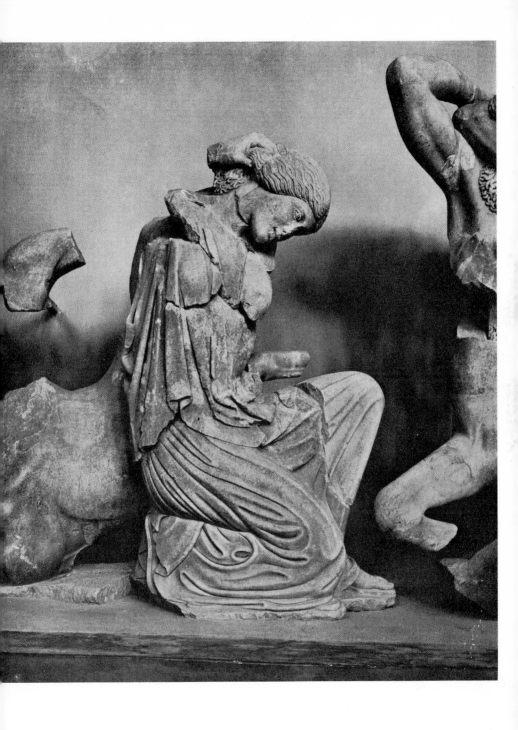

PLATE XV

OLYMPIA WEST PEDIMENT: KNEELING LAPITH

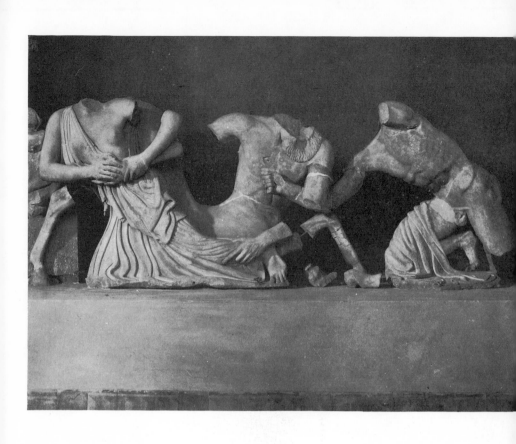

PLATE XV

OLYMPIA WEST PEDIMENT: GROUP OF LAPITHS AND CENTAU

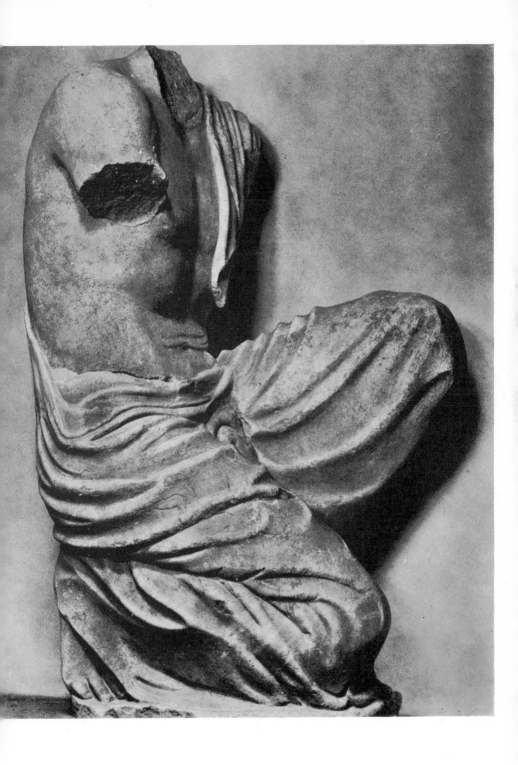

PLATE XVII

OLYMPIA EAST PEDIMENT: ATTENDANT

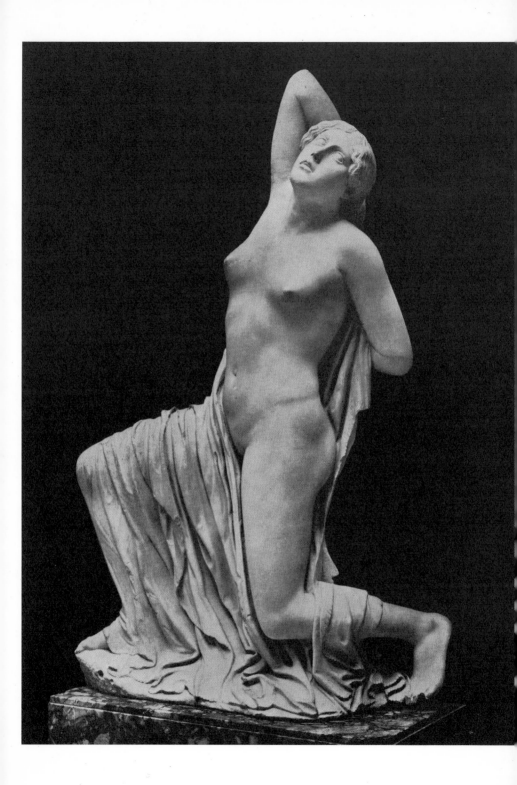

PLATE XVIII

STUMBLING NIOBID

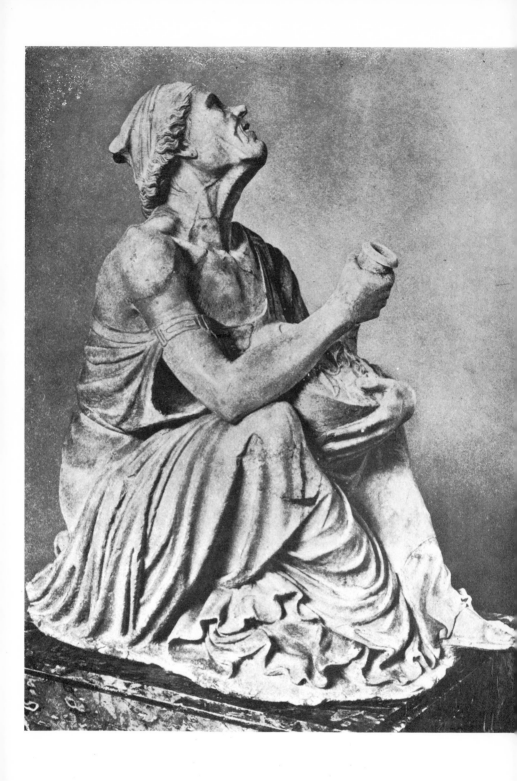

PLATE X·

MYRON'S DRUNKEN OLD WOMAN

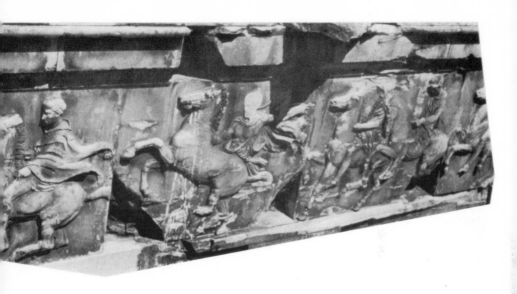

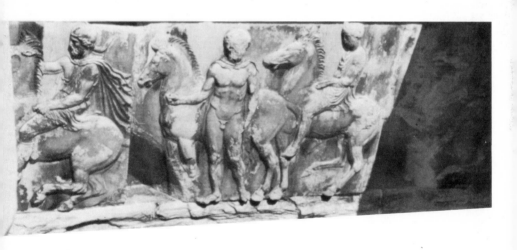

PLATE XXI
PARTHENON WEST FRIEZE: TWO SECTORS

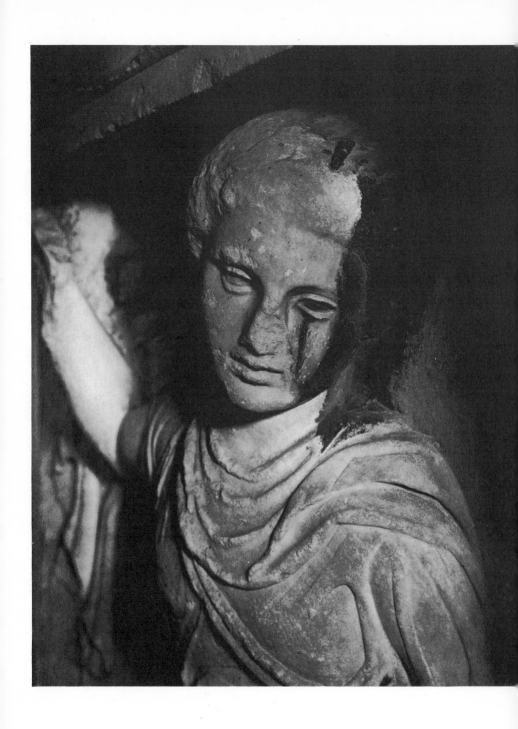

PLATE X)

GRAVE RELIEF OF DEXILEOS: DETA

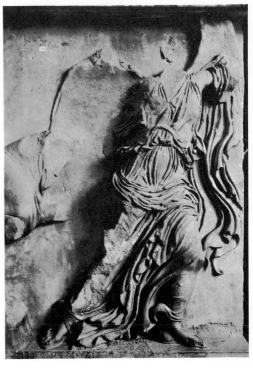

PLATE XXIII

NIKE PARAPET: TWO FIGURES

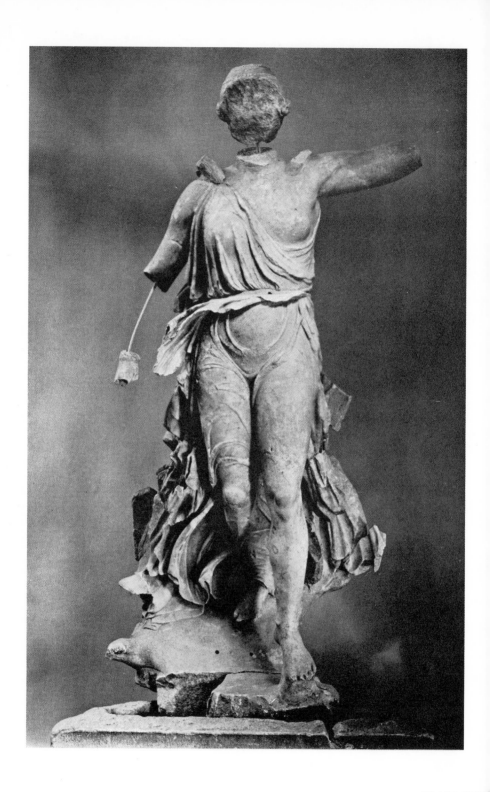

PLATE XXIV

NIKE OF PAIONIO

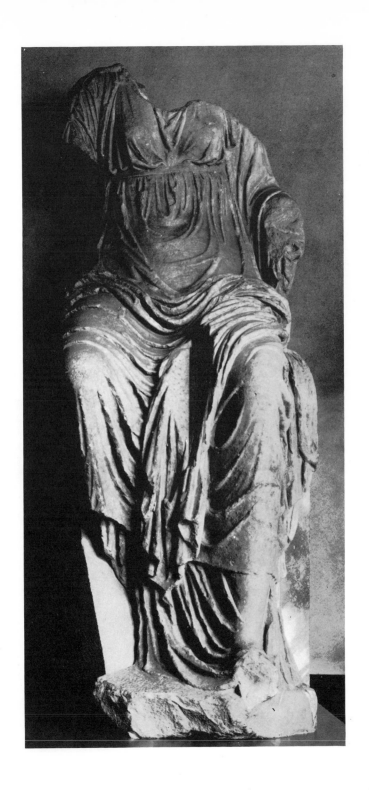

PLATE XXV
COLOSSAL CYBELE

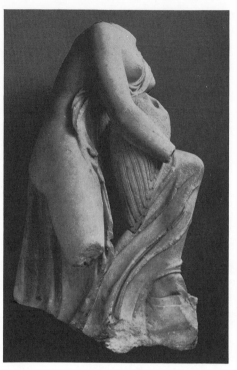

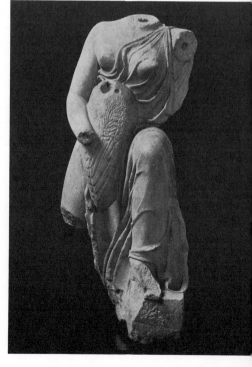

PLATE XX

LEDA WITH THE SWAN: TWO VIEW

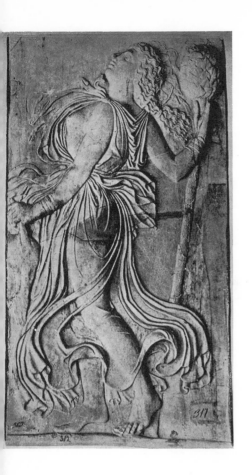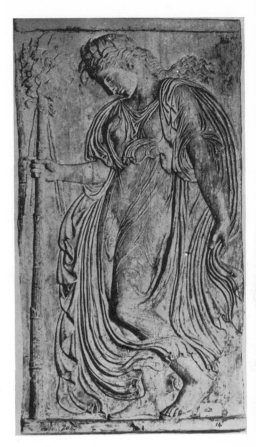

PLATE XXVII

MAENAD RELIEFS: TWO FIGURES

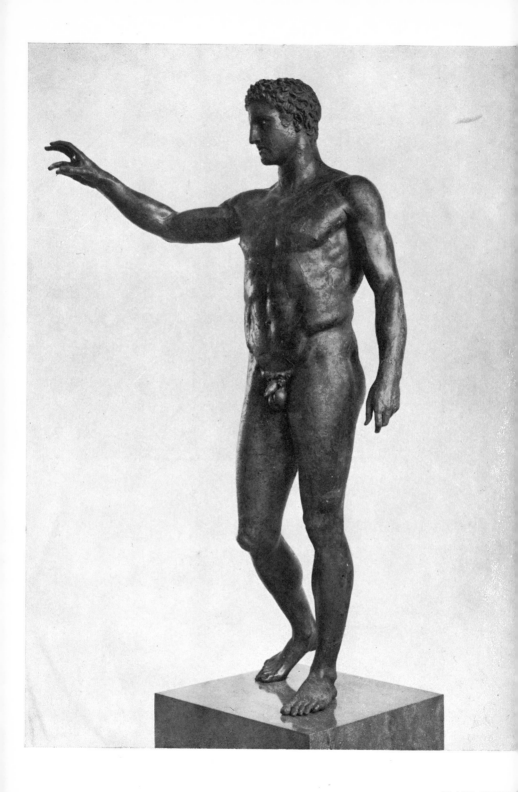

PLATE XXVII
BRONZE BALLPLAYER

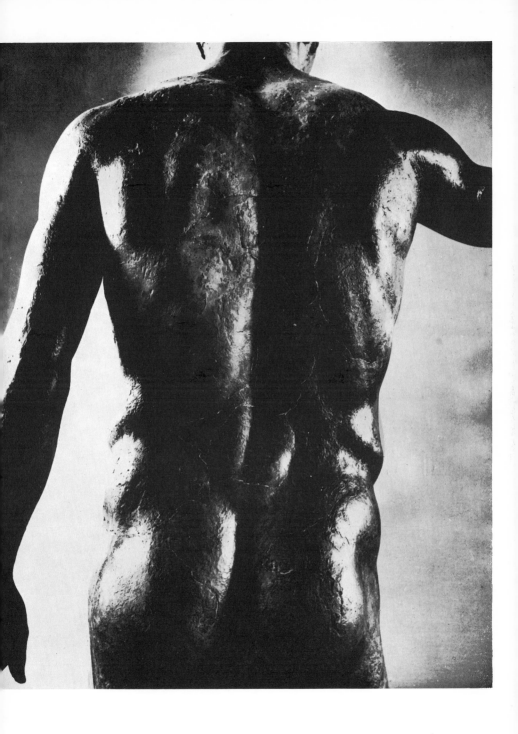

PLATE XXIX
BRONZE BALLPLAYER: DETAIL

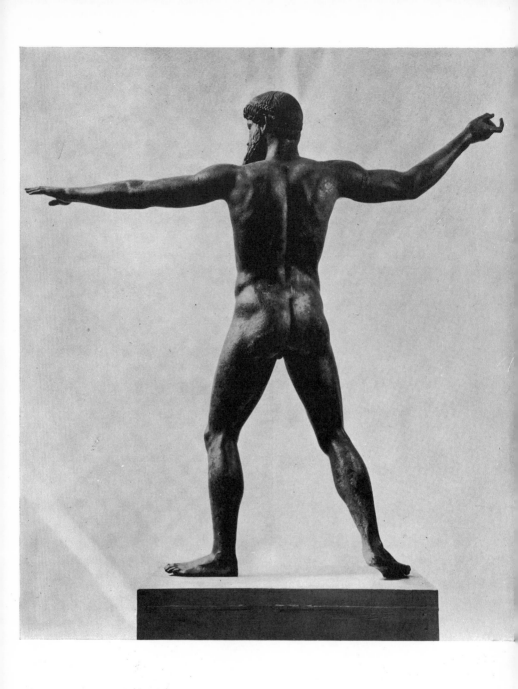

PLATE XXX
BRONZE "ZEUS" OF ARTEMISION

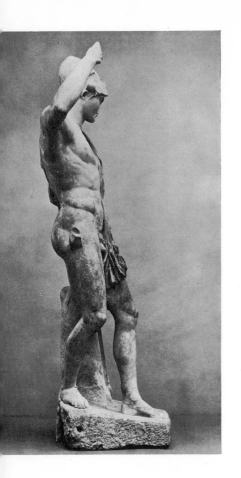

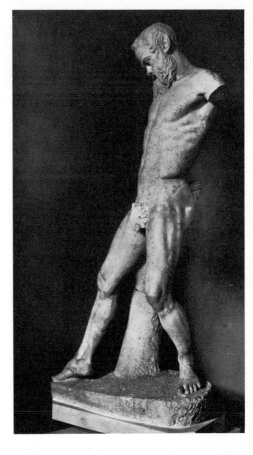

PLATE XXXI
(A) PROTESILAOS
(B) LATERAN MARSYAS

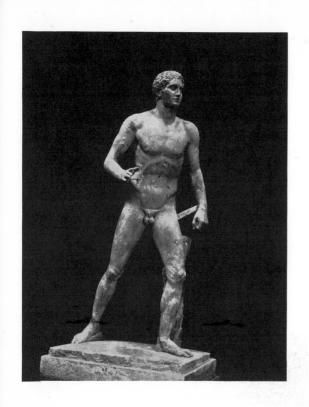

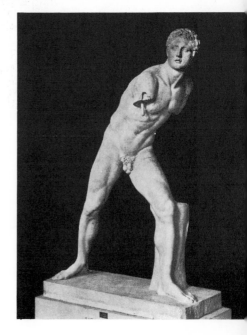

1206

PLATE XXXIII

COLUMN DRUM FROM EPHESOS

PLATE XXXI

BRONZE SEATED HERMES FROM HERCULANEU

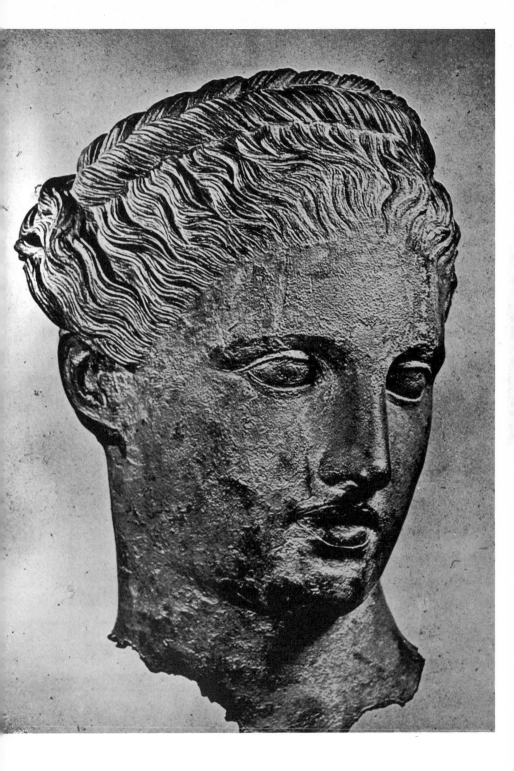

PLATE XXXV

BRONZE HEAD FROM PERINTHOS

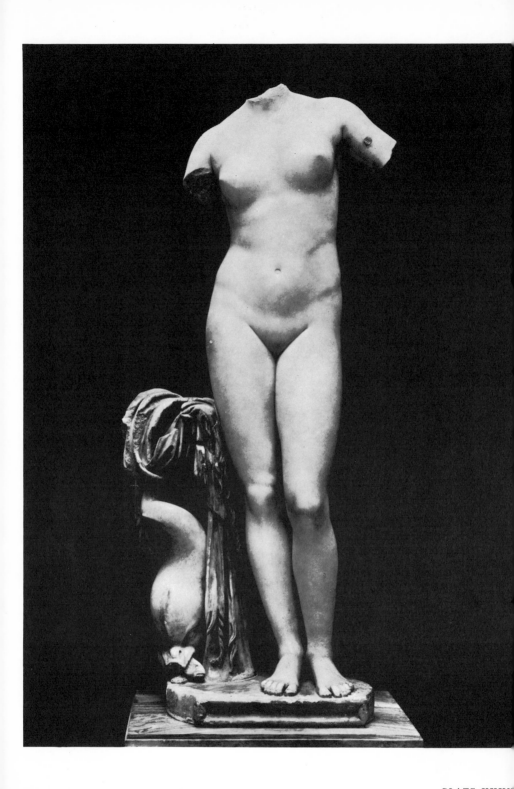

PLATE XXXV

APHRODITE FROM CYREN

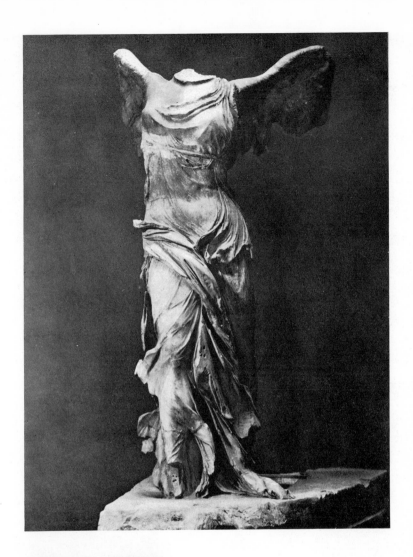

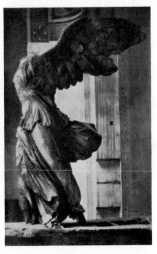

PLATE XXXVII

NIKE OF SAMOTHRACE: TWO VIEWS

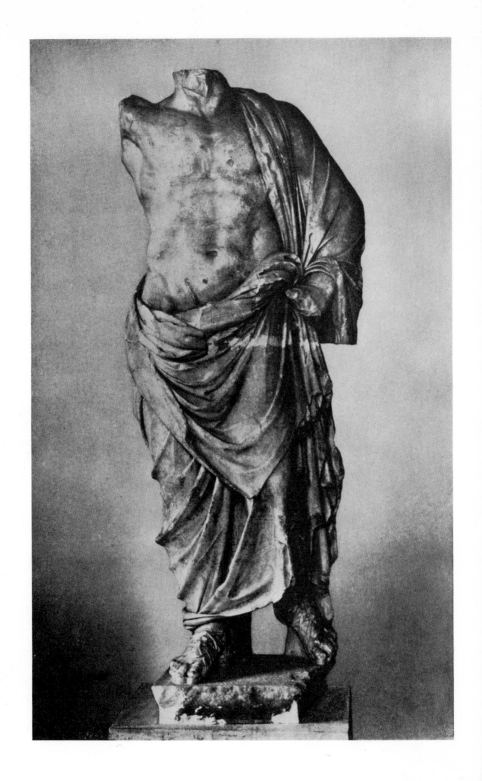

PLATE XXXVII
"ZEUS-HERO" FROM PERGAMON

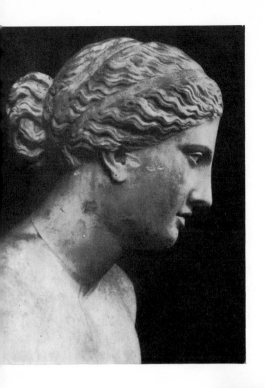

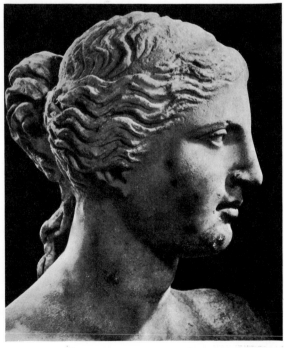

PLATE XXXIX
(A) KNIDIA OF PRAXITELES: HEAD
(B) APHRODITE OF MELOS: HEAD

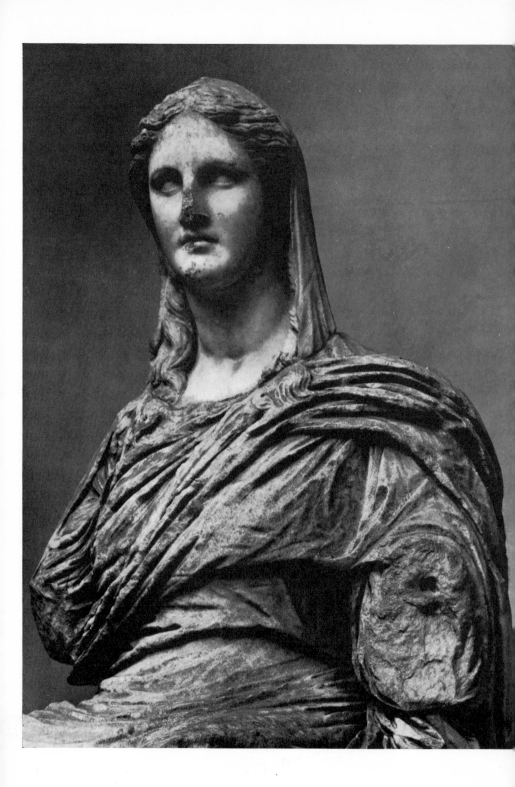

PLATE X

DEMETER OF KNIDO

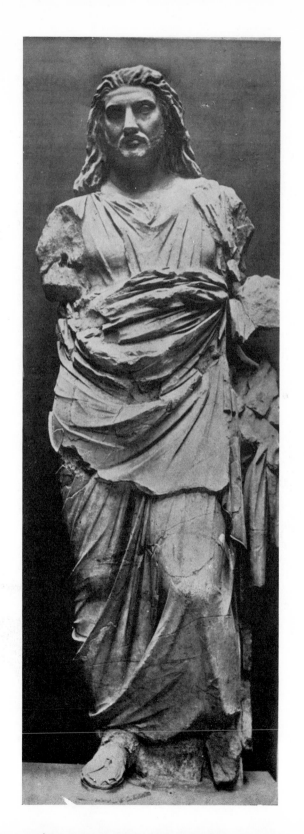

PLATE XLI
"MAUSSOLOS"

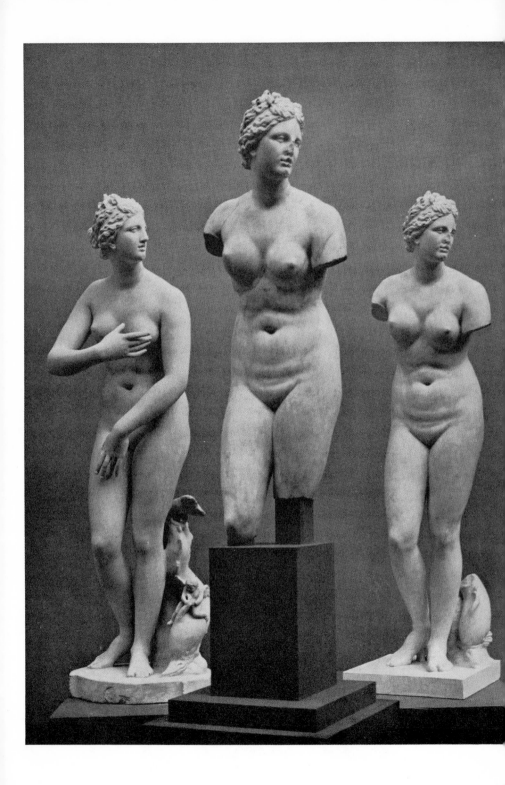

PLATE X

MEDICI VENUS AND NEW YORK REPLI

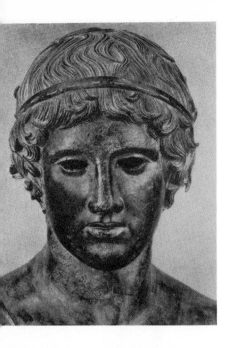
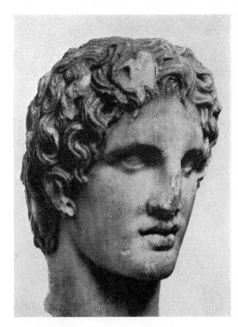
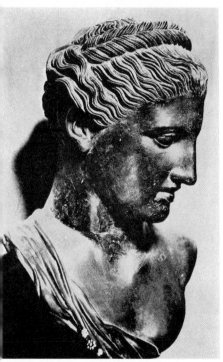
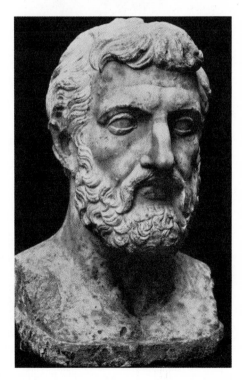

PLATE XLIII
FOUR HEADS: FIFTH, FOURTH, AND THIRD CENTURIES

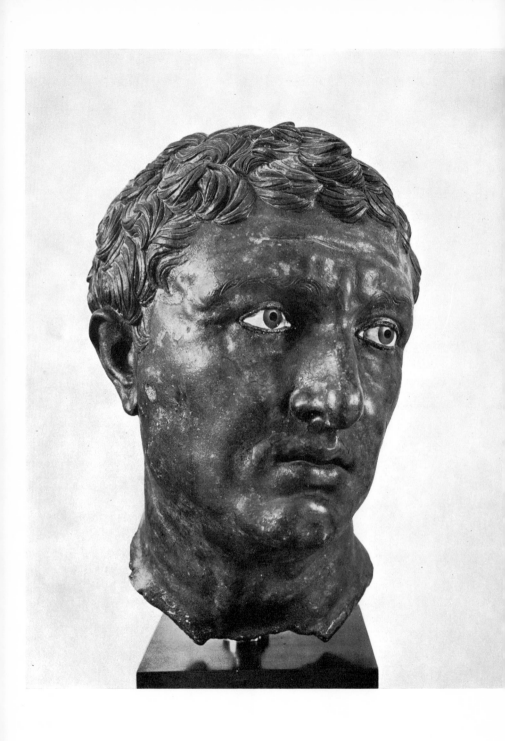

PLATE X

BRONZE PORTRAIT HEAD FROM DE

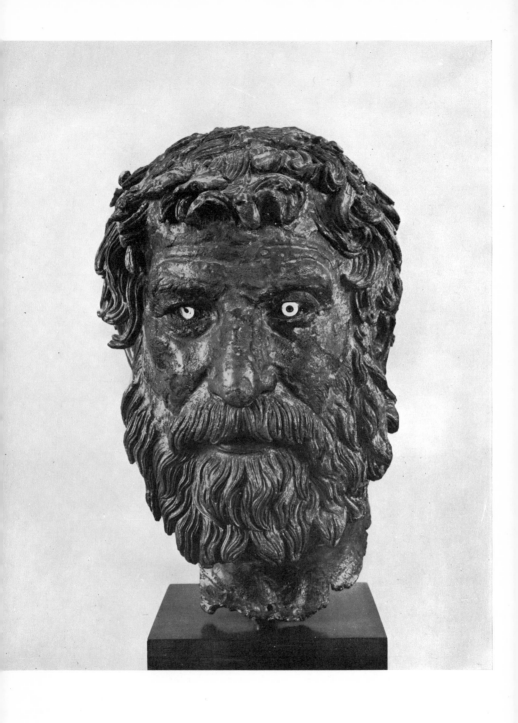

PLATE XLV
BRONZE HEAD OF OLD MAN FROM THE SEA

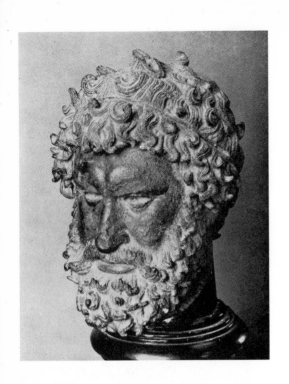

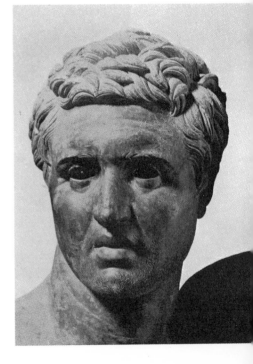

PLATE XL

(A) BRONZE HEAD OF BOXER FROM OLYMPI

(B) "HELLENISTIC RULER": HEA

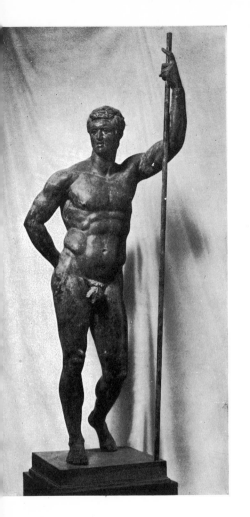
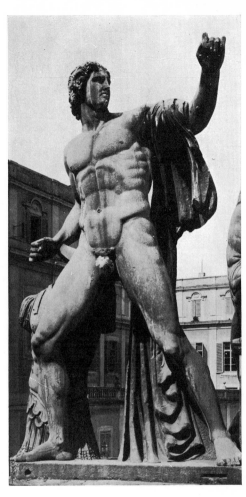

PLATE XLVII
(A) BRONZE "HELLENISTIC RULER"
(B) COLOSSAL DIOSKUROS OF MONTE CAVALLO